SURREALISM

Genesis of a Revolution

Author: Nathalia Brodskaïa

Layout:
Baseline Co Ltd,
33 Ter - 33 Bis Mac Dinh Chi St.,
Star Building, 6th Floor
District 1, Ho Chi Minh City
Vietnam

Nathalia Brodskaïa

SURREALISM
Genesis of a Revolution

PARKSTONE
INTERNATIONAL

ONTENTS

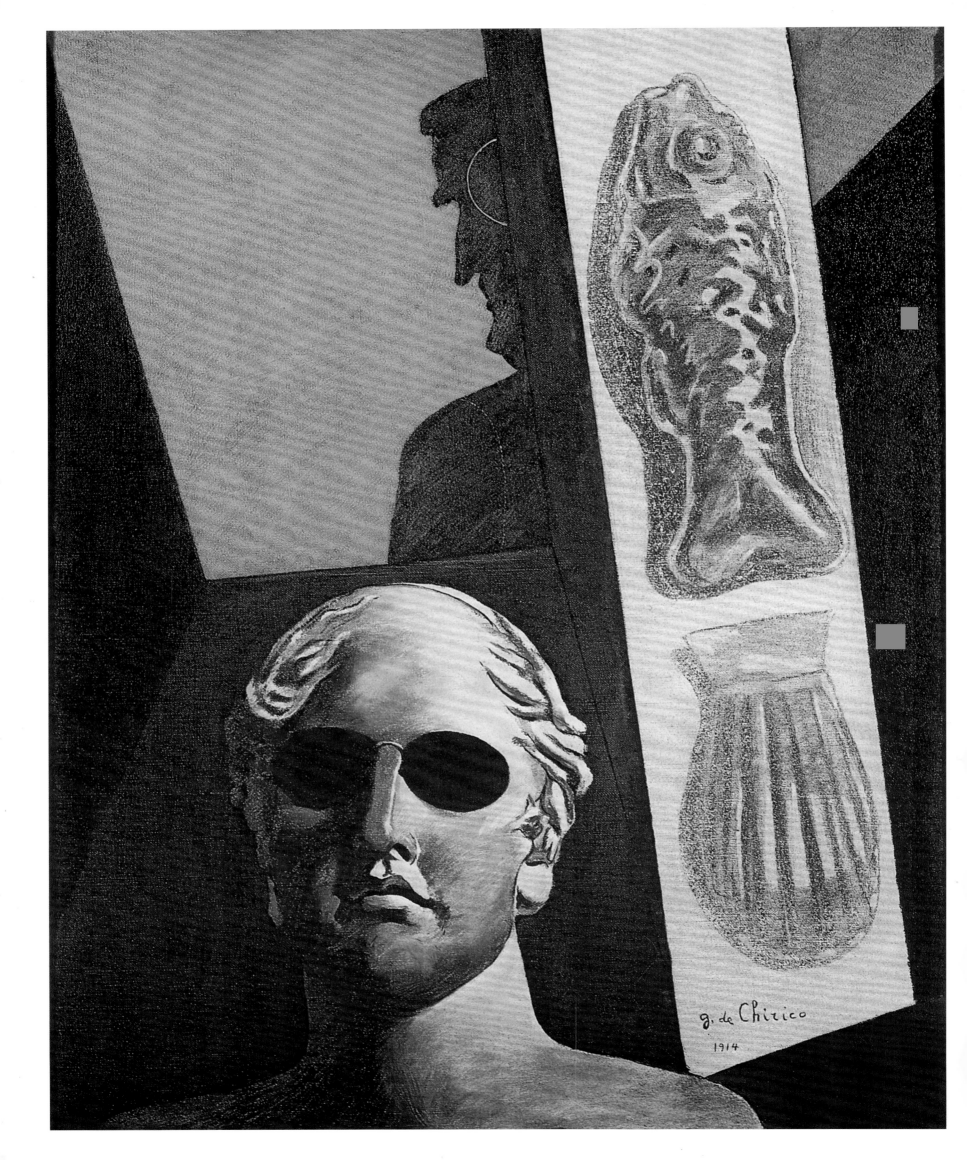

SURREALISM

GIORGIO DE CHIRICO: THE CATALYST OF SURREALISM

The history of Surrealism maintains a beautiful legend. After a long voyage, a sailor returned to Paris. His name was Yves Tanguy. As he was riding in a bus along the Rue La Boétie, he saw a picture in the window of one of the numerous art galleries. It depicted a nude male torso against the background of a dark, phantasmal city. On a table lays a book, but the man is not looking at it. His eyes are closed. Yves Tanguy jumped out of the bus while it was still in motion and went up to the window to examine the strange picture. It was called *The Child's Brain*, and was painted by the Italian Giorgio de Chirico. The encounter with the picture determined the sailor's fate. Tanguy stayed on shore for good and became an artist, although until then he had never held either a pencil or a paintbrush in his hands.

This story took place in 1923, a year before the poet and psychiatrist André Breton published the *Surrealist Manifesto* in Paris. Like any legend, it does not claim to be exact in its details. One thing cannot be doubted: Giorgio de Chirico's painting produced such an unforgettable impression that it became one of the sources of the art of Surrealism as it began to develop after the First World War. *The Child's Brain* had a wonderful effect on someone else besides Yves Tanguy. "Riding along the Rue La Boétie in a bus past the window of the old Paul Guillaume Gallery, where it was on display, I stood up like a jack-in-the-box so I could get off and examine it close up", André Breton later recalled. "For a long time I could not stop thinking about it and from then on I did not have any peace until I was able to acquire it. Some years later, on the occasion of a general exhibition of de Chirico [paintings], this painting returned from my home to where it had been before (the window of Paul Guillaume), and someone else who was going that way on the bus gave himself up to exactly the same impulse, which is exactly the reaction it still provokes in me all this time after our first encounter, now that I have it again on my wall. The man was Yves Tanguy."[1]

The consistency and details of the events are not as important as the basic fact that de Chirico's pictures had an unusual effect on the future Surrealists. The artists themselves guessed at its reasons. However, explanation became possible only with the passage of time, once the painting of European Surrealists had become an artistic legacy, and when the time arrived to render an account of it and interpret its language. The closed eyes of de Chirico's figure were associated with the call of the Romantics and Symbolists to see the world not with the physical but with the inner eye, and to rise above crude reality. At the same time, the artist depicted his figure with a prosaic naturalism. His typical-looking face, his protruding ears, fashionable moustache, and the sparse hairs on his chin, in combination with a body which is by no means unathletic but which has filled out a bit too much, are material and ordinary. The sense of mystery and abstraction from life that the painting carried within it is made frighteningly real by this contradiction. De Chirico's metaphysical painting gave his contemporaries an example of the language of Surrealism. Later on, Salvador Dalí defined it as "the fixation in trompe l'oeil of images in dreams"[2]. Each of the Surrealists realised this principle in his own way; however, it is in this quality of their art, taken outside the bounds of realism, that Surrealism lies. Surrealism would never have occurred at any given moment had it not been for Giorgio de Chirico.

Fate linked Giorgio de Chirico's life to the places and the landscapes which fed his imagination. He was born in 1888 in Greece, where his father built railways. His birthplace was the town of Volo, the capital of Thessaly, from which, according to legend, the Argonauts had set out on their quest for the Golden Fleece. For the whole of his life Giorgio de Chirico retained the vivid impression of the Classical architecture of Athens.

Giorgio de Chirico,
Premonitory Portrait of Guillaume Apollinaire, 1914.
Oil and charcoal on canvas, 81.5 x 65 cm.
Centre Georges-Pompidou,
Musée national d'art moderne, Paris.

"All the magnificent sights that I saw in Greece in my childhood (I have never seen such beautiful ones since) certainly impressed me deeply and remain firmly imprinted in my soul and in my mind", he wrote in his memoirs.[3] There are recollections of Classical architecture and of the sculpture of ancient Greece in almost every one of his paintings. In Greece he received his first lessons in drawing and painting. At the age of twelve, de Chirico began to study at the Académie des Beaux-Arts in Athens. At the age of sixteen, after the death of his father, he left for Italy with his mother and brother. De Chirico then discovered the wonderful Italian cities in which the spirit of the Middle Ages still survived – Turin, Milan, Florence, Venice and Verona. Together with his memories of Greece, these cities lay at the basis of his own private world, the one that he created in his painting. The paintings of de Chirico's youth, in his so-called "Arcade Period", are fascinating because they possess a quality which avant-garde painting often lacked. De Chirico built the city of his dreams. A white city stood on the shore of a dark-blue sea. Its straight streets were lined with arcades, as in Turin or Ferrara. The streets open out onto the area of a square, decorated with ancient sculpture. But this town was completely empty, uninhabited. Only occasionally could a man be seen in the perspective that was formed by a street; sometimes it is not even a man but only his shadow. In some places a cane that somebody had forgotten was still leaning against a wall. Sometimes a little girl ran about in the street, alone in the empty town. Any man might well have dreamed of such a strange town: it was marvellous. The stone of its buildings and the falling shadows were frighteningly real. And at the same time a secret lived there, a notion of the other world, at whose existence we can try to guess, but which only a select few are privileged to see. The Surrealist poet Paul Éluard devoted these lines to Giorgio de Chirico:

A wall announces another wall
And the shadow protects me from my fearful shadow
O tower of my love around my love
All the walls were running white around my silence.

You, who were you protecting? Impervious and pure sky
Trembling, you sheltered me. The light in relief
Over the sky which is no longer the mirror of the sun
The stars of the day among the green leaves

The memory of those who spoke without knowing
Masters of my weakness and I am in their place
With eyes of love their over-faithful hands
To depopulate a world of which I am absent.[4]

Life gave Giorgio de Chirico another marvellous opportunity: he spent two years in Munich where he studied not only painting, but also classical German philosophy. "In order to have original, extraordinary, perhaps immortal ideas", wrote Schopenhauer, "it is enough to isolate oneself so completely from the world and from things for a few moments that the most ordinary objects and events should appear to us as completely new and unknown, thereby revealing their true essence."[5] In Munich he saw a kind of painting which awakened the craving for mystery that lay sleeping in his soul – he got to know [Arnold] Böklin. In 1911 Giorgio de Chirico arrived in Paris and settled in the Montparnasse district, on the Rue Campagne-Premiere. When his paintings appeared at the Salon d'automne, the Parisian artists saw the de Chirico who would later impress them with his *Brain of the Child*, and who wrote: "What I hear is worth nothing, the only thing that matters is what my eyes see when they are open, and even more when they are shut."[6] Giorgio de Chirico himself called his art "metaphysical".

Giorgio de Chirico,
Spring in Turin, 1914.
Oil on canvas.
Private Collection.

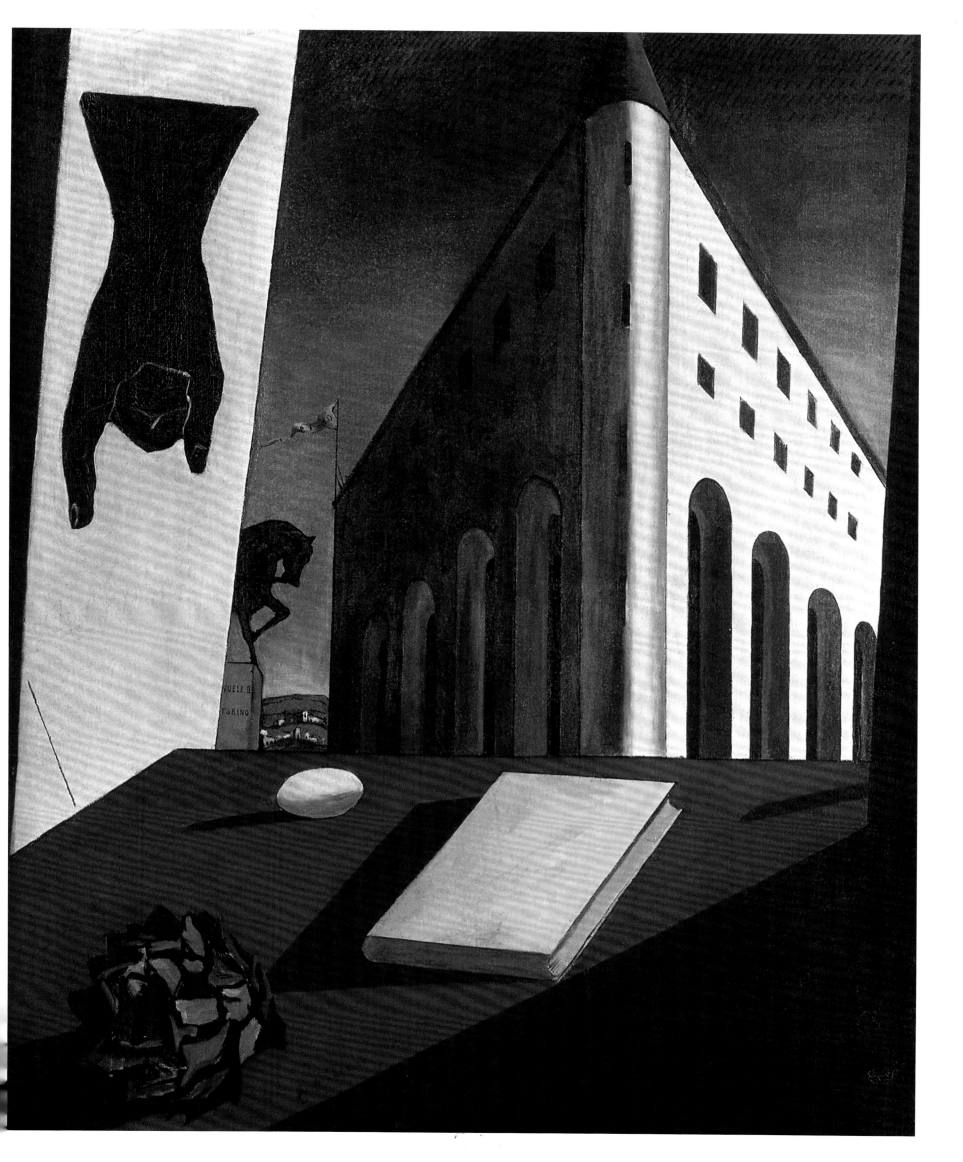

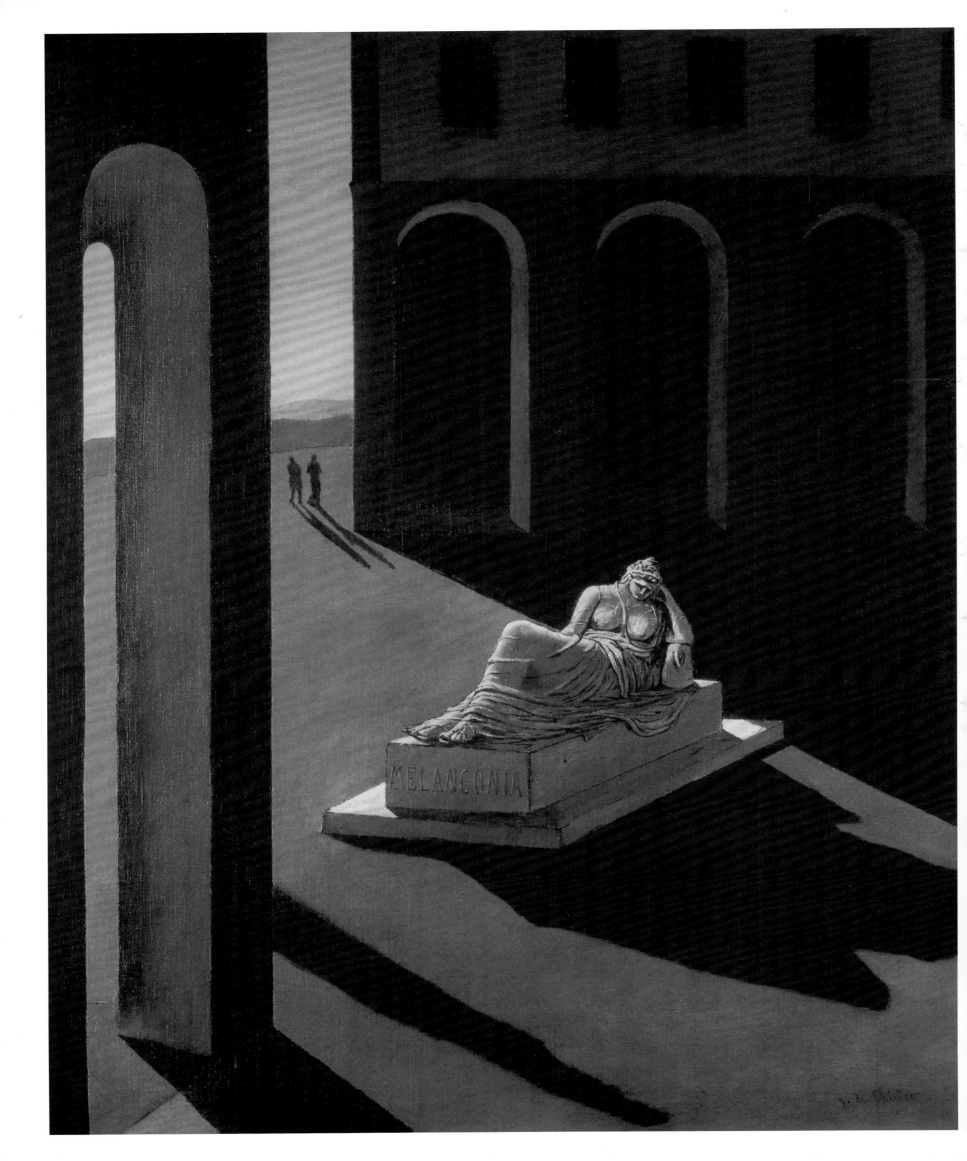

Giorgio de Chirico turned up in the right place at the right time. For the young people of Montmartre and Montparnasse he became an inspiration and almost a prophet. In 1914 de Chirico depicted Apollinaire in profile against the background of a window. On the poet's temple he drew a white circle. When Apollinaire went off to the front soon afterwards, he was wounded in the left temple, in the place shown in the picture. The artist had become a visionary for them, with the power to see into the future. Guillaume Apollinaire himself, an ardent advocate of Cubism, a theoretician of art, colour and form, was overwhelmed by the romantic mystery of de Chirico's paintings. He dedicated a poem to him which was a prototype for the future development in Surrealist literature, and called it "Ocean of Land".

I have built a house in the middle of the Ocean
Its windows are the rivers that pour out of my eyes
Octopi teem everywhere where the high walls stand
Hear their triple heartbeat and their beak knock against the windows

Damp house
Burning house
Fast season
Season that sings
The aeroplanes lay eggs
Look out they are going to drop anchor
Watch out for the anchor they are dropping
It would be nice if you could come from the sky
The honeysuckle of the sky is climbing
The octopi of the land quiver
And then we are so many and so many to be our own gravediggers
Pale octopi of chalky waves O octopi with pale beaks
Around the house there is this ocean which you know
And which never rests.[7]

Giorgio de Chirico summoned to the surface what had been hidden deep within the art of the beginning of the twentieth century. In the course of the following decades, the spirit of de Chirico found its way into the painting of all the Surrealist artists. References to his pictures turned up in their canvases, mysterious signs and symbols born from his imagination; the mannequins he invented prolonged their lives. However, for the seed of the art of Giorgio de Chirico to be really able to germinate, the young generation of the twentieth century would have to experience a vast upheaval.

THE WAR – THE STIMULUS FOR DADA

The art of Surrealism was the most direct outcome of its time. Those who created it, literary men and artists, date from the generation that was born in the last decade of the nineteenth century. At the start of the First World War, each of them was about twenty years old. After the monstrous crimes of the Second World War, after the extermination of millions of people in concentration camps and the destruction of Japanese cities with the atomic bomb, previous wars seemed only like distant historical episodes. It is difficult to imagine what a disaster, and in fact what a tragedy, the First World War was. The first years of the twentieth century were marked by outbreaks of conflict in various parts of the world, and there was a sense

Giorgio de Chirico,
Melancholia, 1912.
Oil on canvas.
Estorick Foundation, London.

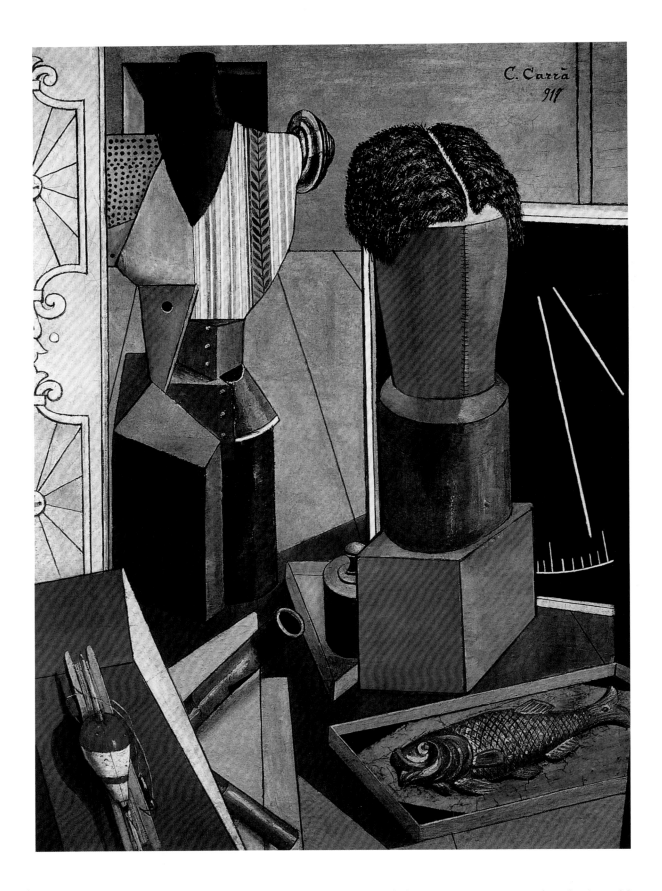

Carlo Carrà,
The Enchanted Room, 1917.
Oil on canvas, 65 x 52 cm.
Private Collection, Milan.

12

that people were living on a volcano. Nevertheless, the start of the war came as a surprise. On June 28, 1914, in the Serbian city of Sarajevo, the student Gavrilo Princip killed the Austrian Archduke Franz Ferdinand and his wife. A war began in the Balkan; events developed swiftly. On the 1st of August, Russia joined the war against Germany, and on the 3rd and 4th of of the same month, France and Britain declared war on Germany. It was only the defeat of the Germans on the Marne from September 5 to 10 that saved Paris from destruction. At the same time, this led to a drawn-out positional war which turned into a nightmare. Many thousands of young people from every country who took part in the war never returned home, but fell victim to shrapnel, died in the trenches from illnesses, or were poisoned by the gas which the Germans used in the war for the first time in 1916. Many returned as invalids and were later to

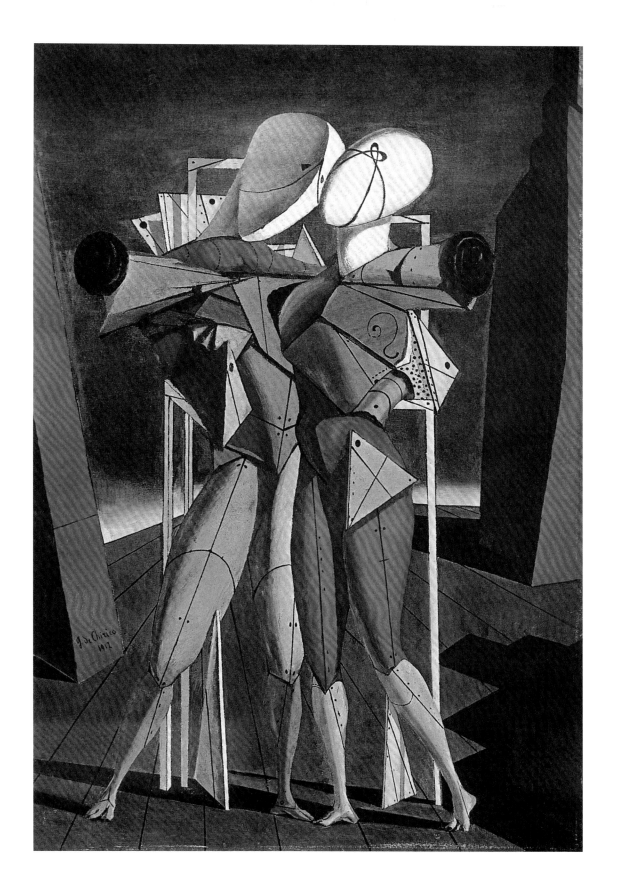

die as a result of their war wounds. And it was exactly this generation that would create the art of the twentieth century and carry on from the boldest beginnings of its predecessors.

Before the war, the artistic life of Paris reveled in the most complete and entrancing freedom. The Impressionists and the masters of the period of Post-Impressionism untied artists' hands. A sense of the barriers in art established by a tradition or a school had vanished. Young artists could permit themselves everything that was possible or impossible. The boldness of the late-nineteenth century generation drew them into the field of the study of colour and form. In 1890, the young painter and theoretician of art, Maurice Denis, put into words for the first time what they had come to realise from the work of their predecessors: "A painting, before it is a warhorse, a nude woman or some sort of anecdote is essentially a

Giorgio de Chirico,
Hector and Andromache, 1917.
Oil on canvas, 90 x 60 cm.
Private Collection, Milan.

flat surface covered with colours put together in a certain order."[8] The most important thing in painting was colour, and it required special investigation. In the 1880s, Seurat and Signac had already turned to chemists and physicists with the aim of establishing a science of colour which they could use for themselves. The texture of the paint that was applied to the canvas contributed to the force of the colour. The nervous expressiveness of the colourful strokes in Van Gogh's paintings enraptured young artists at exhibitions held after his death.

The Salon des Independants was established in Paris as early as 1884, and here anyone who wanted could exhibit his creations without the usual academic jury. In 1903, those who had never taken part in the official Salon that opened in the spring founded their own Salon d'Automne. And it was there that in 1905 Matisse and his group acquired the name "Fauves" because the violence of their colours evoked an association with beasts of prey, with wild animals in the primordial jungle. In 1907, the young poet Guillaume Apollinaire, who was an admirer of Matisse's position in art, obtained an interview with him. In his article he quoted the words of the artist: "I have paints and a canvas, and I must clearly express myself, even in a simple way, applying three or four spots of colour or drawing three or four expressive lines".[9] The Cézanne exhibition of October 1906, immediately after the artist's death, turned the eyes of all young painters towards the form of an object. They discovered abstract forms in the creations of primitive art, in the figurines of the masters of Africa and Oceania which had entered Europe in large quantities. The most striking result of these revelations was Picasso's Cubism: in 1907 he showed his friends his first big Cubist picture, *The Demoiselles d'Avignon*.

Similar processes in the assimilation of the new expressiveness in colour and form occurred in these years in other European countries as well. In 1905 "Die Brücke" ("The Bridge") surfaced in Dresden, rivalling the Parisians in the field of colour. Subsequently, German artists also vied with the French for the claim to be the first to discover primitive art. In 1909, the Futurist Manifesto was published in Milan and then Paris. Its author Filippo Tommaso Marinetti wrote: "Our poetry is courage, audacity and revolt." The Futurists were the first to rise up against old-fashioned art and cultural tradition. "Down with museums and libraries!" wrote Marinetti. "We issue this flaming manifesto as a proclamation announcing the establishment of Futurism, because we want to deliver this country from the malignant tumour on its body – from professors, archaeologists, cicerones and antiquarians… Hurry over here! Burn down the libraries! Dam the canals and sink the museums! Ha! Let the current carry off the famous paintings. Grab the pickaxes and the hammers! Destroy the walls of the venerable cities!"[10] Form served for them as a reflection of the swiftness of movement, of the dynamic of the new industrial world. In Russia, the artist Kazimir Malevich strove to remove the fetters of literature from art, to liberate it "from all the content in which it has been held back for thousands of years."[11] Painting and sculpture were fully liberated from literary subjects, and only the motif remained to give a push to the assimilation of colour, form and movement. In Munich, a group of artists gathered around the journal "Der Blaue Reiter", including the Russian Wassily Kandinsky. Their painting absorbed the whole richness of colour that by that moment had been opened up to the European avant-garde. In 1910, Kandinsky painted his first watercolour, in which there was nothing apart from a spot of colour and lines. The appearance of abstract painting was the natural result of such a rapid development in art. The artistic avant-garde was ruthless in its treatment of the bourgeois aesthetic.

No less important was the fact that the new art was becoming international. Paris attracted all of the insurgents, all those who were finding alternatives to the traditional, much-travelled route. In Montmartre, and later in the district of the Boulevard Montparnasse, a special artistic world sprang up. Around 1900 in Montmartre, "an uncomfortable wooden house, nicknamed the Bateau-Lavoir, housed painters, sculptors, writers, humorists, actors, laundresses, dressmakers and costermongers."[12] The Dutchman Kees van Dongen moved in, "barefoot in sandals, his red beard accompanied by a pipe and a smile."[13] From 1904, the Spaniard Pablo Picasso lived on the floor below with his Parisian girlfriend Fernande Olivier, while artists, sculptors and

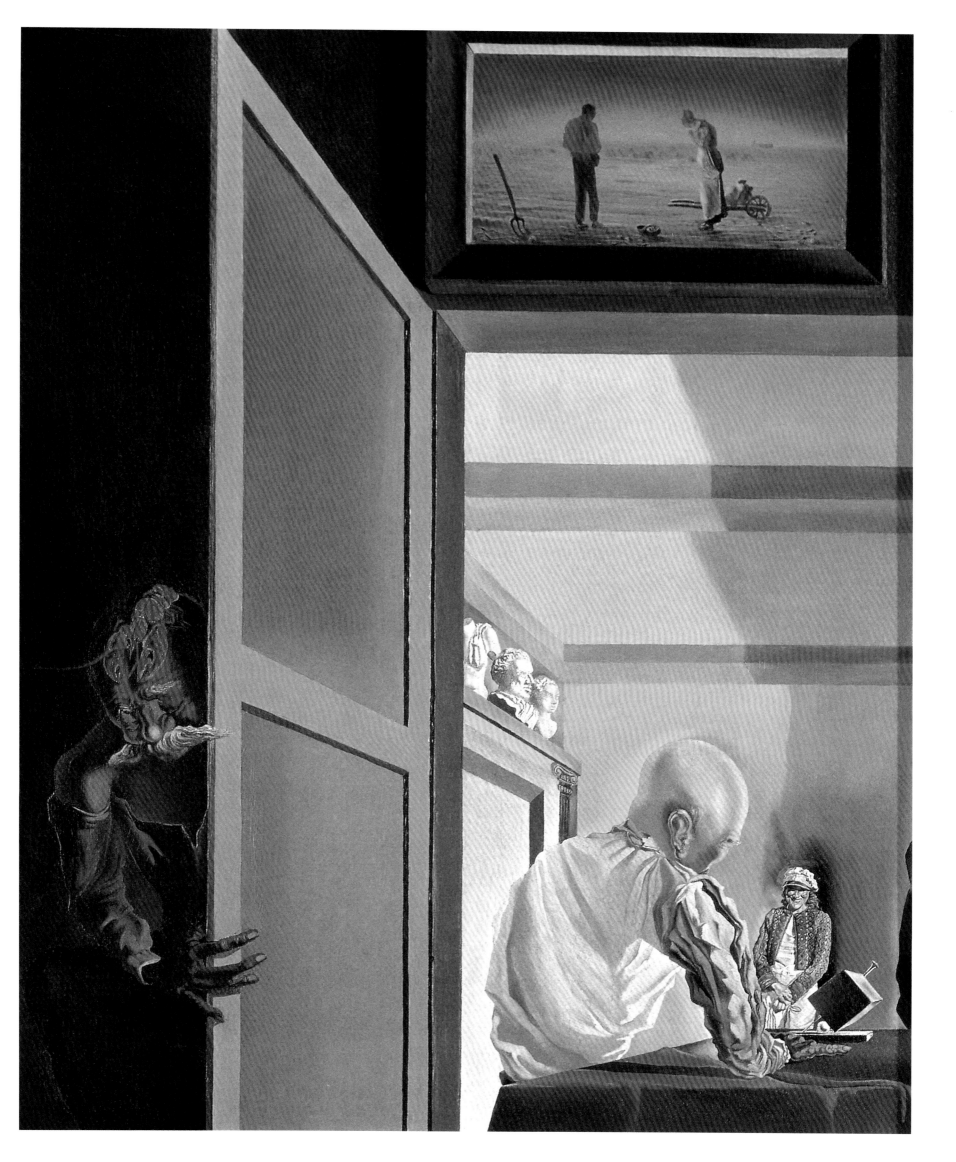

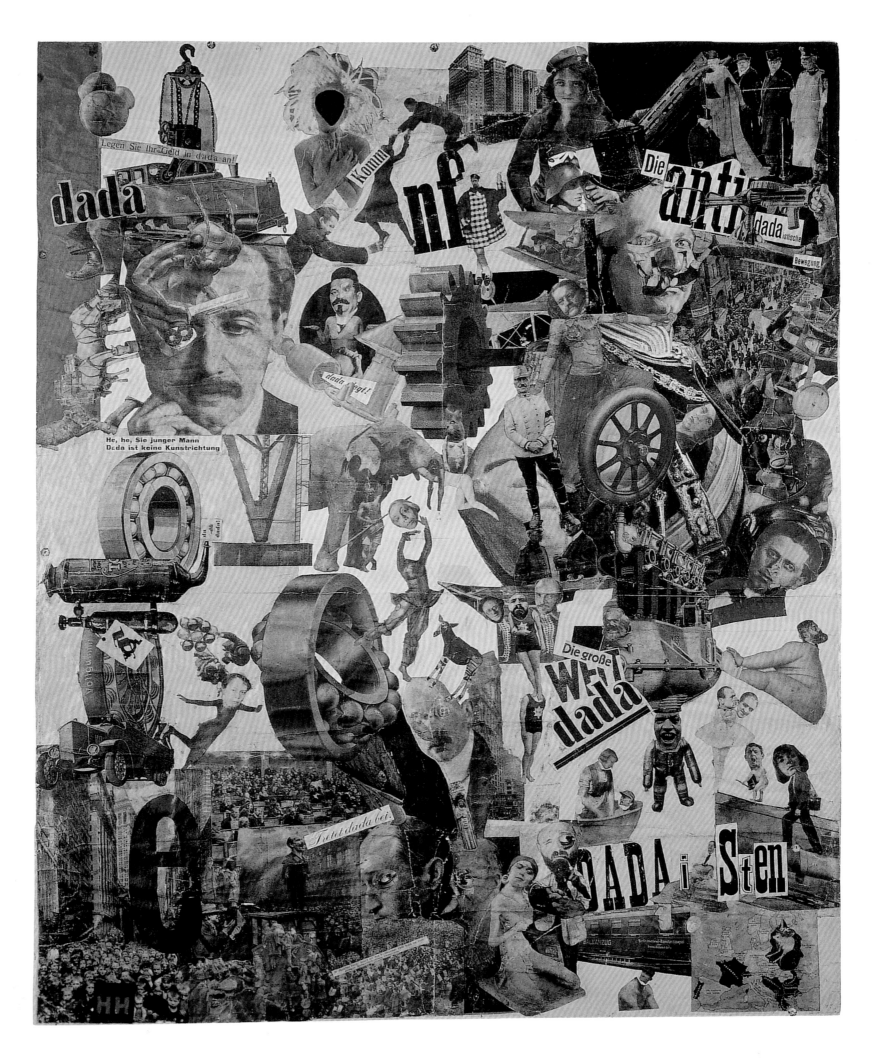

16

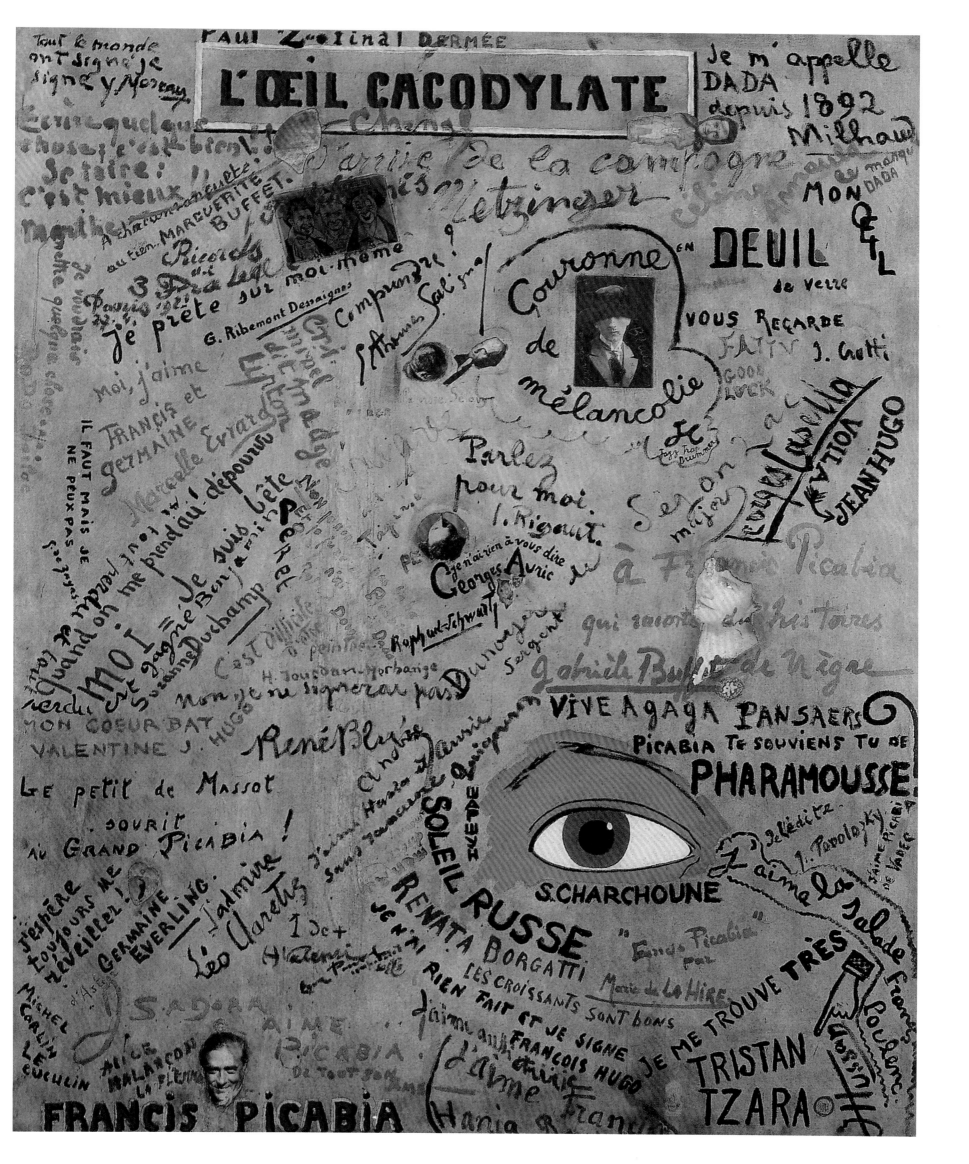

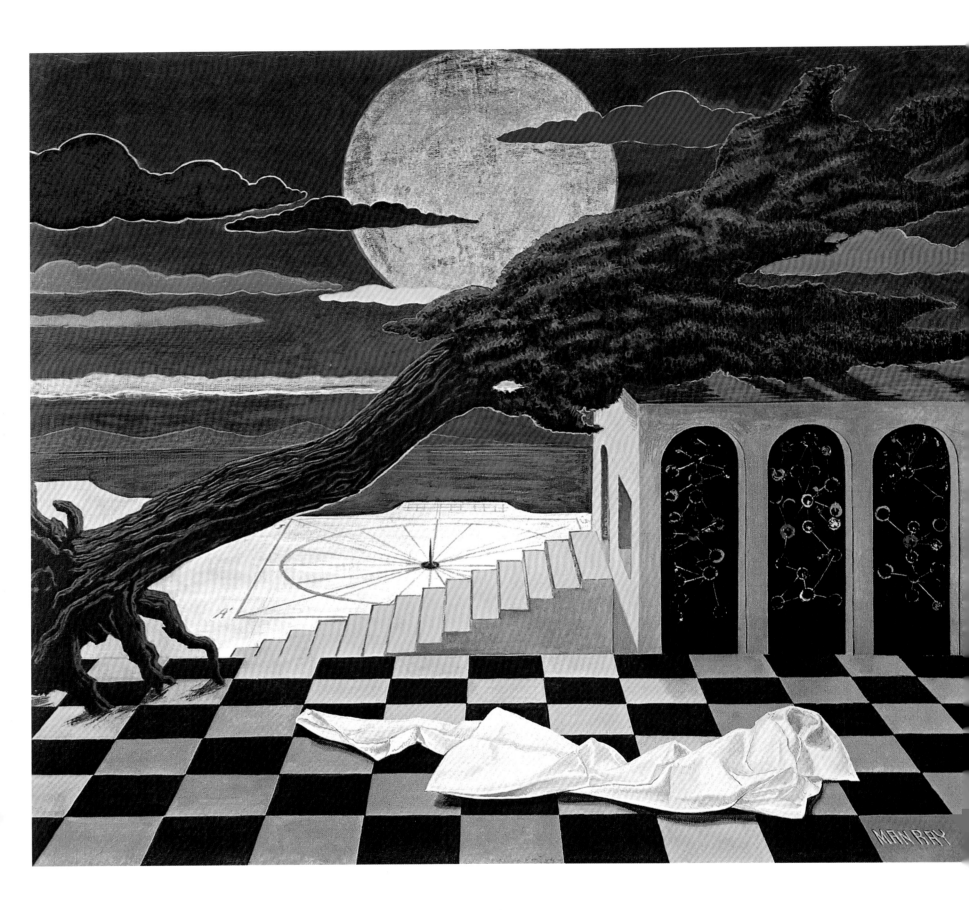

poets from Spain gathered around him. The "Fauves" from the Parisian suburb of Chatou were often seen alongside them – the giants André Derain and Maurice de Vlaminck. The poets Max Jacob, André Salmon and others often came into their group. The ideological inspiration of the group was Guillaume Apollinaire. He met Picasso soon after the latter's appearance in Montparnasse, and became the most ardent defender of the Cubism Picasso had devised. In 1906, the international colony of Montmartre was reinforced by an Italian from Livorno, Amedeo Modigliani. Jews from Russia and Poland, Germans, Romanians, even emigrants from Japan and Latin America entered a variegated artistic community which the journalist from Montmartre André Varnaux wittily called "The Paris School".

The war destroyed the picturesque world of Montmartre which in these men's art had been an inspirational force in its own right. The war brought the ruin of all their hopes. The Parisian Germans had to go return to Germany to take up arms against their friends. The French were also mobilised: some went away to the front, others, like Vlaminck, worked in munitions factories. In December 1914, Apollinaire wrote:

> All the memories of a while ago
> O my friends gone to war
> Where are they, Braque and Max Jacob
> Derain with grey eyes like the dawn
> Where are Raynal Billy Dalize
> Whose names resound with melancholy
> Like footsteps in a church
> Where is Cremnitz who has enlisted
> Perhaps they are dead already…[14]

Apollinaire's poetry is imbued with nostalgia for everything which the war took away from them – love, romance, the beauty of nature, the endless delights of Paris. For them, the radiance of the starry night had been replaced by flashes of gunfire:

> The sky is given stars by German shells
> The marvellous forest where I live is having a ball
> The machine-gun is playing an air in demisemiquavers…[15]

Drafted to the front, Apollinaire remained there only a short time – he was seriously wounded and came back to Paris on March 17, 1916. His old friends rallied round him, as well as poets and artists who were new arrivals in Montparnasse; those on the scene included Max Jacob, Raoul Dufy, Francis Karko, Pierre Reverdy and André Breton. The black bandage which Apollinaire wore round his head after he was wounded was interpreted as a symbol of heroism. However, for many of those who surrounded the bard of the "abandoned youth", the unbridled patriotism which had seized France was repugnant. Distinguished figures in the arts – Anatole France, Jean Richepin, Edmond Rostand, Madame de Noialles and others – praised the heroism of the soldiers who were dying for their country, preached hatred for the Kaisier and called for victory. They called Romain Rolland a traitor for standing out against the war. André Breton, who worshipped Apollinaire, nonetheless criticised him for not talking about the frightening realities of his era, and for reacting to the horror of war only with the desire to return to childhood. However, during the war Apollinaire and other men of letters did support Modernist art.

In 1916 in Paris, the first number of the journal *SIC* appeared, giving modernist poets and artists an opportunity for self-expression. It ran for three years. In 1917 a competitor to it appeared – the poet Pierre Reverdy published the journal *Nord-Sud* which he wanted to serve as a unifying force for Modernist literature

Man Ray (Emmanuel Radnitsky),
Night Sun – Abandoned Playground, 1943.
Private Collection.

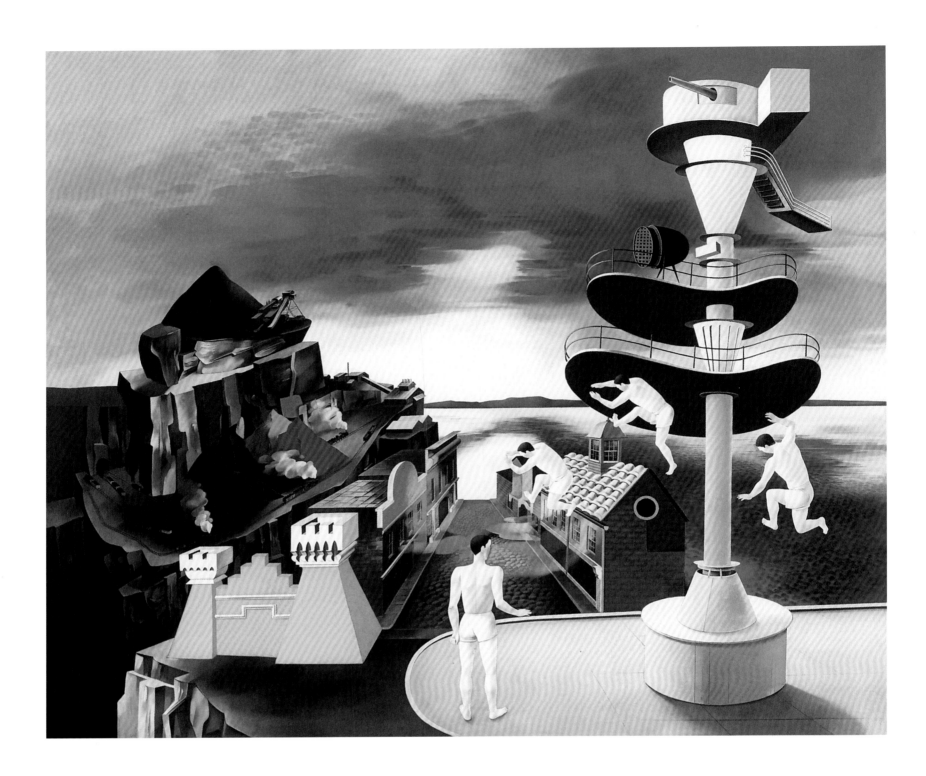

and the visual arts. "Is it any wonder", wrote Reverdy, "if we thought that now was a good time to rally round Guillaume Apollinaire?"[16] Several future Surrealists owed the beginning of their fame to these journals: the poets Philippe Soupault and Louis Aragon, the artist Francis Picabia, and others. However, things became really lively in this circle with Tristan Tzara's appearance in Paris. In the spring of 1917, Max Jacob announced the "advent of the Romanian poet Tristan Tzara", and in an *SIC* article entitled "The Birth of Dada", it was written that "In Zürich the Romanian poet Tristan Tzara and the artist Janko are publishing an artistic journal, whose content looks attractive. The second number of *Dada* will come out shortly."[17]

DADA – THE CRADLE OF SURREALISM

"Dada" – this was actually the name of a journal. But Dada was something much bigger than a journal. Dada was an association of like-minded people, a movement encompassing the international artistic avant-garde. Dada was a coming to light of the tendencies and emotional reactions which were developing simultaneously

in various countries of the world. Dada was a revolt against traditional art – the Dadaists advocated anti-art. And Dada was the cradle in which Surrealism uttered its first words, made its first movements – in short, grew and matured. The Dada movement was the first chapter of Surrealism.

It is usual to regard Zürich as the birthplace of Dada, although its adherents appeared at the same time in America as well. In Europe, the Dada movement gradually spread over various countries. Little Switzerland was the only officially neutral country in Europe, the only tiny island of peace amid the fires of the World War. It was there that those young people who did not want to take part in the European war found refuge. Among those whom the winds of war had blown into Zürich were the Germans Richard Huelsenbeck and Hugo Ball, the Romanians Tristan Tzara and Marcel Janko, and the Alsatian Hans Arp, and many others, including some Swiss intellectuals, joined them as well. What united them more than anything was their hatred of the existing social order, of which they saw the senseless slaughter of the war as the result. Among them were pacifists of various hues, but they did not organise anti-war demonstrations, and did not take an active part in political movements. Their protest took special forms, related only to the fields of literature, the theatre and the visual arts. They all came from bourgeois families and they were all, first and foremost, opposed to official art.

George Marinko,
Sentimental Aspects of Misfortune, c. 1937.
Tempera on masonite, 35.7 x 40.3 cm.
Wadsworth Atheneum Museum of Art, Hartford.

In the spring of 1915 the Romanians Tzara and Janko settled in Zürich. In 1916, on one of the little streets of old Zürich, the German Hugo Ball opened the Cabaret Voltaire. Later he told the story of how the owner of a restaurant, Jan Efraim, gave him a hall for the cabaret on Spiegelgasse, and Hans Arp offered pictures by Picasso, himself, and his friends for exhibition. Tzara, Janko and the Swiss Max Oppenheimer agreed to perform in the cabaret. On February 5th, the first concert took place there: "Madame Hennings and Madame Leconte sang French and Danish songs. Monsieur Tzara read Romanian poems. An orchestra of balalaikas played delightful Russian folksongs and dances", Ball wrote in his memoirs.[18]

The name Dada was invented on February 8th. The godfather of the emerging movement was Tristan Tzara. Legend has it that a paper-knife fell entirely accidently onto the page of a dictionary where Tristan Tzara saw this word. "DADA MEANS NOTHING", Tzara wrote in the "Dada Manifesto 1918". "We learn in the newspapers that the Kru negroes call the tail of a sacred cow: DADA. Brick and mother, in a certain region of Italy: DADA. Wooden horse, nurse, double affirmation in Russian and Romanian: DADA."[19] Declaring that he was against all manifestos, Tzara wrote: "Thus DADA was born out of a need for independence, out of mistrust of the community. Those who belong to us keep their freedom. We do not acknowledge any theory. We have enough Cubists and Futurists: laboratories of formal ideas. Does one create art to make money and to stroke the nice bourgeois?"[20] The basis of Dada was its ambition to destroy, without exception, all old art, on the grounds that it was not free and had been established by the bourgeois order they candidly despised. Dada was the negation of everything: "Every hierarchy and social equation set up as our values by our valets: DADA; ... abolition of memory: DADA; abolition of archaeology: DADA; abolition of prophets: DADA; abolition of the future: DADA..." wrote Tzara.[21] His concept of freedom even extended as far as emancipation from logic: "Logic is a complication. Logic is always false. It drags the edges of notions and words away from their formal exterior towards ends and centres that are illusory. Its chains kill, enormous myriapods stifling independence."[22]

At the Cabaret Voltaire something was always happening. At first, its organisers were content to perform poetic and musical works that were comparatively inoffensive to conventional tastes – they read the poems of Kandinsky and Blaise Cendrars and they performed Liszt's "Thirteenth Rhapsody". Russian and French evenings were organised. At a French evening on March 14th, Tzara read poems by Max Jacob, André Salmon and Laforgue, while Arp read out extracts from Alfred Jarry's *Ubu roi*. In the evenings, they sang the songs of Aristide Briand. At the same time, their own individual works were performed, demonstrating Dada's nihilist position in relation to all art of the past, even the most recent past. The idea of values that lay at the heart of the bourgeois aesthetic was something they utterly rejected. Hugo Ball wrote in his diary on 11 February: "Huelsenbeck arrived. He came out in favour of the intensification of Negro rhythm. If he had his way, he would replace the whole of literature with a drum-roll."[23] On March 29, Huelsenbeck, Janko and Tzara read out the simultaneous poem of Tristan Tzara "The Admiral is Looking for a House to Rent", together with Negro chants – works in which the principles of anti-art were formulated. "It is a contrapuntal recitative, in which three or more voices speak at the same time, sing, whistle or do something in the same spirit, but in such a way that the content of the thing that is put together from the intersections of their "parts" becomes melancholy, cheerful and odd", Hugo Ball wrote of Tzara's poem. "In this simultaneous poem the waywardness of the voice is clearly demonstrated, together with its dependence on the accompaniment. ... The 'Simultaneous Poem' originates in the value of the voice. ... It indicates ... the clash of the 'vox humana' with the menacing and destructive world from whose rhythm and noises it cannot hide."[24]

Later, in 1920, the Dadaists published one of their manifestos in which there were instructions on how "To Make a Dadaist Poem":

Jacques Hérold,
The Game, the Night, 1936.
Private Collection.

Take a newspaper
Take a pair of scissors

Choose from the newspaper an article of sufficient length

That you intend to give to your poem.

Cut out the article.

Then carefully cut out each one of the words which make up this article and put them into a bag.

Shake gently.

Then take out each cutting one after the other.

Copy them out conscientiously

In the order in which they came out of the bag.

The poem will be like you.

And here you will have a writer who is infinitely original and with a charming sensibility,

even though it is misunderstood by the masses.[25]

Tristan Tzara himself never wrote poems using this method, a fact which clearly holds a touch of irony. However, the conception of spontaneity, and the method according to which, in his own words, "thought produces itself in the mouth", later became, to a considerable degree, the foundation of the working methods of the Surrealists.

In July 1916, a plan for an artistic and literary journal to be called *Dada* was announced, but the first number did not appear until July 1917. In 1916, Tzara began to correspond with the Paris dealer Paul Guillaume, who introduced him to Max Jacob, Reverdy and Apollinaire. Apollinaire had become as much of an idol for the leader of the Dada movement, as much of an inspiration as he had been for the Paris avant-garde, "the most lively, alert and enthusiastic of the French poets".[26] Tzara dedicated several lyrical poems to Apollinaire, full of restrained melancholy. In 1918, the Paris journal *SIC* published Tzara's poem "The Death of Guillaume Apollinaire":

We know nothing

We know nothing of grief

The bitter season of the cold

Digs long tracks in our muscles

He would have quite liked the joy of the victory

Well-behaved under the sadness calm in the cage

Nothing to be done

If the snow was falling upstairs

If the sun were to climb into our house during the night

To warm us

And the trees were hanging with their crown

Unique tear

If the birds were among us to gaze at their own reflections

In the peaceful lake above our heads

ONE COULD UNDERSTAND

Death would be a fine long voyage

And an unlimited holiday from the flesh from structures and from bones.[27]

Dadaism in Zürich was making its presence felt most strongly in literature. All the evenings at the Cabaret Voltaire were accompanied by sketches in fancy-dress, masques and productions of Dadaist plays. However, in the galleries, and even in Zürich's biggest museum, the Kunsthaus, exhibitions were organised in which Tzara read lectures on modern art. Here, attention was focused on the Expressionists, to whom several of the

members of the Zürich Dadaists belonged, and in particular on the abstract painting of Kandinsky. The Zürich Dadaists had some artists of their own as well: Marcel Janko illustrated Tzara's poems with engravings, and Hans Arp, who also wrote poetry, was now appearing more often at the cabaret evenings in the capacity of an artist. The opening of the Dada Gallery, at which Tzara gave a lecture on Expressionism and Abstractionism, took place on 27 March 1917, and the following day Tzara gave a lecture on Art Nouveau. In the spring of 1917, after a long stay in America, Francis Picabia arrived in Switzerland. He composed poems that were very similar to those of Tzara. They began to correspond, feeling that they were soul mates. Picabia, inspired by the correspondence, went back to the work in drawing that he had long neglected, while Tzara busied himself enthusiastically on the journal *Dada*. Tzara invited Francis Picabia to the exhibition at the Kunsthaus. They spent three weeks together in Zürich in January and February of 1919. The association, and then the friendship, of Tristan Tzara and Picabia was the beginning of the contact between the Zürich Dadaists and their like-minded colleagues in Paris. On January 17, 1920, Tzara went to see Picabia in Paris, where he immediately became acquainted with André Breton, Paul Éluard and Philippe Soupault, and became involved in the events staged by the Paris Dadaists – the future Surrealists.

DADA OUTSIDE ZÜRICH

Francis Picabia brought to Paris the discoveries of those in America who had gone down the Dadaist road. The American avant-garde knew nothing of the Dadaists of Zürich, yet they were motivated by the same nihilism that had become a generalized feature of this artistic generation. The movement for freedom in art got under way earlier there than in Europe. In 1913, an international exhibition of modern art took place in New York, now well-known under the name of the "Armoury Show". The modernist tendencies of European painting were represented in it; in particular, Marcel Duchamp's picture *Nude Descending a Staircase*, and two pictures by Picabia, *Dances at the Spring* and *Procession to Seville*, were on display – they all provoked outrage and enjoyed success.

Francis Picabia, the son of a Cuban diplomat and a Frenchwoman, was born in Paris in 1879. He studied at the École des Beaux-Arts and the École des Arts Décoratifs, and from 1899 he showed his work at the Salon des Indépendants. In 1909, he painted his first abstract picture, *Rubber*. In 1910, he met Marcel Duchamp. In the nihilist movement in the United States, along with Americans, there were Europeans who had taken refuge from the war. Several avant-garde groups arose in New York. Artists and poets gathered around journals or galleries. These centres included the gallery of the photographer Alfred Stieglitz, the salon of the collector Walter Conrad Arensberg, and certain chess clubs that were currently fashionable. What brought about the real turning-point in this movement was the arrival in America of two French artists – Marcel Duchamp and, following close behind him, Francis Picabia. Duchamp was exempted from his military service, and preferred to take refuge from the ostentatious patriotism of a warlike Paris in the United States. Picabia had been mobilised in the capacity of a driver to one of the generals and ordered to a post in Cuba, but he preferred to remain in New York.

Marcel Duchamp was born in northern France, near Rouen, on July 28, 1887, into a family of artists. The three Duchamp brothers and their sister, like their grandfather before them, chose the path of the artist. Marcel came to Paris in 1904, where he studied at the Académie Julian. In 1910 and 1911, he was passionate about mathematics. Along with Fernand Léger, Jean Metzinger and Juan Gris, Marcel Duchamp organised an association called the "Section d'Or". They were all engaged in an enthusiastic search for the mathematical foundations of art. In 1912 Marcel Duchamp painted *Nude Descending a Staircase* – a Cubist picture, close to Italian Futurism. Duchamp conveyed the movement of a human figure through multiple repetitions of its outlines.

André Breton,
Untitled (Poem Object, for Jacqueline), 1937.
Collage, cloth on cardboard, with ribbon, sheet, tarot card, metal mecanism, punched cardboard, ink, place in a box (not represented here), 39.5 x 30.5 cm.
The Art Institute of Chicago, Chicago.

Victor Brauner, **André Breton**, **Oscar Domínguez**, **Max Ernst**, **Jacques Hérold**, **Wilfredo Lam**, **Jacqueline Lamba** and **André Masson**,
The Marseille Card Game,
published in *VVV*, N°2-3, 1943.
Private Collection.

de ma vie

J'ai compris

J'ai caressé l'enfant perdu
Dans le jardin de la pendule

Il y avait dans le train bleu
Une femme aux cheveux d'hameçons

Pour Jacqueline
Juré
18-1-1937

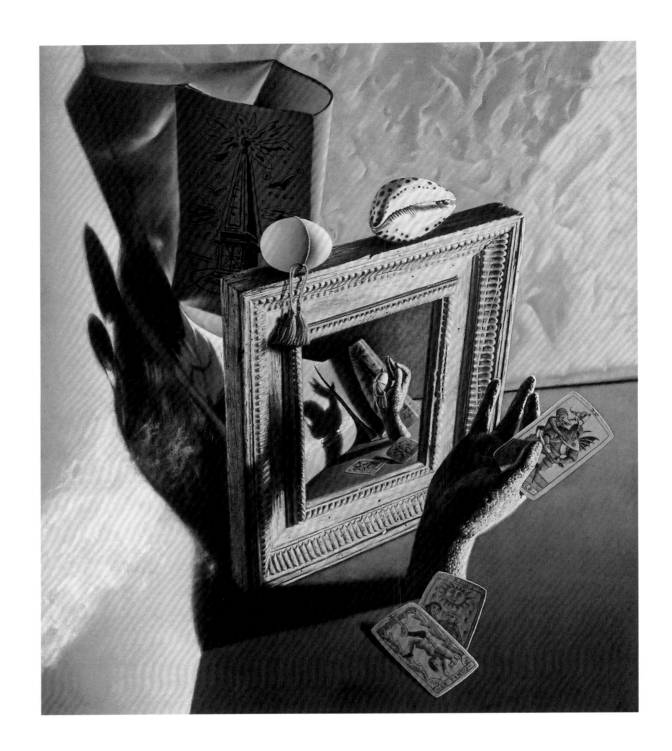

Duchamp introduced Picabia to the circles of his patron and friend Arensberg where he met American artists and poets. They included the remarkable artist Man Ray. Picabia's friends founded a journal which they named *291* from the number of the house on Fifth Avenue where Stieglitz's gallery was located. To the American intellectuals, Duchamp and Picabia were the incarnation of the revolt against bourgeois art. Duchamp strove to put an end to traditional, customary easel-painting. Although they were unfamiliar with the positions of the Dadaists of Zürich, they were travelling in the same direction. "Every pictorial or visual work is useless", Tristan Tzara declared.[28] At the same time in New York, Duchamp was exhibiting what were called ready-mades, not pictures, but objects of everyday use, elevated to the status of a work of art merely by virtue of his choice. Man Ray was the most prominent among the many Americans who understood the point of Duchamp's original lessons. His individual exhibition took place on October 1915 at the Daniel gallery, where he demonstrated his solidarity with his French friend, as well as his talent and his sense of humour.

The real explosion in the artistic life of New York was an exhibition at the Grand Central gallery in March, 1917. It was organised in the manner of the Paris Salon des Indépendants – each contributor who put in $6 had the right to show any work without the need for it to be approved. Under the invented name Richard Matt, Marcel Duchamp submitted to the exhibition an everyday enamelled urinal which he called *Fountain*.

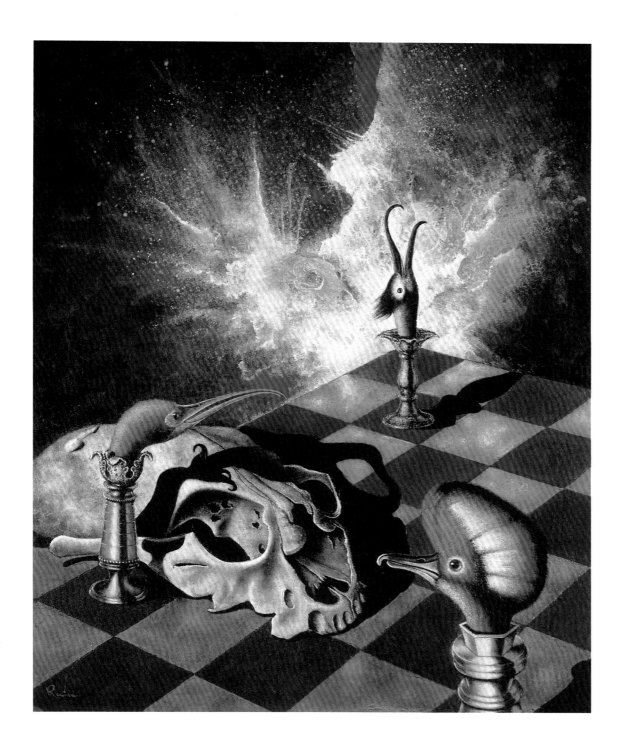

When the organisers refused to exhibit it, Duchamp stormed out of the exhibition's organisational committee. In June 1917, Picabia published in New York three numbers of his own journal, which he named *391*, in the wake of Stieglitz's journal *291*. The entry of America into the war was the impetus for Picabia's departure for Europe and Duchamp set out on a tour around the world in August 1918, the outcome of which was that, following a stay in Buenos Aires, he eventually arrived in Paris. In this way, the most important consequence of the emergence of the American Dadaists was the formation in New York of three outstanding personalities – Duchamp, Picabia and Man Ray. During another visit to New York, Duchamp and Man Ray were involved in bringing out the journal *Societé Anonyme*, which publicised avant-garde art. In the summer of 1921, they both arrived in Paris where Dadaists from other European capitals were gathering.

Fanning out from Zürich, the Dada movement acquired committed supporters in various German cities. In 1918, Dada's own manifesto was published in Berlin. Its author was someone from Zürich, Huelsenbeck, but it was also signed by Tzara, Janko and Dadaism's Berlin adherents – the writer Franz Jung, the psycholanalyst Otto Gross, the poet Raoul Hausman and Gerhard Preiss. It was aimed against Futurism and German Expressionism, and advocated the renewal of poetic forms. Young artists joined them as well, the most brilliant of whom were the caricaturist Georg Gross and the committed Marxist Johann Hartzfeld.

Charles Rain,
The Enigmatic Game, 1945.
Oil on canvas, 28.9 x 23.5 cm.
Courtesy Michael Rosenfeld Gallery,
New York.

31

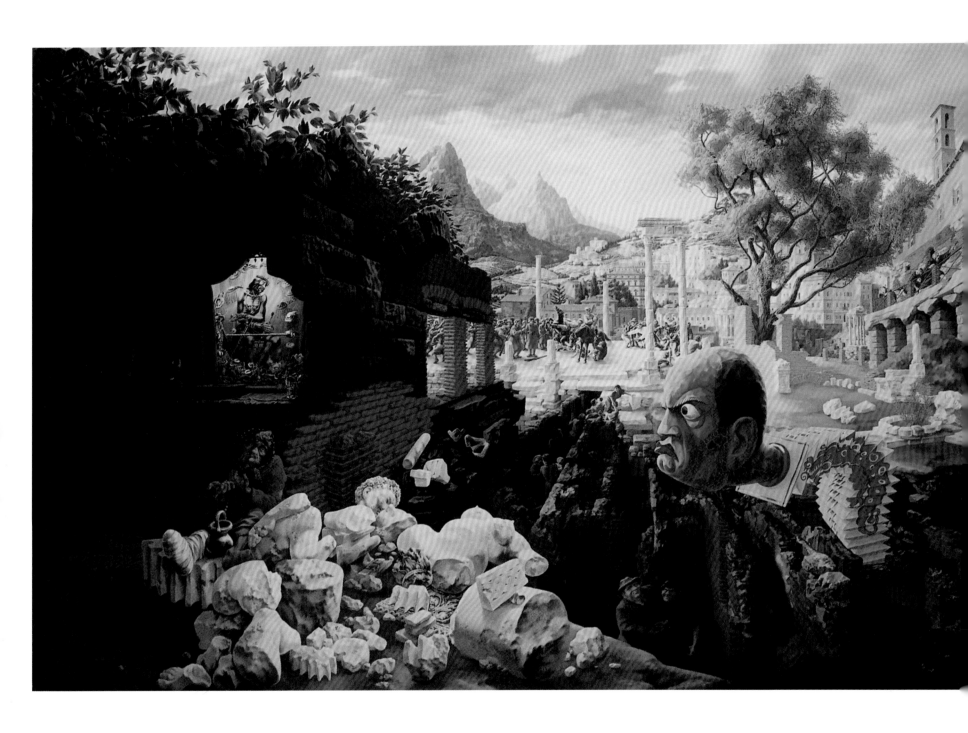

Hartzfeld even changed his German name to the English-sounding John Hartfield as a gesture of protest against German patriotism. Hartfield got the nickname "the Dada-Fitter" for the witty works he produced using the photomontage technique. The Berlin Dadaists publicised their movement and read lectures on Modernist art. The turbulent political events in Germany – hunger strikes, spontaneous worker demonstrations, the brutal repression of the Sparticist uprising, the murder of its ring-leaders, Karl Liebknecht and Rosa Luxemberg – presented the artistic avant-garde with a choice, and they had no hesitation in taking the side of socialist forces. Their journal, called *Der Dada*, openly incited revolt. At the beginning of 1920, the Berlin Dadaists organised a demonstration on a grand scale. In the gallery of Dr. Otto Burkhardt, they amassed 170 Dadaist works, not only from various cities in Germany, but also from Amsterdam, Antwerp, Zürich and even Paris. The exhibition was titled "Erste Internationale Dada Messe".

For Surrealism, growing inside the womb of Dada, there was a movement in Hanover and Cologne with far more significance. Kurt Schwitters, who lived and worked in Hanover, was one of the most brilliant representatives of Dada, embodying its individualistic, anarchistic character. A pupil of the academies of painting in Dresden and Berlin, he completely rejected traditional painting, and created his own individual aesthetic. He collected rubbish, bus tickets, scraps of posters and so on, which he used instead of painting materials to produce abstract compositions. In one of them, a scrap of the word "KomMERZbank" turned up, and he started to call his creative work "Merz", which was no less absurd a name than Dada itself. The spontaneous method of work on the Merz compositions, together with the results of the method – the abstract "colours without form" – positioned Schwitters in the first rank of those artists from Dada who became the founders of Surrealism.

The international Surrealist movement of the future found one of the most significant of its masters from among Dada's Germans. Max Ernst lived in Cologne. Drafted into the army for the duration of the war, Ernst returned to his native Westphalia in 1919. Hans Arp came to him in Cologne, bringing with him his experience of the Zürich Dadaists. Ernst and Arp were joined by a Cologne artist and poet who was well-known under the pseudonym of Johannes Theodor Baargeld. The young Cologne intellectuals, like their counterparts in Berlin, were involved in the revolutionary movement of 1918 and 1919. Under the influence of Arp, the Cologne Dadaists preferred to confine their activity entirely within the framework of aesthetics. It is particularly interesting that these three – Ernst, Arp and Baargeld – worked in the field of collage. Ernst used images he had cut out of didactic works. Arp chaotically distributed the configurations that he had arbitrarily cut out over cardboard. Baargeld made extremely varied Dadaist compositions. Together they created anonymous works which, as a joke, they called "Fatagaga" – "Fabrication de tableaux garantis gazometriques". The three artists called their collective "Centrale W/3", and a small number of other Dada supporters gathered around them. The culmination of the Dadaist performances in Cologne was a scandal at the back-door of the Wintera beer-cellar in April 1920, when the exhibitors' defiant behaviour irritated viewers. In the exhibition, objects were shown which the viewers could not understand, and which were painted with a very individual sense of humour. The displays foreshadowed the future works of Surrealism. Breton invited Max Ernst to the Dada exhibition in Paris. However, as a result of political complications, Ernst was unable to travel outside Germany, and he only met Breton, Tzara and Éluard in the summer of 1921 when he visited the Tyrol. A year later, Ernst moved to Paris where all the important figures in the Dadaist movement had come together after the war. The first shoots of Surrealism grew out of their experience.

DADA IN PARIS

The beginnings of Surrealism within Dada are connected, in the first instance, to poetry rather than to the visual arts. At the centre, as the symbol that united the Dadaist poets, was Guillaume Apollinaire. After he

Peter Blume,
The Eternal City, 1937.
Oil on composition board, 86.4 x 121.6 cm.
The Museum of Modern Art, New York.

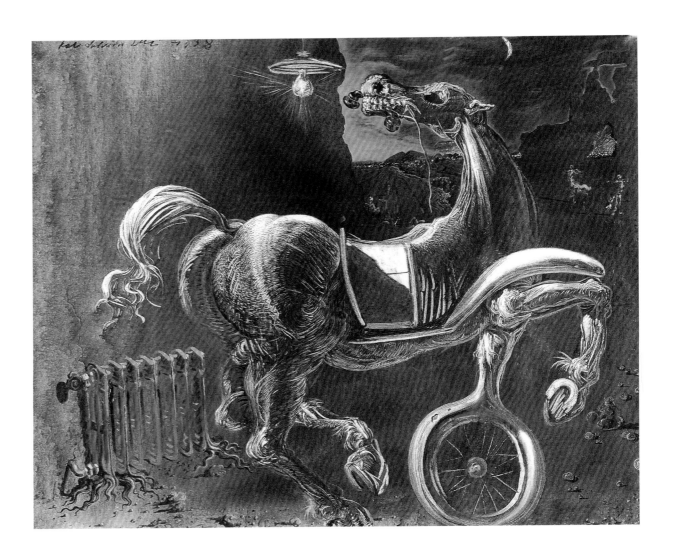

left the hospital, Apollinaire saw his disciples every Tuesday at gatherings at the Café de Flore on the Boulevard Saint-Germain. Earlier on, he had met the young poet André Breton who had visited him in the hospital in 1916, immediately after the trepanation of his skull.

André Breton himself contained all the immense energy which led to the emergence of Surrealism. He was born in 1896 in the little town of Tinchenbray, in Normandy in the north of France. His parents strove to give their only son a good education. In 1913, he began to study medicine in Paris, and was preparing for a future as a psychiatrist. The war got in the way. Breton was drafted into the artillery, but, as a future doctor, he was ordered to serve as a medic. In the Val-de-Grace hospital, he encountered another medical student and poet, Louis Aragon.

Aragon, the illegitimate son of a prefect of police, was born in 1897 in Paris. He was a refined, slim and delicate young man who admired Stendhal and had studied at the Sorbonne. The companions of his youth never doubted that he was going to be a poet. During the war, he twice obtained a deferment, but doctors were needed at the front and Aragon was sent into the rapid training programme for "doctor's assistants" at Val-de-Grace. After this he went to the front, where he acted heroically. Breton even criticised him for his excessive selflessness and patriotism: "Nothing in him at that moment rose up in revolt. He had been teasing us in some ways with his ambition to overthrow absolutely everything, but when it came down to it, he conscientiously obeyed every military order and fulfilled all his professional (medical) obligations."[29] His military experience, without a doubt, played a big role in his Dadaist and Surrealist poetry.

It looked as though a medical future also awaited a third poet, a man of the same age, Philippe Soupault. He came from the family of a famous doctor, and studied jurisprudence, but his greatest enthusiasm was poetry. In 1914, while in London, he wrote his first notable poem: "Chanson du mal aimé". In 1916, he obtained a deferment, but was then drafted into the artillery and sent to officers'

Salvador Dalí,
Debris of an Automobile Giving Birth to a Blind Horse Biting a Telephone, 1938.
Oil on canvas, 54 x 65 cm.
The Museum of Modern Art, New York.

Federico Castellon,
Untitled (Horse), c. 1938.
Oil on board, 37.2 x 32.4 cm.
Courtesy Michael Rosenfeld Gallery,
New York.

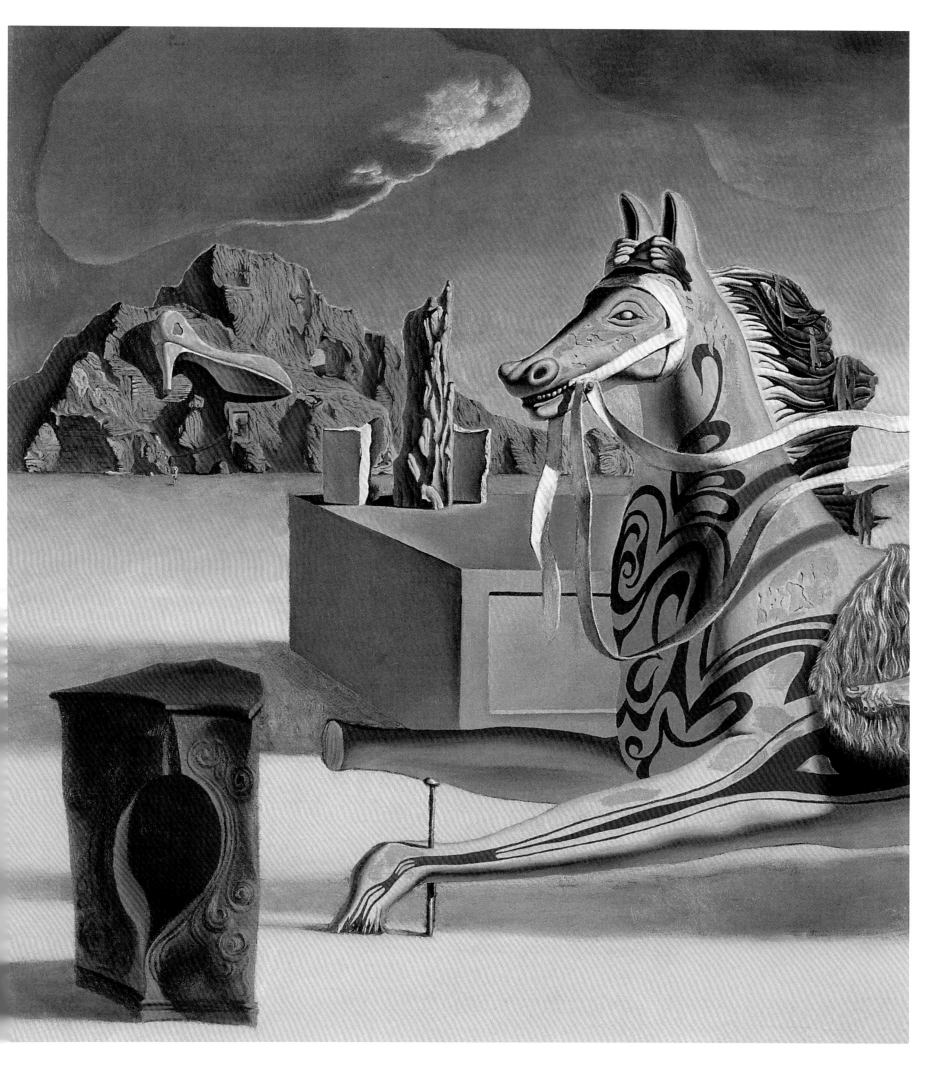

school, though he never actually got to the front. Soupault spent many weeks in hospital after the officers had been given an anti-typhoid serum in an experiment. There he wrote poems which he sent to Apollinaire. In 1917, Apollinaire published a poem of Soupault's in the journal *SIC*, and introduced him to Breton and Aragon. None of them was thinking about medicine any more. The three poets planned to found a literary journal.

The journal *Littérature* came out in February 1919, taking over from *SIC* and *Nord-Sud*. Many in the world of letters hailed the birth of the journal, including Marcel Proust. As well as their own poems, the three printed those of Apollinaire, Isidore Ducasse, Rimbaud and the Zürich Dadaist Tzara. An unknown serviceman, Paul Éluard, submitted a poem to the journal. His real name was Eugène Grendel, but he used his maternal grandmother's surname, Éluard, as a pseudonym. After he left school, he contracted tuberculosis and spent two years in Switzerland in a sanatorium. In Davos Éluard met a Russian girl, Elena Diakonova, whom he married in 1917. Elena entered the world of the Dadaists, and later, by which time she was known as Gala, "the muse of the Surrealists. "At the front, Éluard was exposed to German poison gas, and, following a period in the hospital, he made his way to Paris.

Later, after he arrived in Paris, Picabia joined the group, followed by Duchamp as well. In the spring of 1919, *Littérature* published the first chapters of a work by Soupault and Breton entitled "Magnetic Fields". They wrote these pieces together, and one can only guess at the authorship of the individual poems. Soupault later stated that in the course of his experiments, he had tried using "automatic writing" – a method which makes it possible to become liberated from the weight of criticism and the habits formed at school, and which generates images as opposed to logical calculations:

> Trace smell of sulphur
> Marsh of public health
> Red of criminal lips
> Walk twice brine
> Whim of monkeys
> Clock colour of day.[30]

Breton wrote that the "Magnetic Fields" constituted the first Surrealist, as opposed to Dadaist, work, although Surrealism was destined to appear officially only in 1924. Granted, one can find there much evidence of the influence of the French Symbolists and Lautréamont. Granted, the nihilist character of Dada is still present. However, the poems of Soupault and Breton did not make a complete break, either with logic, romanticism, or reflection on aspects of real life and modern times. A new style of literature and fine art was prefigured in the combination of all these qualities.

> Opening of sorrows one two one two
> These are toads the red flags
> The saliva of the flowers
> The electrolysis of the beautiful dawn
> Balloon of the smoke of the suburbs
> The clods of earth cone of sand
> Dear child whom they tolerate you are getting your breath back
> Never pursued the mauve light of the brothels…[31]

The appearance of Tzara in the home of Francis Picabia in Paris coincided with the start of an event staged by the Parisian Dadaists. Tzara's experience of work in the Cabaret Voltaire instilled new energy into

Leonora Carrington,
The Inn of the Dawn Horse, 1937-1938.
Private Collection.

James Guy,
Venus on Sixth Avenue, 1937.
Oil on paperboard, 59.7 x 74.9 cm.
Columbus Museum, Columbus.

the plans of Breton and Soupault's set. The first evening took place on January 23, 1920, in the hall of the Palais des Fêtes at the Porte Saint-Martin. The show included a reading by Breton of poems about artists, and a display of paintings by Léger, Gris and de Chirico. When Picabia's pictures were shown to the public, their obscene content provoked a storm of indignation. The audience left the hall, and the organisers felt that Dadaist art had brought them closer together. They were very young, they regarded the audience with contempt, and they were openly aiming to destroy the rules and norms that had been inherited from the past. They usually got together at the home of Picabia, where they discussed their plans.

The second public event took place in the Grand Palais on February 5. Tzara published a provocative announcement in the newspapers that Charlie Chaplin was going to be present, and this brought in the crowds. The Dadaist manifestos also sounded provocative when they were read aloud. "The audience reacted with fury", Ribemont-Dessaignes later recalled. "The organisers of the evening had achieved their main objective. It was essential to incite hostility, even at the risk of being taken for utter fools."[32] Someone accused them of promoting German propaganda. All the same, the owner of the Club du Faubourg in the Paris suburb of Puteaux offered the Dadaists his hall for the next event, which took place two days later on February 7. A naughty speech by Aragon incited a squabble between the anarchists and the socialists, which was brought to an end by Breton's reading of Tristan Tzara's "Dada Manifesto 1918". Afterwards a demonstration was held in the People's University in the suburb of Saint-Antoine. The following evening,

on March 27, there was a musical and theatrical event at the Théâtre de l'Œuvre. There, Breton read aloud Picabia's "Cannibal Manifesto", which was a parody of the kind of patriotic orations which were used to encourage audiences in the rear. Picabia once again offended bourgeois taste with his ensemble painting. A furry stuffed animal, an ape, was attached to the canvas, surrounded by Picabia's: *Portrait of Cezanne*, *Portrait of Rembrandt*, *Portrait of Renoir* and *Still Life*.

A Dada festival was held two months later, on May 26, 1920, in the spacious Salle Gaveau on the Rue La Boétie. It was their most sensational event in Paris. There were music and sketches, and plays by Breton and Soupault were staged. The unusual dynamism of Dada shows in 1920 attracted new and younger disciples to their ranks, among whom were the poets Robert Desnos and Benjamin Peret, and the artist Serge Charchoune. The last sensational performance of 1920 was held in December. Picabia once again organised a provocative exhibition, and Jean Cocteau led a jazz band in which random performers played on random instruments. Tzara read out his manifesto with the instructions on how to compose poems. In 1920, Marcel Duchamp, whose works were shown under the pseudonym of Rrose Sélavy (in French, sounds like "*Eros, c'est la vie*", in English, "Eros is life"), exhibited his famous *L.H O.O.Q.*, one of his Ready-Mades – a reproduction of the Mona Lisa to which the artist had added a beard and a moustache in pencil. It contained all the Dadaist denial of the classics and all their contempt for art in general. However, the excessive strain, the incredible rhythm of the performances, and the clashes among the incompatible personalities called for a breathing-space in their activity.

Salvador Dalí,
The Old Age of William Tell, 1931.
Oil on canvas, 98 x 140 cm.
Private Collection.

The year 1921 was marked by a new outburst of Dadaist activity. The year started with the implementation of the "visits" project, conceived by Breton – a Dadaist parody of the traditional code of polite society in past times. However, the act near the church of Saint-Julien-le-pauvre virtually came to nothing on account of rain. Nor did the trial of the writer Maurice Barres have the success they expected of it. A tribunal chaired by Breton found him guilty of the nationalism and extremism of the war years. The song sung by Tristan Tzara, "Dada Song", livened up the event.

The song of a Dadaist
Who had Dada at heart
Overtired his motor
Which had Dada at heart

The lift was carrying a king
Heavy fragile enormous
He cut off his big right arm
And sent it to the Pope in Rome

This is why
The lift
No longer had Dada at heart

Eat chocolate
Wash your brain
Dada
Dada
Drink water.[33]

More interesting still, in the context of the gestation of Surrealism, was the exhibition of Max Ernst which opened on May 2. Until then, the main figure from the visual arts that had made an appearance under the aegis of Dada was Picabia. Around that time, he was distancing himself more and more from Breton and Aragon's company. Ernst was invited, to a large extent, out of a desire to play a joke on Picabia. They rented the bookshop Sans Pareil on the Rue Kleber for the exhibition. The invitation – the so-called "Pink Prospectus" – was couched in a half-nonsensical, derisive tone: "Entry is free, hands in pockets. The exit is guarded, painting under the arm."[34] Everybody who mattered attended the viewing. One of the Dadaists, who had hidden himself in a cupboard, shouted out absurd phrases from inside it, along with the names of famous people: "Atttention. Here is Isadora Duncan", "Louis Vauxcelle, André Gide, van Dongen." As it happened, both Gide and van Dongen were among those who attended. The stage was in the basement, all the lights were turned out, and heart-rending cries could be heard coming from a trap-door. … Breton struck matches, Ribemont-Dessaignes repeatedly shouted out the phrase "It's dripping onto the skull", Aragon meowed, Soupault played hide-and-seek with Tzara, while Peret and Charchoune spent the whole time shaking hands. As always, poems were read.

Even Parisians who had seen many sights were surprised by the exhibition itself. Ernst showed the most varied pieces: there were "mechano-plastic" works inspired by mechanical forms, objects, painted canvasses and drawings. Ernst's collages were fundamentally different from the collages in which the Cubists had already given lessons – they had a poetic quality and provoked numerous associations. Ernst gave inexplicable titles to his works – for example, the *Little Eskimo Venus*, *The Slightly Ill Horse*,

Toyen (Marie Cermínová),
The Sleeper, 1937.
Private Collection.

Yves Tanguy,
Landscape with Red Cloud, 1928.
Private Collection.

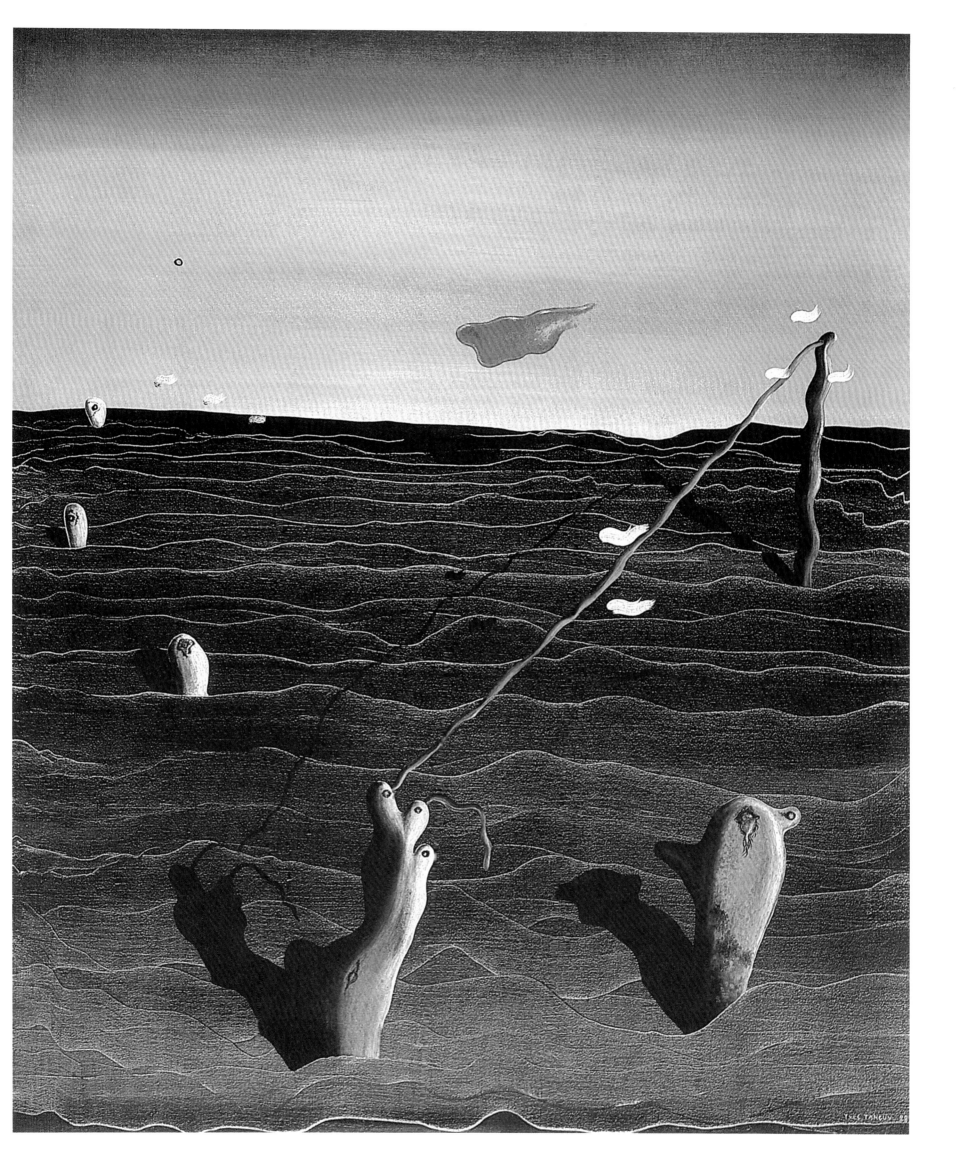

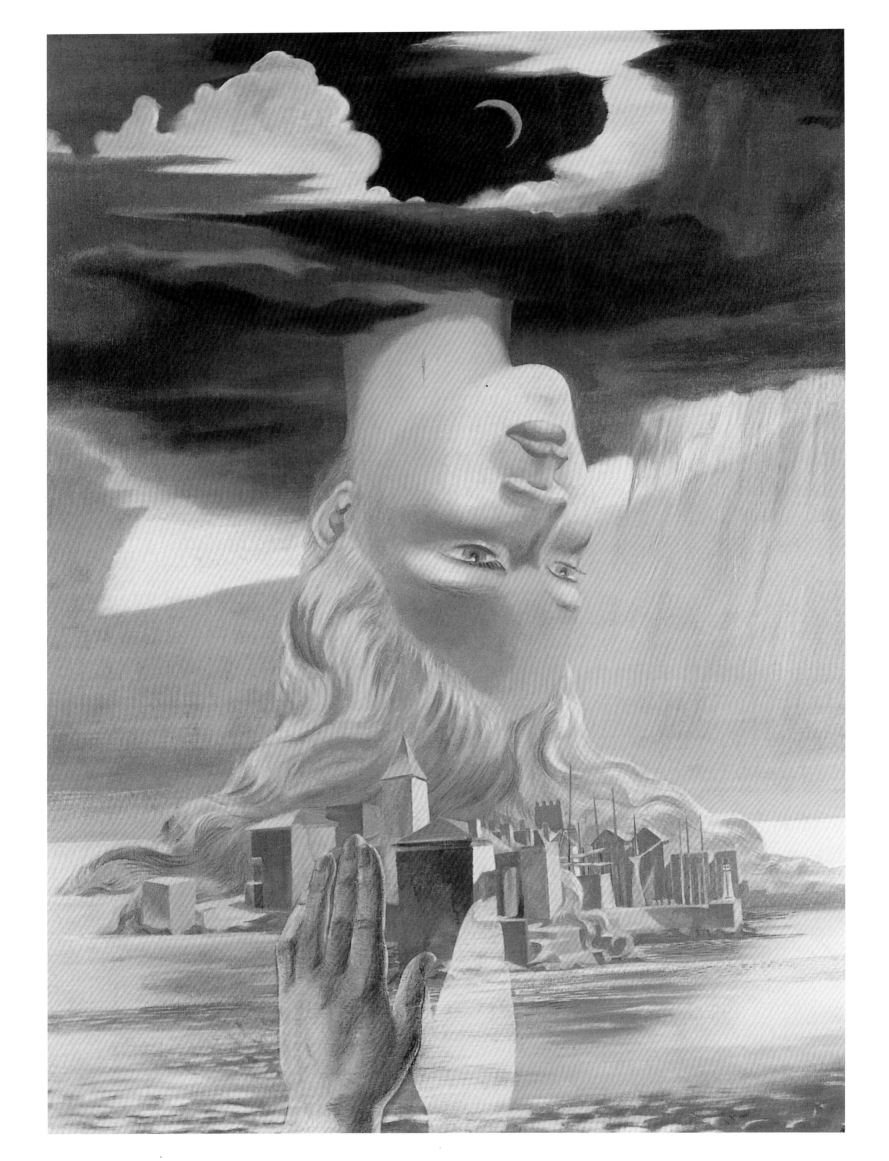

Dada Degas – and accompanied them with "verbal collages". His poems were close in spirit to those of Breton's circle. Indeed, it was after this exhibition of Max Ernst that Breton worked out a few fundamental principles of Surrealism for his later manifesto.

The next exhibition was that of the Salon Dada which opened on June 6, 1921 on the Champs-Elysees, and lasted until June 18, extending over all the evenings which entered into the Salon Dada programme. In the exhibition hall, a very wide range of objects hung from the ceiling: an opened umbrella, a soft hat, a smoker's pipe, and a cello wearing a white tie. Since the exhibition was advertised as an international one, invitations were sent out to Arp in Switzerland, Ernst and Baargeld in Germany, Man Ray in America, as well as other artists. Ernst exhibited his *Cereal Bicycle with Bells* for the first time. One picture by Benjamin Peret showed a nutcracker and a rubber pipe, and it was called *The Beautiful Death*, while another showed the Venus de Milo with a man's shaven head. Under a mirror belonging to Philippe Soupault and reflecting the visitor's own face was the inscription: *Portrait of an Unknown Figure*. Other works by Soupault were titled *The Garden of My Hat*, *Sympathy with Oxygen*, and *Bonjour, Monsieur*. In addition to all the other absurd inscriptions, a placard hung in the lift-cage which read "Dada is the biggest swindle of the century". This exhibition already clearly pointed to Surrealism.

Despite the very serious contradictions between the strong individual personalities in the Dadaist movement, Breton designed one further "big swindle" in 1922. The Dadaists decided to hold their own Paris Congress – "The International Congress for the Determination of Directives and the Defence of the Modern Mind". Despite almost six months of preparation, a wealth of publications, and a lively correspondence between Tzara, Picabia, Breton and others, this plan experienced a setback. André Breton was forced to admit that the movement was already dead and buried, and that there was no point in trying to resurrect it. However, just at that moment, in the spring of 1922, an event took place heralding the birth of Surrealism from within the Dadaist movement. A new number of *Littérature*, a journal which had not come out for some time, appeared on March 1, 1922. In it were published Breton's "Three Tales of Dreams", and his article entitled "Interview with Professor Freud in Vienna". In 1921, at the time of his visit to Vienna, Breton failed to get an interview with Freud, but both publications testified to the author's interest in using psychoanalysis for the expression of the unconscious in art. From the fourth number of the journal onwards, Breton took the entire management of the journal on himself. Appealing to those who remained in his camp, Picabia, Duchamp, Picasso, Aragon and Soupault, Breton wrote: "It cannot be said that Dadaism served any purpose other than to support us in a state of lofty emancipation, which we now reject, being of sound mind and memory, in order to serve a new vocation."[35] The Dada movement bade farewell to its child. "I have closed Dada's eyes", wrote Peret in the fifth number of the journal, "and now I am ready to go, I look to see from where the wind is blowing, unconcerned about what will happen next or where it will take me."[36]

Breton's lead article in the following number was called "The Outlet of the Medium". The former Dadaists found their means of tapping the subconscious in the enthusiasm for spiritualism and for everything supernatural that was common in Paris after the war: in spiritualist séances, automatic writing and the narration of dreams. They were drawn to word-play, and preoccupied with the mystery of the telepathic link between Duchamp, who was in America, and his young protégé in Paris, the poet Robert Desnos. Later, Breton recalled his first encounter with the mystery of the dream: "In 1919, my attention focussed on the sentences, more or less fragmentary, which, when one is in complete solitude, just before going to sleep, one's mind is able to pick up without being able to detect any prior purpose behind them. One evening, in particular, before going to sleep, I apprehended clearly articulated, … a fairly bizarre sentence, which reached me without carrying any trace of the events in which, according to my consciousness, I found myself involved at that moment, a sentence which struck me as insistent, a phrase, I would venture to say, *that felt like it was banging at the window-pane* … it was something like: "There is a man cut in half by the window." "[37] At that moment Breton was passionate about the methods of research into the human psyche which Freud had used,

Roland Penrose,
Seeing is believing, 1937.
Oil on canvas, 100 x 75 cm.
The Roland Penrose Collection, Sussex.

Yves Tanguy,
The Hand in the Clouds, 1927.
Oil on canvas, 65 x 54 cm.
Staatsgalerie, Stuttgart.

Oscar Domínguez,
The Hunter, 1933.
Oil on canvas, 61 x 50 cm.
Museo de Bellas Artes, Bilbao.

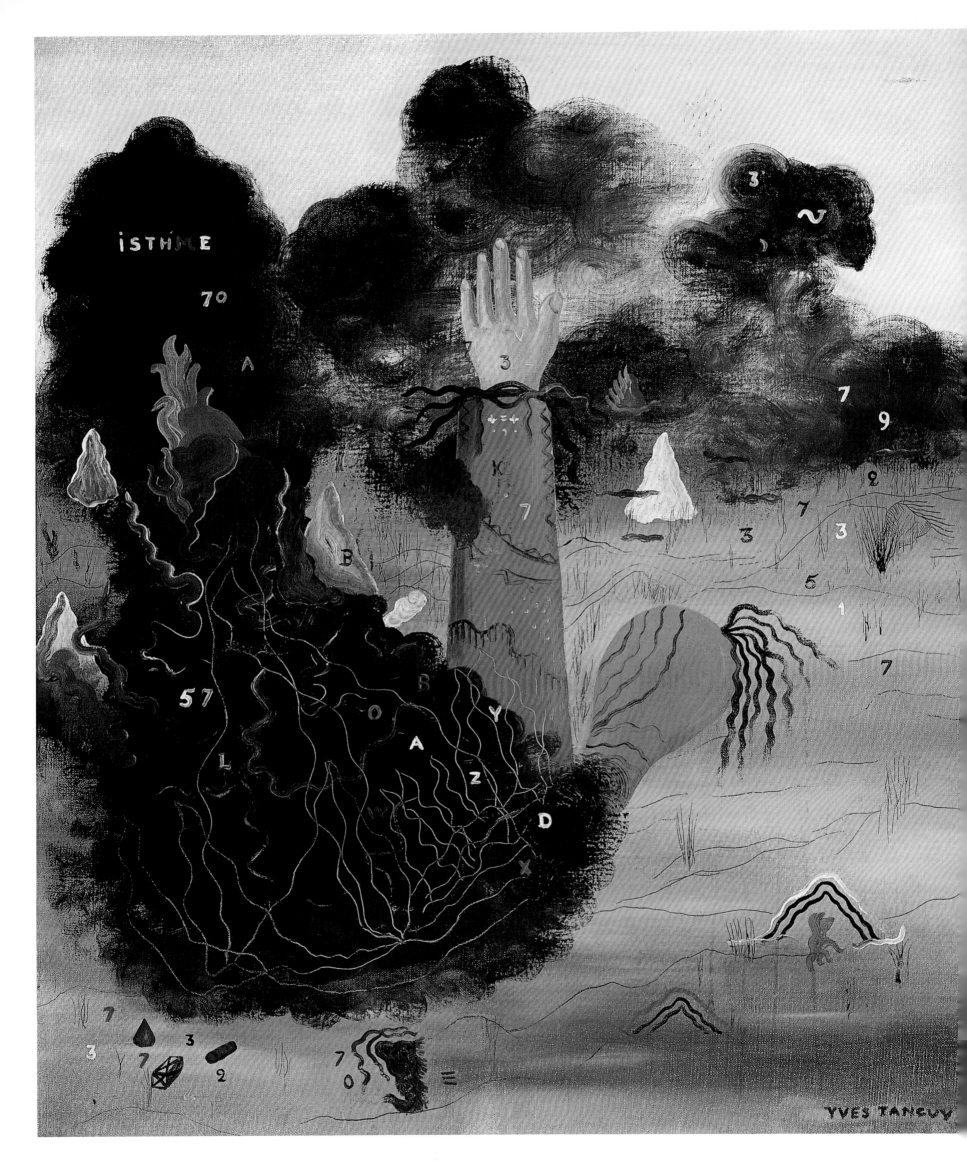

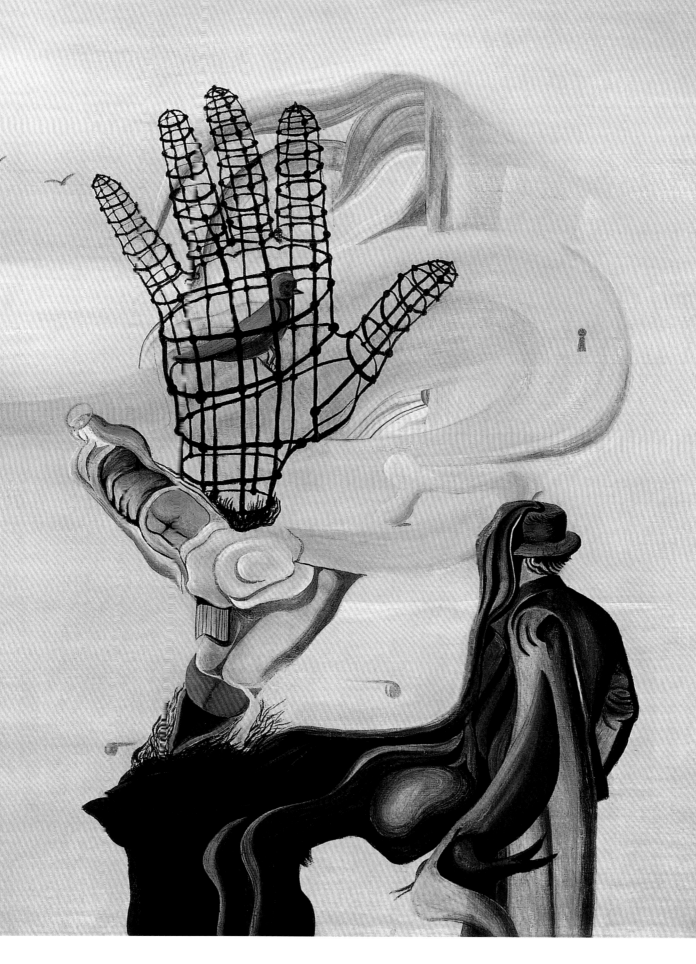

and which he himself tried to use in the course of his professional experience with patients during the war. He came to the conclusion that "the speed of thought is no greater than that of words, and that it does not necessarily challenge the tongue, or even the pen moving across the paper." Breton shared his revelation with Philippe Soupault, and it was actually then that they got down to work on "Magnetic Fields", putting into practice the method of automatic writing.

The young Parisian poet René Crevel turned out to be a medium, and when in a state of hypnotic trance he would utter strange phrases. Crevel had brought out the Dadaist journal *Aventure* in 1921 along with Francois Baron, Georges Limbourg, Max Moris and Roger Vitraque. He agreed to Breton's proposal to participate in spiritualist séances. As a result, his gift drew the future Surrealists into the passion for spiritualism. In this way, according to Aragon, by the end of 1922 "an epidemic of sleeping hit the Surrealists … Seven or eight of them came to live only for those instances of forgetfulness when, once the lights were out, they spoke unconsciously, like drowned people in the open air…"[38] After that there arose a fashion for "speaking one's dreams", even though for this there was actually no need to sleep. This period in the history of Surrealism was later called "the era of rest".

Unable to resign himself to the death of Dada, Tristan Tzara tried in July 1923 to organise a performance at the Michel Théâtre in Paris entitled "Evening of the Bearded Heart". Although the evening did have the expected impact, it ended with a fight on the stage between Éluard and Tzara, and the involvement of the police. The Dada era was already in the past. Dada had performed its destructive role, and on its ruins a new movement was now in the process of being constructed – Surrealism. Dada had assembled so many outstanding people in Paris from many different countries, that a brigade of construction workers was already on stand-by. Dada had developed numerous new concepts and ideas, which Surrealism was later to use. But the main thing was that through Dada, the major artists of Surrealism became Surrealists.

However, it seems that too much was destroyed. Dada strove to deprive literature and art of everything in it that was romantic and lyrical, of everything that stirred and roused the impulses of the soul. When the science of psychoanalysis, the spirituality of Symbolism, and the romanticism of all the centuries of the past were all combined together and then added to the anarchism and absurdism of Dada, the result was Surrealism.

THE BAPTISM OF SURREALISM

Surrealism found its name almost as spontaneously as had Dada, the only difference being that unlike "Dada", the term "Surrealism" possessed an exact meaning. The word "Surrealism" means "above realism", "higher than realism". Not only as a term, but also as a concept, Surrealism arose far earlier than the artistic tendency that sprang up over Dadaist foundations. The inventor of the term was Guillaume Apollinaire, idol of the avant-garde, author of "Alcools", and, according to Louis Aragon, "the only man still capable of sprinkling with precious alcohol a France which had been dried up by the war."[39] The premier of his play, "The Breasts of Tiresias", was held in the Théâtre René-Maubel in Montmartre on June 24, 1917, but according to Apollinaire it was written much earlier, in 1903. The subtitle read: "A surrealist drama in two acts with a prologue". In the preface to the play Apollinaire stated that he had written it for the French in the way that Aristophanes had written comedies for the Athenians. Although the theme – the problem of procreation – is very important, he did not want to write a play in a moralising tone, and summoned his fantasy to his aid. "I warned them (the French – N.B.) of the serious danger, recognisable to all, which a nation laying claim to prosperity and power would undergo if it was fast losing the desire to bring children into the world, and I showed them how to deal with the crisis and what ought to be done to that end."[40] In his article in the newspaper *Le Pays* the critic Victor Bach wrote: "M. Guillaume Apollinaire's play is a surrealist drama, that is,

Frida Kahlo,
The Love Embrace of the Universe, The Earth (Mexico), I, Diego and Señor Xólotl, 1949.
Oil on canvas, 70 x 60.5 cm.
Private Collection, Mexico.

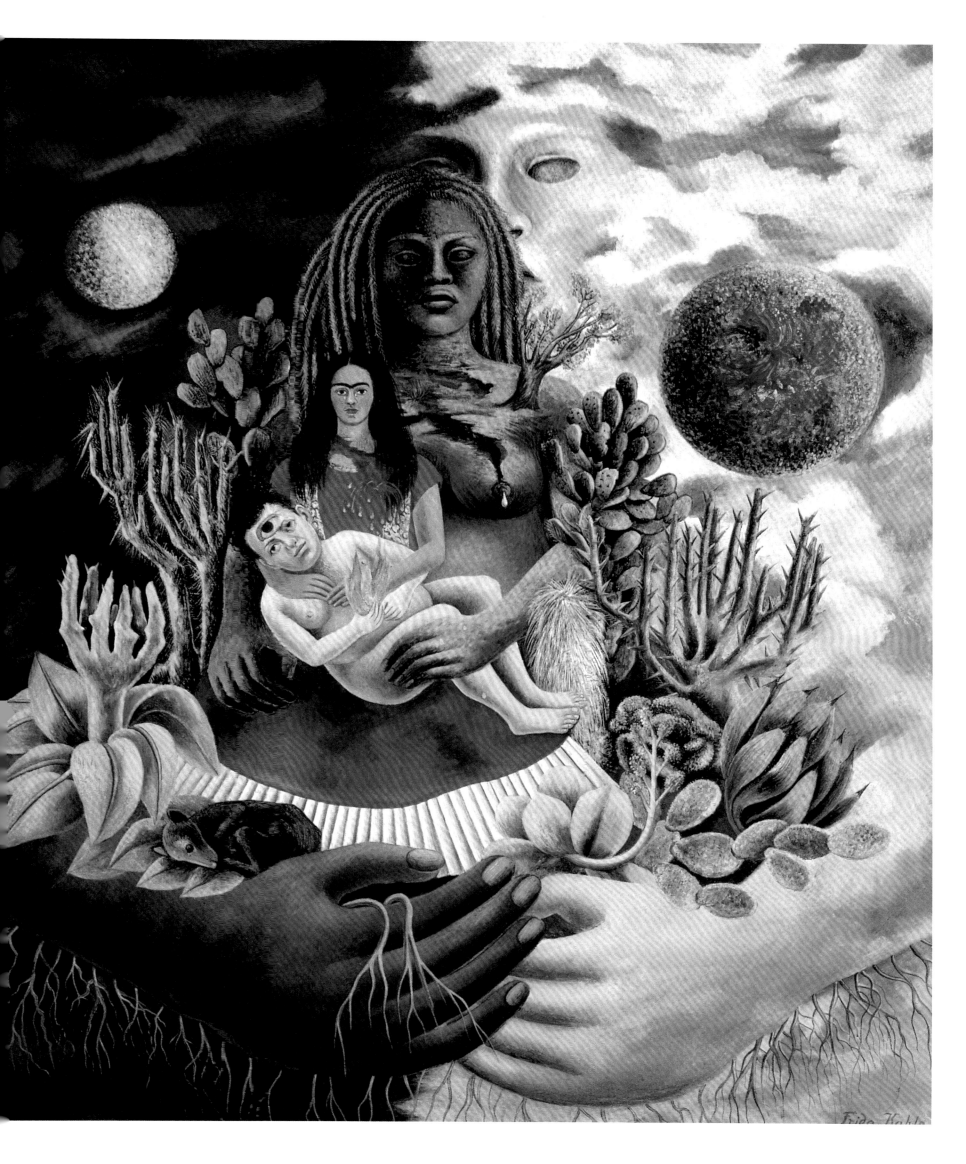

50

in plain French, a symbolist drama."⁴ Apollinaire wrote in the preface to the play: "For the definition of my drama I made use of a neologism, which is something for which I ought to be forgiven, as that sort of thing rarely happens with me, and I thought up the adjective 'surrealist' – it does not conceal any symbolic meaning … but fairly exactly defines a tendency in art which, although it is not new, like everything under the sun, has in any case never up to now served to formulate any kind of credo, any kind of artistic or literary hypothesis."⁴² Apollinaire said that he was aiming to be above the blind replication of nature; he did not want to imitate nature in the manner of photographers. In his search for a term, he strove to be as exact as possible. "All things considered", he wrote in one of his letters, "I really think that it would be better to adopt surrealism rather than 'supernaturalism', which is what I used first. Surrealism does not yet exist in the dictionaries, and it will be more convenient to use than the word 'supernaturalism' that is already in use."⁴³

Apollinaire's term showed itself capable of being widely employed. It was applied both to theatre and literature, and also to every branch of the visual arts. It could relate to new art and to the work of artists of the past; it was of sufficiently wide scope to be able to accommodate the ambition of many generations of creative artists to go outside the framework of the visible, real world. Surely poets and painters have striven throughout the ages to rise above reality, to find the freedom for fantasy, to open an outlet to the world of the unknown and the mysterious. Apollinaire introduced an expressive example into the preface to his play: [while] searching for a way to imitate walking, man invented the wheel, he wrote, which is not at all the same as the leg; in other words, man discovered Surrealism without knowing it. Before Apollinaire passed away on November 9, 1918, he had sketched out the contours of the Surrealist movement that was about to come into existence, and had given it a name. But it was not until 1924 that André Breton linked the term Surrealism to the new direction being taken by literature and the fine arts. "In homage to Guillaume Apollinaire", he wrote, ' … Soupault and I assigned the name of Surrealism to the new mode of pure expression …"⁴⁴ Nevertheless, Breton could not agree completely with Apollinaire. He thought that for the new artistic language, "supernaturalism", the term that was employed by Gérard de Nerval, was possibly more suitable. Nerval intended this term to cover not only his own art, but creative work of any kind that was made subject not to the copying of reality, but to the imagination, the same approach Apollinaire had in mind. Every artist whose dreams and visions are transformed in the work into a reality creates "in this state of supernaturalist reverie", he wrote.⁴⁵

THE DEVELOPMENT OF SURREALISM

Even before it had obtained its official name, Surrealism was already rapidly gathering momentum. Over the course of 1922 and 1923, the journal of the movement that was taking shape was *Littérature*, a collaboration between Breton, Aragon, Éluard, Ficabia, Peret and Ernst, together with Robert Desnos, who wrote under the pseudonym of Rrose Sélavy which he had taken from Marcel Duchamp. New, youthful forces were constantly finding their way into the journal. Surrealism, like Dadaism before it, manifested itself most obviously in literature in the initial phase of its development. Its head, without a doubt, was the highly energetic and single-minded André Breton.

Adrienne Mounier, who ran a bookshop on the Rue d'Odeon, described André Breton as she saw him in 1916 as follows: "He was beautiful, with the beauty, not of an angel, but of an archangel (angels are graceful and archangels are serious ..). His face was massive and well-outlined; he wore his hair fairly long and brushed back with an air of nobility; his gaze was always distant from the world, even from himself, and with its lack of animation, it resembled the colour of jade … Breton did not smile, but he would sometimes laugh, with a brief and sardonic laugh which would suddenly appear in the middle of his conversation without disturbing the features of his face, in the way you see with women who are careful

about their looks. With Breton, it was his violence that made him like a statue. His weapon is the sword. He has the motionless quickness of perception found in mediums."[46] He wore green spectacles purely to catch attention. The André Breton of the 1920s in which this attractive young man had been transformed, possessed qualities which made everyone who had joined the new world of Surrealism drawn to him, and led them to gather around him. His contemporaries spoke of the peculiar magnetism of his personality. He was a man who proved capable of persuading others, and of forming a circle of supporters who made up the driving force of the movement. But Breton also knew how to take command; he had the particular type of authority that comes from the exercise of power.

In 1924, the poet Ivan Goll, who had been involved in the Dada movement in Zürich during the war, published a journal entitled *Surrealism*. In an attempt to steal Breton's thunder, he published his own personal *Surrealist Manifesto*. He accused Breton of confusing art with psychology, and of creating a false version of Surrealism through his misleading notions about the all-importance of the dream. However, the most brilliant Dadaists and the young generation of literary talent that had joined them formed a group around Breton, in spite of the wide range of individual characters and conflicts between different personalities that often proved impossible to resolve.

"It is said that every day, at the time when he went to sleep, Saint-Pol-Roux would tell someone to put a notice on the door of his manner, Camaret, which read: THE POET IS WORKING." For Breton, the legend of the symbolist poet was almost a formula of the method of Surrealist creativity.[47] A man's whole experience of real, everyday life enters into contradiction with his imaginative capability, with the experience of a different life, the life of his dreams. Breton therefore rejected everything in art that was connected to realism and, in the final analysis, to all the classics that the Dadaists were trying so hard to destroy. "… The realist attitude, inspired as it is by positivism, from St. Thomas to Anatole France, actually strikes me as hostile to intellectual and moral progress of any kind. I have a horror of it, because it is the product of mediocrity, hatred and dreary self-satisfaction."[48] For genuine creative work one requires freedom, and it is essential to throw off the weight of everything that oppresses man in real life, everything upon which the structure of realism is founded. "We are still living under the reign of logic… But logical processes, in our time, can now only be applied to the resolution of problems of secondary importance. The absolute rationalism which is still the fashion only allows one to consider the facts that narrowly pertain to our experience. What we have lost, on the other hand, are logical aims. Needless to say, even experience has got to the stage of assigning itself limits. It turns around in a cage from which it is more and more difficult to get it to come out. It, too, rests on immediate utility, and it is watched over by common sense. Under the guise of civilization, under the pretext of progress, we have reached the point of banning from the mind everything which can be criticised, rightly or wrongly, as superstitious or chimerical; of forbidding any method of seeking after truth that does not conform to the standard approach."[49] What has to take the place of rationalism, and of the source of inspiration provided by the realities of everyday life, is the imagination: "The imagination is perhaps on the point of reasserting its rights. If the depths of our mind contain strange forces that are capable of adding to those at the surface, or of winning the fight against them, there is every interest in capturing them, in capturing them first, to tame them afterwards…"

The Surrealist poet had at one time embarked on a medical career in psychiatry, and so, when he went in search of the sources of the imagination, he turned to the experience of Freud, who was the first man to appreciate the vast place in the life of man occupied by dreams. "Man, when he is no longer asleep, is above all the toy of his memory, and in his normal state the latter gratifies itself by feebly retracing for him the circumstances of the dream, depriving the dream of any real importance, and causing what he thought was the only determining factor at the time he left it a few hours earlier to disappear: whatever firm hope he cherished, or fear he felt. Afterwards he has the illusion of carrying on with something that is worthwhile."[50] The objective of Surrealism is to make use of the dream, which will open the way to the Great Mystery of Life

Valentine Hugo,
Toad from Maldoror, 1936.
Gouache and pencil on paper, 47 x 30.5 cm.
The Neshui Ertegun and Daniel Filipacchi
Collections.

Štyrský
1937

in the cause of his own art – which for Breton basically meant literature. "I believe in the future resolution of these two states, so contradictory in appearance, that are the dream and reality, into a sort of absolute reality, a "surreality", if one can put it that way. This is what I am striving to attain…"[51]

The imagination of André Breton erected a castle, at once fantastic and real, inhabited by both the former Dadaists and the Surrealists: "This castle belongs to me, I see it in a rustic site, not far from Paris … Some of my friends have come to live there: Louis Aragon is just leaving; … Philippe Soupault gets up when the stars come out, and Paul Éluard, our great Paul Éluard, is not yet back. Here are Robert Desnos and Roger Vitrac, who are in a park deciphering an old edict on the duel; Georges Auric, Jean Paulan; Max Morise, who rows so well, and Benjamin Peret, engaged in his funny equations; and Joseph Delteil; and Jean Carrive; and Georges Limbourg…; and Marcel Noll; here comes T. Fraenkel who is signalling to us with his captive balloon, Georges Malkine, Antonin Artaud, Francis Gérard, Pierre Naville, J.-A. Boiffard, and then Jacques Baron and his brother, hale and hearty, and so many others as well, and some ravishing women… Francis Picabia comes to see us, and last week, in the hall of mirrors, a gentleman named Marcel Duchamp, who had not previously been introduced, came to call. Picasso hunts in the grounds."

After sketching a portrait of the Surrealist circle, Breton eventually gives his definition of what Surrealism is:

> **Surrealism**, n. A purely psychological form of automatic reflex by which one sets out to express, either verbally, or in writing, or in any other fashion, the operation of thought. Dictation from thought, in the absence of any exercise or control on the part of reason, outside every aesthetic or moral preoccupation.
>
> **Encyclopedia of Philosophy.** Surrealism rests on a belief in the superior reality of certain forms of associations that, until it appeared, had been neglected, on a belief in the absolute power of the dream and in the disinterested play of thought. It aims to ruin conclusively all the other psychological mechanisms and to substitute itself for them in the resolution of the principal problems of life.[52]

In this fashion, Breton consolidated the language of Surrealism, for the sake of which the Dadaists had been striving to destroy the outdated language of art. Breton's automatism of composition was basically a literary affair. In his manifesto he gives a lesson in this kind of writing, asserting that: "[L]anguage was given to man for him to use it in a surrealist way."[53] When it came to the language of other fields of art, such as painting and sculpture, Breton's disciples would have to find it by themselves in their own individual fields.

From December 1, 1924, the journal *La Révolution surréaliste*, run by Pierre Naville and Benjamin Peret, and printing the work of Aragon, Éluard, Soupault, Vitrac and numerous others, became the printed mouthpiece of the Surrealists. It was dressed up to look serious, outwardly imitating such scientific journals as *La Nature*, and became one of the most talked-about journals in Paris. From 1925, Breton was in charge of the journal. They established an "Office of Surrealist Research", rather like a laboratory, where they would engage in Surrealist experiments. "At number 15 on the Rue de Grenelle", wrote Aragon, "we opened a romantic hostel for unclassifiable ideas and ongoing revolts. Anything in this universe of despair for which there is still hope, may one day look up in its final delirium towards our pitiful little workshop: we were trying to arrive at a new declaration of the rights of man."[54] They sent briefings to the press – their "butterflies" flew out of the office at very frequent intervals. Every Surrealists' get-together, at the apartment of one of the group, or at one of their favourite cafes – Certa, Cyrano, the *tabac* on the Place Pigalle, or the Café de la Place Blanche – was usually accompanied by games. In 1925, the Surrealists published their first "exquisite corpses" – the

Jindrich Styrsky,
Book-Object, 1937.
Private Collection.

result of their favourite game. "A game with folded pieces of paper, which consists in having a sentence or a drawing put together by several persons, without any of them being able to take account of the contribution or contributions that preceded it. The example, now a classic, which has given the game its name, is contained in the first sentence obtained in this fashion: "The exquisite corpses will drink the new wine." For the Surrealists, this game was an example, first of all, of automatic, absolutely unpremeditated creativity, and second, of the creativity of a team.

La Révolution surréaliste carried on the business of Dada, overturning the authorities of the old art. A pamphlet against Anatole France was entitled "A Corpse". "An old man like the rest of them", wrote Éluard. "A ridiculous character, and so empty", Soupault seconded him. "Have you ever given a dead man a slap in the face?" inquired Aragon, and gave a summing-up: "On certain days I have dreamed of a rubber to erase the squalor of humanity."[55] All this created a loud scandal, as did the special events they organised. One of them was the "Homage to Saint-Pol-Roux" organised by "Les Nouvelles littéraires" on the Boulevard Montparnasse, at La Closerie des Lilas. Here the Surrealists poured scorn on writers who, in their eyes, belonged to the category of obsolete literature. Their conduct itself was abusive and unacceptable: Soupault, for example, swung on the chandelier. The woman writer Rachilde later complained that a tall fellow there with a German accent kicked her (it was probably Max Ernst). The scandalous situation which had started in the restaurant spilled out onto the street. However, for the future of Surrealism, the views they expressed that were related to art and the language of painting were of much more importance.

In addition to the journal, the Surrealists published separate declarations as well. The "Declaration of 27 July 1925" stated: "Surrealism is not a new or easier means of expression, nor even a metaphysic of poetry. It is a means of total liberation of the mind and of everything in common with it. … Surrealism is not a poetic form. It is a cry of the mind…"

In 1926, collections of Surrealist poems by Aragon, Paris Peasant, and Éluard, The Capital of Pain, rolled off the press. Éluard's poems were enigmatic and refined:

> The river which I have under the tongue
> The water which people do not imagine, my little boat,
> And, the curtains lowered, let us talk.[56]

Despite their seemingly accidental quality and spontaneity, and the word-games and automatic writing they employ, these poems produced a striking image of the Surrealist world which the poets and the artists alongside them were creating:

> In a few seconds
> The painter and his model
> Will take flight.

> More virtues
> Or fewer misfortunes
> I notice a statue

> A sort of almond
> A shiny medal
> For the biggest grief.[57]

Kay Sage,
I Saw Three Cities, 1944.
Oil on canvas, 92 x 71 cm.
Princeton University Art Museum,
gift of Kay Sage Tanguy, Princeton.

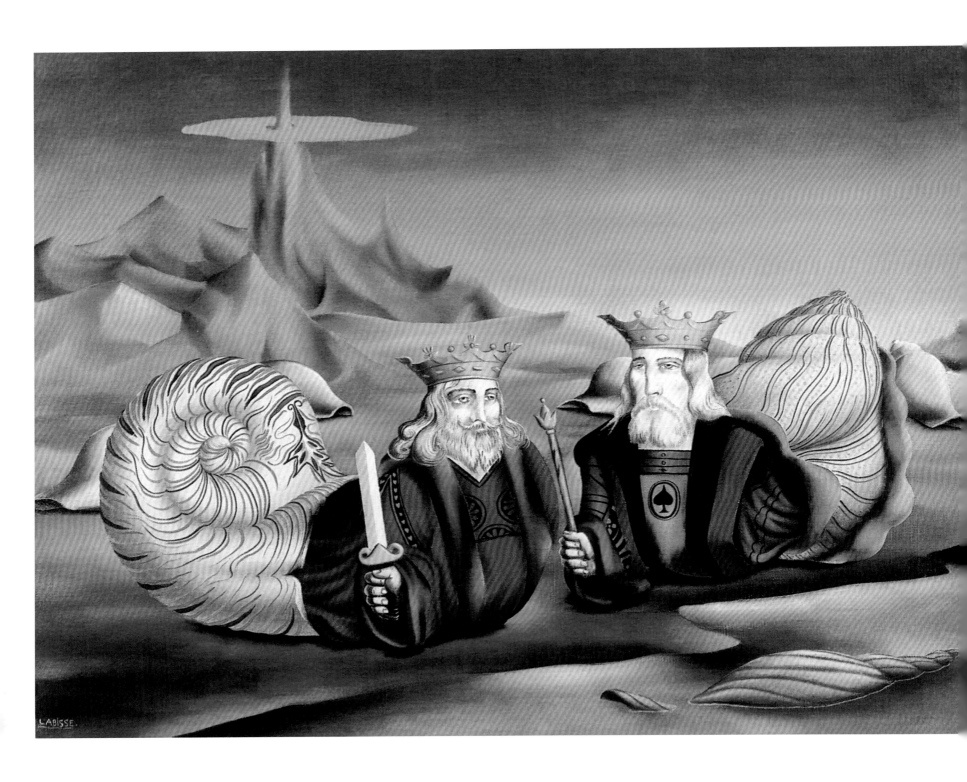

Sometimes an Éluard poem is limited to only one line, to give the maximum possible concentration to its expressive impact:

She tells the future. And I am responsible for confirming the truth of it.[58]

Sometimes the poet, it seems, forgets about mystery, about Surrealism, and reveals realistic human emotions:

The heart bruised, the soul aching, the hands tired out, the hair white, the prisoners, all the water has come upon me like an open wound.[59]

In 1925, there also occurred an event of exceptional importance: the first joint exhibition of Surrealist painting was held in Paris at the Galerie Pierre. The artists involved were Arp, de Chirico, Ernst, Klee, Man Ray, Miró, Picasso and Pierre Roy. It was the beginning of the succession of displays of painting and sculpture that make it possible to speak of Surrealism both as a phenomenon and at the same time as the union of diverse and outstanding aesthetic talents. In the same year, the Galerie Pierre organised an exhibition of Juan Miró. On 26 March 1926, the Galerie Surréaliste was solemnly opened, and it showed work by Duchamp and Picabia, as well as those artists already named. In 1928, the Galerie Bernheim put on an individual exhibition of Max Ernst. The ranks of the Surrealist artists in Paris were reinforced by incomers from other countries. In 1927, René Magritte arrived from Belgium. In 1928, Salvador Dalí came from Spain to Paris for the first time, and he had his first personal exhibition in Paris in 1929. In 1931, Alberto Giacometti, a native of Switzerland, exhibited his Surrealist sculpture-objects for the first time. The Surrealist artists illustrated books, painted scenery for contemporary theatrical productions, and made Surrealist films. It would be fair to say that at this stage, the Surrealists' creative work pointed in different directions: literature ceded pride of place to the visual arts which were steadily gathering momentum.

However, Surrealism as a movement had already experienced the moment of its triumph. Even in the early stages, absolute unity had not been one of its characteristics, but now disagreements were becoming increasingly acute. The events in the political and social life of Europe at the beginning of the twentieth century were bound to be reflected in a movement which took such an uncompromising, even anarchist position on the subject of the bourgeois world. First the Revolution in Russia and the wave of unrest that hit the whole of Europe as a result, along with Lenin and Trotsky's writings; then the war in Morocco, and the necessity for the French intelligentsia to determine their own position in relation to it – all this provoked not only heated polemics from the Surrealists that were directed against other groups of intellectuals in Paris, but also sharp disagreements within the movement. It seemed as though the Surrealists only had to go one step further before they found themselves moving into social and political activism. In any event, in the middle of the twentieth century they left their ivory tower, feeling that they had a bond with the destructive forces of the revolution. "The authentic art of today is hand in glove with the social function of revolution: art, like the latter, aims to confuse and to destroy capitalist society", Breton wrote.[60] In this situation, the question arose: what in practical terms could the Surrealists accomplish? Pierre Naville put this question in his article, "Intellectuals and the Revolution". According to him, the Surrealists had the choice of two directions: "either to persist in a negative attitude along anarchist lines, a false attitude from the outset because it does not justify the idea of revolution which it proclaims, an attitude which is subordinate to the refusal to compromise one's own existence and the sacred character of the individual in a fight which would lead towards the disciplined action of the class struggle; or, commit oneself resolutely to a revolutionary course, the only revolutionary course, the Marxist course."[61] Breton affirmed his solidarity with the Communist Party.

The most decisive position on the political level was taken by the Five ("Les Cinq"): Aragon, Breton, Éluard, Peret, Unik. In November 1926, they excluded Antonin Artaud and Philippe Soupault from the Surrealist

Félix Labisse,
The Camp of Drap d'Or, 1943.
Private Collection.

Oscar Domínguez,
The Minotaur, 1938.
Private Collection.

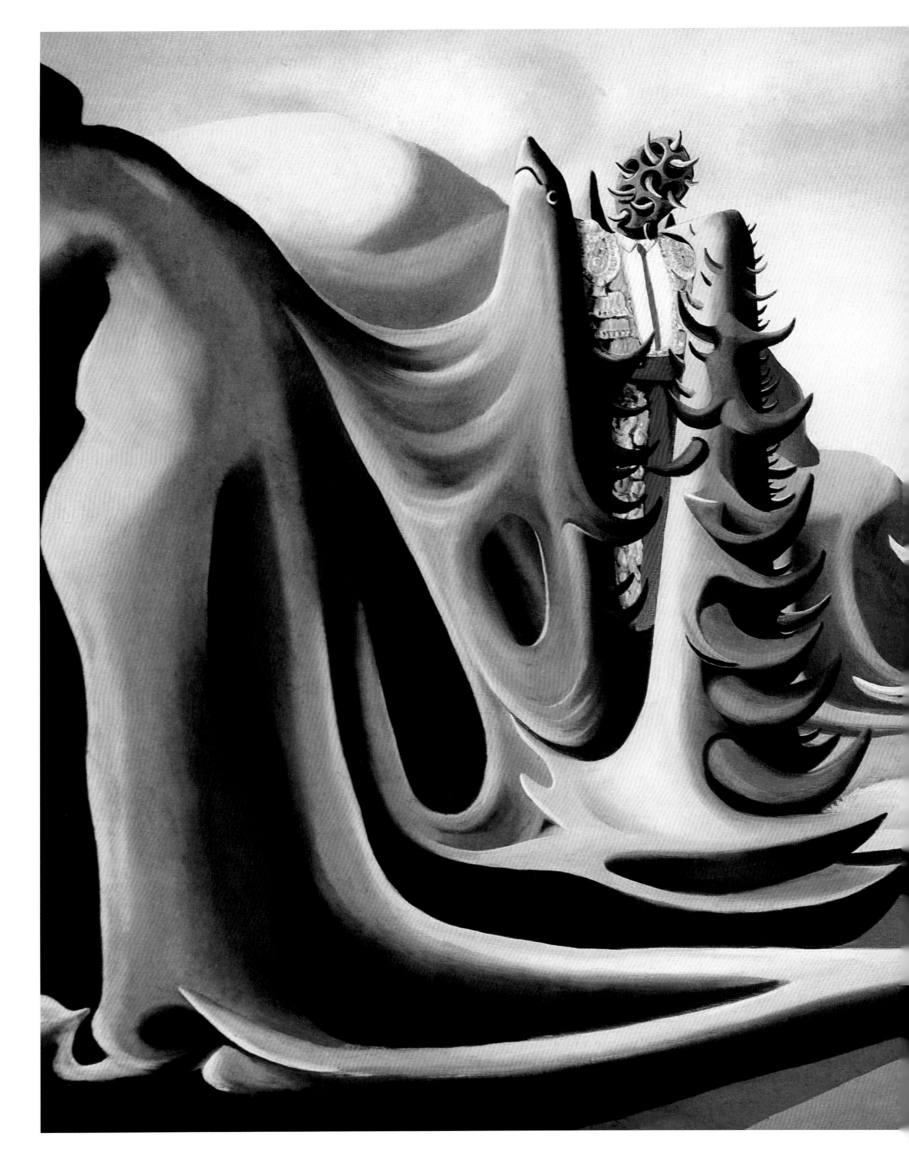

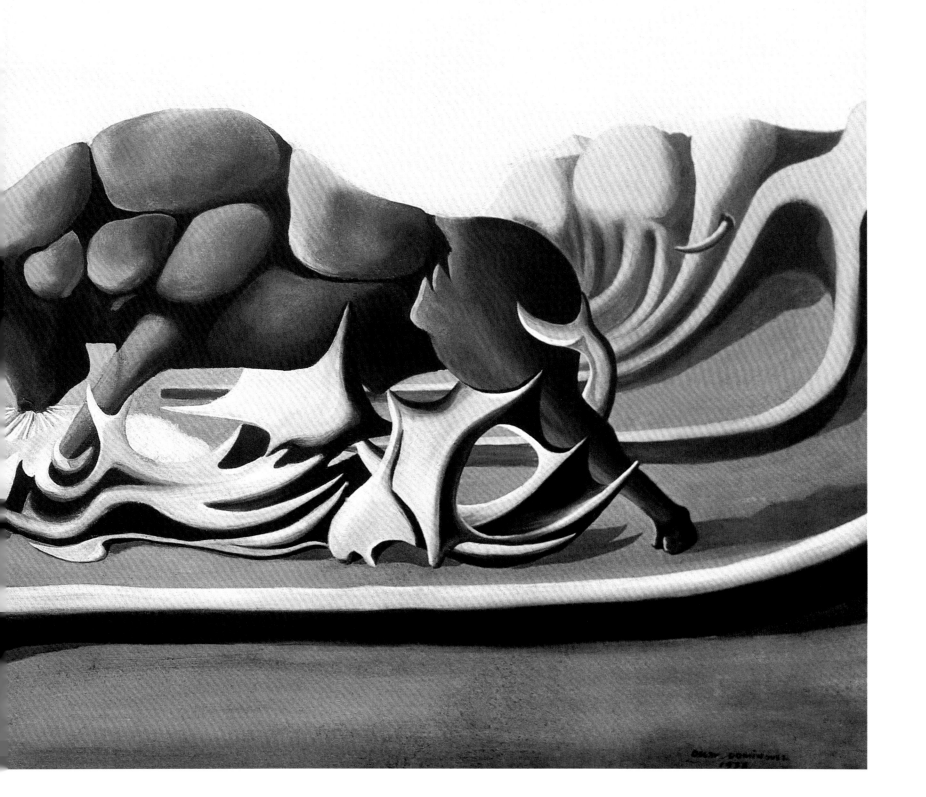

movement for "incompatibility of aims". They thought that it was now no longer enough to state one's position: one had to take the side of the party of revolution. Ties which had once seemed so strong were cut as friendships were destroyed by these heated arguments. The framework of Surrealism seemed to some of them to be too narrow. Desnos and Naville left the movement. Breton was implacable towards his former friends. He demanded that the performance which Artaud was arranging should be taken off the stage, despite the fact that Artaud had already been excluded from the group, and he got the police to come to the theatre. Breton's position gave rise to an increasing level of discontent, and he was reproached for his tyrannical treatment of the members of the group. Breton thought that it was necessary to manage every Surrealist to make sure that his individual activity conformed to the revolutionary line. In 1929, *La Révolution surréaliste* published the Second Surrealist Manifesto. Breton thought it was his duty to remind everyone else what the principles of Surrealism were and to purge it of everything that, from his point of view, was a betrayal. In response to this, his former friends published a stinging pamphlet under the same title as the one given to their pamphlet against Anatole France: "A Corpse". As a result of these political conflicts, by the 1930s the Surrealist movement had arrived at a state of bifurcation: on one side was Breton's group, which took a position of revolutionary engagement; on the other side were those artists who from the mid-1920s were providing a demonstration of Surrealism in the visual arts, and establishing its place within them.

Aside from the growing activity of the artists in Paris, Surrealist art was now in evidence beyond France's borders. In 1931, the first important Surrealism exhibition was held in the United States, with works shown by Dalí, de Chirico, Ernst, Masson, Picasso, Miró and others. Personal exhibitions of the Surrealists came to various American cities. Additionally, in 1933 a Surrealist exhibition was held in Teneriffe. By the end of the 1930s, exhibitions of the Surrealists had covered the whole of Europe, reaching Belgium and Holland, Zürich, Copenhagen, Prague and London. Japan and Latin America also received their fair share of Surrealism. In the 1940s, the activities of the Surrealists continued primarily in America where many of them had gone to escape the Second World War. During the war, a large exhibition of Surrealist art was held in London. In 1945, a collection of Breton's writings on painting came out in the United States, entitled *Surrealism and Painting*. In June 1947, the International Exhibition of Surrealism was held in Paris at the Galerie Maeght. It could truly be said that the visual art of Surrealism had conquered the whole world. The fame of its artists, and the huge interest in its painting was far greater than the public profile of Surrealism in literature, although this was where the movement had started. A moment in the history of art had probably come when art needed an influx of new forces. If the visual language of painting at the beginning of the twentieth century had been the focus of concern of Fauvism, Cubism and Futurism, of Matisse, Picasso and Kandinsky, then the nihilism of Dada, in combination with the philosophy and literature of the Surrealists, at once created the conditions which enabled art's internal vacuum to be filled. And, as will always be the case, Surrealist painting did not spring up out of a desert. The history of European art is remarkable for such a wealth of treasures that here and there the future Surrealists were able to find the first shoots of what would later, with careful nurturing, function to make up the special language of their art. If the first road to Surrealism traversed through Dada, then the second road lay through that existing tradition in art which had constituted a manifestation of Surrealism long before the movement was officially christened in the twentieth century.

THE SURREALISTS BEFORE SURREALISM

The artist Hieronymus Bosch was born in the mid-fifteenth century in a tiny Dutch town not far from the German border. His name was derived from the name of his native town, Hertogenbosch, known in French as Bois-le-Duc. He died in 1615, leaving behind a legacy in painting which already struck Giorio Vasari in the sixteenth century as "*fantastiche e capriciose*". Choosing not to compete on the same ground as his great

Toyen (**Marie Cermínová**),
At the Chateau Lacoste, 1946.
Private Collection.

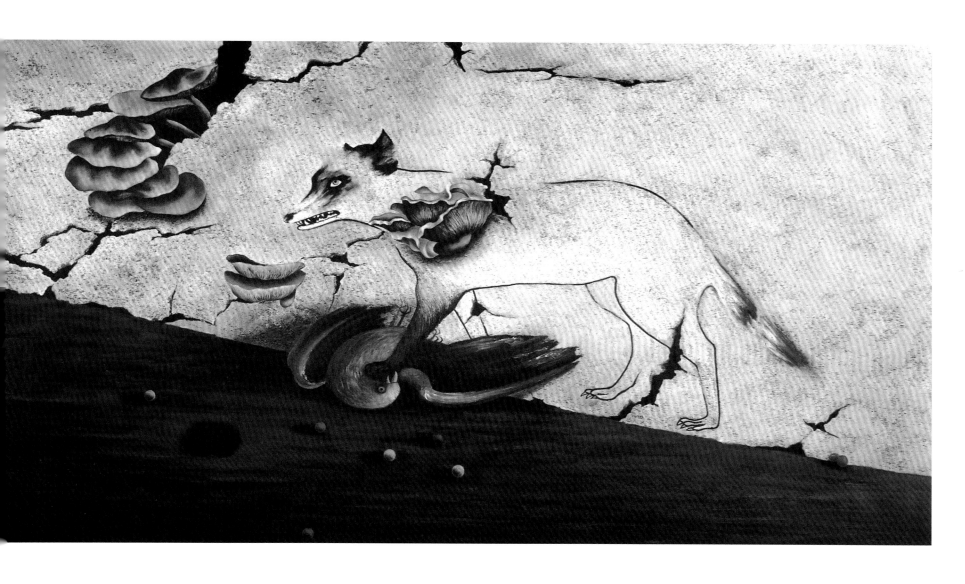

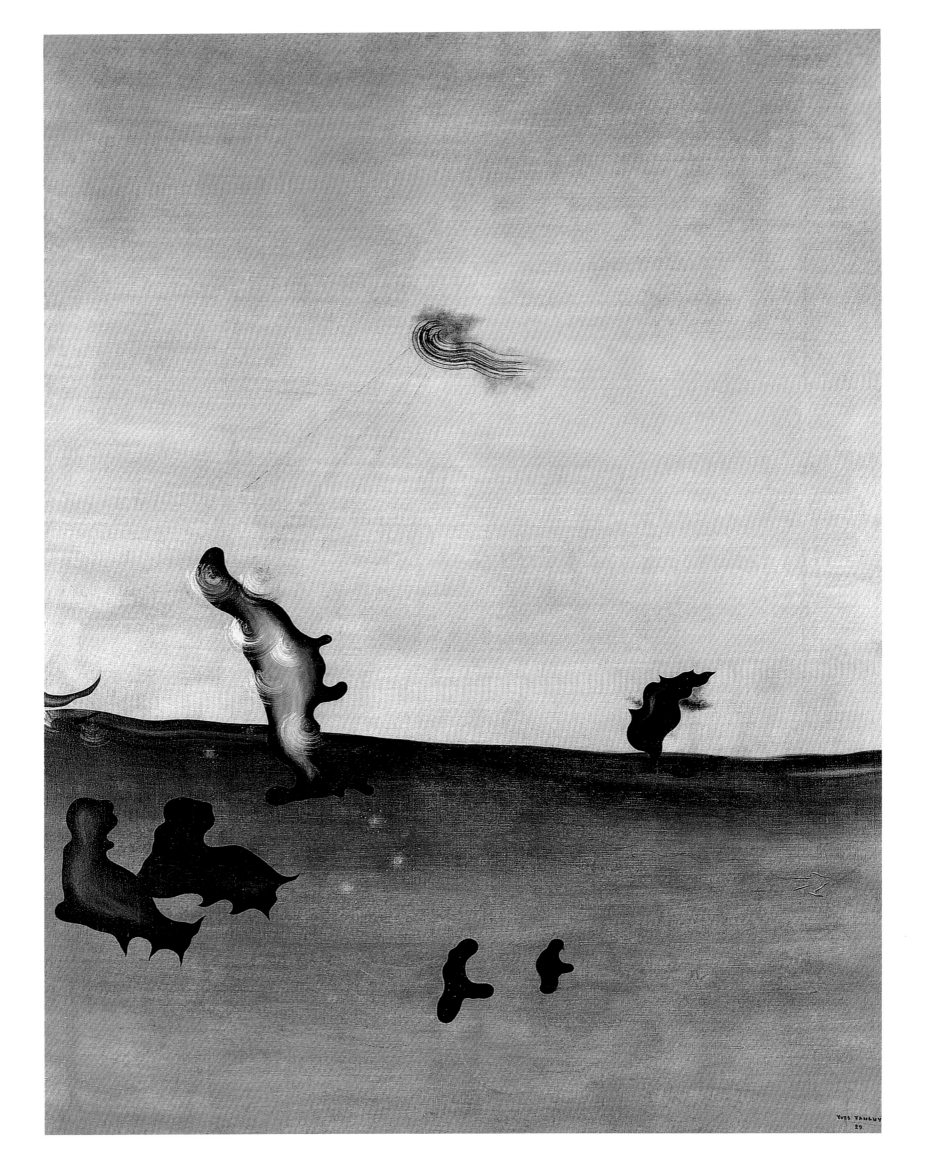

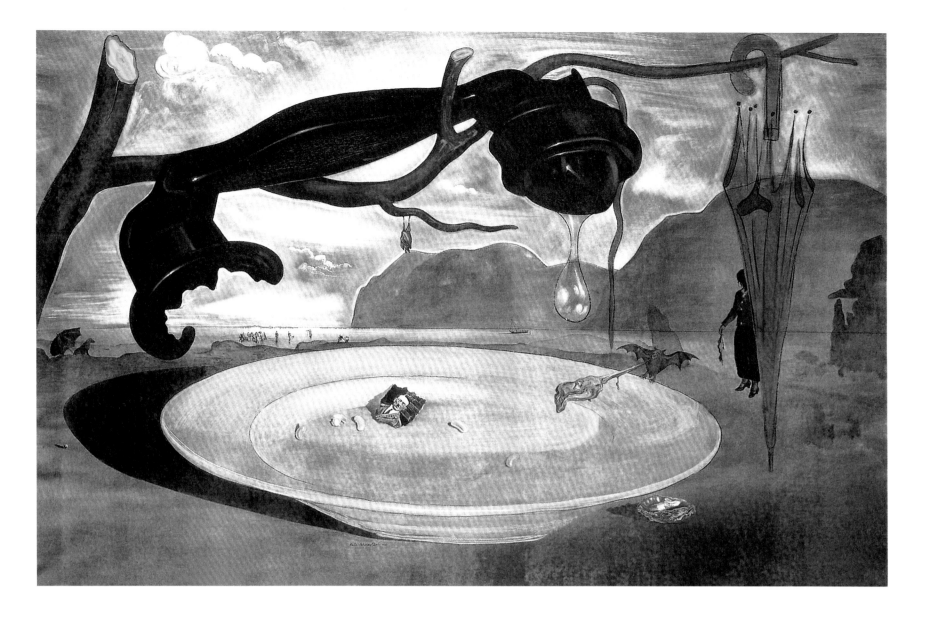

contemporary Jan van Eyck, Bosch astonished people with the unbridled fantasy of the world he had created. The Italian Lomazzo, author of the *Treatise on the Art of Painting, Sculpture and Architecture*, wrote in Bosch's lifetime: "The Fleming Girolamo Bosch, who in depicting strange appearances, and frightening and horrible dreams, was unique and truly divine."[62] In the sixteenth century he had already acquired a reputation as "the creator of devils". At that time, medieval monsters and fantastic images whose purpose was to strike fear into the heart of man and to curb his pride were still customary, and their symbolism could be well understood. However, the pictures of this Dutchman made a deeper impression than the monsters on the capitals of Romanesque churches or in the miniatures of Gothic manuscripts.

The images created by Bosch possessed such a convincing character, and were so tangible and material, that it was simply impossible to have doubts about their reality. When Bosch painted the scales of a fish, the pelt of a rat, or the human body, all of them looked real; metal was firm and shiny, while an eggshell was brittle and lustreless. And it was all the more frightening that the mosaic that formed such an appalling fantasy world should have been assembled from these natural details, taken from real life. When you view this world five hundred years after it was painted, you are surprised by the artist's imagination. It might seem as though a large number of creatures living in this world were beyond the power of any man's invention. A rat's head is positioned above a man's torso, the wings of a butterfly are growing from the back of a bird with the hands of a man, and a scholar in spectacles has a spherical metallic torso and the legs of an insect. Their surroundings are no less fantastic: dead tree-trunks growing from boats floating in the water are surmounted with an egg-like receptacle populated by strange beings.

It is difficult to judge how the pictures of Hieronymus Bosch came into being in his imagination, but what he was doing in the sixteenth century is the same thing as what Salvador Dalí, Max Ernst and René Magritte

Yves Tanguy,
The Inspiration, 1929.
Oil on canvas, 130.5 x 97 cm.
Musée des Beaux-Arts, Rennes.

Salvador Dalí,
The Enigma of Hitler, 1939.
Oil on canvas, 51.2 x 79.3 cm.
Museo Nacional Centro de Arte Reina Sofía,
Madrid.

would end up doing in the twentieth century. Bosch combined the uncombinable – living flesh with metal or glass, parts of a man's body with animals, insects, birds and fish. Opening out like the head of a flower is the transparent sphere in which man's independent life goes on. In his fantasy world he played with proportions: there the dimensions of an ordinary bird far exceed those of a man, gigantic human ears become part of a frightening engine of war, and an enormous feathered monster with the legs of a man has swallowed up people. The fantastic creatures of Bosch recall the "exquisite corpses" of the Paris Surrealists. The naturalism of his painting suggests the idea that the artist has embodied the visions of his dreams on the canvas. Bosch's art could quite easily have acquired the name "over-realism", that is, "Surrealism", and become a school and source of examples for an artist of the twentieth century. "As examples of my favourite painters", said Yves Tanguy, "I can cite Hieronymus Bosch, Cranach and Paolo Uccello from among the old masters."[63]

Does this mean that Surrealism has always existed? Yes, if we mean a combination of fantasy with extreme realism, even naturalism, of representation. However, in the first place, artists like Bosch were rare and strange characters; they were not typical of the art of their time, but were an exception to it. In the second place, the art of each of them carried the ideas of its time, and for the Surrealists of the twentieth century it could serve only as an example of a kind of "automatic drawing". The imagination of the Surrealists of previous centuries was not necessarily as rich in fantasy as is the world of Bosch's pictures.

The Milanese artist, Giuseppe Arcimboldo (1526-1593) worked in the sixteenth century at the Habsburg court in Vienna. After failing to find employment for his talents in his native city, Arcimboldo became court painter in Vienna to three emperors – Ferdinand II, Maximilian II and Rudolph II. However, it was not the usual full-dress portraits that brought him fame.

Maximilian II was typical of a Renaissance period personality. He invited the Italian humanists to his court, built villas in the Italian style, and was interested in science, particularly botany. Under him the Zoological Garden was established, and was continually being supplied with rare animals from distant countries. Arcimboldo was brought up in Milan and he worked on the decoration of the Milan cathedral alongside his craftsman father. After the arrival in Milan of Leonardo da Vinci, the artists of the town became interested in the science of painting he had established, in his drawings of monsters and chimeras, and in his sketches of the hideous creatures of the natural world. Coming into contact with the range of opportunities at the Viennese court, Arcimboldo was made the expert responsible for the Emperor's cabinet of curiosities, and he put together a collection of rarities in art for him. Out of the combination of the skill of the portrait-painter and of his scientific knowledge grew Arcimboldo's amazing genre of painting – he put together a human face on the canvas out of fish, animals, plants and household objects. What is striking about his works is not so much their weird faces as is the naturalism of the depiction in every one of the details. The symbolic portrait of *Summer* is constructed from real fruit, that of *Winter* is from dry branches and roots, and *Water* appears as a mosaic of the most varied sea-creatures. In the face of the grotesque *Lawyer,* the cheeks are made up of chicken legs and the nose from a plucked chicken. Arcimboldo won fame for the court of Maximilian and his son Rudolph with his strange portraits, but later on his work was largely forgotten. It surfaced again only at the start of the twentieth century.

In the first *Surrealist Manifesto*, Breton set out a list of those who in his opinion were Surrealists before the beginning of Surrealism:

> The NIGHTS of Young are surrealist from beginning to end
>
> Swift is a surrealist in his maliciousness
>
> Sade is a surrealist in his sadism
>
> Chateaubriand is a surrealist in his exoticism
>
> Hugo is a surrealist when he is not stupid
>
> Poe is a surrealist of adventure
>
> Baudelaire is a surrealist in his morality, etc.[64]

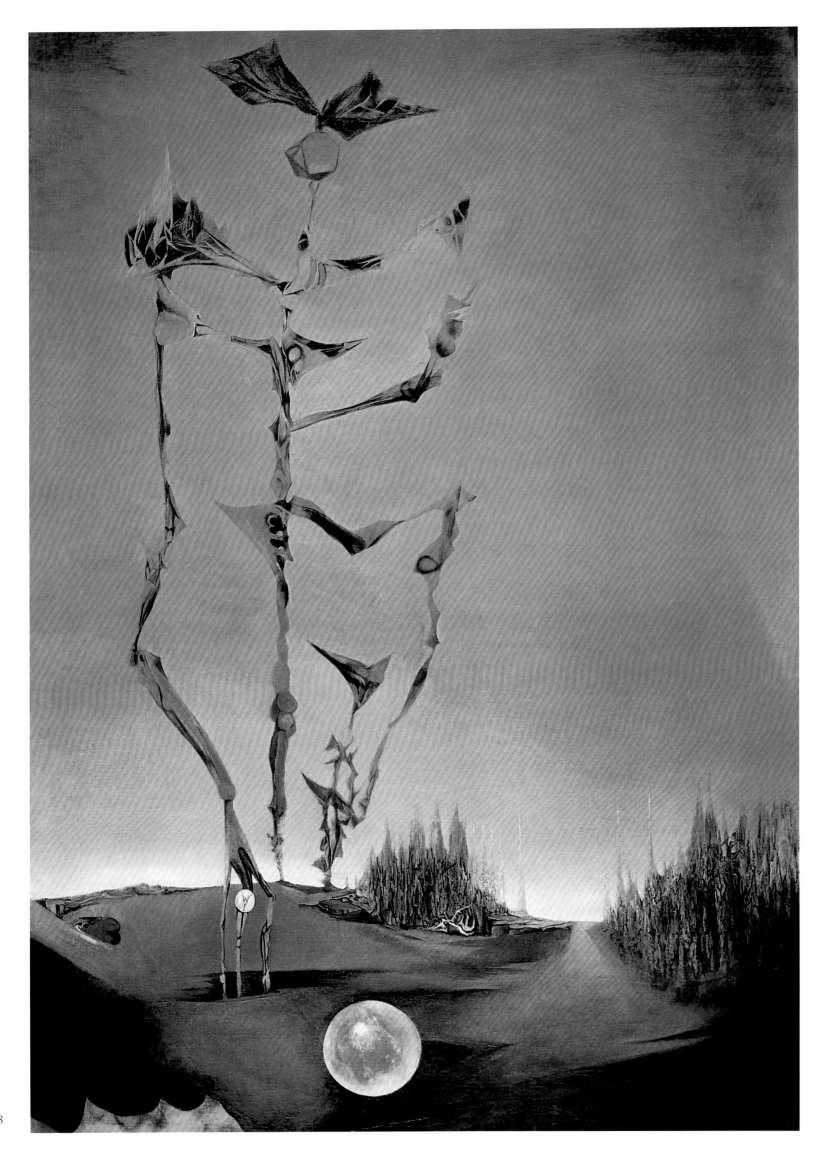

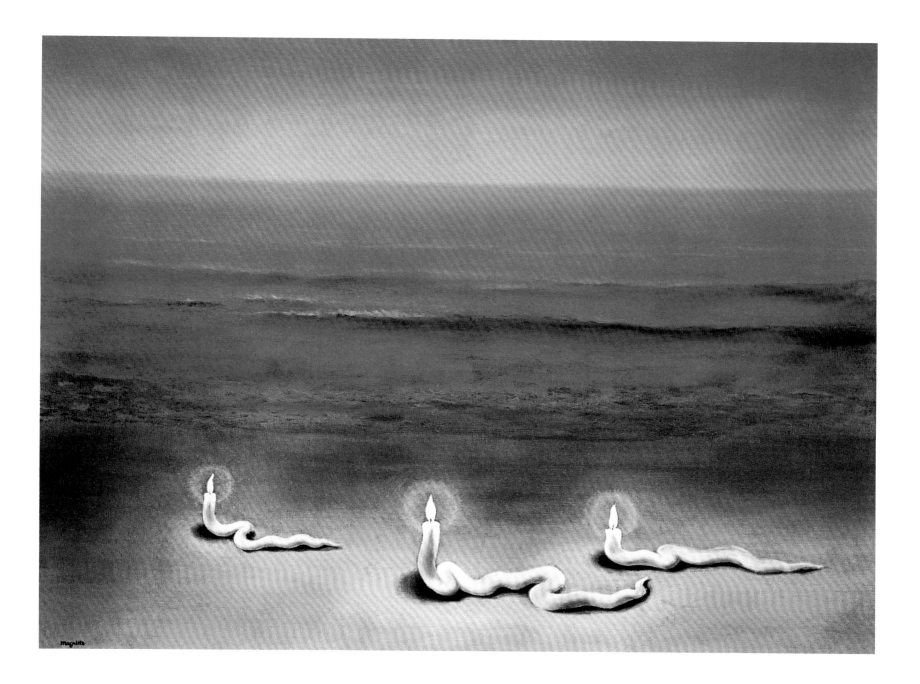

Breton took his examples from the field of literature, which was closer to him. However, he adds that in this in fact endless list, the names of artists from the past and the present, such as Uccello, Seurat, Gustave Moreau, Matisse, and so on, could be included. Despite a good deal of Surrealist irony, Breton is fairly serious in his conclusions. "I insist on this point", he said. "They are not always surrealist, in this sense, that with each of them I am picking out a certain number of preconceived ideas to which they were – very naively! – attached. They were attached to them because they had not heard the surrealist voice, the one that carries on preaching on the eve of death and above the storms, because they were unwilling to be employed merely in orchestrating a wonderful score. These instruments were too proud, and that is why they did not always make a harmonious sound."[65]

Breton's list looks rather amorphous. Not every great and original artist, by any means, can be counted as among those whose painting corresponds in some way or another to the notion of "over-realism" – "Surrealism". Another thing that is essential, apart from fantasy and the method, is a bridge to the world of the unknown, to the beyond, a glimpse into which is the property of only a few exceptional people. In the end, whatever may have been the dominant tendency in art at any particular moment in history, there were always artists to be found who did not conform to the dominant tendency. There had always been peculiar personalities whose creative work had a ghostly quality, more the expression of a dream than of reality. They were very often not understood in their own time.

Wolfgang Paalen,
Study for Totem Landscape of My Childhood, 1937.
Private Collection.

René Magritte,
Meditation, 1937.
Oil on canvas, 34 x 39 cm.
Adward James Collection Foundation,
Chichester.

In the nineteenth century, when the world of romantic emotions replaced the classical rationalism and the clarity of antiquity in art, several German artists set out on the road that would eventually lead to Surrealism. The landscape painter Caspar David Friedrich (1774-1840) was not properly appreciated by his contemporaries. He had the usual life of an artist at the end of the eighteenth century and the beginning of the nineteenth century – he studied at the Academy in Copenhagen, lived the whole of his life in Dresden, and made friends with the painter Otto Runge and the poets Tieck and Novalis. Yet there was something about his art which went beyond the bounds of ordinary painting. Friedrich's landscapes are not depictions of a particular corner of his country; they look abstract, lacking in the specificity of everyday life usually found in German pictures. He painted scenes receding into the distance, an uninhabited coastline, the sun setting over the ridges of blue mountains. If people appear there, they are small and lost in the midst of the indifferent grandeur of the immutable features of the landscape. Friedrich was a painter of stillness, solitude and dreams. Above all, the painting of this artist is reminiscent of a dream. However, the dreamlike quality in Caspar David Friedrich is expressed in surprisingly realistic language. When he painted a shrivelled tree, each of its branches and each knot was drawn with such startling naturalism that it looked like it was coming alive on the canvas. In his painting, Friedrich created his own special world which was real and unreal at the same time. Patrick Waldberg, close to the Surrealists, wrote: "Caspar David Friedrich, an ineffable painter, illuminated with mystical grace, formulated for all time the first commandment of the Surrealist artist: 'Close your physical eyes in order to see your picture after that with the eye of the mind. Then bring to light what you have seen in the night.'"[66]

The European Romantics in literature, from Hugo and Nerval to Lautréamont, talked about how they preferred dreams and imagination to reason for the purpose of genuine creativity. In every age, there have been artists who have been guided by this principle: one need only mention the Englishman Blake and the Swiss artist Fuselli. The later German Romantics employed a very wide range of symbolic figures in their dark and sinister paintings. Hans von Mare, Hans Toma and Franz von Stuck painted satyrs, Hesperides and Lucifer, in woodland groves. The Belgian Knopf depicted sphinxes and pretty little girls in a garden filled with flowers. These were figures from the Symbolist literature of these artists's time. Their art was in keeping with the Symbolist outlook which was widespread in Europe in the second half of the nineteenth century. However, none of these artists moved in such a direct route towards Surrealism as did Arnold Böcklin (1827-1899). Born in Basel Switzerland, Böcklin studied in Düsseldorf, Germany, and then in Belgium. He spent the rest of his life in Italy – he was a European in every sense of the word. Böcklin did nothing unusual in terms of the subject of his painting; he mainly painted landscapes. Despite the fact that there is no resemblance to Friedrich's painting in his landscapes, Böcklin was in fact his only real heir. In the Italian countryside, Böcklin found the motifs which he employed in his almost visionary pictures. In his *Villa on the Coast* and *Sacred Grove*, an entirely real and observable landscape becomes an image of timeless, indifferent nature. Böcklin's works hold a mystery which all artists close to Symbolism sought in vain. Böcklin expressed in painting what Baudelaire had written about in his *Correspondances*:

> Nature is a temple where living pillars
> Sometimes let out confused words
> Man moves there across forests of symbols
> Which observe him with familiar glances.

In *The Isle of the Dead* from 1880, he created an image of earthly nature which was able to embody a reflection of the supernatural world. There is a mood of solitude and despair to this painting which generates a feeling of mystery. The Symbolist artist Odilon Redon wrote: "I thrill so deeply to the mystery that comes out

of the wilderness."[67] Familiarity with Böcklin's painting played a significant role in the formation of the art of numerous painters, including Giorgio de Chirico and the Surrealists.

The French painter and graphic artist Redon (1840-1896) came closest of all to Surrealism. Redon received a classical training in Paris in the studio of Jean-Léon Gérôme. However, he never made use of Greek mythology or biblical stories, the usual subjects for the classical school. Everything he created was related to the field of fantasy. In his native Bordeaux, he saw Rodolphe Bresdin's engravings, in which fantastic images were incomprehensible to his contemporaries. In Bordeaux, Redon was also in close touch with the botanist Armand Clavaud. Redon's attitude to nature was attentive and loving. "I love nature in all its forms", he wrote. "I love it in the smallest blade of grass, the humble flower, the tree, the ground and the rocks, and all the way to majestic mountain peaks."[68] He studied nature thoroughly and drew plants and insects. For Redon, nature was the force which impelled the artist to create, and because it is only subject to spontaneous intuition, it liberated him from the pressure of rules. This was eactly the position of the Surrealists: "Nature is also what instructs us to obey the gifts which she has given to us. Mine have led me towards dreams."[69] Redon's images could only appear in a dream: he drew a lily of the valley, whose flower opens out into a human skull, and a spider with a human face. "In the nature of plants there are… secret and normal tendencies of life which a sensitive landscape painter should not refuse to recognise", he wrote. "A tree-trunk with its forceful character thrusts out its branches in accordance with laws of expansion and with its sap, something a true artist has to feel and to depict."[70] Redon often worked in black and white lithography, and illustrated books. In his own words, his drawings were something which "imagination has liberated from the cramping concern with the characteristics of reality."[71] In his fantastic creations, Redon united elements of plants, animals and the human figure, and all the same, they nevertheless looked convincing and real. "No one can take away from me the distinction of having given the illusion of life to my most unusual creations", the artist wrote.[72] At the same time, the naturalistic anemones and poppies in his still life compositions appeared to be alive, and they haunt the viewer with the faces of living human beings. Redon's creative methods completely corresponded to those of the Surrealists. In 1890, Redon painted the picture *The Closed Eyes* which is almost a programmatic statement of Surrealism. A beautiful human face, whose gaze is directed not into the outside world, but inside itself – all this was a virtual expression of the basic position of Surrealist art. "What a sense of mystery means is to be all the time in a state of ambiguity, which is double or even triple-sided, hints of aspects (images within images), forms which are going to come into being, or which will come into being according to the viewer's state of mind", wrote Redon.[73]

Among the most direct heralds of Surrealism who came close to a feeling for what is inexplicable, mysterious and inaccessible to the understanding of man was Alfred Kubin (1877-1959). He was born in Bohemia, and studied in Austria and Munich. He was called the "wizard of Zwickledt", the village where he lived for almost the whole of his life. At the basis of the creative work of this "wizard" were not only the philosophies of Nietzsche and Schopenhauer, but also the works of Freud and Jung. He sensed his closeness to Redon, whom he met in 1905. Kubin illustrated the books of the writers to whom he felt close – Edgar Allan Poe, Nerval, Gauff, Strindberg and Oscar Wilde. A brilliant graphic artist, Kubin found a manner of drawing which enabled him to unite the everyday and the fantastic in a completely natural way. The artist called himself "an organiser of dusk and of uncertainty." The graceful strokes of his pen generated images which were horrific, erotic, and startling in the familiarity of their realistic details, but he never lost a sense of humour. Spirits of the mountains and forests, spectral beasts, cats, dogs and mice, "war horses" – such was the world created by Kubin. In 1911, Kubin joined The Blue Rider group, and Kandinsky called him "the clairvoyant of decadence". He wrote a fantasy novel, *The Other Side*, in which hallucinations and images of dreams are interwoven with the fears and pains of real life. A contemporary of the Surrealists, Kubin belonged to the generation that preceded them and was, by virtue of his character,

Paul Delvaux,
All Lights, 1962.
Oil on canvas, 150 x 130 cm.
Fondation Paul Delvaux, Saint-Idesbald.

a solitary artist. His creative output maintains the line that runs through the whole of European art to Surrealism.

And of course there was also "le Douanier Rousseau", a Parisian, and a "Sunday painter". In 1908, Guillaume Apollinaire brought him from the Left Bank to Montmartre where a table made of planks was set out in Pablo Picasso's studio. Artists, poets and the first buyers of avant-garde pictures assembled there for a banquet in honour of Henri Rousseau. It seems that he was not especially memorable to any of the Surrealists in comparison to their other predecessors. However, at the Salon des Indépendants of 1897, his *The Sleeping Gypsy* impressed his contemporaries. A dark-skinned woman with a staff in her hand has fallen asleep in the desert. Near her, a lion passes by on the dunes, its tail and mane silvered in the moonlight. Perhaps the lion has just appeared to her in a dream. But perhaps the whole thing is a dream of the artist's. With the unusual intuition peculiar to him, the naïve painter Rousseau has caught what was blowing in the wind, and what the Symbolists were moving towards – the hunger for the strange and mysterious, an ambition to penetrate into another world, accessible only in dreams.

In 1871, Nietzsche wrote: "The development of art is linked to the duality of the Apollonian and Dionysiac origins."[74] Nietzsche linked various sources of inspiration in various lines of the development of art with the Greek gods. "In order to understand both impulses more deeply", he wrote, "let us conceive them to ourselves to begin with as two disconnected artistic worlds: the world of dreaming and the world of intoxication." Nietzsche connects with Dionysus the art that "sculpts man" – "a drunken state of activity… which takes no account of the individual personality and even attempts to destroy individuality" and brings to art the reflection of human passions and suffering.[75] In opposition to Dionysus, Apollo, the inspirer of the other line of art, was the oracular god, and genuine visual creative art, the formation of the beautiful, is linked with him: "… The grandiose images of gods were revealed to people's souls, above all, in a dream, and a dream also brought to the great sculptor the ravishing outlines of the bodies of the celestial beings."[76] For Nietzsche, the gift of the artist is associated with an Apollonian origin, and is capable of revealing that "beneath the state of activity in which our life passes by lies another, quite different state."[77] At the basis of the creative work of Surrealism lay the concept of dreams as the source of art. Nietzsche set it down in words which could have been said by the Surrealists: "The wonderful illusions of the world of dreams, in the creation of which each man behaves as a real artist, are the premise of every kind of visual art… through this nocturnal activity, although it may have been unrealized in real life, a certain sense of its world of illusion forced its way."[78]

Nietzsche's words might be interpreted as a kind of philosophical abstraction, but they in fact sum up the development of European art over hundreds of years. The thirst of man for the unknown, for things that cannot be made subject to a simple and natural explanation, has always existed. At various times, artists have appeared who, in the language of painting which is connected to realistic objects and ideas, have tried not to explain but to express the mystery with which man comes into contact in a dream or a vision. The lines of the art of realism and of fantasy, of serving everyday life and rising above reality, are interwoven, diverge and coexist in parallel. By the start of the twentieth century art had come to a point where its old forms and classical language could depict anything, but were not capable of expressing the tension and the emotional reaction which the events of history were causing, the new rhythms of life. One of the lines followed by the artists in their explorations was the line which Nietzsche associated with Apollonian art. In the context of the varied artistic innovations of the masters of the twentieth century, this line of development was one of the most effective. The Surrealist artists knew German classical philosophy; Nietzsche was one of their favourite authors. They very soon attained recognition in Europe and America, and dominated the world of the visual arts for half a century. Surrealism was made famous by a cohort of major painters who demonstrated the very diverse possibilties of its methods.

MAX ERNST

1891-1976

Devoured by feathers and given up to the light,
He has let his shadow pass into the flight
Of birds of freedom.
He has left
The handrail to those who are falling under the rain,
He has left their roof to all those who have proved themselves to be true.

His body was in good order,
The body of the others has come to break up
This organization that he maintained
From the first imprint of his blood on the earth.

His eyes are in a wall
And his face is their heavy finery
One lie more from the day,
One night more, there are no longer any blind.[79]

In the world of painting created by Max Ernst, birds play a special role. Sometimes it is an inoffensive nightingale, which introduces unaccountable fear and panic into the life of the characters of the painting, and sometimes it is a menacing bird with the torso of a man and a spear in its hand. In the thicket of a forest, or in the outlines of figures can be discerned the features of the bird which obsessively haunted the artist all his life. Max said that in his childhood he had a favourite pink parrot. One day in the morning, he found it lying dead in its cage. At that very moment he was told that his sister Apollonia – Loni – had been born during the night. The shock was so strong that the fifteen-year-old Max fainted. The bird acquired a mystical significance for him, it became the incarnation of the forces of life and death, and in a sense his totem. Max called her Loplop, Commander of the Birds, a sinister name in which there is also a note of irony, reminiscent of Dada. The image of Loplop gradually took a fully finished, laconic graphic form, which came close to a formula. The organisers of the exhibition held in New York in 1984, "Primitivism in the Art of the Twentieth Century", juxtaposed the Loplop of Ernst's pictures with the depiction of the bird in petroglyphs from one of the Easter Islands. The coincidence was striking: it created the impression that Ernst had taken an aboriginal drawing from Oceania as the basis for his Loplop. This stone was discovered in 1914, and the inhabitants of the island regarded the bird depicted on it as a god. The stone carvings were published in 1919 in a book entitled *The Mystery of Easter Island*. Two possible explanations of this coincidence exist: either Ernst really did see this publication in Germany or in Paris, or he arrived on his own at the same schematic drawing of a bird which an inhabitant of the Easter Islands had been able to achieve in ancient times.

What stands out in the relationship between Max Ernst and Loplop is the Surrealist artist's manner. The half-forgotten impressions of childhood, half of them from a dream, and half of them from the real world, always preserved for him the mystical significance of images extracted from his unconscious. Together with that, during the Dada period, he went down the path of rejecting bourgeois aesthetics and classical art which had prompted the Surrealists to embark on their search for a new artistic language. Like all avant-garde artists at the start of the twentieth century, they were in search of the expressive impact that

Max Ernst,
The Lake Bethesda, 1911.
Watercolour on cardboard, 53.5 x 42 cm.
Kasimir Hagen Collection,
Kunstgewerbsmuseum, Cologne.

came from making the means of expressiveness as laconic as possible. Max was aiming for an economical use of the language of painting no less seriously than were his contemporaries. However, it was essential for his visual language to be able to combine two factors: naturalism of representation, and mystery. His painting was an embodiment of the most striking aspects of the art of Surrealism.

Maximilian (Max) Ernst was born on April 2, 1891, in the town of Bruhl, near Cologne. Fate had ensured that his childhood was to be spent in a strange, surrealistic setting. Max's father, Philip Ernst, obtained the post of teacher in a school for the deaf and dumb on the Rhine. Max and his brothers and sisters grew up in an atmosphere of silence. The school was surrounded by a dark forest of ancient trees. Their powerful roots were interwoven over the ground in fantastic patterns, and the treetops allowed no sunlight to break through. Max's taciturn, withdrawn father devoted the whole of his free time to painting. Max drew and painted from his earliest years, and this became habitual for him. In his childhood he had already reached a point of perfection, which he had acquired by copying the pictures of the nineteenth century. He loved the German tales – of the brothers Grimm, Gauf and Hoffman – and the adventure novels of Fennimore Cooper and Jules Verne. He saw the collections of paintings in the Cologne Museum, and admired the fantasy of the masters of the fourteenth and fifteenth century, the romantic pictures of Caspar David Friedrich, and the illustrations of the stories of Moritz von Schwind. He loved the poetry of the Romantics and wrote poems himself. His family dreamed of seeing him become a doctor or a lawyer, but Max stubbornly began a course in philosophy at the University of Bonn, dreaming that he would later specialise in medicine, in the branch of psychiatry. In the process of studying psychology, he had already had to spend some time at the psychiatric clinic in Bonn. There, he saw the patients' sculptures and drawings, which everyone regarded as absurd. Max found them remarkable. He was excited by their compositions, devoted as they were to the world of the irrational and the subconscious, to the territory of dreams.

At the age of twenty, Max made some new friends who were artists. His friendship with August von Macke, who lived in Bonn, played an especially large role. A remarkable painter and poet, and a man of universal culture, Macke brought the young artists within reach of the new movements developing at the beginning of the century in the world of the European avant-garde. He was in contact with "The Blue Rider", the group founded by Kandinsky in Munich. Among Max's friends were the strange Franz Henseler, a medium, who organised the same kind of séances in Cologne as Robert Desnos organised in Paris; and Karl Otten, who had studied in Vienna under Dr. Sigmund Freud, and who instilled in his friends the passion for dreams. These young people came together in a group called "The Young Rhineland". Later on, they were joined by the Expressionist Heinrich Campendonck and the painter Naunen, who was known as "the Matisse of the Rhineland". In this way, the scene was being set for Dada in Cologne, then a major cultural centre. In 1911, the Sonderbund Exhibition, at which young artists could see the painting of Cézanne, Van Gogh, Gaugin, Munch, Picasso and others, was held in the city. Max said that it was in fact after this exhibition that, bowled over by Picasso's painting, he finally decided to become an artist. In 1913, Max Ernst's own picture was exhibited in Berlin, at the first German Salon d'Automne. That year, he spent a month in Paris for the first time and got to know Hans Arp. In the summer of 1914, the war betrayed all their dreams for the future.

"The hearts of all of us were full of rage at the idea of sacrificing our wonderful lives – whether we wanted to or not – for something trebly pointless: God, the Emperor, the Fatherland", Ernst later wrote. "We were also grimly aware that the catastrophe was certain to put an end to our youth, to our joys and to our loves."[80] Max went into the artillery, and for two years he unstintingly endured all the burdens of the trenches. At the very end of the war he was transferred to the cartographic service, which was rather easier. A month before the end of the war, Max married his girlfriend from his university days in Bonn, Louise Strauss – Lou.

Numerous friends from before the war had been slain at the front, or had died during the war, but in Cologne, new, youthful forces were appearing. The artist and poet Alfred Grunewald, famous under the pseudonym of Baargeld, became Max's best friend. Baargeld was inspired by the idea of a revolution in social life and in art. His energy helped Max to find his way in the post-war world. One fine day, the Cologne

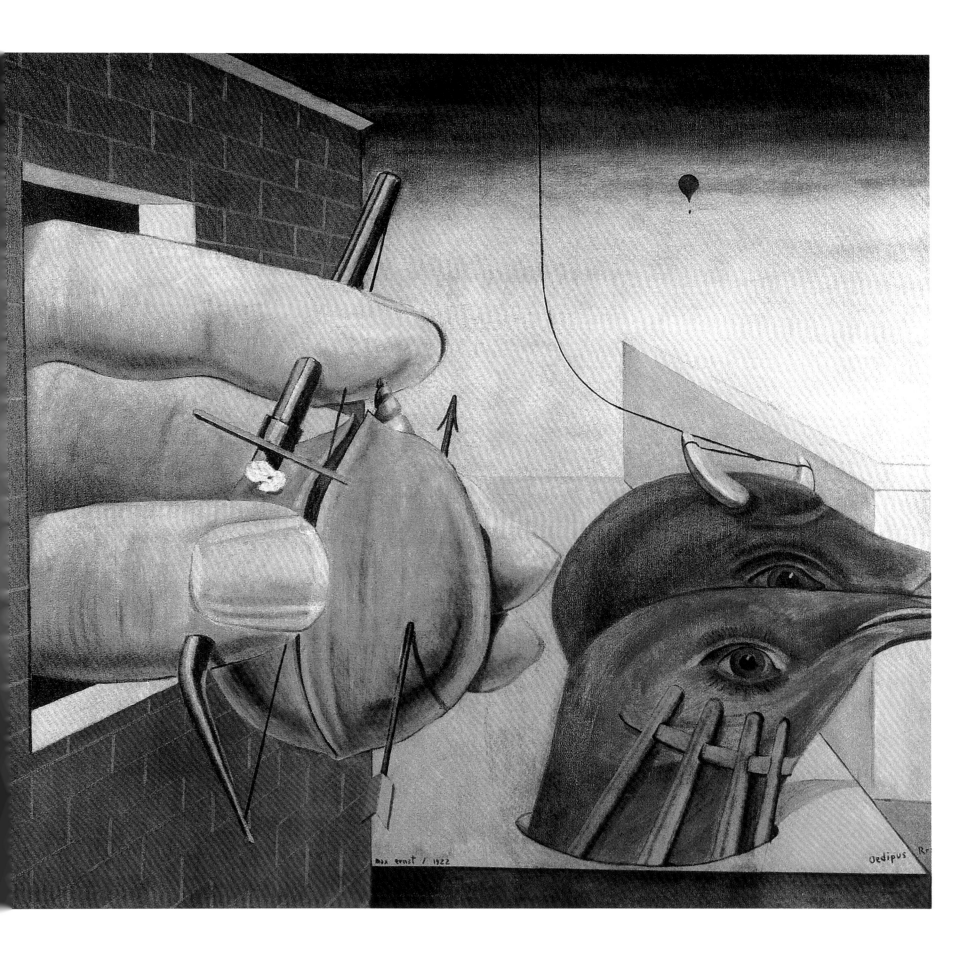

max ernst / 1922

Oedipus R

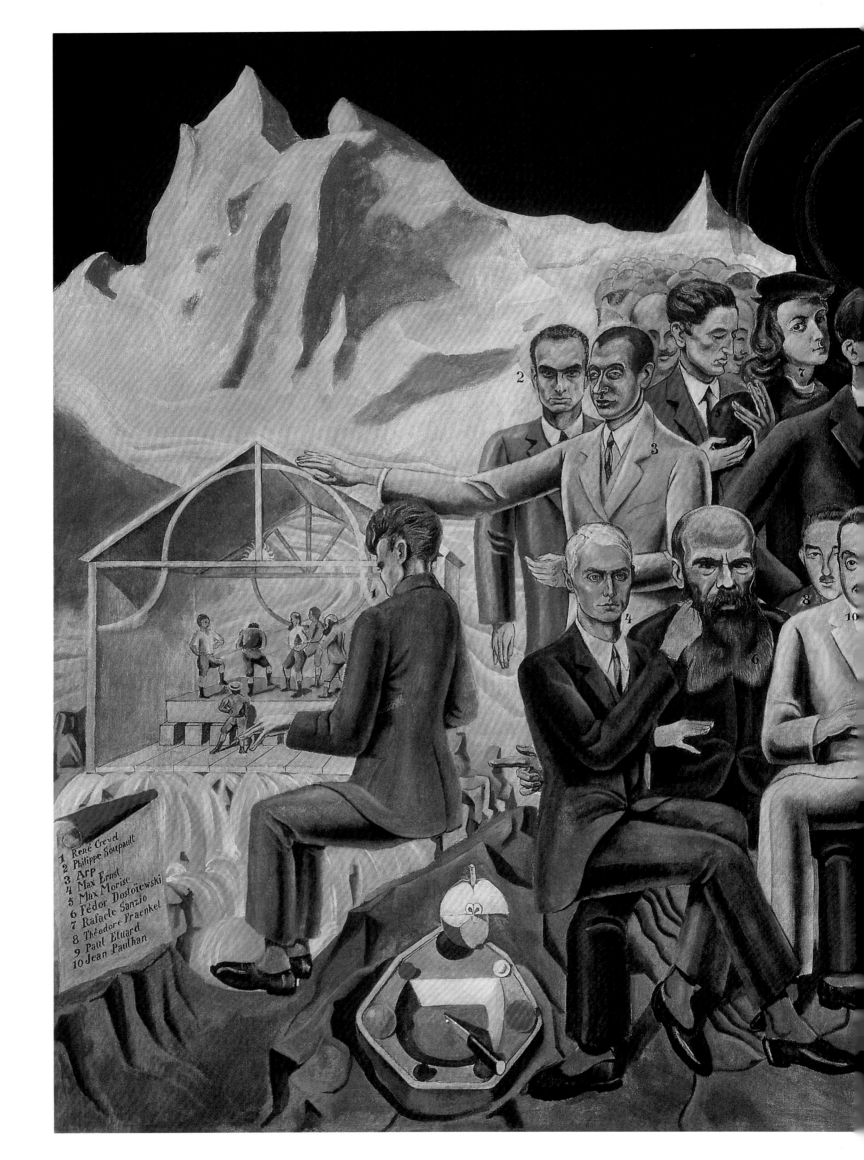

1 René Crevel
2 Philippe Soupault
3 Arp
4 Max Morise
5 Fédor Dostoïewski
6 Rafaele Sanzio
7 Théodore Fraenkel
8 Paul Eluard
9
10 Jean Paulhan

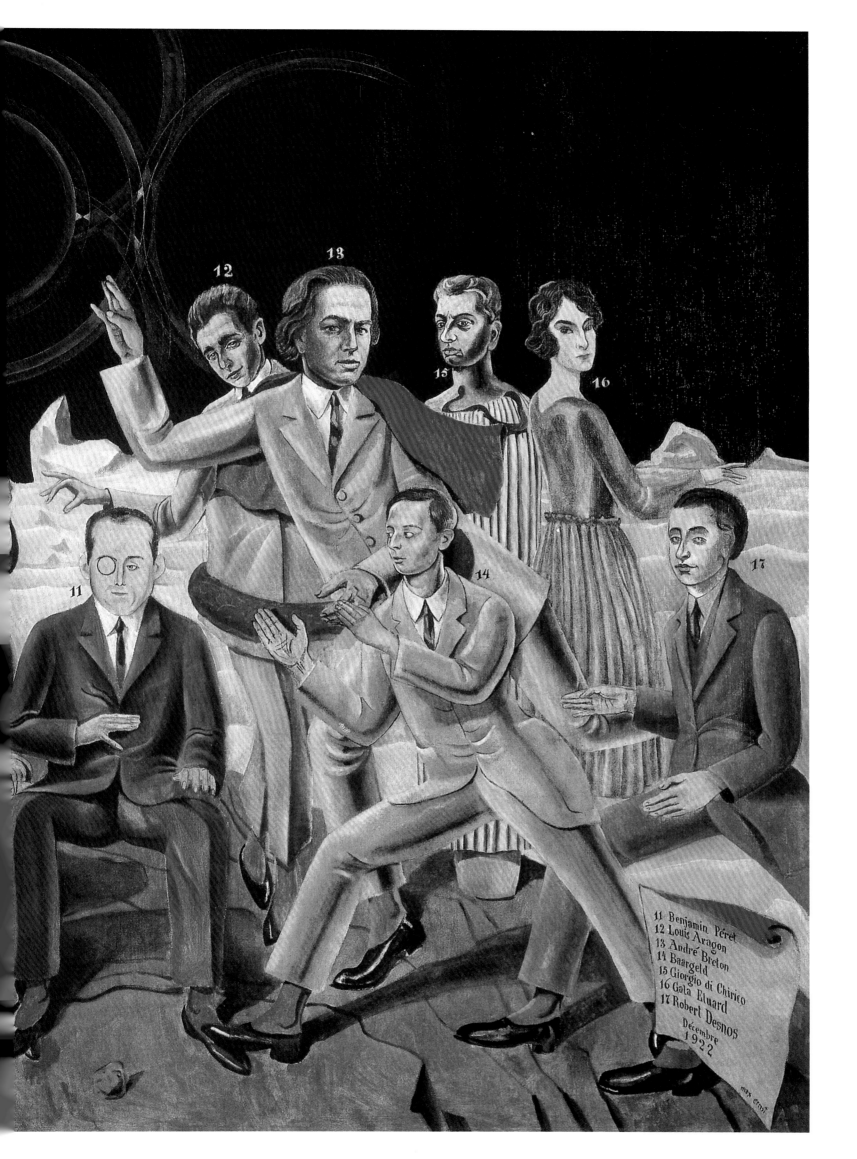

11 Benjamin Péret
12 Louis Aragon
13 André Breton
14 Baargeld
15 Giorgio di Chirico
16 Gala Eluard
17 Robert Desnos
Décembre
1922

anarchists invited Max to come with them and break up the militarist show "The Young King". The programme of their protest was thoroughly worked out, and every one of its members was right on cue. The event was a success and made a great scandal, and the police intervened. The only one of the demonstrators whom the police recognised was Max. The consequence of this was, on the one hand, Ernst's exclusion from "The Young Rhineland", and, on the other, the whirl of Dadaist activity in Cologne.

In 1919, Max headed for Munich, and there he discovered Dadaist printed matter from Zürich, as well as the Italian journal *Valori plastici*, with reproductions of the paintings of Giorgio de Chirico; it had then published an album with eight lithographs in de Chirico's honour. The two things put together laid the foundations for Ernst's new aesthetic. Along with Baargeld and Arp, who had recently arrived in Germany, Max enthusiastically set to work creating the so-called "Fatagaga," attracting his fair share of condemnation from the German bourgeoisie. Their celebrated exhibition – Dada Austellung – held in the spring of 1920 in the glazed courtyard of the Wintera beer garden, provoked maximum indignation. It could only be entered through the men's toilet. At the exit, visitors were met by a little girl wearing a first communion frock who recited rude poems. In the centre of the courtyard, Ernst had positioned a kind of wooden block, to which an axe was fastened with a chain. The visitors would strike the axe down on the wood, contributing their tiny share to destruction of the block.

In the apparently frivolous circumstances of the Dadaist period, Max Ernst created his own special category of works – the collage. The collages of Picasso and the Cubists who surrounded him were pursuing the objective of creating purely visual works, and what interested them was form and volume. Schwitters in Hanover made his Merzes, absurd, spontaneous collages of anything that came to hand, but there was no representative element to them. The German artists also made their own kind of collages during the war, but these were photo-montages for purposes of agitation. Ernst's collages were the works of a graphic artist. It is true that they lacked a traditional, classical subject, and did not have the purpose of creating a relief. Ernst's creative method was already entirely Surrealist. He used fragments of photographs, illustrations of books, and supplemented them with his own drawings or painterly elements. "One day in 1919," Max Ernst wrote:

> Finding myself in wet weather in a town on the Rhine, I was struck by the obsessive effect which my irritated gaze was suffering from the pages of an illustrated catalogue in which objects for anthropological, microscopic, psychological, mineralogical and paleontological demonstration appeared. I found the elements of figuration assembled there so distant from one another that the mere absurdity of this collection provoked in me a sudden intensification of visionary faculties, and gave birth to a hallucinatory succession of contradictory images, double, triple and multiple images, coming on top of one another with the persistence and the rapidity which are the property of memories of love and the visions that one has when half-asleep. These images themselves called forth new ideas on how to meet them in a new unknown … It was enough at that point to add something on to these pages of the catalogue by painting or drawing, and achieving that merely by docilely reproducing what made itself visible in me, a colour, a doodle, a landscape with nothing in common with the objects represented, the desert, a sky, a geological section, a floor, a single straight line signifying the horizon, to obtain a faithful and fixed image of my hallucination…[81]

Ernst's collages were, in fact, much more complex and carefully planned. The joining together of realistic representative fragments that were very diverse in their essence, scale and execution, created a sense of mystery, an enigma which could not be destroyed with the weapon of logic, and which made the collages Surrealist works. The name represents an integral part of the composition. This name could be a word, a phrase, or a whole passage, and it was absolutely out of keeping with the image, but it constituted an independent poetic

Max Ernst,
The Couple, 1923.
Oil on canvas, 101.5 x 142 cm.
Museum Boijmans Van Beuningen, Rotterdam.

Max Ernst,
The Shaking Woman, 1923.
Oil on canvas, 130 x 96 cm.
Kunstsammlung Nordrhein-Westfalen, Düsseldorf.

Max Ernst,
Long Live Love or *Charming Land*, 1923.
Oil on canvas, framed: 148.6 x 114.3 x 6.4 cm.
Saint Louis Art Museum, Saint Louis.

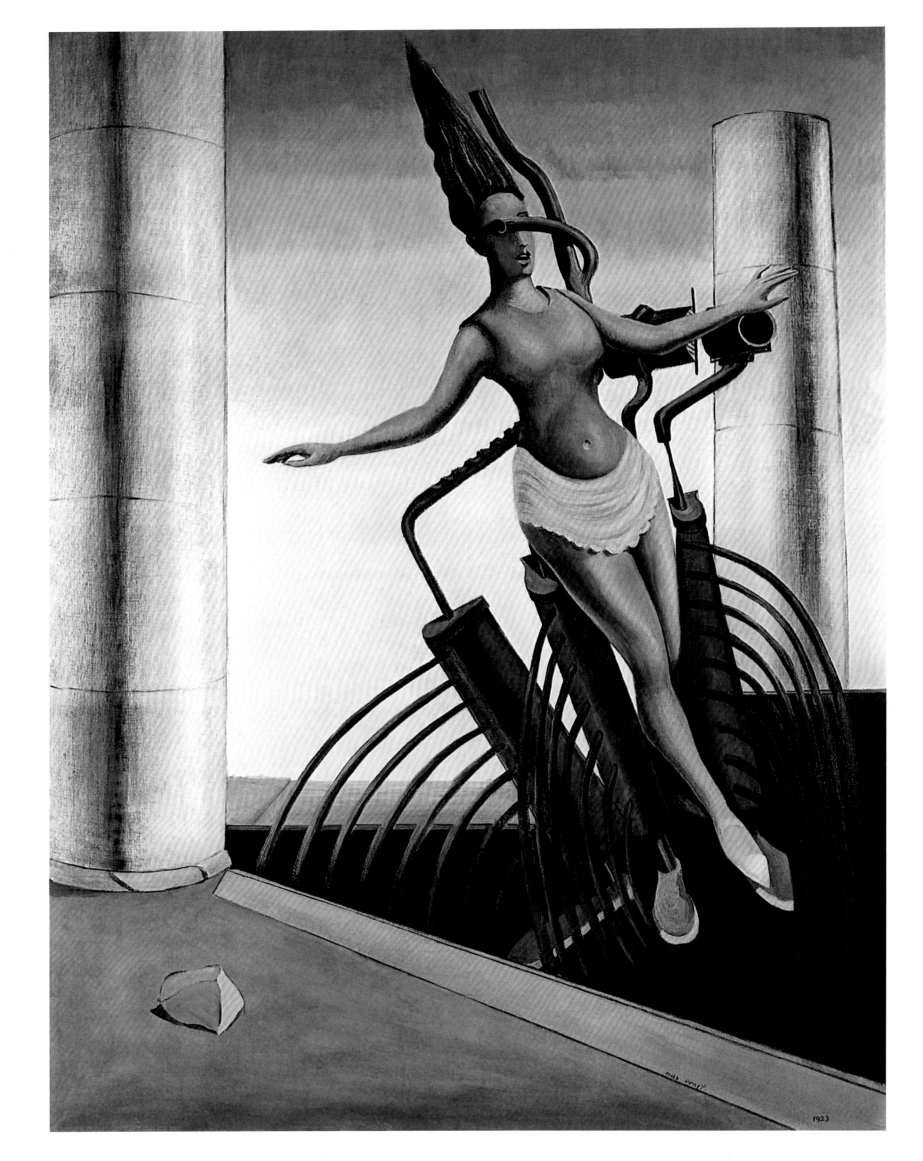

1923

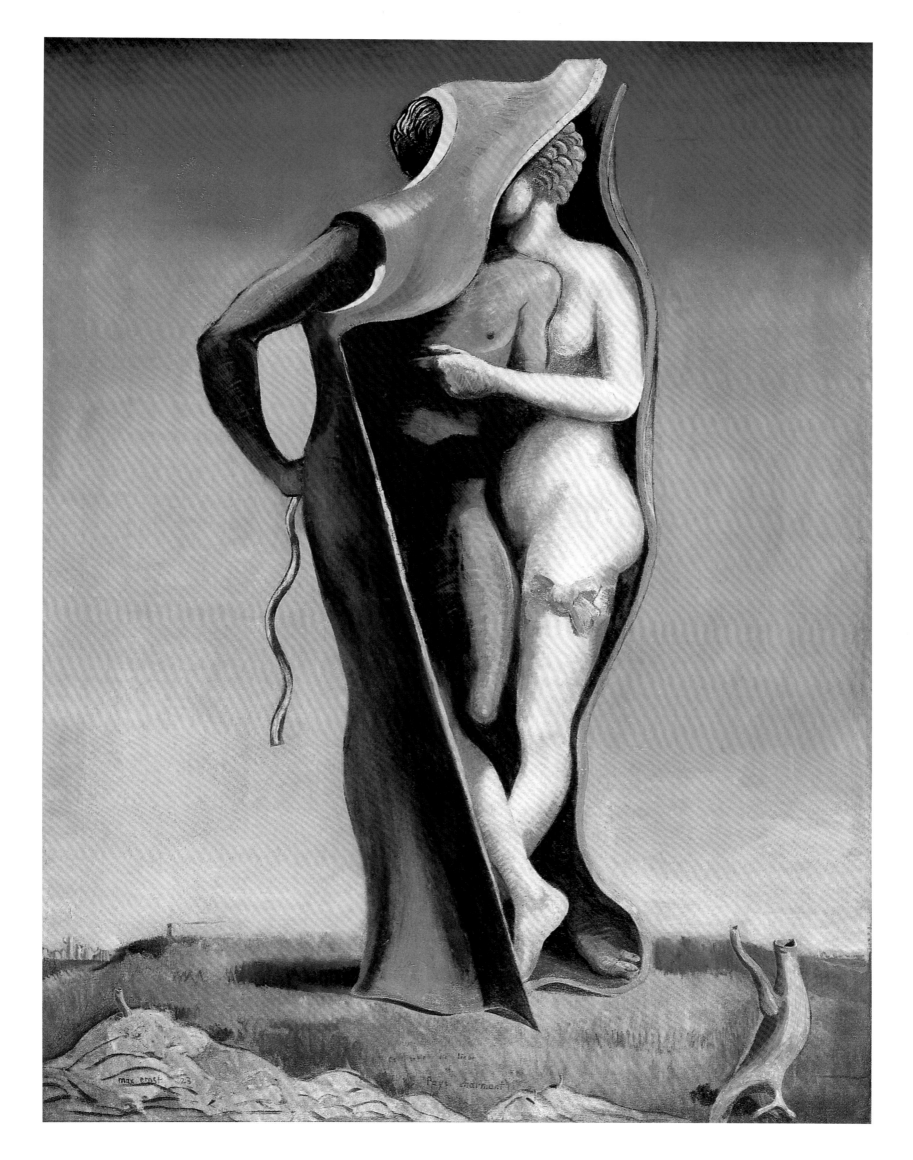

work in its own right. "Above the clouds midnight is walking. Above midnight glides the invisible bird of the day. A little higher than the bird the ether pushes, and the walls and the roofs float."[82] The lines of verse underlined the mystery contained in the collage and the poetry peculiar to Ernst's character. Later in the 1920s, he would use lines of text in the painting as well; sometimes they entered the picture, simultaneously becoming a representative element: "In a town full of mysteries and poetry, two nightingales, sheltered for the night under sloping roofs, rest in an embrace. The silence of eternity that presides over their discussions encourages them towards the tenderest confidences. The still life standing in the centre seems to protect them."[83] The collages were the origin of Ernst's work on the creation of the proper figurative language, which for painting could not be restricted by the same kind of automatism used in writing.

In the summer of 1921, a meeting occurred in the Tyrol between several of the Dadaists – Tzara, Breton, Arp and Ernst, and their wives and girlfriends. Max's painting and collages impressed the company. Not long after that, he met Éluard and his wife Gala. Following the holiday, they brought out a collection of Éluard's poems and Ernst's collages, *Repetitions*, and then a second collection, *Troubles of the Immortals*, in which Max Ernst's poetic works were also printed. Éluard was the first buyer of Max's works – he acquired two of Ernst's remarkable pictures from 1921.

The Elephant Celebes represents a strange being, something like an animated iron cauldron. The picture is saturated with elements reminiscent of de Chirico. A fragment of a plaster figure in the foreground recalls the classical sculpture of his paintings, as does the representation of the main figures constructed with drawing tools. But de Chirico's shadows were what made the greatest impression upon Max. In Giorgio de Chirico's painting, shadows are a type of sign, they emphasise the feeling of solitude within the deserted arcades of his cities. Although *The Elephant Celebes* was a tribute to and a sign of his respect and admiration for the art of Giorgio de Chirico, all in all it was the outcome of Ernst's imagination, the result of his experience with the collages. The iron boiler with a hose instead of a trunk, taking steps on its short legs, prompts a smile, and, simultaneously a feeling of anxiety.

In the picture *Oedipus Rex*, Ernst used the methods which were soon to enter the language of painting of all the Surrealists. He played with proportions – gigantic fingers, painted with the utmost naturalism, stick out of the window of a no less naturalistic brick house. The artist pierced these fingers through with a strange instrument, perhaps something surgical, inducing a sense of pain and horror in the viewer. And, finally, at once natural and artificial, birds appear in this picture, and they remained a feature of Ernst's painting for the whole of his life.

Éluard persuaded Max to move to Paris, and in the summer of 1922, he settled beside the Canal Saint-Martin. That year, 1922, was notable for a documentary picture that is exceptional in Ernst's body of work, a portrait of the former Dadaists and the future Surrealists entitled *A Friends' Reunion*. Life after the war was not easy. Ernst turned up in Paris without documents of any kind; he found employment only with difficulty in a workshop where they made souvenirs. His only comfort was the meetings with poets and artists at Éluard's house in Saint-Brice, near Paris. Many of these people are depicted in the group portrait. The mountainous background is perhaps an allusion to the happy holiday in the Tyrol.

In the first row, to the left, with his back turned, sits Crevel, and beside him is Ernst himself. Max was a strikingly handsome man. He was tall-looking because he was slim and well-proportioned; he held his head high, he had light and curly hair, delicate features, an aquiline nose and clear, piercing blue eyes – this was how his friends and contemporaries described him. He had an irresistible effect on women. Éluard's wife, Elena Diakonova, who was called Gala, could not hold out against Max's charms. In the group of Ernst's portrait, she is the only woman. Gala, the future "muse of the Surrealists" is shown on the right at the top. Their sudden affair did not put an end to the friendship between Ernst and Éluard. Éluard is standing on the second row at the centre, turned to the right, his figure occupies one of the main places in the picture. Éluard and Ernst were linked by their passion for adventures and escapades, and this made their friendship stronger. In the following

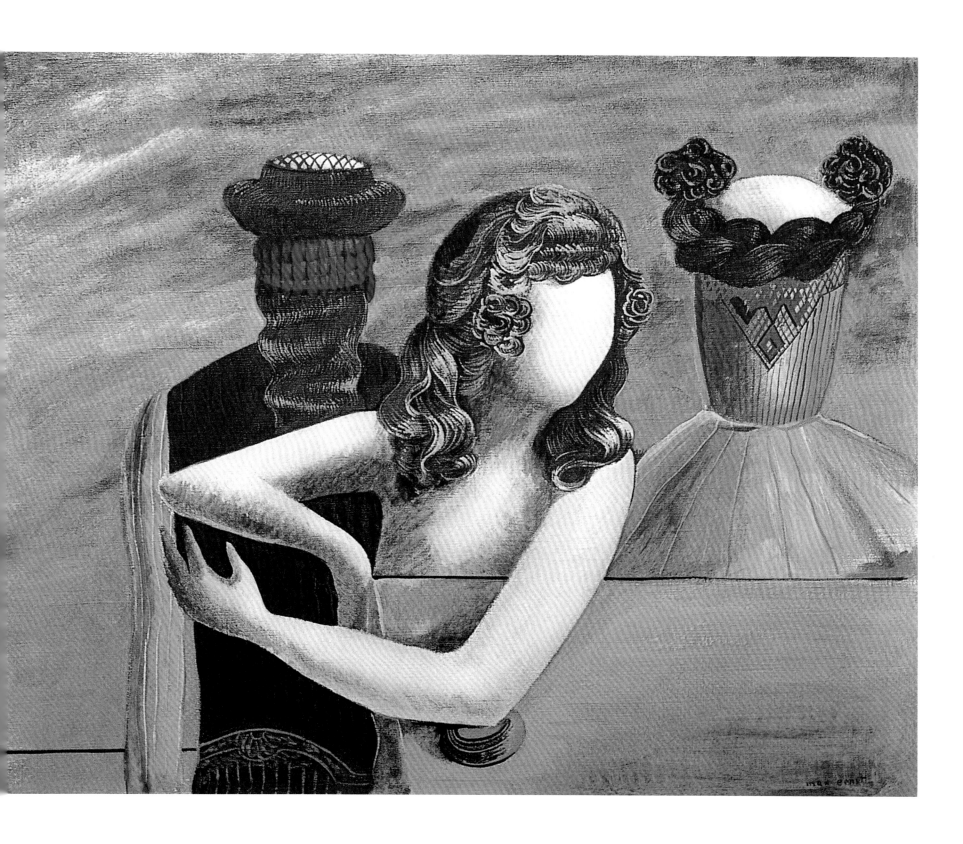

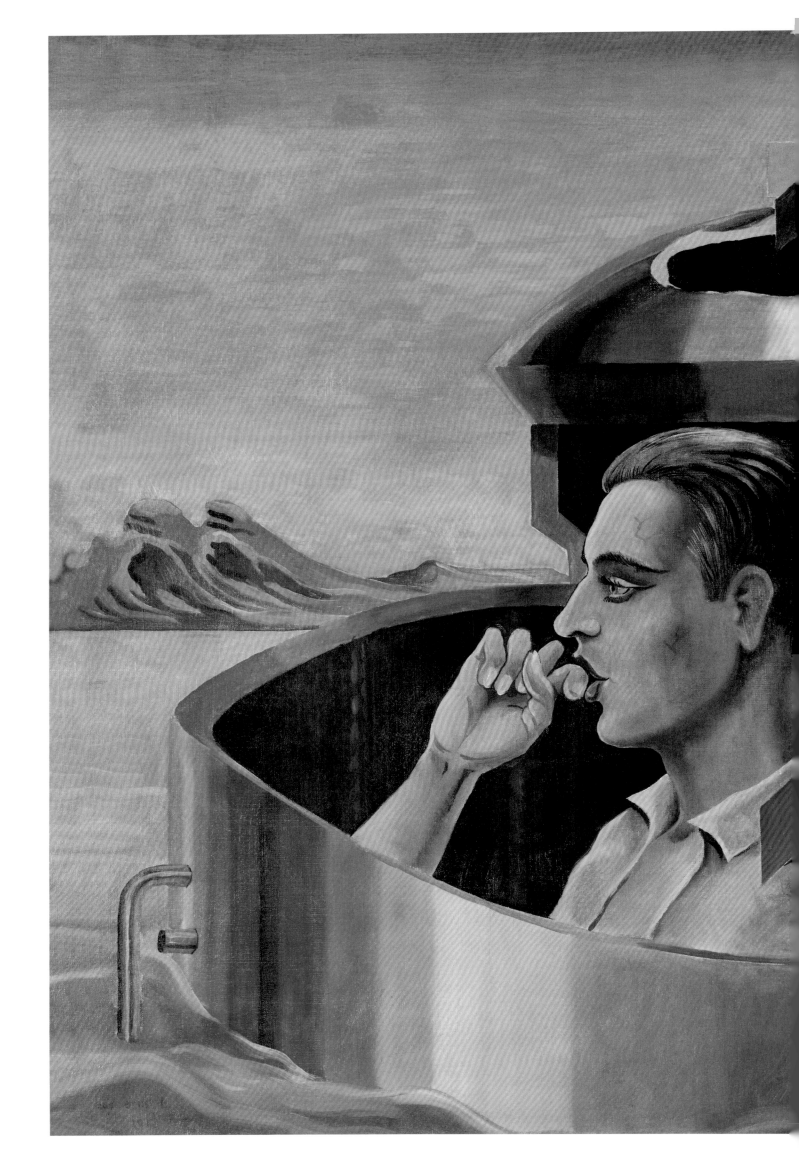

year, 1923, Éluard made a good sum of money and made a snap decision to leave for Tahiti in the footsteps of Gauguin. Gala received a telegram from there in which Éluard set a date for her and Ernst to come and join him in Saigon. As a result, the three of them all met up in Singapore. This adventure enabled Ernst to see the East, which, although hitherto unknown to him, was one of the regions which avant-garde artist often visited at the start of the twentieth century, in search of the basis of a new worldview, and which proved a source of material for contemplation and aesthetic inspiration.

On the right in the picture, turned towards Éluard, is André Breton. The vibrant spot of colour – the red scarf against the background of a yellow suit – defines Breton's key place, underlined by the gesture of his raised hand. To the left, Louis Aragon peeps out from behind Breton's shoulder. To the right, lower down, Baargeld and, after him, Desnos, have made rapidly for the centre. On the left behind Ernst stands Hans Arp. At the very centre, in the first row, with a monocle, sits the celebrated Parisian Dadaist, the poet Benjamin Peret.

However, the most interesting thing in Ernst's portrait is the presence of a few characters whom it was impossible to meet in Éluard's house: next to Max one can see the bearded head of Dostoevsky; in the top row, next to Éluard, the handsome face of Raphael; and on the right, next to Gala, in a Greek chiton with straight archaic folds, stands Giorgio de Chirico. Three of the numerous Surrealists who were the predecessors to the Surrealists of the twentieth century took their place in Éluard's picture.

In Saint-Brice, they talked, argued, played their Surrealist games, and recounted their dreams. The whole group went for walks in Saint-Leu forest. For Max, the forest possessed a wholly special significance. To it were linked his childhood impressions which are always the clue to the paths taken by Ernst's creativity. It recalled his father's watercolour which he latter called *Solitute*. His father depicted a hermit seated at the roots of an ancient tree on the outskirts of a forest. Max was then three years old, and the hermit was for him a frightening and incomprehensible figure. Like every naïve, untaught artist, his father laboriously drew every leaf, and the life-like quality of nature frightened the child all the more. When his father first took him to the forest, "Max Ernst experienced there the same discomfort even more severely; a delightful and dreadful feeling, made up of panic and enchantment, which subsequently throughout his life he would often try to recapture", as he later recounted to Patrick Waldberg.[84]

The Ernst children often went into the forest. Max observed the leaves, the grass and the insects; he examined and studied them, just as Leonardo da Vinci had done long ago. All this study survives in his painting. He made paintings of entangled blades of grass, where each leaf, each flower and each blade is represented with absolute precision. Insects, also precisely drawn, live within the clumps of grass. In Ernst's canvases, grasses are transformed into a forest populated by strange and fantastic beings which inspire the feelings that the little Max experienced in the forest on the Rhine. The endless series of forests reached a sort of culmination in 1936 in the picture which he called *Joy of Life*. This forest was inhabited by the most peculiar creatures, with the combined features of birds, lizards and insects; here and there on the blades, eyes grow like fruit, and a nymph and a Sphinx live there too. "All of Max Ernst is expressed in this work, a sort of Bosch-like "Hell" transported into a dreamlike forest of le Douanier Rousseau", wrote Waldberg.[85] That special world of Max's pictures was the inspiration for the next poem that Éluard dedicated to him:

> In a corridor the agile insect
> Buzzes around the virginity of a little dress
> In a corner the sky delivered up
> To the prickles of the storm lets out white balls.
>
> In a lighter corner all eyes
> Await the poisons of anxiety
> In one corner is the carriage of summer greenery
> Immobile, glorious and for all time.

Max Ernst,
With the First Pure Word, 1923.
Oil on a plaster wall in the house of Paul Éluard
in Eaubonne, transferred on canvas,
232 x 167 cm.
Kunstsammlung Nordrhein-Westfalen,
Düsseldorf.

By the light of youth

Of lamps lit very late

The first girl shows her breasts that some red insects are killing.[86]

Sometimes the forest in Max's painting appears like a continuous wall of closely packed trunks, generating a sensation of depression and helplessness. Often, the round disc of the moon rises above his forest, bewitching with the mystery of the night. Sometimes this disc is torn open at the centre by a round aperture. And almost always, within the trunks of the trees or the blades of grass a bird has concealed itself, none other than Loplop, who simultaneously inspires fear and joy. "It was summer", wrote Ernst. "It was the time of snakes, earthworms, feather-flowers, scale-flowers, tubular-flowers. It was the time when the forest soared and the flowers struggled under the water. The time of the circumflex jellyfish."[87] Within the trunks of the trees, the flowers, and the blades of grass can be seen the sharp beak and round eye of Loplop.

Max Ernst's fantasy was always born from impressions that had been experienced by him either in a dream or in reality, but it often moved very far from those impressions. He told the story of how, in his childhood, he lay on his bed with a high temperature and looked at the wall with its false mahogany veneer. On this shabby old panel he could see a thicket of the forest, monsters of some kind, and many other things as well. In 1925, he read Leonardo da Vinci's *Treatise on Painting* for the first time and was struck by how much his own sensations coincided with those about which the great Italian wrote. Leonardo objected to Boticelli, who poured scorn on landscape painting, and who said that one only needed to throw a paint-stained sponge at a wall for the blot left by it to become a landscape straight away. "He (Boticelli) is right", wrote Leonardo, "in a stain of that kind one is bound to see some bizarre inventions; I mean that anyone who chooses to look at this stain attentively will be able to see there human heads, many different animals, a battle, rocks, the sea, clouds, corpses and other things besides: it is like the ringing of a bell which makes one hear what one is imagining."[88] In the coloured spot on the wall, one need not see anything at all. The only man who will see anything is someone who wants to use the stain to awaken a fantasy. For Ernst, a blot on a sheet of paper or the accidental stains of paint on a canvas were enough. And, of their own accord, as if the artist was unaware of his intentions, moving, flying, running shadows were born from the smudge of paint, and here and there Loplop's features emerge as well. In fact, only in that way could the automatism which Breton declared to be the Surrealist's working method be expressed in painting. Max Ernst discovered this approach intuitively, without thinking very deeply about method, and he submitted himself only to the element of imagination, which is unfettered by any kind of logic.

In that, year Max made a startling discovery. It happened on August 10, 1925 on the coast at Pornic. "… Finding myself, during the rain, in a guesthouse by the sea", he recalled:

> I was struck by the obvious interest my eyes seemed to be taking in the floor, the grooves of which seemed to have been accentuated by a thousand washes. I decided then to interrogate the symbolism of this obsession, and to come to the assistance of my meditative and hallucinatory qualities, I obtained from the planks a series of drawings, by placing sheets of paper over them at random which I set about rubbing with graphite. While closely examining the drawings I had thus obtained, the dark and other sections which emerged in a gentle half-light, I was surprised by the sudden intensification of my visionary faculties, and by the hallucinatory succession of contradictory images, superimposing themselves on one another with the persistence and the rapidity which are the peculiarity of memories of love."[89]

Max Ernst,
*Two Children are Threatened by
a Nightingale*, 1924.
Oil on wood with painted wood elements and
frame, 69.8 x 57.1 x 11.4 cm.
The Museum of Modern Art, New York.

92

2 enfants sont menaces par un rossignol /M: ernst

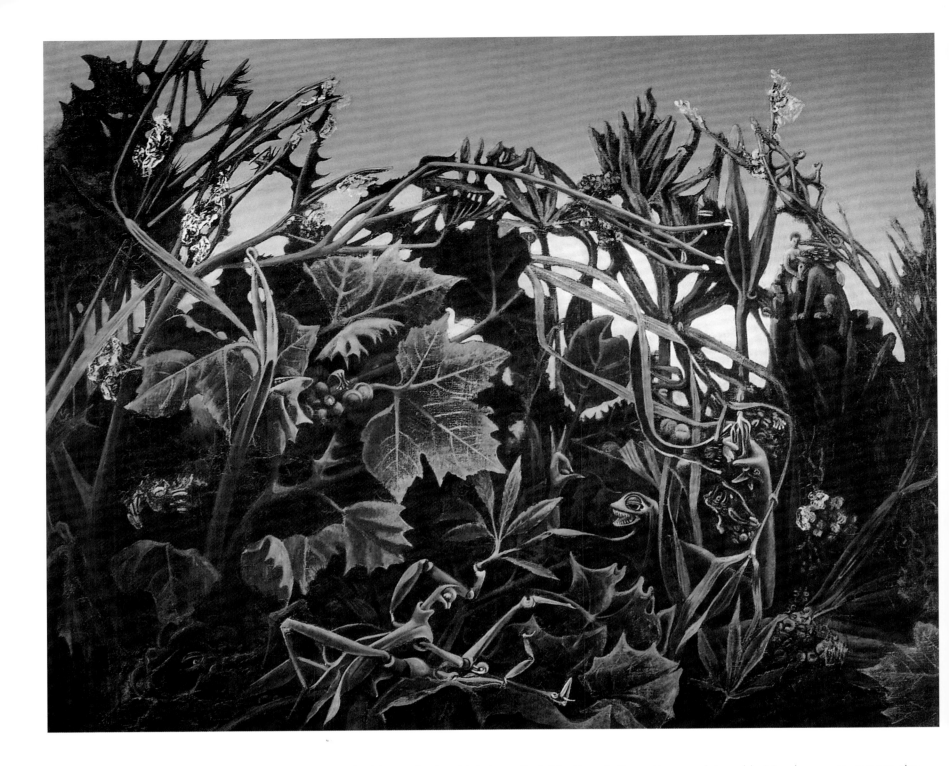

With this method, which he called "frottage" (from the word to rub), Max began to expose the designs of the veins on a leaf; the rough texture of a sack, the fibres with which rope is woven; the interlacing of the sticks from which a basket is made. According to him, he found the most varied images in the drawings he had obtained: the sea and the rain, human heads, animals, sphinxes, landscapes, a shawl with flowers and even Eve. He grouped together the first results of the rubbing under the name "Natural History". "I insist on the fact that the drawings thus obtained", wrote Ernst, "lose more and more, through a series of suggestions and transformations which present themselves spontaneously – in the way that happens with hypnotic visions – in the character of the material under investigation (the wood, for example), and take on the appearance of images of an unhoped for precision, with the capacity, no doubt, to reveal the initial cause of the obsession, or to produce a simulacrum of this cause."[90]

Max transferred his method from graphic art to painting, in his own words, "by adapting to the technical means of painting (for example: scratching colours on a background prepared in colours and placed on an uneven surface) the process of rubbing which first of all appeared applicable only to drawing…"[91]

Max Ernst,
The Joy of Living, 1936.
Oil on canvas, 73 x 92 cm.
Sir Rolland Penrose Collection, London.

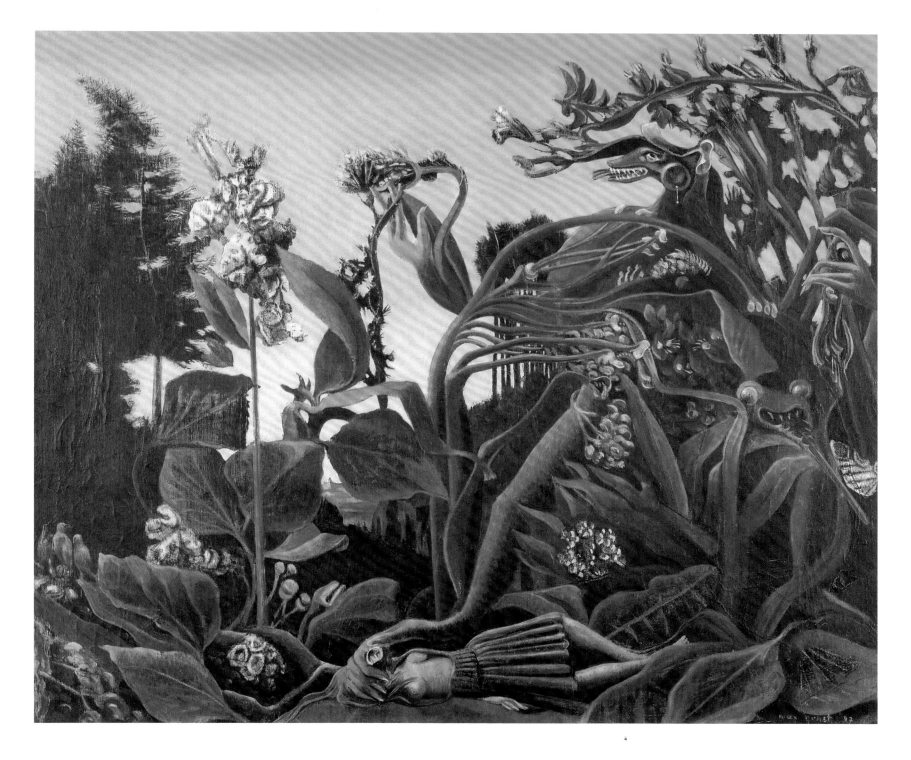

However, these methods of Surrealist automatism only meant that the techniques that Ernst was already using became more firmly established in his art. He used various textures, the natural transfer of which only intensified the impression of the image created by him. In 1923, Max Ernst painted *Ubu Imperator*, a character created by Alfred Jarry and a favourite of the Surrealists, in the form of a child's spinning-top. The realistic, seemingly tangible wicker surface of the top looks as if it might serve as the frame for a mysterious being hidden inside. The top is urged on with the help of a whip, shown nearby. Max said that once in childhood, when in a state of semi-consciousness, he saw his father with a pencil in his hand, it seemed to him that with this whip-pencil his father was driving a gigantic top around his bed. His father was a character whose many-sided nature determined much in Max's life. Undoubtedly, his father's immersion of painting, in fact his main activity in life, did a great deal to determine his son's future. However, Ernst's memoirs also record his father's taciturnity, and a harshness verging on cruelty.

In the following year, 1924, Ernst created a picture titled *Two Children Are Threatened by a Nightingale*. In fields receding into the distance, towards a Roman triumphal arch (yet another throwback to de Chirico!), figures of children are visible, one of which is already lying on the ground, while the other, brandishing a knife, endeavours to defend himself against a tiny bird, hardly noticeable in the expanse of the sky. The nightingale,

Max Ernst,
The Nymph Echo, 1937.
Oil on canvas, 46 x 55 cm.
Private Collection.

which traditionally was always the embodiment of music and art, the incarnation of the beautiful…how can it be threatening? This is a mystery, one of the enigmas of the forest world of Max Ernst. "But it is in the past, it seems to me. Perhaps…" he wrote in 1934:

> In that epoch in the past, nightingales did not believe in God: they were bound in
> friendship to mystery.
> And man, in what position did he find himself? Man and the nightingale were in
> the most favourable position for imagining: they had, in the forest, a perfect point
> of connection to dreams.
> What is a dream? You are asking me too much there: it is a woman who fells a tree. [92]

In this world everything is strange: someone has climbed onto the roof of a chalet in a state of panic and is trying to reach the bell. Here an element of the real world enters the painting: the bell is not painted on the canvas, but instead is a real bell. It is attached to the wood frame of the picture and is much bigger in scale than the painted objects. Also pertaining, no doubt, to real life are the unidentified instrument the purpose of which is impossible to understand, and which is attached to the door of the construction, and the wooden gate. The wooden gate, also nailed to the frame, opens the way out of the picture and into the space of the real world. The play of various techniques, the juxtaposition of different scales, different materials, and, as a result, different worlds – the real world and the world represented on the canvas – it is through these methods that the artist constructs his enigma. Ernst went one step further, if you compare him to his colleagues: he united the painting with reality, that is to say, created a form of art which is fully entitled to be called Surrealism.

In the mid-1920s, Max Ernst took the place he deserved in the Surrealist group. The Paris galleries noticed Ernst and began to exhibit his work. He obtained recognition in the French provinces – it turned out that there were people who appreciated his pictures even in Carcassonne. Ernst's exhibitions were organised in Berlin; the Belgian Surrealist René Magritte, who joined the group in 1927, admired his painting. Magritte wrote in a letter to P. Waldberg:

> Max Ernst's painting depicts the world that exists outside of insanity and reason.
> Even setting aside his pictures in which his virtuosity appeals to the consideration of
> competent technicians, and the pictures whose style depends on the assiduous
> imitation of an idea, there is all the same only one consideration that really
> corresponds to what makes them interesting: the fact that nature is rendered with
> wonder and admiration… Max Ernst has the "reality" that is capable of awakening
> our trust in the marvellous, if it is sleeping, and that cannot be isolated from the life
> of the present in which it is shown.

In December 1928, one of the most prestigious galleries in Paris, the Galerie Bernheim-Jeune, opened an exhibition entitled "Max Ernst, his birds, his new flowers, his flying forests, his curses, his demons." René Crevel wrote the catalogue text. The first buyers of Ernst's pictures made themselves known. In 1929, he brought out his first album *The Hundred Headless Woman*. However, the first crack in his relationship with André Breton also dates from this period. Picasso brought Serge Diaghilev to Ernst's exhibition and advised him to commission scenery from Ernst and Miró for *Romeo and Juliet* in the production to be staged by Diaghilev's Ballets Russes. Ernst liked the idea and he told Breton about the commission. As a result, in its seventh edition, *La Révolution surréaliste* published a "Protest" signed by Breton and Aragon. "It may have seemed to Ernst and Miró that their collaboration with M. Diaghilev, legitimised by Picasso's example,

Max Ernst,
The Whole City, 1936-1937.
Oil on canvas, 96.5 x 160.4 cm.
Peggy Guggenheim Collection, Venice.

Max Ernst,
Europe after the Rain, 1940-1942.
Oil on canvas, 54.8 x 147.8 cm.
Wadsworth Atheneum Museum of Art,
Emma Gallup Sumner and Mary Catlin
Sumner Collection, Hartford.

would not lead to especially serious consequences", they wrote. "However, it makes us obliged, as people who care more than anything to keep the forward positions of the intellect out of the reach of slave-merchants of any kind, it obliges us to denounce, without any personal consideration, an attitude which hands over weapons to the worst partisans of moral disengagement."[93] Breton's tyranny was to some extent smoothed over, in as much as in the following number of the journal, reproductions appeared of two pictures of Ernst together with a piece by Éluard, who wrote: "We are going to have to work out once again where we stand, and our enemies, once again, must give up the right to judge us... The purest remain on our side."[94] Nevertheless, every artist needs freedom, and a Surrealist, who aspires towards the spontaneous expression of his subconscious, simply cannot create things without freedom.

The conflicts with Breton did not cause any damage to the personal friendships that were so important to the Surrealists. Paul Klee, Joan Miró, Yves Tanguy and others still remained among Ernst's closest friends. Touchingly, they assisted Ernst in extricating himself from the awkward situations in which he constantly found himself. Before embarking on his stormy affair with Gala Éluard, Max had separated from his wife. Max's friendship with Paul Éluard had been forced to undergo many trials. Gala's attractiveness continued to be the cause of their quarrels. "Maya daragaia" (my darling – in Russian)", Éluard wrote to his wife on May 25, 1927... "Yesterday evening at Breton's I got into a fight with that pig, Max Ernst, or rather, he suddenly hit me in the eye, quite hard, I couldn't see a thing and hit out at random... Imagine! My best friend hit me, disfigured me. ... I will never see Max again. Never."[95] However, this "never" was very quickly forgotten. The fact was that in 1927, a twenty-year old Parisian girl, Marie-Berthe Aurenche, entered Max's life. Her parents had given Marie-Berthe a convent upbringing, and were horrified by her intimacy with a German. Max had to elope with Marie-Berthe to Noirmoutier, and then the Surrealist friends, Desnos, Jacques Prévert and André Breton rescued him from the police station. This adventure came to an end with a marriage, which lasted successfully until 1936.

In terms of Ernst's work, the summer of 1934 played an important role. Max spent it in Maloja, in Switzerland, where he had been invited by Alberto Giacometti. It was there that Ernst began to work in sculpture. The very form of granite blocks, developed by time and rough weather, appeared to Max to be so wonderful that he barely altered it. Sometimes he carved out a delicate relief on the stone, and sometimes he merely painted the stone. Of his work in sculpture one could say the same words he used of his "rubbing": in his creative work he was present "as a spectator". The ability to enable the imagination and the material to take the artist in a direction seemingly independent of his will became completely natural to Ernst. Alberto Giacometti introduced him to the young Swiss painter, Meret Oppenheim, a woman of a Surrealist character, and the creator of the celebrated "fur cup". In spite of the difficulty of daily life in Paris, where artists were often compelled to live on unemployment benefits, Max did not lose the light-heartedness that was an essential part of his character. In 1936 and 1937 he was often seen in Paris on the Left Bank in the company of the artist Leonor Fini, a striking, beautiful and temperamental woman, well known as the "Italian Fury" for her shocking behaviour. In 1937, during his exhibition in London, Max met Leonora Carrington. A twenty-year old girl from an upper-class background, she was familiar with Max Ernst's paintings, and had an admiration for them.

Max settled with Leonora in the wildest spot in the Ardèche, where he bought an abandoned, dilapidated house. While he was restoring it, he decorated the exterior walls with a cement relief. The inhabitants of the village were disturbed by the monsters which appeared on the walls of this house: lizards with the heads of birds and fantastic insects. Leonora decorated the walls of the rooms with frescoes of pretty, stylized horses.

Ernst's painting from the late 1930s and early 1940s is the work of a true visionary. After the forest, in his pictures there now appeared cities. The technique of "scratching" produced a striking effect. The woven texture that appeared on the canvas created the impression of stone blocks decorated by an ornamental design. Pyramids are constructed from these blocks. In the picture which Ernst called

Max Ernst,
Attirement of the Bride, 1940.
Oil on canvas, 129.6 x 96.3 cm.
Peggy Guggenheim Collection, Venice.

Max Ernst,
The Painter's Daughters, 1940.
Oil on canvas, 72 x 60 cm.
National Gallery of Art, Washington, D. C.

Max Ernst,
The Antipope, 1941-1942.
Oil on canvas, 160.8 x 127.1 cm.
Peggy Guggenheim Collection, Venice.

The Whole City, an ancient pyramid rooted in the earth has become overgrown with the flowers and grasses which Ernst so loved to draw. Sometimes, the enormous disc of the white moon rises in the bright sky above the pyramid. Now the mystery of Max Ernst is tinged with a sense of melancholy and solitude. The people who built the pyramid have vanished, the earth is closing over the ancient cities, and silence and oblivion reign everywhere.

It is true that in these years in various pictures the "Angel of the Hearth" appears, a funny monster in flapping garments that evokes memories of fairy stories. Ernst had a peculiar sense of humour which never left him. However, the Surrealist artist could not remain indifferent to the mood of anxiety and uncertainty which pre-war Europe was experiencing. In 1937, he painted a picture called *Barbarians*. The fairy-tale spirits of the domestic hearth have given place to monstrous incarnations of war and pillage. And one of them, of course, has taken on the appearance of Loplop.

In 1936, the Spanish artist from the Canary Islands, Oscar Domínguez, invented one more means of automatic drawing – "decalcomania without a preconceived objective". Earlier, Max had already made use of the method of splashing a spot or blot of paint on paper, for the intuitive manifestation in painting of fantastic figures. Dominguez proposed to pour black Indian ink or gouache onto paper, then to cover this sheet with another and to press the latter down. The random smudges of paint created stains and chiaroscuro transfers in which the fantasy gave birth to the most varied images. All that remained was to reveal them, to finish drawing a few details and to accentuate the contours. Ernst used this method in oil painting. He laid thick paint directly onto the canvas. When the blob of paint was spread around, unforeseen images were obtained: human faces, plants, forests, cities and fabulous beasts. In Max's hands, one further method appeared: he now used not only the colour, but also the texture of the thick paint itself. In his pictures, mysterious images appear, entering his strange, conceivably supernatural world and the creatures which inhabit it. Under the eyes of the viewer, incomprehensible and frightening transformations take place (*The Antipope*). The body of a beautiful woman becomes overgrown with bright red fur (*Attirement of the Bride*). It has already covered the whole of her head, and instead of a face, the eyes and beak of an owl force their way through the fur. And by the disappearing nude model, as though the presiding genius over all of these changes, stands Loplop, with the legs of a man, the head of a bird and a spear in its hand. Loplop had never actually left the artist, and in fact commanded and represented him. Loplop opened up for him the sources on which he drew for the creation of his pictures, and his imagination never ran dry.

"In 1930, after furiously and methodically composing my novel *The Hundred Headless Woman*", wrote Max, "I had a visit almost every day from the *Commander of the Birds*, named *Loplop*, an unusual ghost of exemplary loyalty, devoted to my person. He presented me with the *Heart in Cage*, the *Sea in Cage*, *Two Petals*, *Three Leaves*, *Flower* and a *Young Girl*. And also *Man with Black Eggs* and *Man in Red Cape*."[96]

The happy life with Leonora Carrington in Ardèche was abruptly cut short with the start of the war in 1939. Max, like all Germans in France, was immediately interned. The conditions of life in the prison of Largentière were difficult to bear. It is true that at the end of his stay there, Max, as an artist, was given a certain amount of freedom, and was permitted to walk in the nearby area with Leonora. For this, he had to pay with a picture. However, the landscape which he offered horrified the man in charge of the camp, and Max's walks were subsequently abolished. Soon, all the prisoners were removed from the prison to the Milles prison camp near Aix-en-Provence in the south of France. The camp was located on the site of a former brickworks, and there were bricks everywhere. In the camp, Ernst met the German Surrealist artist Hans Bellmar, who made a portrait of Max out of the bricks. An appeal by Paul Éluard to the president enabled Ernst to be discharged from the camp. By Christmas, Max had returned to his own village of Saint-Martin in Ardèche, but not for long. In May he was handcuffed and sent away to a camp in the Drome. Leonora did not stand up to these trials and landed in a psychiatric clinic. When Italy

Max Ernst,
The Eye of Silence, 1943-1944.
Oil on canvas.
Private Collection.

Max Ernst,
Day and Night, 1941-1942.
Oil on canvas, 112 x 146 cm.
The Menil Collection, Houston.

entered the war, Ernst was once again transferred to the Milles camp. The Germans invaded, and prisoners for whom to fall into Gestapo hands would have meant death, asked the authorities to release them. Max found himself on a train bound for Bayonne, together with hundreds of other prisoners. After unforeseen delays en route, he ended up in the Saint-Nicolas camp at Nîmes. In the course of these adventures he met the German Surrealist artist Wols, the writer Feuchtwanger and his wife, and he came to know the poet Ferdinand Hardekopf. Worn out after these endless trials, Ernst ran away from the camp and one night arrived on foot at his village, Saint-Martin d'Ardèche. However, as a result of an anonymous tip-off, he was once again sent to Saint-Nicolas. Having realised that liberty could be granted to a man who was married to a Frenchwoman, Max and Marie-Berthe declared that they were living together as man and wife, and covered up their divorce. Tired of waiting until all the necessary papers were in order, Max ran away yet again. Fortunately, one of his friends managed to detain him in Nîmes. Max was liberated, and set out once more for Ardèche.

It might appear that in the conditions of the camps, creative activity would be out of the question. However, between 1939 and 1941, Ernst did in fact paint pictures: *The Angel of the Swamp*, *The Stolen Mirror*, *Napoleon in the Wildnerness*. The appearance of the planet was changing before his eyes.

The recollections of history are still preserved, the ancient pyramids and strange sculptures are still visible. But these are merely the relics of a former culture. Only in places, from under the rust and mildew covering the earth, can be seen the beautiful body or face of a woman, but soon, they too are inevitably hidden under a thick layer of encrustation. The surface texture of the paint is incomparably beautiful, and at the same time frightening. It embraces the viscosity of clay, the ruggedness of stone and the roughness of rusty iron. The most prophetic of these paintings is undoubtedly *Europe after the Rain*. A landscape which was once made up of mountains, trees and human habitations has been transformed into disfigured stones and fragments; its previous purpose can only be guessed. It is as though this earth, this Europe, has experienced a gigantic catastrophe. The objects and people fused together under the impact of this terrible explosion have been transformed into a rusty, warped sculpture. Here and there the outlines of a human figure can be guessed at, rooted in the rock-face or the ruins of a house together with the skeleton of an animal and birds. There are birds everywhere, they are of different kinds, but over all this devastation, almost at the very centre of the composition, Loplop is triumphant. All this is united by the colouring of rust and of green mould against the background of the blue sky. "Europe after the rain – a sombre vision indeed!" the artist himself wrote.[97] Max Ernst's painting had never until then attained such expressiveness and such pathos.

Max Ernst,
Painting for Young People, 1943.
Oil on canvas, 60 x 76.2 cm.
The Menil Collection, Houston.

It is not surprising that his painting should have impressed the American Peggy Guggenheim, who was quick to buy up everything he painted in these last years.

He met Peggy in Marseilles where he had gone to organise his departure for America – his son from his first marriage had already sent all the necessary papers for this. In Marseilles, the Surrealists – André Breton, Benjamin Peret, Oscar Domínguez, Marcel Duchamp and many others – were awaiting the chance of a passage to America. On May 1, 1941 Ernst decided to try his luck, although not all of his documents were in order. All the customs officers gathered in amazement round Max's pictures, which were on display beside the walls of the customs-house. They asked the artist to provide an explanation. "I spoke that day about painting in a way I had never spoken about it before, and in a way I would find it impossible to speak again", the artist later recalled. "I put into it all the energy, the warmth and the conviction that my powers allowed me to summon. And I forced myself to be simple. I had the feeling that I was playing for my life, which was the truth!"[98] His Surrealist painting persuaded his listeners. The customs chief notified Max that his papers were not correctly presented, and showed him a train bound for Madrid – having warned him not to make the mistake of sitting down inside it. Ernst understood perfectly, and by the following day he was already in Spain, soon sailing from there to America. On July 14, 1941 he arrived in New York and soon afterwards married Peggy Guggenheim, from whom within a few months he was divorced.

In the years of the Second World War, it was actually possible to put together a presentation on the art of the European avant-garde in America. One of the New York galleries assembled in an exhibition the works of the most varied artists – Chagall, Ernst, Tanguy, Zadkine, Matta, Léger, Breton, Mondrian, Masson and others. When combined, they formed a striking panorama of the diversity of modern art. In 1942, Ernst painted a picture entitled *Surrealism and Painting* in which a monster, something midway between an elephant and an amoeba, is painting plants intersected with geometric lines with a delicate brush. At the very heart of the monster there are birds, their heads joined and tied together in a knot. Loplop, as before, is menacing and comforting at the same time: the painting unites within itself the positive and negative phenomena in which everything originates, life and death.

In America, Max Ernst met the young artist Dorothea Tanning, whose painting impressed him by the way it corresponded to what the European Surrealists were doing. She soon became his wife. In 1946, Ernst and Dorothea settled in on the edge of forests and desert in Sedona, Arizona. The surrounding landscape was a reminder of the fantastic landscapes in Max Ernst's pictures. With his own hands, Ernst built a house and a studio there for himself. He discovered the art of the American Indians. The new impressions found a reflection in his painting, although, as before, his earlier fantastic forest world had pride of place in his work. In the 1940s, geometric motifs appeared in his pictures and they accorded harmoniously with the world of natural history. *Cocktail Drinker* and *Euclid* were painted in 1945. There was a period when tiny pictures appeared in Max's paintings, landscapes at times the size of a postage stamp; he called them "The Microbes". In 1948, his book, *Au Dela de la peinture*, came out in America, and in the same year he received American citizenship. For both of them, Max and Dorothea, this was an extraordinarily productive time.

In 1953, Max and Dorothea returned to France. In 1954, he obtained the grand prize at the Venice Biennale, and was immediately excluded from the Surrealist group: they were against all official awards. However, by this time Max was one of the greatest painting masters in Europe. The house in Ardèche was sold, and Max and Dorothea settled in the vicinity of Chinon, on the neglected farm of Huismes, which in the space of a year Max transformed into a comfortable house and garden. The bronze *King Playing with the Queen* was stationed among the trees in the garden. Max Ernst worked there until his death in 1976. "Max Ernst involved himself and identified himself with what he showed us", wrote Paul Éluard. "By directing his gaze beyond this dull reality to which we are supposed to resign ourselves, he makes us go straight into a world where we consent to everything, and where nothing is incomprehensible."[99]

Max Ernst,
Vox Angelica, 1943.
Oil on canvas, 152.4 x 203 cm.
Private Collection.

YVES TANGUY

1900-1955

The house of Yves Tanguy
Which one only enters at night

With the hurricane-lamp

Outside the transparent country
A soothsayer in his element

With the hurricane-lamp
With the sawmill so industrious that one no longer sees it

And the toile de Jouy of the sky
– You, go and hunt for the supernatural!

With the hurricane-lamp
With the sawmill so industrious that one no longer sees it
With all the damn stars…

One bruises there one heals there
One hatches plots without a roof over one's head

With the hurricane-lamp
With the sawmill so industrious that one no longer sees it
With all the damn stars
With the tram-cars in all directions reduced only to their antennae

With the endless plume of the Argonaut
With the dazzling furniture of the desert
With the signs that lovers exchange from afar

This is the house of Yves Tanguy[100]

Yves Tanguy entered Surrealism without getting involved in Dada. André Breton was amazed at the sight of Tanguy and his friends' house in Paris near the Gare Montparnasse. It was a Surrealist house. A house where everything was made by Yves Tanguy's hands. But Tanguy had built not only a house. Yves Tanguy's house was not just a country, but a whole world. This world was born of his imagination. He could not have seen it anywhere because there is no such world; it does not exist. And if it did exist, then it would not be found on planet earth. Maybe Yves Tanguy saw it in a dream – and lived in it. He knew it very well, but this does not make the world of Yves Tanguy any more understandable. And he did not know if this world existed, and if it did not, then why he was depicting it. Yves Tanguy wrote: "If I had to look for the

Yves Tanguy,
The Bridge, 1925.
Oil on canvas, 40 x 33 cm.
National Gallery of Art, Washington, D. C.

reasons for my painting, this would be a bit like imprisoning myself."[101] He said that he took up painting as a result of the impression made on him by an encounter with a picture of Giorgio de Chirico. However, direct influences of de Chirico can never be detected anywhere. Yves Tanguy instead was influential on other people. He could not paint his pictures without absolute freedom. The intellect was not allowed to control his art: he found that reason and logic constrained him.

Yves Tanguy was born on 5 January 1900 in Paris, right in the centre of the city, on the Right Bank of the Seine. Yves's father, Felix Tanguy, was a captain who made long voyages. His family lived in the Naval Ministry on the Place de la Concorde. His father and mother were both natives of Brittany. His father's father and uncle were both sailors. In the Tanguy family, they all thought of themselves as Breton. In his childhood, Yves spent much time visiting his relatives in Britanny, near Nantes and on the north coast at Plestin-les-Greves. After the death of his father in 1908, Yves's mother acquired a tobacco shop. Yves studied in Paris, first at the Lycée Montaigne and then at the Lycée Saint-Louis. By a quirk of fate, he found himself at the lycée in the same class as Pierre Matisse, who brought Yves to the studio of his father, Henri Matisse. Matisse's painting made a huge impression on the fourteen-year-old Yves; this was the first time he had come into close contact with art. However, at that point he still had no thought of becoming an artist. In 1912, Yves's mother bought an old-fashioned house in Brittany which dated to the sixteenth century, in the village of Locronan. The village had its own naïve painter who painted rural scenes which he sold to tourists. He did his work imperturbably, right on the street, wearing a pair of dark glasses. His work attracted Yves's interest. It may be that it was here that he began to draw.

In 1914, Yves Tanguy was only fourteen. He spent the duration of the war in Paris, under the care of his elder sister. His freedom was complete. According to his own recollections, he got to know the life of Paris's lower depths, drugs, prostitution and vagrancy. This period came to an end in 1918, when Yves joined the merchant navy. Life itself seemed to have given him the opportunity to see the most varied and fabulous natural scenery. As well as European countries, he saw Argentina, Brazil and North Africa. During his military service, in 1920, he met someone in barracks who became his best friend. The name of the young Parisian was Jacques Prévert. They parted when in 1921 Yves joined the African "chasseurs" (hunters). He found himself in the south of Tunisia, in places notorious for their punishing regime. On the other hand, the landscapes there were fantastic! After he was demobilised in 1922, Tanguy returned to Paris and met up once again with Jacques Prévert. Together, they tried to survive in the post-war world by taking on any kind of work that came their way. Prévert introduced Yves to his brother Pierre, and his friend from military service, Marcel Duhamel. Things really were looking up for them: Marcel Duhamel was a man of means and managed the hotel Grosvenor which belonged to his uncle. Duhamel rented a house, a former shop, in the Montparnasse district, on 54, Rue du Château. They all made their home there together. The two couples – Yves with his girlfriend Jeanne Ducrocq, and Prévert with his girlfriend Simone Diènne – were joined by Pierre Prévert, Marcel Duhamel and their girlfriends. At that time, they had not yet become close to the Surrealists. But in 1923, Yves caught sight of a de Chirico painting and began to draw. It seems that the first person to pay attention to his drawings was Maurice de Vlaminck. He had never studied painting either, and the expressiveness of the young, untrained artist's sketches made an impression on him. Vlaminck recommended Yves to the critic Florent Fels, the director of "L'Art vivant", who invited him to enter three drawings for exhibition at the Salon de l'Araignée. Marcel Duhamel gave Yves oil painting materials. During these years Yves Tanguy painted his first canvases.

This was a period of avid absorption in Parisian life for Tanguy and his friends. They were drawn to everything related to the world at the margins of society. They sought out the most improbable cafés, walked the streets, and read everything they could find. They saw the films about the "genius of crime", Fantômas, that were made by Louis Feuillade from the serial novels that were published between 1911 and 1913. Yves Tanguy loved the cinema all his life. With his friends, he admired the films of the German Expressionists. Pierre Prevért worked as a projectionist, which enabled them to spend a lot of time at the cinema. In 1924, they read the Surrealist Manifesto and the first number of La Révolution surréaliste. In November, 1925,

Yves Tanguy,
The Girl with Red Hair, 1926.
Oil on canvas, 61 x 46.2 cm.
Jacqueline Matisse-Monnier Collection.

Yves Tanguy saw the Surrealist painting exhibition organised by the Galerie Pierre, where works by de Chirico, Arp, Ernst, Klee, Masson, Miró and Picasso were shown. His friends said that afterwards, he destroyed everything that he had painted earlier. Fortunately, Tanguy's very first picture, *Rue de la Santé*, has been preserved. It was painted on the basis of his impression of Paris at night, when they all went for drives with Marcel Duhamel's cousin. This canvas was the typical work of a naïve artist, with mistakes of linear perspective and touching attention to small details. However, it conveyed the sensation of the speed of the motor-car as it rushed along the street, and the wonderful fascination of the city at night. In that year, 1925, Tanguy painted a picture devoted to Fantômas on a long piece of board, 50 cm by 149.5 cm. With all its naivety, it is still fantastic and enigmatic.

In December 1925, Duhamel and Tanguy met André Breton. At this point, the Rue du Château had become one of the Surrealists' favourite haunts. Desnos, Peret, Aragon and finally, Breton often dropped round there, and Breton, like the others, was amazed by the unexpectedly Surrealist lifestyle of these young

people. The house was filled with a mass of new people. At Rue du Château, the Surrealists played their favourite games – "exquisite corpses", and every possible variation of it. The "exquisite corpses" made with Tanguy's participation were ingenious and at the same time gracefully drawn. In one of the versions of the word-game, the first player had to write a phrase beginning with "if" or "when", after which the second player would write its continuation without having seen the start. Notes of the game in which Yves Tanguy took part have been preserved:

> – If the Marseillaise did not exist
> – The meadows would cross their legs.
> Or:
> – If the ladybirds were of tin-plate
> – One could no longer do anything.[102]

Yves Tanguy,
The Lamb of Invisibility, 1926.
Oil, pencil and collage on canvas,
99 x 72 cm.
Private Collection.

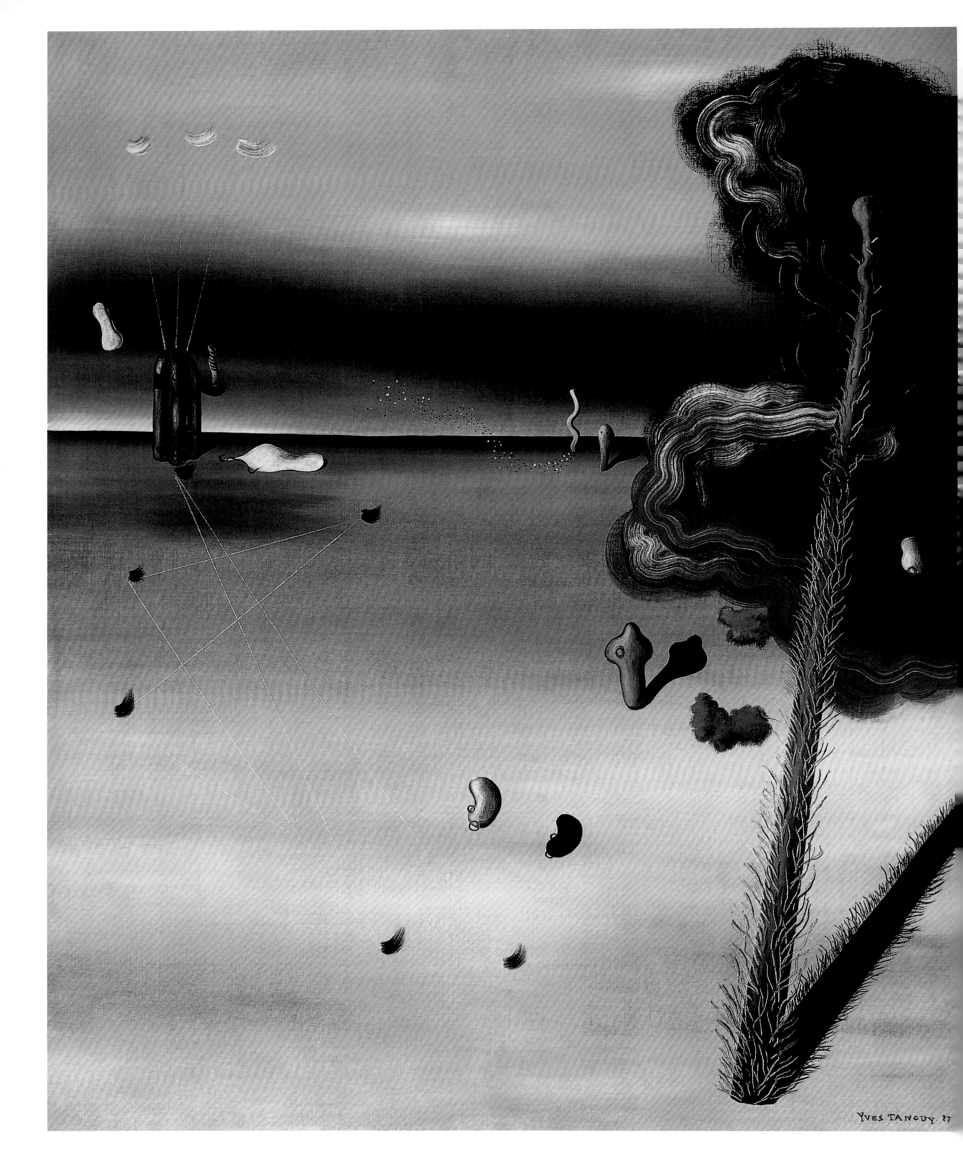

Yves Tanguy himself worked on the décor of their lodgings on the Rue du Château. They furnished the house with simple peasant furniture, which Tanguy painted green. The walls were decorated with collages and patterned fabrics. Cinema posters were positioned next to mirrors in the spirit of the film *Doctor Caligari*. On one of the walls, Tanguy wrote the words of Aragon's frightening poem, "The Brothers the Coast":

> The tidal wave will come into the room
> Where all the little family are assembled
> It says Hello everyone
> And carries Mum off into the cupboard
> The youngest son starts bawling his head off
> It sings him a ballad of its home country
> Which talked about bits of wood
> Bits of wood bits of wood
> Like that…[103]

On the doors of Jacques Prévert's room, Yves painted the intricate oil composition *The Will of Jacques Prévert*, which had everything: trees, houses and lights, candles and matches, sailors and elephants, dice and women (among whom was his girlfriend Jeanette). In this composition, a gramophone plays, someone hangs a picture while standing on the back of a naked woman, and another picture with the image of a sailing boat serves as an eye in a pale Surrealist face. Fortunately, this composition has been preserved. Georges Sadoul, who lived on the Rue du Château in 1936, took the door away because the house had to be destroyed.

In these years Tanguy painted strange landscapes. In them the buildings of Paris and Nantes are sometimes confused, sometimes only one brick tower looms up against the background of a starry night. But in every landscape there was invariably an expanse that recedes into the distance, and a sense of the horizon, even when the line of the horizon was not drawn (*Dancing*; *Untitled*).

In the mid-1920s, Yves Tanguy tried out all the Surrealist work methods: he used rubbing, scratching and collage, and he began to make drawings using the automatic method. He drew in pencil, Indian ink and watercolour, combining drawing with collage. The combination of techniques produced striking results. In 1926, he made a large composition on canvas in which he combined oil painting, pencil-drawing and collage – *The Lamb of Invisibility* – which was reproduced in number seven of *La Révolution surréaliste*. In the picture there are sea waves and a horizon; high-up above is the endless sky and the clouds. The transparent figures were drawn in pencil and, it would seem, soar in the air. They are spectral beside the heavy, thick stone. At this time, Tanguy was beginning to feel his way towards his own individual attitudes and his own way of playing with space, which Salvador Dalí would later borrow from him.

In the mid-1920s, Tanguy began to illustrate the collections of poems of his Surrealist friends. In 1927, he made fourteen drawings for Benjamin Peret's book *Dormir, dormir dans les pierres*. His automatic drawings are airy and light, and fit organically into the pages of the book. Friends noted the unusual degree to which Tanguy's drawings were in keeping with the text. In 1929, Tanguy made two drawings for Aragon's book, *La Grande gaité*. In 1932, he made drawings in Indian ink, and, for the first time in his life, an engraving, for Paul Éluard's collection of poems, *La Vie immédiate*, and Paul Éluard dedicated a poem to him:

> One evening every evening and this evening like the others
> Near the hermaphrodite night

Yves Tanguy,
Mama, Papa Is Wounded!, 1927.
Oil on canvas, 92.1 x 73 cm.
The Museum of Modern Art, New York.

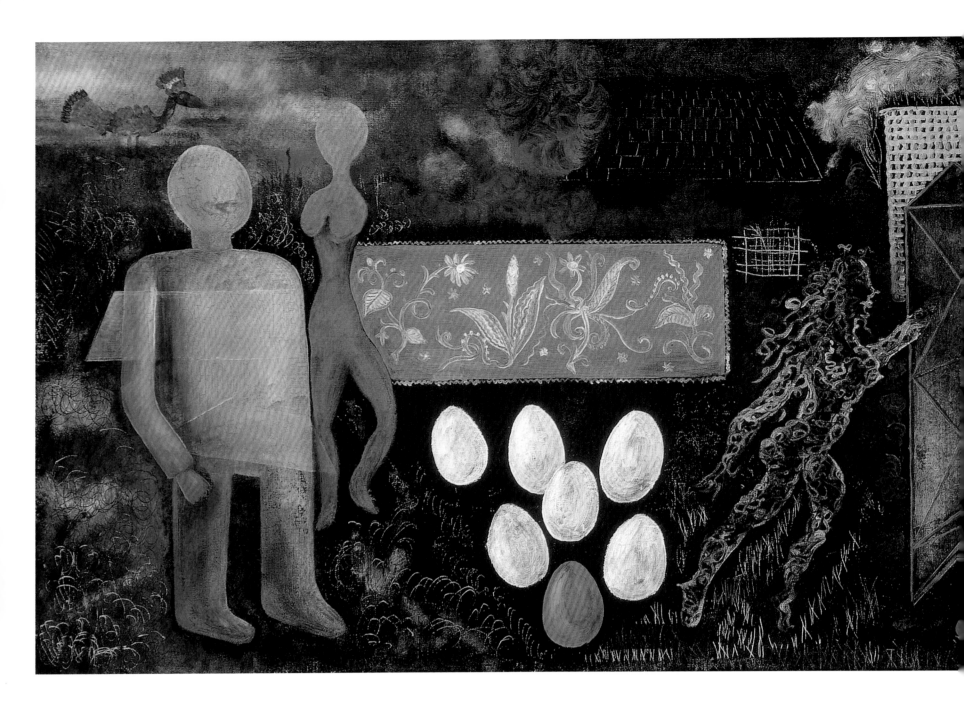

With growth scarcely delayed

The lamps and their venison are sacrificed

But in the burned eye of the lynxes and the owls

The great interminable sun

Heart-break of the seasons

The family crow

The power to see that the earth surrounds

There are stars in relief on the cold water

Blacker than the night…

The poem finished with the words:

We have decided that nothing should define itself

Except according to the finger placed by chance on the controls

Of a broken camera.[104]

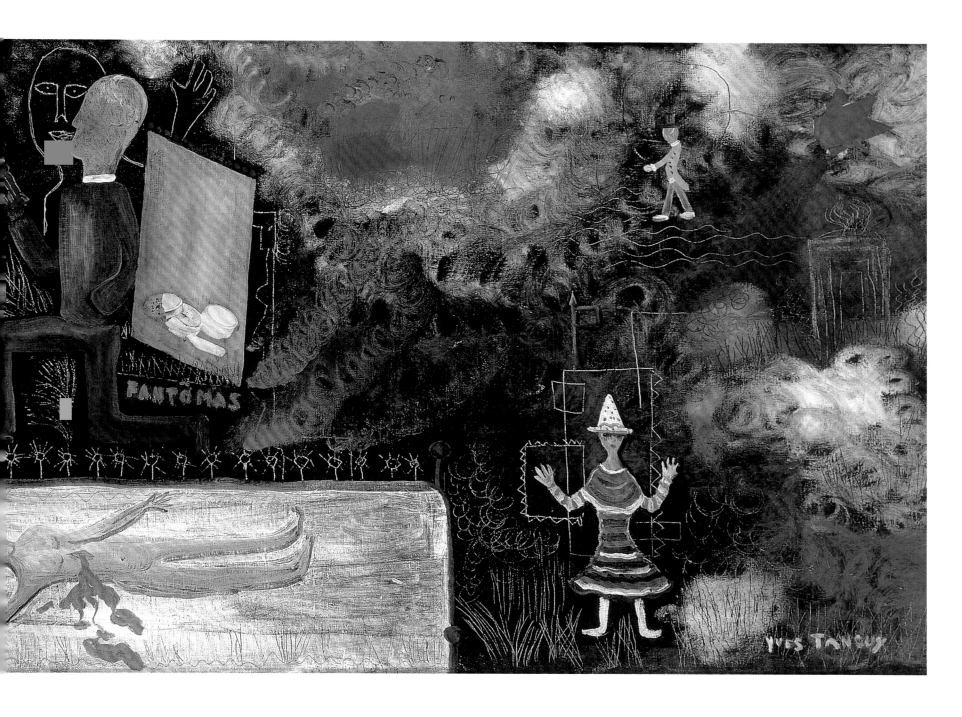

In the mid-1920s, Yves Tanguy worked incredibly intensely. It was at this time that he constructed his Surrealist world and established himself securely within it for the whole of his life. It seems that he saw it in a dream. Yves's visions possessed a total specificity: he knew all the very smallest details and constituent parts of his world. Sometimes this world was underwater, completely black or grey-green (*The Storm (Dark Landscape)*). The slow movements of the water cause the underwater plants to sway. Strange creatures dwell there. Sometimes they are opaque and cast shadows. Sometimes these creatures are almost transparent; they acquire transparent, changing forms (*Death Watching his Family*). More often, his landscapes represent a flat surface which recedes to the horizon line. Plants grow and stones lay in the painting. It is possible that they are not stones at all, but live beings – or objects of some kind whose purpose is unintelligible. Much later, in the mid-twentieth century, the Strugatsky brothers (Russian writers) wrote a novella with the title *Roadside Picnic* in which a spacecraft from another planet touches down on the earth, repairs whatever damage needs fixing, and then flies away, leaving behind a large number of bafflingly strange objects. Possibly these were complex mechanisms of some kind, but for the residents of the earth, they simply represented unnecessary fragments or stones. This is roughly the kind of impression that the world of Yves Tanguy's painting and drawing produces, a world which is fantastic

Yves Tanguy,
Fantômas, 1925-1926.
Oil on canvas, 50 x 149.5 cm.
Pierre and Maria-Gaetana Matisse
Foundation Collection, New York.

and realistic at the same time. It is possible that at its foundation lies Yves's attachment to the landscape of Brittany.

Brittany is a strange and wild land. It is not at all similar to the regions of France surrounding it. The waves of the open sea dash themselves against the rocks of its shores. As the horizon line is washed away by the fog, what you can see in the distance is lost from view. And when the outgoing tide causes the ocean to recede, a strange world is revealed, of stones rubbed smooth by the water, seaweed, and the little creatures for which the sea is home. Brittany has dolmens and menhirs, fortresses, tombs and statues. People who lived many thousands of years ago constructed these things out of vast lumps of stone. Brittany retains a lively sense of its history, and has many legends about those who peopled it far back in time, about Celts and Druids, miraculous spirits, and sirens who lured sailors into their nets. Here, strange sculptural crosses stand at the crossroads. In his childhood, Yves Tanguy would hear family tales about his sailor ancestors when he stayed with relatives over the summer. From 1912, when his mother bought a house in Locronan, he lived in Brittany every summer. Not far from Locronan lies the Douarnenez Bay. Here, the waves throw fragments of carvings onto the shore, fishermen's nets cling under the water to fragments that seem to have been formed from part of a wall or from an iron grille. But the local inhabitants tell the story of how they can hear the ringing of bells from under the water. Legend has it that two thousand years ago this was the site of the town of Ys, which has since been hidden under water. Booklets of folk-tales at fairs and the songs of the local people tell the story of Princess Dahut, who perished together with the town and was turned into a siren.

Yves Tanguy was so accustomed to this landscape that he felt himself to be more a Breton than a Frenchman. "He was a Breton like no one else…", the head of the Surrealists, whose own surname happened to be Breton, wrote to Yves's sister Emilie Tanguy in 1955.[105] Once he and his friends had made their home on the Rue du Château, Yves brought the whole group down to Locronan every summer. They travelled around the whole of Brittany by car and on foot. Photographs of the four friends – Yves Tanguy, the Prévert brothers and Duhamel – all still very boyish in striped sailors' sweaters, imprinted their image onto the beaches and rocks of Brittany. Jacques Prévert's poems retained traditional Breton motifs. It was the happy time of their youth, the time of love:

> Do you remember Barbara
> It never stopped raining on Brest that day
> And you were walking along smiling
> Beaming delighted dripping-wet
> Under the rain…[106]

Whatever else may have happened in their lives, the nuances of all varieties of their feelings were connected to Brittany. It was a kind of "endless homecoming":

> Here is a Breton coming back to the land of his birth
> After pulling quite a few strokes in his time
> He is taking a stroll in front of the factories at Douarnenez
> He does not recognise anyone…[107]

In 1930, the day came when Tanguy and Jacques Prévert parted company, but the painting of the former and the poetry of the latter retained the striking unity of their Surrealist youth. Prévert's poems are the mirror image of Tanguy's pictures:

> Demons and marvels
> Winds and tides

Yves Tanguy,
Untitled, 1927.
Oil on canvas, 61 x 50 cm.
National Gallery of Art, Washington, D. C.

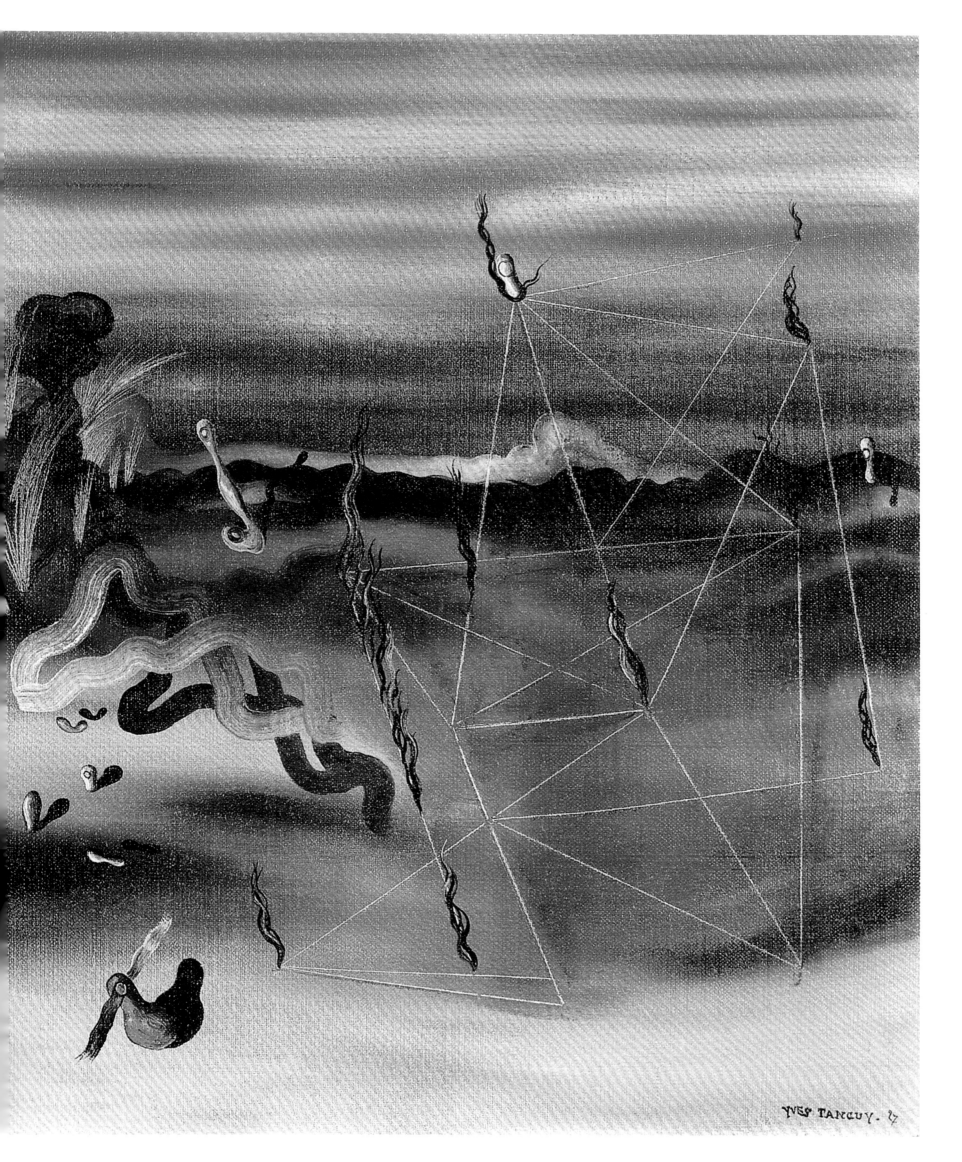

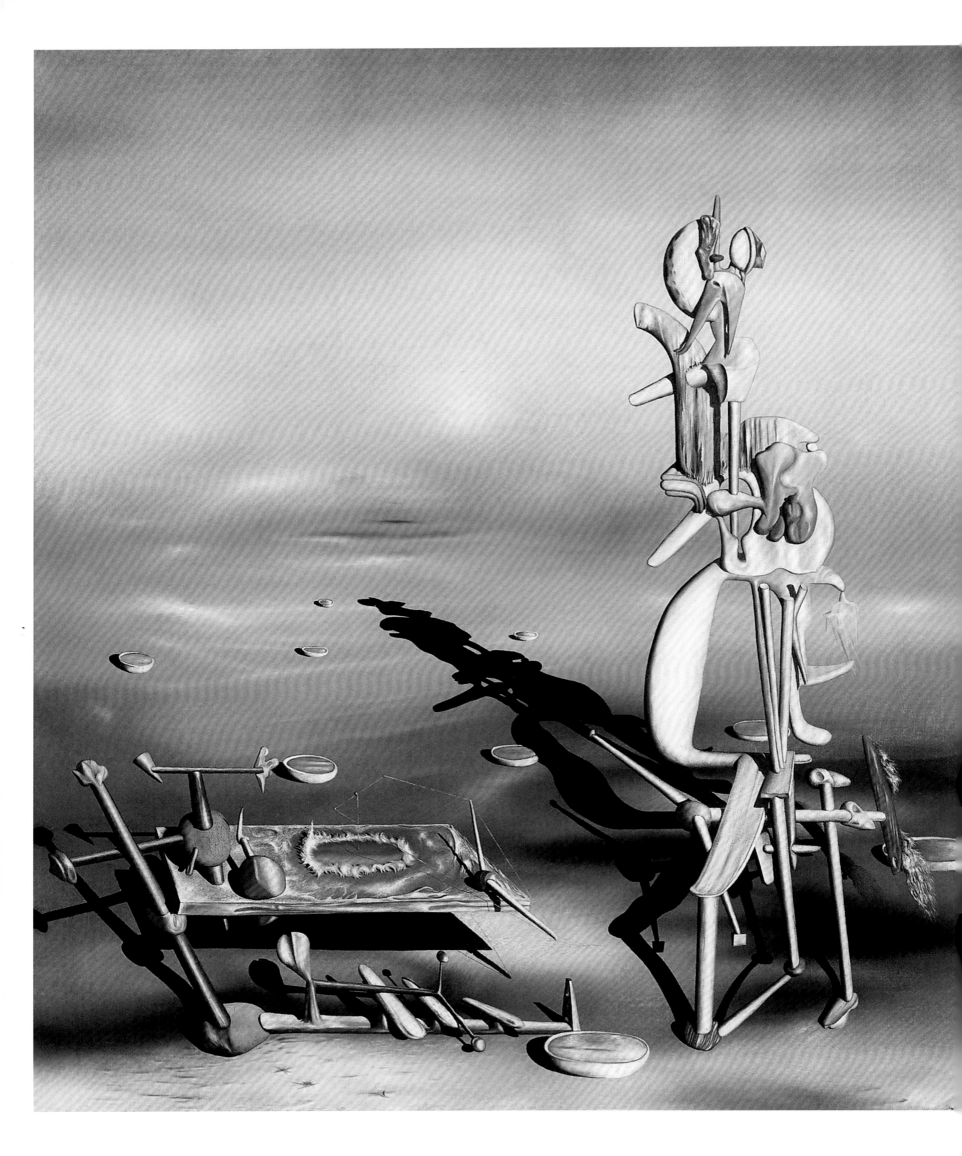

The sea has already drawn far out

And you

Like a piece of seaweed gently caressed by the wind

In the sands of the bed you shift in your dreams

Demons and marvels

Winds and tides

The sea has already drawn far out

But in your half-open eyes

Two little waves have stayed

Demons and marvels

Winds and tides

Two little waves to drown me with.

None of Tanguy's drawings completed in Brittany have survived. In any case, Yves probably did not draw from life. His pictures never offer a reminder of particular places. Instead, they are visions evoked by recollections of Brittany, an image of another Brittany born from his imagination. His surprising and fantastic landscapes impressed people at the time.

From 1926, the Galerie Surréaliste at 16, Rue Jacques Callot opened its doors to Yves Tanguy. In May 1927, his first personal exhibition took place there, entitled "Yves Tanguy and Objects from America." Quite a few of the twenty-three works exhibited in it had already been given to friends – Aragon, Éluard, Breton, Roland Tual, Nancy Cunard (an English poetess who became one of the Surrealists' muses). Tanguys' pictures bore strange titles: *Their White Belly Had Struck Me*, *Dung on the Left, Violets on the Right*, *Finish What I Started*, *I Have Come as I Had Promised*. *Farewell*and and *Mama, Papa is Wounded*! At this point, Tanguy was inspired by his contact with the Surrealists and enthusiastic about their concepts. With Breton's help, he took many titles from psychiatry textbooks. "I remember spending a whole afternoon with him (André Breton)... leafing through books on psychiatry in the search for statements of patients which could be used as titles for paintings." Tanguy said. "The picture ... *Mama, Papa is Wounded!*, is one of them."[108]

It is one of Tanguy's most impressive pictures. In it there is everything that he found in his fantasy world up until then: a flat plain, the line of the horizon, small, indefinable objects or creatures. There is the debt to the art of Giorgio de Chirico – falling shadows, and a figure recalling a classical torso. However, the combination of objects and space creates an entirely new impression. The emptiness of the endless plain, the threatening cloud of black smoke moving overhead, the solitary, prickly plant and the forsaken, helpless creature-objects inspire a sensation of acute anxiety. When the geometry of the lines uniting the objects is entered into the general picture, a feeling of doom arises, a feeling of helplessness. In this picture each detail occupies a place that has been strictly determined for it; there is nothing superfluous here. "This is one of my paintings that I saw entirely in my imagination before starting", wrote Yves Tanguy.[109] Breton said that Tanguy had found the source from the town of Ys. "Yves Tanguy invites us today to meet him in a place which he truly discovered", he wrote in the catalogue of the exhibition of 1927. "...There are no landscapes. There is not even a horizon. There is only, from the physical point of view, our immense suspicion which surrounds everything."[110]

From that time on, Yves Tanguy became a contributor to all the Surrealists' exhibitions, and reproductions of his pictures continually appeared in their publications. In 1928, Yves and Jeannette Tanguy left the Rue du Château, and Aragon and Georges Sadoul moved in to replace them. In 1930, Tanguy and his wife made a trip to North Africa. The artistic result of this trip causes one to reflect on the influence of direct personal impressions on the art of Surrealism. This does not mean that Tanguy's "landscapes" (and he continued to call his pictures landscapes!) were reproductions of natural African

Yves Tanguy,
Indefinite Divisibility, 1942.
Oil on canvas, 101.6 x 88.9 cm.
Albright-Knox Art Gallery, Buffalo.

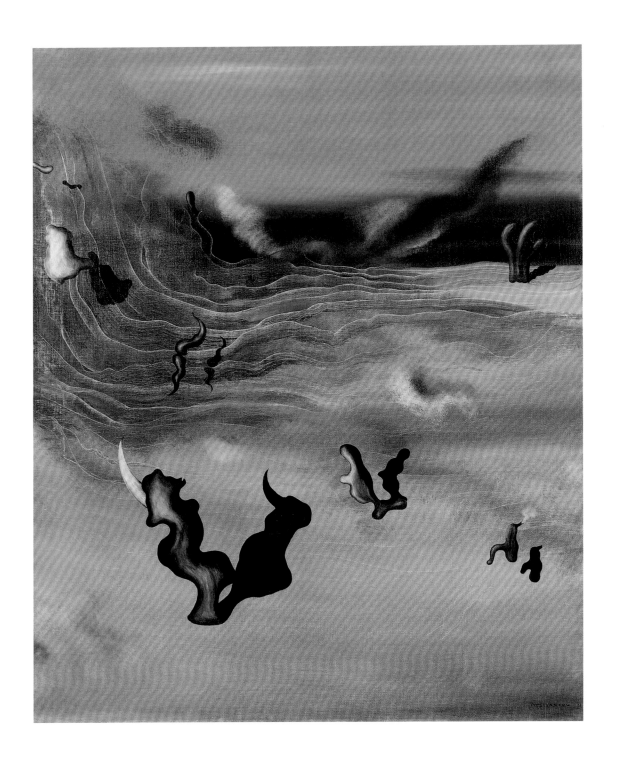

scenes. But the places which "he truly discovered" were altered, as though he had headed further along the roads of his fantastic world. He travelled around this endless plain, stretching to the horizon. But now castles rose up in his path. They were not erected by the hands of builders. They are, instead, rocky formations, accumulations of natural forms on many floors. It is possible that their basis was the Atlas Mountains which he had seen in Africa. However, these formations also recall the coastal rocks of Brittany. The new landscapes are populated by the same object-creatures that had inhabited his pictures before. And he names these landscapes differently: *Palace Promontory*, *The Tower of the West*, *Neither Legends nor Figures*, *The Wardrobe of Proteus*. Tanguy's attention was now fixed on modelling forms, and his indeterminate floating objects of the underwater world stayed in the past. New forms required thorough study, and Tanguy changed his methods. First he made a drawing of the future picture before starting to paint with colours. However, to some extent this meant a betrayal of automatic drawing. "I discovered that if I was thinking up the picture in advance, it was never surprising", Yves Tanguy later wrote. "Well, it is the surprises that are my pleasure in painting."[111] In the following years, the rock castles only occasionally appear again in his pictures, which are often

Yves Tanguy,
Untitled (He is coming), 1928.
Oil on canvas, 92 x 73 cm.
Private Collection.

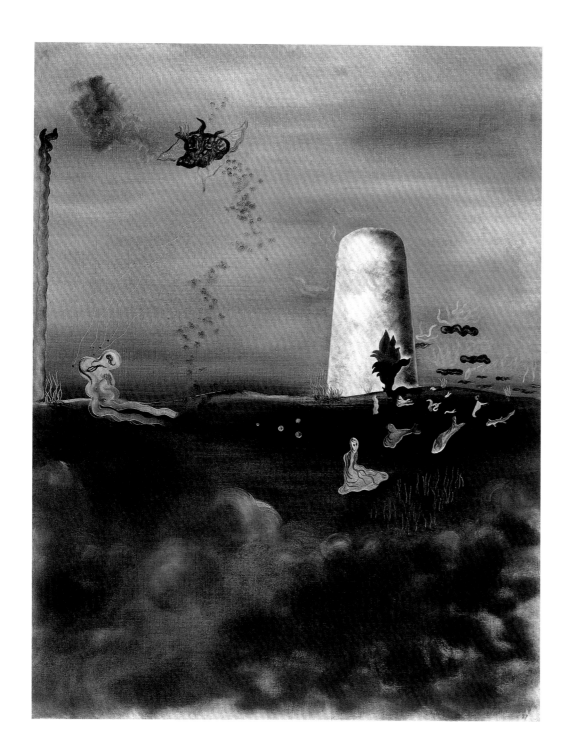

simply entitled *Untitled*. Sometimes, by contrast, it is only in the picture's title that a recollection of the castles is glimpsed – *The Palace of Windowed Rocks*.

The 1930s brought Yves Tanguy wide recognition. In addition to personal exhibitions in the galleries of Paris, he contributed to all the Surrealists' exhibitions, his pictures, collages, objects and drawings appeared in England, Belgium, Japan, New York and Tenerife. In 1939 André Breton summarised Tanguy's artistic journey. "If… Tanguy's star rises higher still, it is because he is ideally honest and intact, and with his nature he escapes any sort of compromise", he wrote in number 12-13 of the journal *Minotaure*. "Tanguy's painting still holds many other things besides its charm: later it will reveal its secret… I am persuaded that the manifest elements of Tanguy's painting which remain impossible to interpret, and among which, as a result, the memory finds it difficult to choose will be made clear with the aid of the steps that the intellect is about to take. These are words of a language which is not yet understood, but which people are soon going to read, which they are going to talk, and which they are going to perceive is the best adapted to the new changes."[112]

Around this time, Tanguy's relations with the other Surrealists became even closer. In 1927, he helped hide Max Ernst from the parents of Marie-Berthe Aurenche. Later on, after his return from Africa, he and

Yves Tanguy,
Composition (Death Watching his Family), 1927.
Oil on canvas, 100 x 73 cm.
Museo Thyssen-Bornemisza, Madrid.

Jeanette lived on the Rue du Moulin Vert, where their neighbours were Victor Brauner and Alberto Giacometti. In 1934, his neighbour on the Rue des Plantes was Max Ernst. At this time Tanguy was on particularly friendly terms with him and with Marcel Duchamp. He was a constant participant in the gatherings at the Surrealists' favourite cafes. Yves Tanguy was one of the members of the group who was most loyal to the political convictions of André Breton. Although he behaved very modestly, and did not enjoy being in the public eye, Tanguy was prepared to take decisive steps. In 1930, Jacques Prévert, Desnos and several other Surrealists signed the pamphlet against Breton titled "A corpse". Tanguy broke with his friends. He signed all the Surrealist manifestos and publications, and illustrated the works of Breton and of other poets. In 1933, Tanguy, along with Éluard, Peret, Crevel, Giacometti and Breton, was involved in the "Experimental Research on the Irrational Knowledge of the Object". Breton thought that Yves Tanguy was the most consistent Surrealist to have employed the method of "absolute automatism". "Yves Tanguy, the painter of a terrible grace, in the air, below the ground and on the sea, the man in whom I can see the moral garb of the times: my adorable friend", Breton wrote in the catalogue to Tanguy's exhibition in 1938.[113] In the period between the two wars, Yves Tanguy's work also became widely known in the United States. In November 1939, following the declaration of war, Yves Tanguy left for America.

In New York, Tanguy encountered the American artist Kay Sage. They had already met in France. Kay was involved in helping those artists who had remained in Europe during the war. In 1940, she became Tanguy's wife, and from that point on she was his lifelong companion. They lived first in Greenwich Village, but in 1941 they moved to Woodbury in Connecticut. As soon as Tanguy had arrived in New York in December 1939, his former lycée classmate, Pierre Matisse, organised an exhibition of Tanguy's work in his gallery. In 1940, Tanguy, together with Kay, journeyed around the cities of the American West, holding exhibitions during their trip. In 1941, Tanguy's pictures were shown in the International Exhibition of Surrealism in Mexico organised by Breton. In spring 1942, his second exhibition at Pierre Matisse's gallery took place, and a few of his pictures were also shown in the "Artists in Exile" exhibition. Tanguy's exhibitions at Pierre Matisse's were regularly repeated in the following years. On 24 October 1942, Art of this Century, Peggy Guggenheim's New York gallery, opened and here Tanguy's pictures were also shown. Virtually no Surrealism exhibition during war years, whether organised by Breton or Americans, got under way without his involvement. The American critics devoted numerous articles to him, and for them he was the living embodiment of Surrealism.

Tanguy's fame in America brought him sharply into conflict with André Breton. In 1945, at the time of one of Tanguy's exhibitions at the Matisse gallery, Breton criticised Tanguy for his "embourgeoisement" and suggested that Matisse should break off his contract with him. Max Ernst rallied fiercely in Yves Tanguy's defence. Numerous friends, including Marcel Duhamel and Marcel Duchamp, spent time at Town Farm, the farm which Yves and Kay had bought in Woodbury. In 1946, Pierre Matisse published a book on Tanguy's art which was written by Breton in collaboration with Duchamp. In 1948, he obtained American citizenship. In 1952, Tanguy received a visit on the farm from Jean Dubuffet, whom he told: "I am not going to Europe because I am angry with André Breton." In 1953, all the same, Yves Tanguy did return to Europe. In Paris, he saw all his old friends, apart from Breton. He could not resist going to see Locronan one last time, and then he left France for good.

During all of his years in America, Yves Tanguy worked with his usual energy. "As you know, the fashion here is now for abstraction", he wrote in Paris to his friend Marcel Jean in 1952. "Why don't I just let the paint flow over a big canvas, and then cut it up into smaller pieces to put on sale? And there you go! It isn't any more difficult than that."[114] Tanguy's painting never went down the road of abstraction. In 1954 he gave an interview to *Art Digest* in which he affirmed his loyalty to the method of Surrealist automatism. All of his art practise was one big journey into a country which for him was a

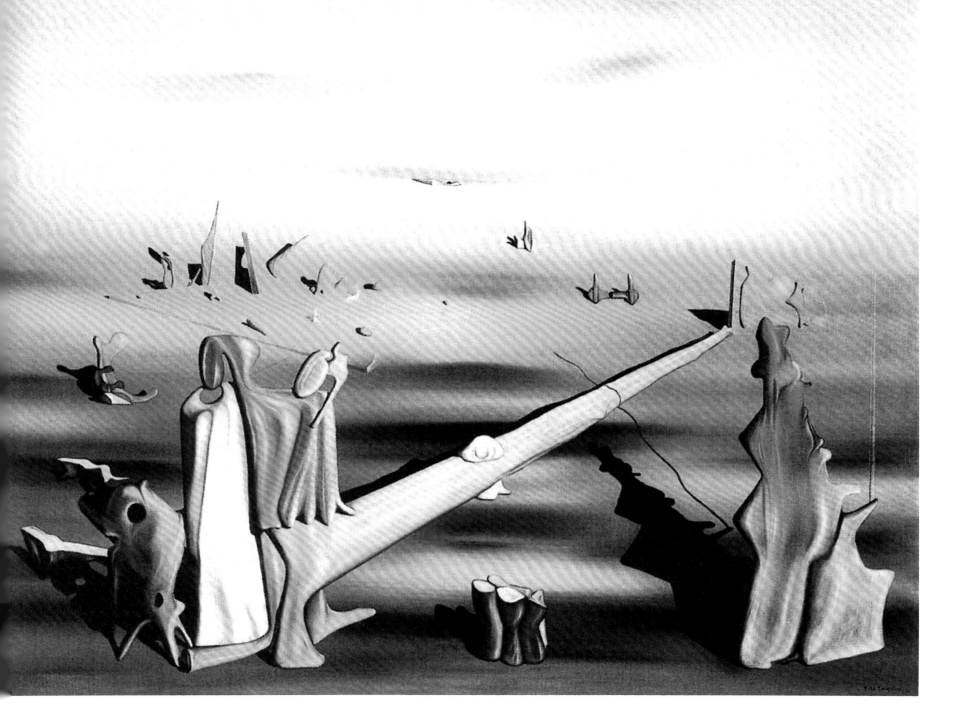

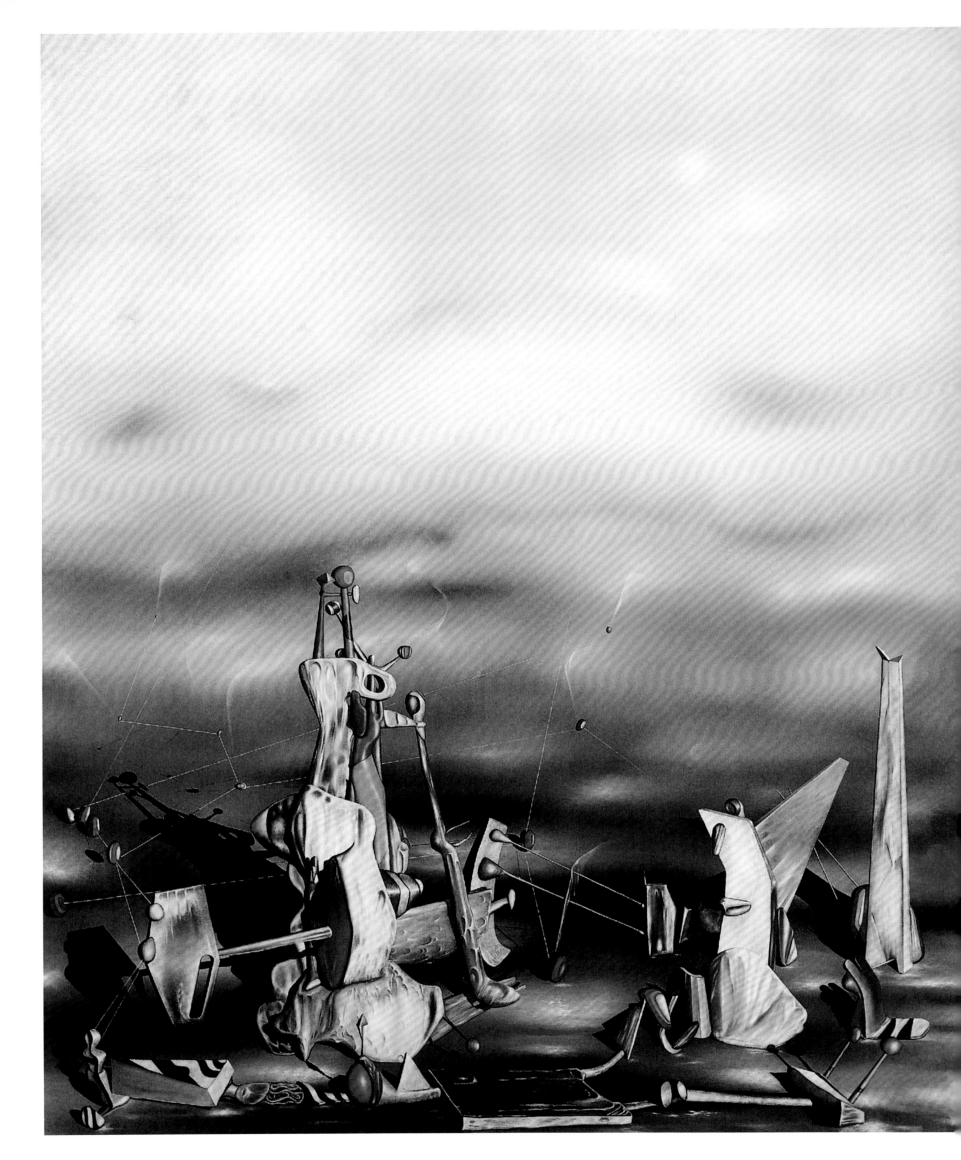

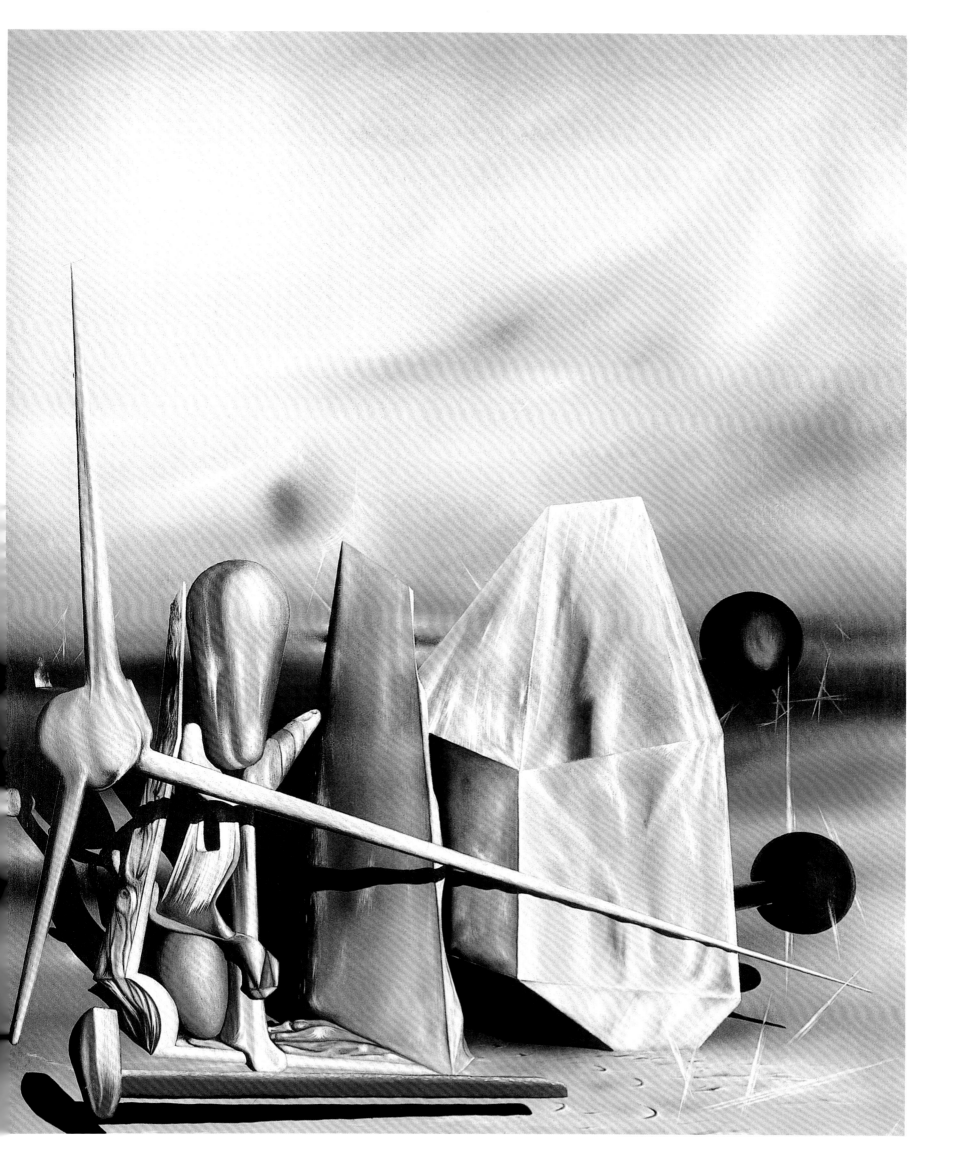

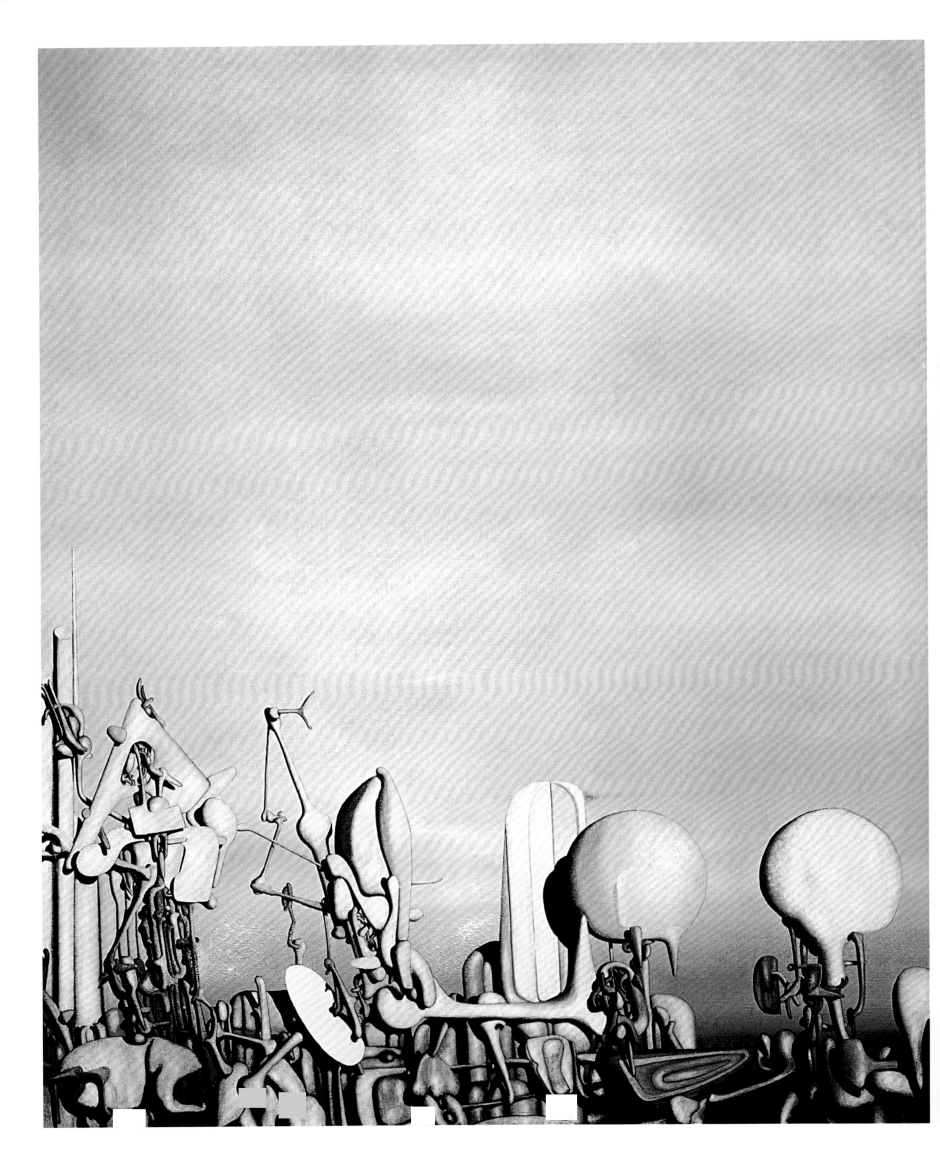

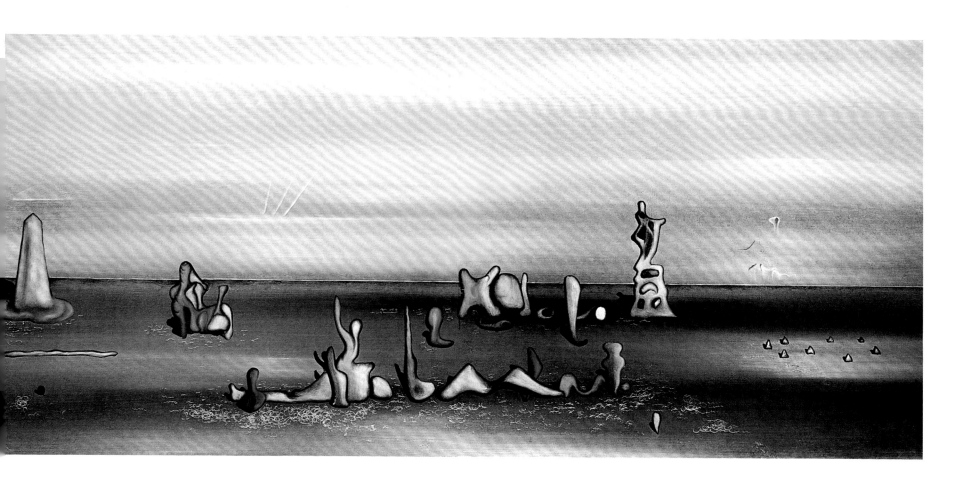

reality. In the years of war on planet Earth, changes of some kind were happening in his world, too. Everything in it was becoming more vivid. The veil of water or smoke, which had created the illusion of mystery, disappeared. In this new, clearly-outlined world, more colour appeared. But, above all, its inhabitants had changed. If they were biological creatures, then their nature became more complex. The membrane of skin had come off them and uncovered tangles of internal organs (*The Hunted Sky*). If they are mechanical constructions, then they have become intimidating. Sometimes they are complicated and elegant structures which rush higher and higher away from the eternal plain (*From Pale Hands to the Wearied Heavens*). Sometimes they remind one of menacingly advancing engines of war (*Indefinite Divisibility*). Sometimes they are ships heading into the night of the unknown (*From One Night to Another*). It seems that towards the end of his life, Tanguy became accustomed to this world which ceased to be mysterious for him. Yes, it turned out to be much more complex than it had seemed in his youth (*Time, a Mirage*). But even if the elements of which it consisted may have been incomprehensible, they are still real, solid and substantial, and they have form and volume (*Imaginary Numbers*). At the end of his life, Tanguy painted a huge picture on which, in his own words, he worked eight or nine hours a day over the course of five weeks. Here, there was everything that could be seen in his pictures before: the plain, the clouded sky, the line of the horizon. Only now the plain is so crowded that no place on it is left empty. The creature-objects are solid, like stones, and at the same time, they seem alive. They multiply under our eyes. The artist grasped their secret, although it would be much longer before the viewer was ever likely to guess it (*Multiplication of Arcs*). "Clearly he felt that *Multiplication* represented the summary of the goals and preoccupations of a whole life", wrote the critic James Thrall Soby after having seen Tanguy at his work.[115]

Yves Tanguy died on 15 January 1955 on his farm in America. In accordance with his will, Pierre Matisse scattered his ashes over the Douarnenez Bay in Brittany.

Yves Tanguy,
This Morning, 1951.
Private Collection.

Yves Tanguy,
A Continuing Smile, 1934.
Private Collection.

JOAN MIRÓ
1893-1983

Sun of prey prisoner of my head
Remove the hill, remove the forest
The sky is more beautiful than ever.
The dragonflies of the grapes
Give it precise forms
Which I dispel with one movement.

Clouds of the first day
Impervious clouds which nothing sanctions,
Their burning seeds
In the straw fires of my glances.

At the end to cover itself with a dawn,
The sky will have to be as pure as the night.[116]

Joan Miró loved Catalonia. All his life he painted its dazzling blue sky. It is difficult to say whether, in the body of work Miró has left us, there is even one picture without the sun. Under the sun live dragonflies, butterflies and funny, playful dogs and cats. Wherever he worked, whether in a Paris studio or on the island of Majorca, the colour and light of Catalonia always remained in his painting. His painting had no frightening mystery. It was light, colourful and transparent. "I am overwhelmed when, in an immense sky, I see a crescent moon or the sun", said Miró. "Indeed, what my pictures have are tiny forms in big, empty spaces, empty horizons, empty plains, everything which is stripped down has always impressed me very much."[117] He did not come to Surrealism by accident. Everything which he created is a dream. Sometimes it is incomprehensible and disturbing, like any dream. But more often it is happy, with child-like purity and naivety.

Joan Miró was born on April 20, 1893 in Barcelona. He was the first-born child of Miguel Miró Adzerias, a goldsmith and watchmaker, and Dolores Ferra, daughter of a cabinet-maker from Palma on the island of Majorca. In his family, where fine and serious work – the kind of work which can be compared to an art – was appreciated more than anything, he acquired the skills of a craftsman and the habit of going deeply into a problem in order to find the right solution to it. "I work like a gardener or a wine-grower", Miró said. "Things come slowly. My vocabulary of forms, for example, is not something I discovered straight away. It was formed almost in spite of myself."[118] Frequent visits to his uncle on Majorca, an ancient land where dolmens and menhirs are preserved, helped him to achieve an artistic language of maximum simplicity. All his life he took lessons from those artists who had left their images of bison and horses on caves vaults in the Pyrenees.

Miró was not conspicuously successful at school, and what mattered most to him began after the lessons, in drawing classes. "That class for me was like a religious ceremony", he recalled. "I carefully washed my hands before touching the paper and pencils. The instruments I used for working became sacred objects for me and I worked as though I were performing a religious rite."[119] His parents sent him to commercial school, but he put all his effort into his drawing at the art school in Lonja.

Joan Miró,
Head, 1974.
Acrylic paint on canvas, 65.1 x 50 cm.
Fundació Joan Miró, Barcelona.

Joan Miró,
The Coffee Grinder, 1918.
Oil and collage on cardboard,
62.5 x 70.5 cm.
Private Collection.

Joan Miró,
The Table (Still Life with Rabbit), 1920.
Oil on canvas, 130 x 110 cm.
Private Collection.

His teachers taught him according to the classical system, but Miró preferred folk art. "Popular art always moves me", he later said. "There is nothing tricky or phoney about this art. It goes straight to the point. It surprises, and it is so rich in possibilities."[120] When he reached the age of seventeen, his parents insisted that he should work in the Barcelona trading firm of Dalmau Oliveras. Miró was obliged to abandon art school. When he became seriously ill, his parents sent him to their house in Montroig, a village on the Tarrogne plain. There he was able to devote himself completely to painting. In 1912, Miró enrolled at the Escola d'Arte de Francisco Gali in Barcelona, and simultaneously studied at the Académie libre du dessin du Cercle Saint Luc. There he met Joan Prats, who became his best friend. Miró entered a circle of young artists. Among them were Llorens Artigas, a lifelong companion, and E.C. Ricart, together with whom he rented a studio. They read the Paris journals and the French poets – Apollinaire, Reverdy; they saw a large exhibition of French art organised in Barcelona by Ambroise Vollar. In 1917, Miró met Picabia, saw his painting, and became familiar with the Dadaist journal *391*. The influence of Cézanne, van Gogh and Matisse can be felt in Miró's paintings from this time. He painted landscapes of Montroig, and his first *Self-Portrait* dates from 1917. The years from 1915 to 1917 are known as his "fauve period".

After the failure of his first individual exhibition at the Galerie Dalmau in Barcelona, Miró settled in Montroig, where a new language began to develop in his painting. Now it was as though Miró was examining everything around him under a microscope. He painted farms, fields and kitchen-gardens, depicting each little ridge and each blade of grass with a peasant's love and a miniaturist's care – the "detailist" period in his work had begun. "What interests me above all", he said, "are the calligraphy of a tree or the tiles of a roof, leaf by leaf, branch by branch, blade of grass by blade of grass"[121] (*The Farm*). In the spring of 1919, Miró travelled to Paris for the first time where he immediately became friends with another artist from Barcelona, Pablo Picasso. Much later, Miró would introduce Salvador Dalí to Picasso and draw the young Catalan into the circle of the Paris Surrealists. Picasso insisted that Miró give him the self-portrait he had just painted (*Self-Portrait*). Here, Cubist impulses are revealed, particularly in the way the artist planned the decoration – some kind of ornamental pattern of volumes and geometric designs take shape in the face and torso. The fascination of this portrait is hidden in its absolute directness, in its language, similar to the language of naïve art, in the beauty of the saturation of the colour. In summer, in Spain, he painted several landscapes of Montroig and the wonderful *Nude with Mirror* completed with the same ornamental interpretation of Cubism. The brightly-coloured butterflies embroidered on the seat fabric might have come straight out of folk art. After this picture, there followed still lifes. On the canvas, the table surface has been flattened, along with the objects that are placed there, thus turning the picture into a single, decorative plane (*Still Life with a Rabbit*; *Glove on a Table*; *Grain of Wheat, Gas Lamp*).

In 1920, together with André Masson, Miró rented a studio in Paris at 45, Rue Blamet, an address which became one of the Surrealists' favourite haunts, and where Desnos, Artaud, Limbour, Salacrou, Tual and Breton all gathered. Miró made friends with Jacques Prévert and with Paris' Americans – Henry Miller, Ezra Pound and Ernest Hemingway, who later bought Miró's *Farm*. From that point on, Miró spent every winter in Paris. However, he could not live without Catalonia, and every summer he went back to Montroig. Miró called himself an "international Catalan". In 1921, his first exhibition in Paris was held at the Galerie la Licorne, on the Rue La Boétie. In 1923, Joan Miró painted his first unusual picture – *The Tilled Field*, and following that, *The Hunter*. He threw himself into Surrealism, in Breton's words, with "an innocence and freedom which have not been surpassed".[122]

Now the widest variety of creatures and things was scattered around the plane of the canvas: "monstrous animals and angelic animals. Trees with ears and eyes and a peasant in a Catalan cap,

holding a hunting-rifle and smoking a pipe…"[123] He no longer painted landscapes from nature. In the studio he continued to create images of his beloved Montroig, but now they had become fantastic. In 1924, the *Surrealist Manifesto* was published. Miró was in the Surrealist front line – he took part in the group meetings, and the journal *La Révolution surréaliste* reproduced his pictures.

Between 1925 and 1927, Miró worked under the enormous impact of the theory of automatic drawing. He painted in a trance, as though in the state of hypnosis or a dream. "I work in a state of passion and frenzy", he said. "When I start on a painting, I am obeying a physical impulse, a need to spring into action; it's like a physical release."[124] In 1924, he painted *Harlequin's Carnival*. It was an explosion of childlike rapture before all the beauty and variety of the world. In a realistic interior, little insects, toys, and fabulous figures, one with a violin torso and the eyes of a man, circle and dance; someone has jumped out of a box, someone has shot upwards on a spring, and a sprinkling of musical notes has been thrown over the room. This is a festival of colour and of unclouded joy.

Occasionally Miró held himself back. "I experience a need to reach the maximum of intensity with the minimum of means", he said. "This is what has led me to give a more and more stripped-down character to the painting."[125] In 1925, he painted four versions of the *Head of a Catalan Peasant*, achieving results which are almost diagrammatic. Only a few symbols make up the likeness of the Catalan peasant: the pipe, the moustache and the Catalan beret. Occasionally an even greater degree of parsimony with the lines was sufficient. *Figure Throwing a Stone at a Bird* represents a being consisting of an enormous leg, a schematic torso and a small head. In *Insect Dialogue* the colourful little figures, flying and crawling, leave the earth and wide expanse of the sky vacant. In the very centre of this world, against a light-blue background, under the gaze of a crafty half-moon with eyes and a nose, a yellow and red creature whirls round. "Painting must be fertile", said Miró. "It must give birth to a world. Whether you can see flowers, figures or horses there doesn't matter very much as long as it reveals a world, something that is alive."[126] What gave life to this world was colour.

Max Ernst told the story of how one day he entered Miró's studio and caught sight of a vast canvas standing on the easel. At its centre was a spot of beautiful, dazzling light-blue colour, and around it, like a garland, was wound the inscription, which the hand of Joan Miró had put into calligraphy: "This is the colour of my dream." This picture became something akin to Miró's own manifesto. Subsequently he painted a whole range of pictures in which the canvas is covered with this incomparable light-blue colour. Colour was the construction material for Joan Miró's painting, something that embodied his dreams and transferred his visions onto the canvas.

In Miró's art, Surrealism found a well-prepared ground. "Little by little, I abandoned realism", he later recalled. "From 1925 onwards, I virtually never drew any more except on the basis of hallucinations. At this point I lived on a few dried figs every day. I was too proud to ask for help from my fellow-artists. Hunger was one of the best ways of producing hallucinations. I sat still for a long time, staring at the bare walls of my studio, and I tried to capture these forms on paper, or on jute canvas."[127] He said that the starting-point for one of his pictures could be any small detail that he had glimpsed by chance, just as for a Surrealist poet it could be a single word, and for a musician it could be a single note. Sometimes the spot on the painted canvas, the light-blue colour is transformed into spiders, and gives new meaning to the painted area (*Blue Landscape*). Sometimes, nothing more than a tiny spot of red or black paint, which looks like an accident, provides spatial depth to the flat surface. Automatism in painting for Miró was absolutely natural. His natural directness and sincerity enabled him to abandon himself joyfully to the creative instinct. A speck introduced some white, and the drop of paint which had fallen onto the canvas, covered over with whatever colour, was then smeared by the brush and there by transformed into figures and whole subjects (*The Joy of Loving my Brunette*).

Joan Miró,
The Tilled Field, 1923-1924.
Oil on canvas, 66 x 92.7 cm.
Solomon R. Guggenheim Museum, New York.

In the 1920s, line entered Miró's painting. When he became acquainted with Paul Klee's drawings, it proved to be a wonderful discovery for him. "It was near the Rotonde, in a little gallery at the corner of the Rue Vavin and the boulevard Raspail, that I saw my first examples of Klee's work", Miró said in one of his interviews. " ... For me, this was very important. Klee made me feel that there was something else, in any form of expression in the plastic arts, besides painting for the sake of painting; that it was necessary to go beyond that to reach zones that are more moving and profound."[128] The delicate line, as naïve as is Miró's colour, introduced a touching fragility into his painting (*Composition with a Bird*). Often the artist's inscription became a graphic element of the picture. It added both to the decorative resonance and the interpretative possibilities of the picture (*A Big Crowd*).

Between 1926 and 1927, he painted "imaginary landscapes" with figures while in Montroig. The earth and the sky were given the most varied colours: they could be black, yellow or brown. Little toy animals lived their natural life in them (*Dog Barking at the Moon*; *The Hare*). The moon observes their games from above, and it is even possible to reach it by a staircase. Miró had already created his own world, cheerful, bright, and of a childlike purity.

In the spring of 1928, Miró travelled to Holland. Vermeer's painting, and the genre paintings of the "little Dutchmen" entranced him. He bought postcards from Holland which became the basis for the fantastic interpretations of Dutch pictures he painted during the summer – three "Dutch interiors". The figures, assembled from the most diverse object-parts, possess the features of living people: ears, eyes, hair. They play on musical instruments, race against each other, and together make up a colourful arabesque. André Breton gave Miró's painting its due, even calling it "the most beautiful feather in Surrealism's cap". However, he could not resist criticising it for its insufficiently deep understanding of the methods of automatism. Friends loved Miró's painting. Michel Leiris wrote:

> Violet, indigo, blue, green, yellow, orange, red.
> What plague has crept its way
> Into the night of its veins
> To make the world, insidiously contaminated, become transformed
> Into this flowering of tattoos and stains?"[129]

In 1928, an exhibition of Miró's painting from 1926 and 1927 was held at the Georges Bernheim gallery on the Rue du Faubourg Saint-Honoré. In 1929, Miró married Pilar Juncosa, a girl who came from an old Majorca family, and who in 1931 presented him with his only daughter, Dolores. In 1930, Miró's individual exhibition in Paris at the Galerie Pierre offered examples of a new aspect to his work – paper collages. In the same year he had his first New York exhibition.

The beginning of the 1930s was a time of inquiry for Miró. He created the most varied things: his first lithographs, carved wooden objects, collages and drawings. His compositions had a sense of humour, they were decorative, and they were thoroughly thought out in terms of their construction and colour. He was drawn to the collage, and combined old photographs with drawings and paintings, but then moved away from that approach and returned to painting once again. "In 1933", he said in an interview, "I was tearing up newspapers roughly, and then I would stick these forms on the cardboard. Day after day I accumulated them. When the collages were finished, they served as a point of departure for my paintings. I did not copy the collages. I simply allowed them to suggest forms to me."[130] For sculpture, he used household objects that lay to hand: parts of old furniture, an umbrella, sinks (*Man with an Umbrella*). In 1932, he produced the scenery, costumes, curtain and "toys" for Massine's ballet, *Jeux d'enfants*, which was scored by Bizet.

Joan Miró,
Gentleman, 1924.
Oil on canvas, 52.5 x 46.5 cm.
Popular Art Collection,
Kunstmuseum Basel, Basel.

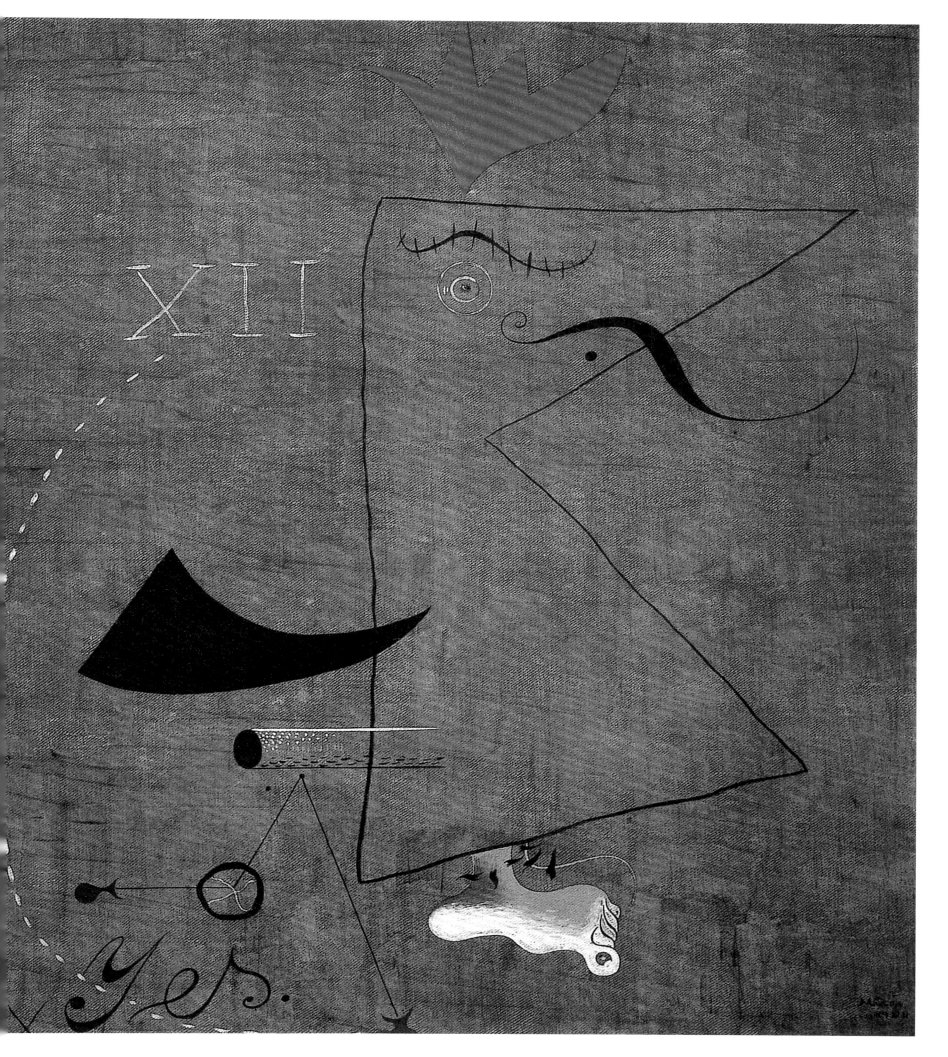

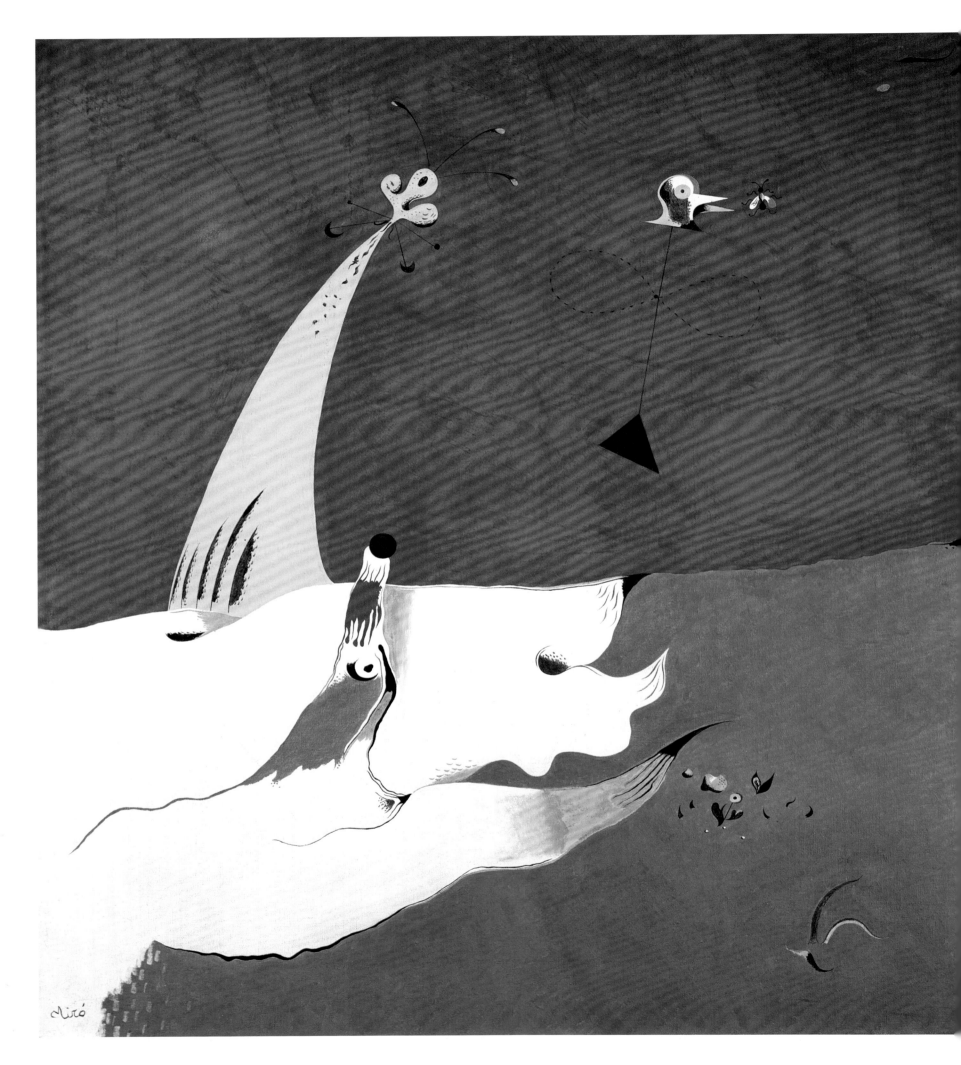

In 1933, Miró and his family were obliged to spend the whole year in Barcelona as a result of financial difficulties. With a craftsman's curiosity that was particular to him, Miró worked in the most varied materials and techniques: including paintings on glass-paper, watercolour-drawings, and large pastels on velvet paper. By that time, his paintings reached a harmony, to the point where he found the strength to make the transition to monumental works. He painted eighteen large canvases on collages. Unusually for Miró, their mood is gloomy and severe; the colouring has become much darker, while spots of red, black and white, like flashes, enliven a background that is at once warm and cold. Every spot of colour exists separately; they are no longer interwoven into a single, ornamental pattern. However, the plasticity of the form has been very precisely developed, and the rhythm is peaceful and sublime. Miró by now had arrived at the system of monumental painting that made him one of the greatest European artists. In 1934, he also began working on pasteboard for wallpaper. Later, in 1937, he completed a painting for the Spanish Pavilion of the International Exhibition in Paris, and later still, painted murals in Cincinatti, at Harvard, in New York in 1953, and finally, over 1957 and 1958, his masterpiece, *Walls of the Sun and the Moon*, for the UNESCO building in Paris.

In the mid-1930s, Miró's painting become even darker and more troubled. In the spring of 1934, he completed sixteen large pastels which he himself called his "wild paintings". In them, strange creatures, which one of Miró's biographers has called "monstrous effigies with a disturbed and unhealthy eroticism", appear.[131] With a flash of orange fire, the profile of a man set against a dark background, has started to burn (*Human Head*). Monsters with predatory jaws and a menacing stare are summoned to life by the heavy atmosphere of the time and the threat that was hanging over Europe. In Germany, Fascism was already triumphant. Miró managed to go to Berlin, where he stayed briefly and saw the work of those German artists whose paintings, by then, were no longer being shown. The situation in Spain was about to catch fire since the Civil War was just beginning. Miró reacted to the changing atmosphere very spontaneously. "For Miró it was no longer a question of painting or of painting well", wrote his biographer, Jacques Dupin, "but only of living, of holding on, of unburdening himself day after day – the word 'art' no longer had any meaning... Faced with the ordeal, Miró would no longer paint as a form of observation, but would engage in violent, direct and instinctive forms of exorcism."[132] Around this time he created restrained and severe works, and he employed techniques that corresponded to the new mood; he started to paint on masonite and stone, on tar-paper and sand-paper. The images in his painting became increasingly dark and disturbed. In the spring of 1936, Miró, together with his family, left Spain. He later recalled: "I had to leave because a friend came and told me: 'You've got to get out right now, the guys from the FAI (Federation Anarquista Iberica) want to get rid of you!' I was astonished! This is what had happened: my sister had married an idiot from the extreme right. I had been present at the wedding and a local newpaper published the guest-list, on which, obviously, I appeared. ... I had to leave immediately..."[133]

Miró then established himself in Paris. He and his family spent the summer in Varengeville in Normandy as guests of the architect Nelson. Miró worked with extraordinary energy. In 1938, he wrote an account which was subsequently published: "The more I work the more I want to work", he wrote. "I would like to try my hand at sculpture, at pottery, at prints, to have a press. And also, within the limits of possibility, to see if I can get beyond easel-painting, which to my mind is a mean-spirited enterprise, and get closer through painting to the great multitudes of human beings, about whom I have never stopped caring.[134] Only such an unusual artist as Joan Miró could achieve all of that. But before this was accomplished, the period of the war began. "I lived unconsciously in the atmosphere of uneasiness that characterises moments when something serious is just about to happen", he remembered after the war. "It gets like that before the rain: your head is weighed down, your bones ache, and the humidity is stifling. The sense of discomfort was more physical than moral. I felt that a

Joan Miró,
Landscape, 1924-1925.
Oil on canvas, 47 x 45 cm.
Museum Folkwang, Essen.

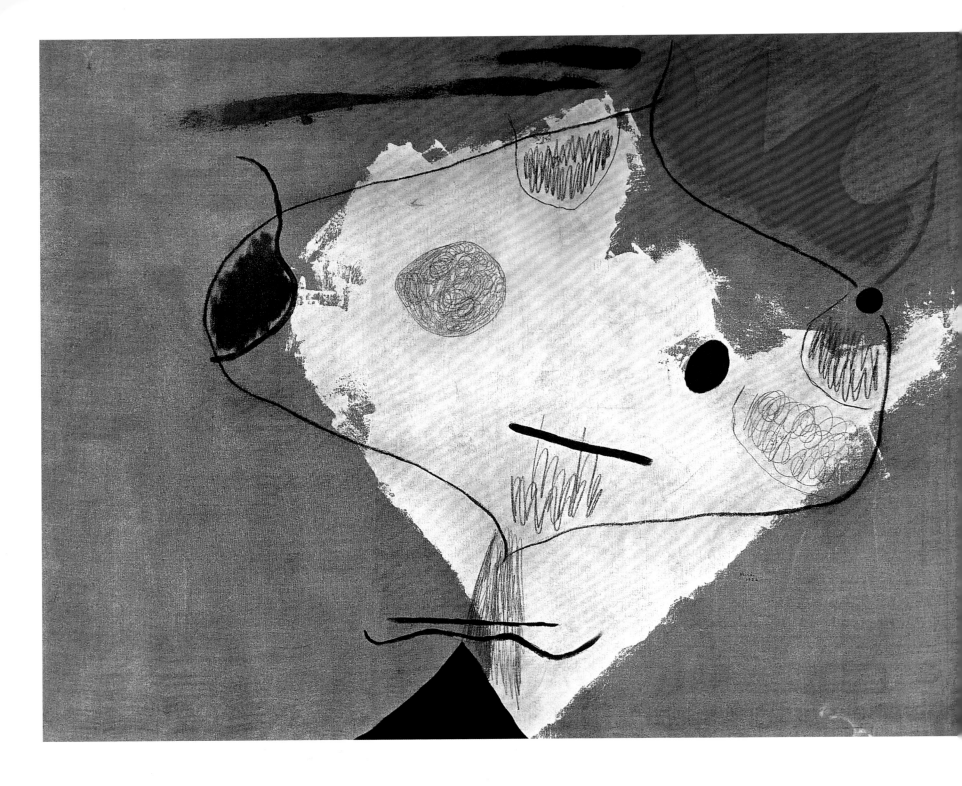

catastrophe was on its way but I did not know what: it was the Spanish Civil War and the world war. So I tried to represent the tragic atmosphere that I felt in myself, that was torturing me."[135] In his painting, the earlier images remained; there were, as before, both birds and insects. Its colour, as earlier, glittered with the contrasts of dazzling light-blue, yellow and red, white and black. Only now in his colour there was no joy, and the fantastic creatures bore evil within themselves (*Summer*; *Birds and Insects*). Miró possessed the gift of conveying, through both an ordinary collection of objects and of colour, the tragedy that was occurring. He placed a bottle on a table, put out an apple with a fork sticking into it together with a piece of bread, and beside them he positioned an old shoe (*Still Life with an Old Shoe*). Over the sky-blue background, with the orange flashes of the sun, black patches have formed. The light is fractured in the cracks in the objects, strangely transforming them. The fork has bared its crooked teeth. And the shoe, the old shoe is triumphant in this world of transformed things.

The beginning of the world war found Miró in Varengeville, where Queneau, Braque and Calder were then living. Miró continued to work. "I felt a profound desire for escape", he later said. "I turned in on myself deliberately. The night, music and the stars began to play a major role in the suggestion of my

le corps de ma brune

p..ue je l'aime

comme ma chatte habillée en vert salade

comme de la grêle

c'est pareil

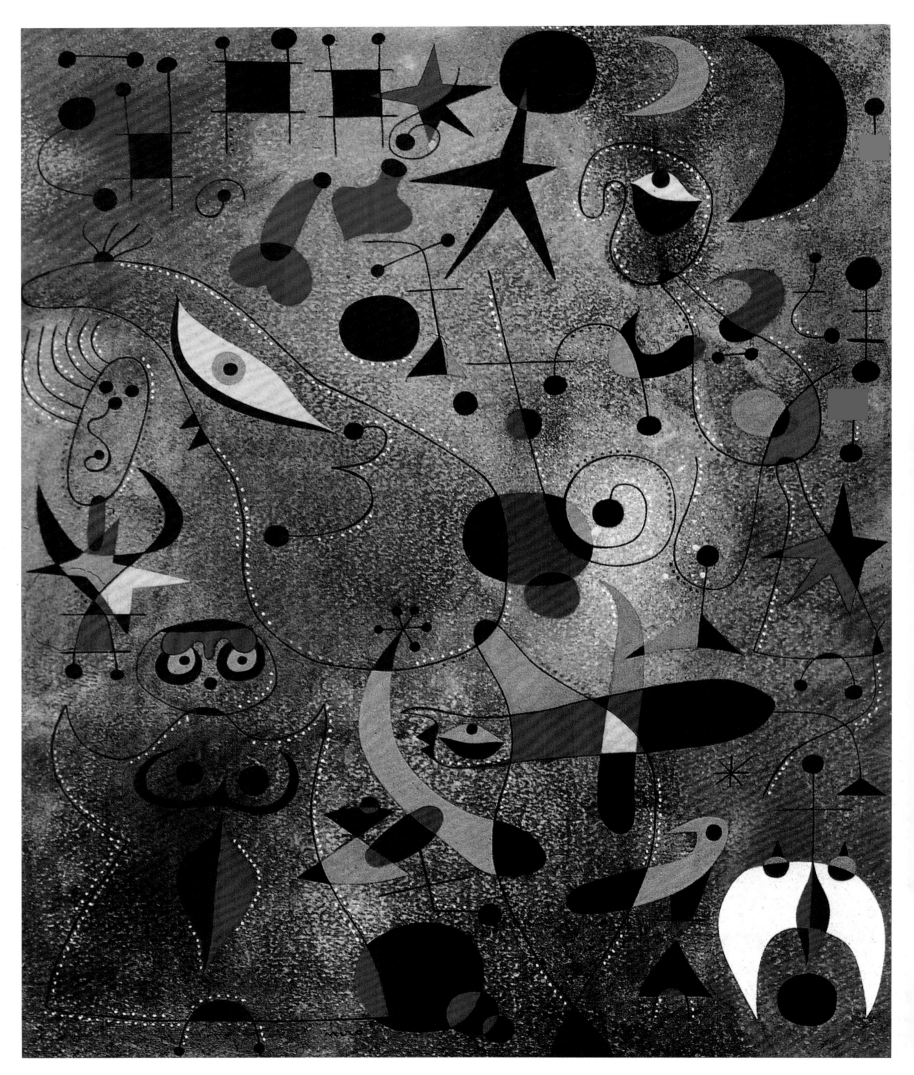

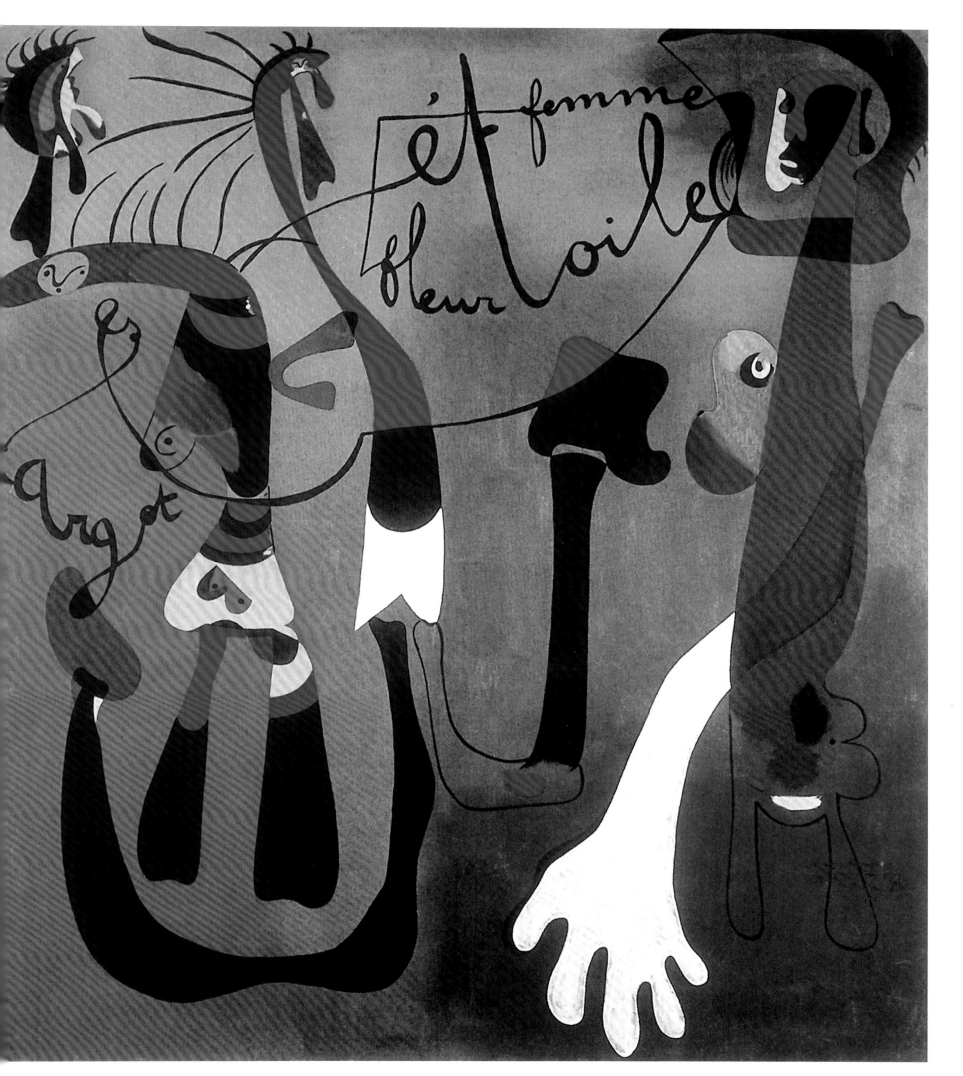

147

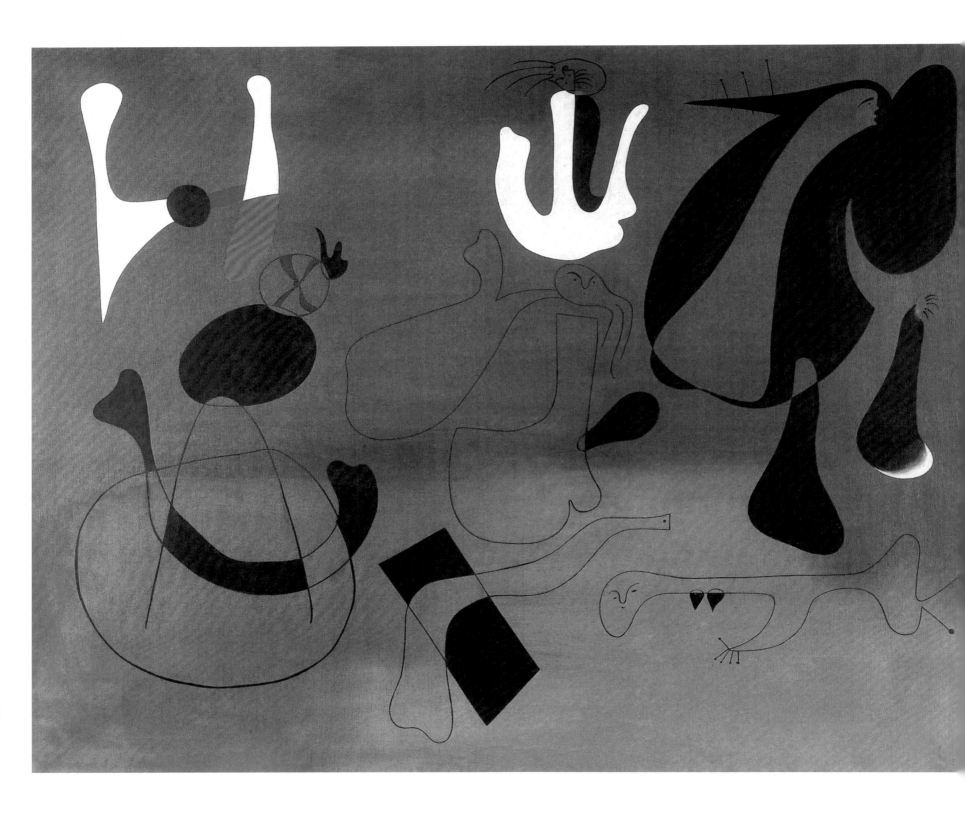

paintings."[136] In the war years, he made endless compositions in gouache, pastel and oils, and depicted the stars, women and birds. But the night in his pictures lost its fairy-tale spirit, and the stars twinkled sadly. On May 20, 1940 they fled the invading German forces, first to Paris and then to Spain. Pilar's parents on Majorca took in Miró's family. In 1942, they moved to Barcelona.

In 1939, Miró painted decorative canvases with a great number of figures. The precise line of the drawing outlines the contours of birds, jellyfish, strange little figures and a human eye. Sometimes they bear titles which to him were traditional – *Figures and Birds in the Night*. Sometimes their simple, naïve names are a reminder of the Surrealists' word-game, "exquisite corpses" – *A Drop of Dew Falling from a Bird's Wing Awakens Rosalie Who Has Been Sleeping in the Shade of a Spider's Web*. In these games, Miró was no less skilful than his friends. Miró's texts resembled his pictures; they continued to build the world of his painting and in them colour also plays the main role:

A glass of white milk on a white tablecloth

A red cherry

Green beetle

Rainbow

Shooting star

A guitar

Tomb of sky

The strings of this guitar cross space

The swallows

Make a nest on every string

This string strangles a woman who was beautiful.[137]

From the first days of the war, Miró had started to work on a large series of gouaches entitled *Constellations*. "This was a very long and extremely arduous job, some forms suggested here called for other forms elsewhere to balance them out", he said. "These latter in their turn called for others still. This seemed endless…"[138] On the sheets of paper, the sun, the moon, and a large number of red and black stars make up the constellation designs. In their interlacing, one can discover a human eye, the head of a bird, spiders, sharp-toothed fish and many of the other things that populate Miró's painted world. At first glance, they look like an abstract pattern in a carpet, but on close examination, increasing details are visible to the viewer. "In the painting, one ought to be able to discover new things each time one sees it", said Miró.[139]

In 1944, Miró began to work in ceramics together with his friend Artigas. In 1945, his ceramics and sculpture in terracotta were shown for the first time in New York at Pierre Matisse's, and had a great success. He made his vases and plates with the skill of a genuine craftsman. However, each object was individual and impossible to recreate. The terracotta figurines are a reminder of the clay toys that the people make on Majorca. Miró attached great importance to them. "That's why folk art is so important: there is a large unity between the whistles of Majorca and Greek things", he said.[140] He painted the plates and the vases with stars, a sun, a half-moon, birds and naïve human figures. The ceramics are part of the same world which he created in painting.

Miró rounded off the war period with the creation, in 1945, of a large picture – *The Running of the Bulls*. He told the story of how the French consul in Barcelona brought the picture to France, and how he gave it to the Musée Nationale d'Art Moderne. It was a truly Spanish painting. The large canvas, covered with an uneven layer of colour out of which the ground peeps, looks like the surface of a stone. The precise line of the drawing, almost in the manner of Ingres, is reminiscent of the paintings

Joan Miró,
Constellation: Awakening in the Early Morning, 1941.
Gouache and oil wash on paper,
46 x 38 cm.
Kimbell Art Museum, Fort Worth.

Joan Miró,
"Snail Woman Flower Star", 1934.
Oil on canvas, 195 x 172 cm.
Museo Nacional Centro de Arte Reina Sofía,
Madrid.

Joan Miró,
Composition, 1933.
Oil on canvas, 130.2 x 161.3 cm.
Wadsworth Atheneum Museum of Art, Hartford.

on rocks of the prehistoric artists. "… This painting", said Miró, "is something I prepared less by drawing than by writing, that is to say by noting down all the impressions of actual experience during the bullfight…"[141] The line is the main representative means in the picture, and only a few spots of red, black and green supplement the drawing. Like the stone-paintings of prehistoric artists, Miró's picture speaks to the viewer with the language of symbols, yet these symbols are ones that had already entered his artistic language much earlier. He himself said that it was necessary for him, "[f]or the running of the bulls, to find poetic symbols: that the banderillera should be like an insect, the rags like pigeon's wings, the wounds of the horse like immense eyes… The way the blood spurts is like an ideogram which ends in a star…"[142] The artist changed the picture in the process of its creation. In the final version the mare has become quite small, and her gaping wound is depicted in the form of an eye. Two wide-open eyes also mark the bull's wounds on its legs and horns. The chief colour accents remain in the bull's eyes and in the figure of the banderillera, recalling the clay toy of folk art. The colour red is the colour of rage and blood; however, the colour only symbolises them (rather than literally representing them). In the picture, there is none of the truth of a bullfight, none of its cruelty and emotional experience. A great master of decorative art, Joan Miró, with a maximum economy of means, set down on the canvas a Spanish epic. "Let my work be like a poem set to music by a painter", he said. Joan Miró was a born artist, sculptor and painter. "It is on that account that I have never entirely been in agreement with the Surrealists, who used to judge a picture according to its poetic content, or even according to the content of the sentiments or minor details. For my part I have always evaluated the poetic content in terms of what it can offer the form."[143]

Miró's post-war period began with a series of large canvases – Women and Bird in the Night. Most often, the language of a line against a bright background with a few spots of colour is predominant in them (Woman Dreaming of Escape). He was still living in Barcelona. He enjoyed any news of the Paris art world – under Franco in Spain, artists were virtually isolated from the outside world. In 1947, he travelled for the first time to the United States, where he was already well-known. He worked there on an enormous mural, 2 m by 10 m, for the Terrace Hilton Hotel in Cincinnati. Its composition and colouring again pick up those of the Women and Birds in the Night series. In the spring of 1948, after an absence of eight years, Miró returned to Paris. In his individual exhibition at the Galerie Maeght, eighty-eight paintings and ceramics pieces appeared. In 1949, his exhibitions came to Barcelona, the Berne Kunsthalle and Basel. At the age of fifty, Joan Miró had attained worldwide recognition. He returned to Barcelona and continued to work with redoubled energy.

In the 1950s, Miró painted dozens of canvasses, large and small. Whatever the size of the composition, his painting now became increasingly monumental. It seems that he was aiming to purge the world he had constructed in painting of anything superfluous, and to acquire maximum expressiveness. By his own admission, he was moving further and further away from easel painting. His pictures fascinate as much as ever; they remain poems in colours, enigmatic and appealing. The poetry begins with a title: Dragonfly with Red Wing-Tips in Pursuit of a Snake Sliding in a Spiral Towards the Comet Star. However, contrary to expectations, there is no detailed narrative or wealth of characters – only two people, created from round eyes and the line of a nose, little coloured wings and a coloured geometric pattern. The centre is marked with a black circle surrounded by a red halo. The numerous suns and stars, light-blue, yellow and black, are balanced against a classic light-blue background. Miró did what all the best artists of the twentieth century strove to do in their own way: he attained expressiveness with a maximum economy of means. About this time, Miró was creating decorative compositions that took the form of a frieze. In 1950, he made a mural for Harvard University; in 1957 he began to work on the creation of Walls of the Sun and the Moon for the UNESCO building in Paris, for which he received the grand prix from the Guggenheim Foundation in

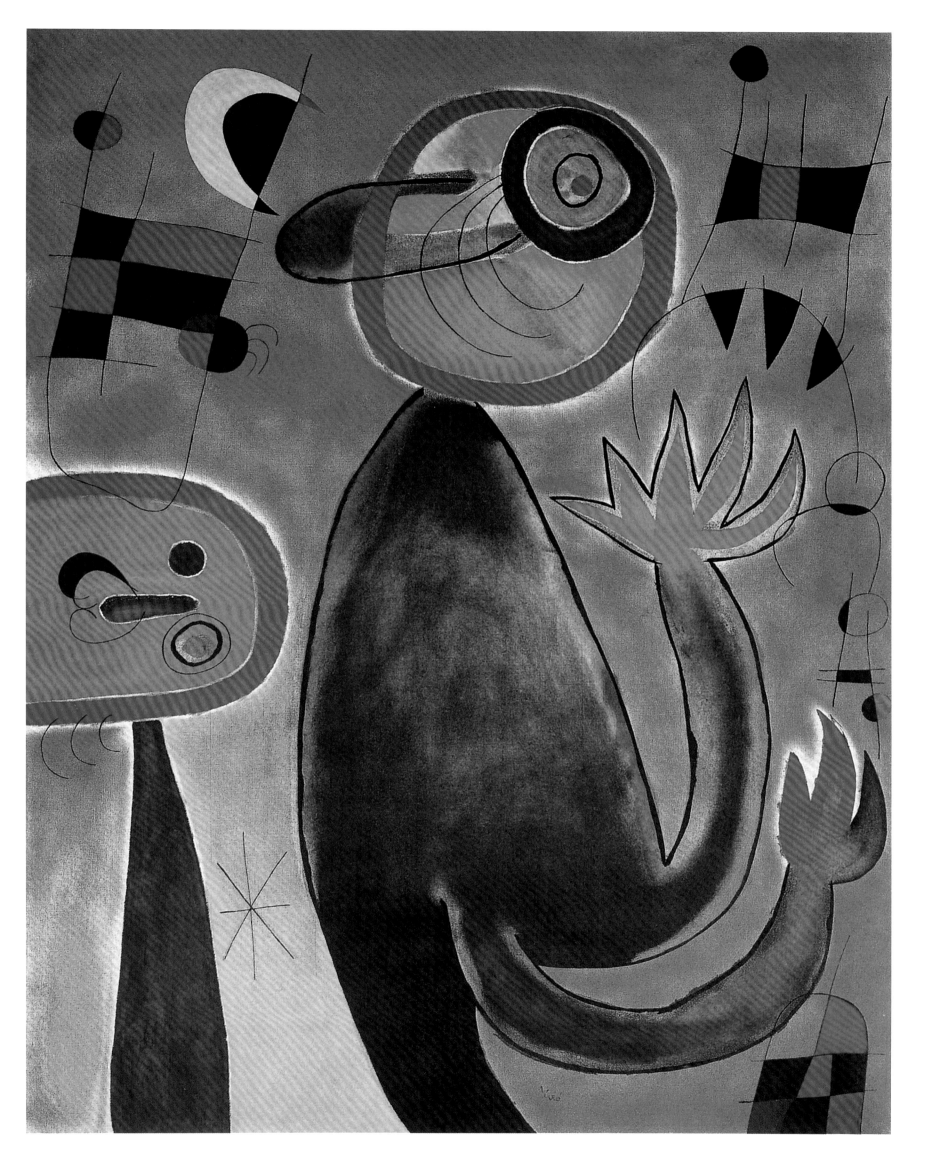

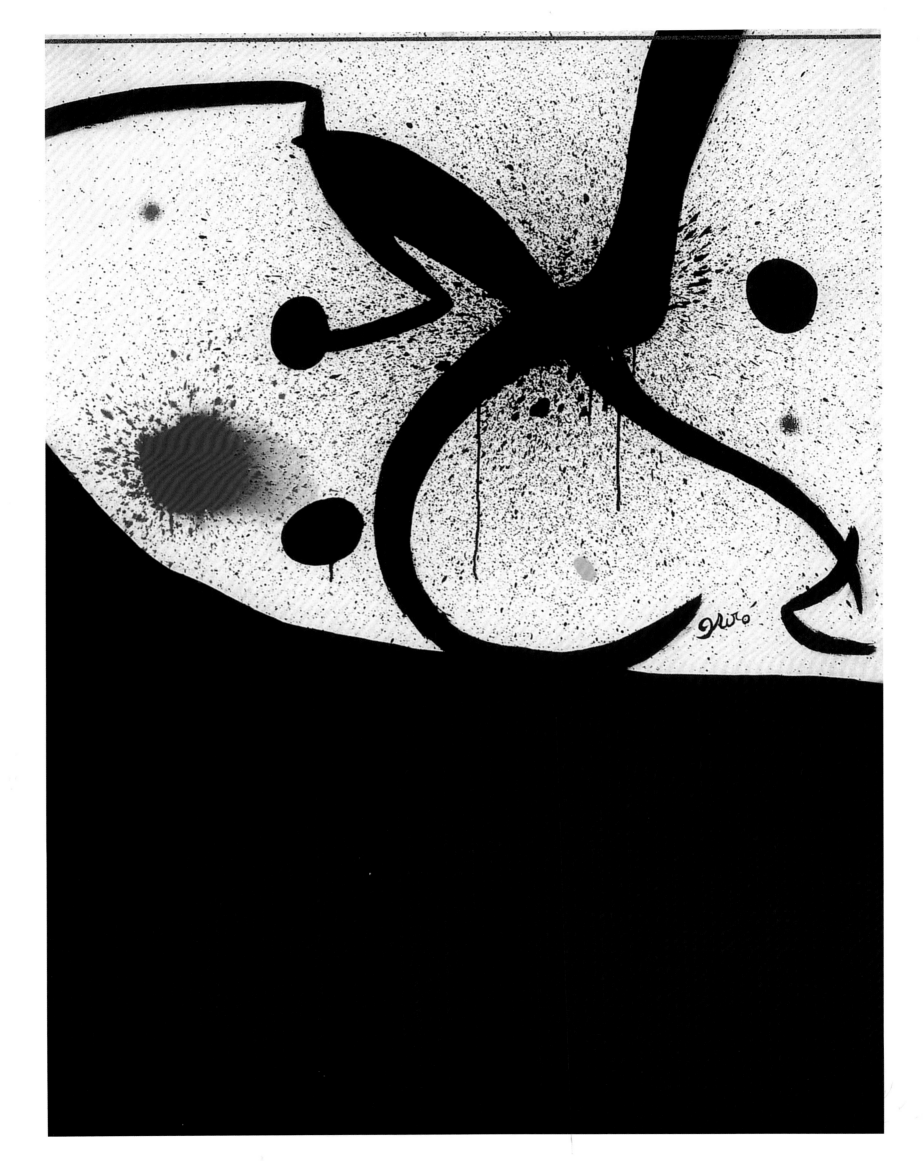

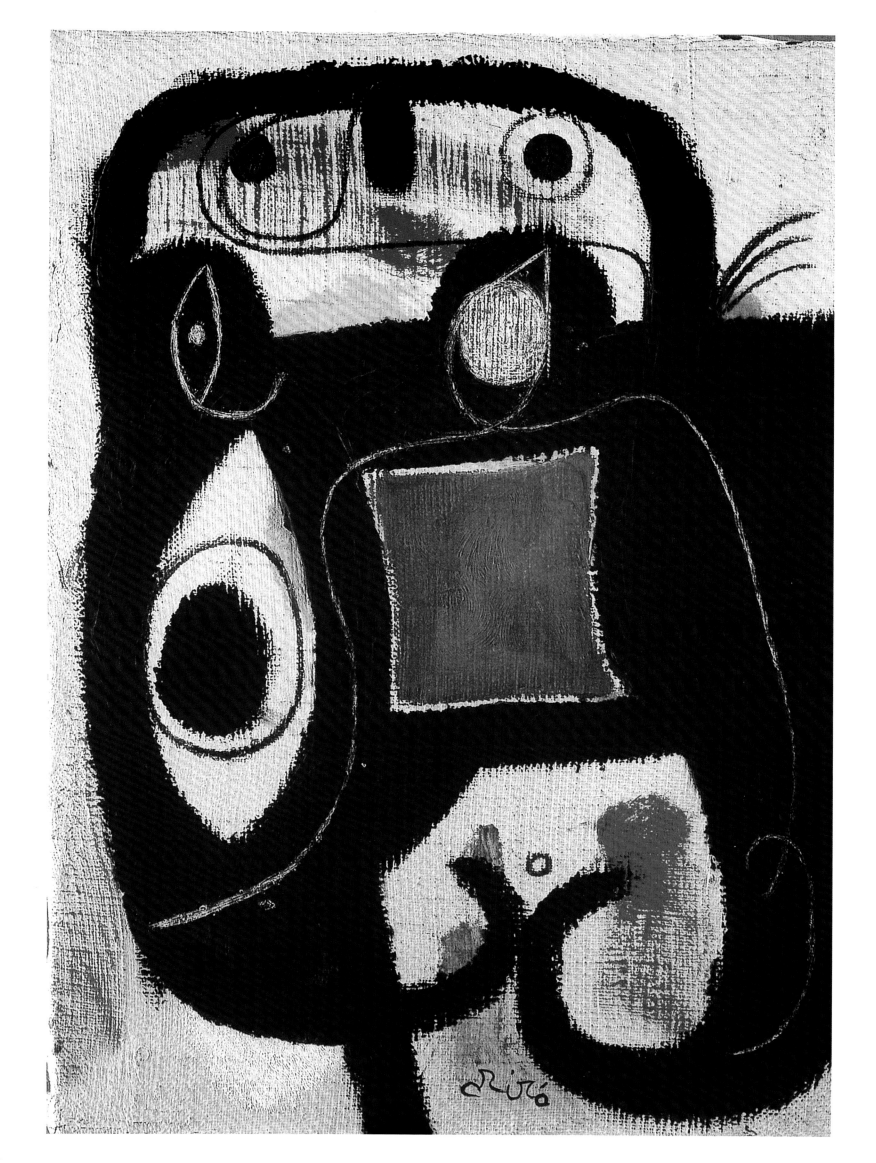

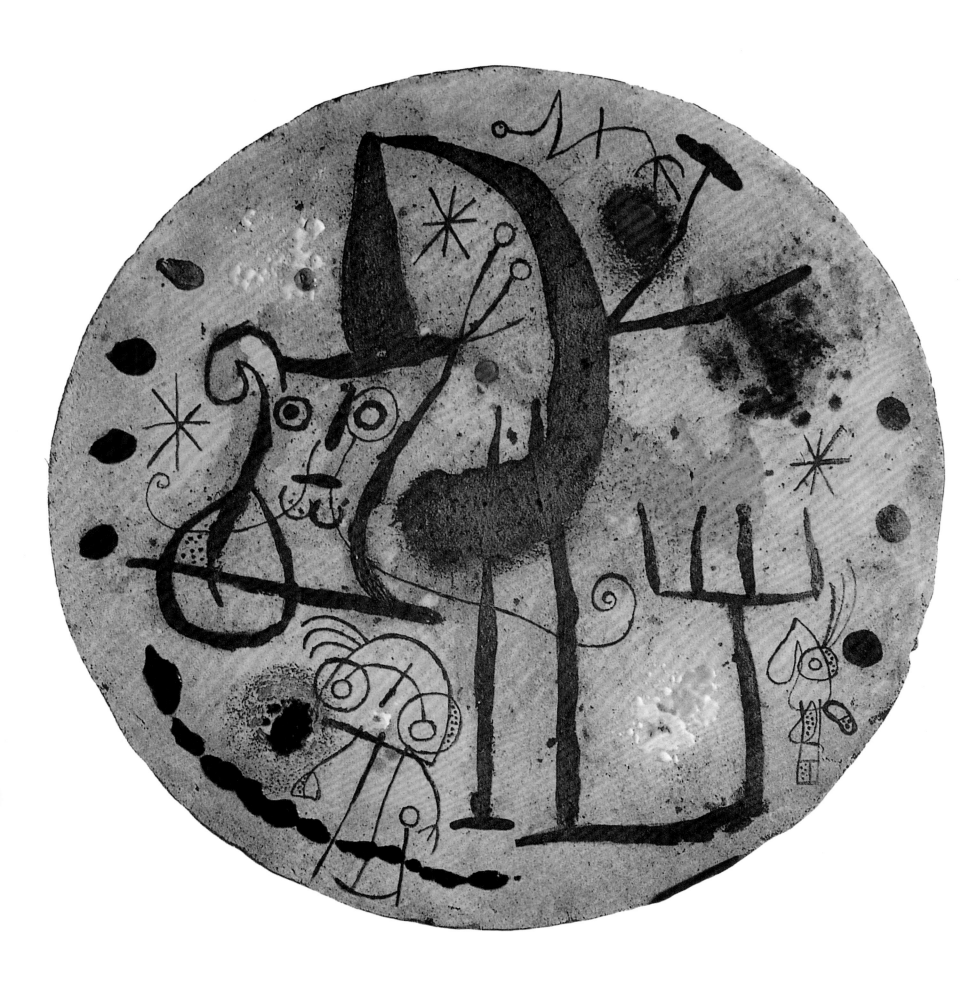

1959. Exhibitions of his painting and drawing took place in various European countries, and in American museums and galleries.

In the mid-1950s, Miró resumed his work on ceramics together with Artigas. Ceramics acquired such an importance for him that within a few years he abandoned painting. He and Artigas had been friends since 1918, and now, after the experience of the 1940s, they once again sensed that there were opportunities in joint creative work. Artigas offered Miró his very highly-developed skill as a ceramicist through the richness of the forms he created. Miró brought to earthenware vases and dishes the resplendence of his pure colour and all the fantastic images of his painting. Miró's ceramics were naturally becoming sculptures. His sculpture strove towards monumentality and found its physical form in bronze. Now all art forms were shown side by side in his exhibitions: painting, drawing, ceramics and sculpture.

Miró kept his promise; he became a "universal Catalan". In 1964, the opening of the Maeght Foundation took place in France in Saint-Paul. One of the rooms in the museum and a garden called "Labyrinth" were given over to Joan Miró's art. Later, new sculptural compositions appeared in this garden which turned into Miró's amazing fairy-tale preserve. He continued to devote himself to painting, perfecting his art of monumental composition. In the 1960s he devoted enormous decorative panels to his favourite colour, light-blue. In each of them, against a light-blue background, only a few red or black spots and one delicate line, constitute both the space and balance of the composition, and the harmony of its colour (*Blue I*; *Blue III*). Occasionally, one economically painted figure dominates the large canvas. At other times, it is not a figure but a single spot of colour (*The Red Disk*). The "Giants" in his lithographs series are no less monumental than the mural images. They again are a reminder of Miró's constant link to the work of the primitive masters.

Miró's art had become truly international. He received the highest awards in international exhibitions, he lived in Barcelona, in Majorca and in Paris, and he travelled in Europe, America and Asia. However, his fascination always remained connected to the fairy-tale, intimate world, delightful and mysterious, that he had been creating in his painting since his youth. Jacques Prévert wrote about him with the kind of poetic language that corresponds to the language of Miró's painting:

Sunspot
Ell of the pre-Columbian egg
The thunderbird coos in the distance

Already drunk since noon
Dragging the trap-door of the morning away with it,
The black sun falls into the cave of the evening
Grey half-light and transported shadow
Red crash of broken green

Joan Miró died on December 25, 1983 in his house in Palma, Majorca.

The widow laundress whom people call the night
Suddenly and soundlessly appeared
And in the blue of her washing
Miró's star
The late star
Shines...[144]

Joan Miró,
Round Panel, 1956.
Ceramic, diameter: 36 cm.
Private Collection.

ANDRÉ MASSON
1896-1987

Cruelty is tethered and agile gentleness becomes untied. The lover of the wings assumes expressions which are quite closed, the flames of the earth escape by the breasts, and the jasmine of the hands opens on a star.

The completely dull sky, the sky which sacrifices itself is no longer over us. Forgetfulness, better than the evening, erases it. Deprived of blood and of reflections, the rhythm of the temples and the columns remains.

The lines of the hand, so many branches whirling in the wind. Slope of the winter months, pale day of insomnia, but also, in the most secret rooms of the shade, the garland of a body around its own splendour.[145]

It is impossible to separate the work of André Masson from Surrealism, despite the fact that he did not stay long within the membership of the group. In 1923, he associated himself with Breton, and in 1929 moved away from him and was excluded from the group. In the second *Surrealist Manifesto* Breton reckoned him among the "fellow-travellers". "We are fighting against poetic indifference, art as entertainment, scholarly affectation and pure speculation, under whatever guise they may appear, and we want nothing to do with the misers of the mind, great or small", he wrote. "There are no acts of cowardice, no abdications and no betrayals that will prevent us from getting rid of this junk… This is actually why I had promised myself to abandon silently to their miserable fate a certain number of individuals who seemed to me to have revealed enough about themselves already; this was the case with Messrs. Artaud, Carrive, Delteil, Gérard, Limbour, Masson…"[146] Breton's indignation did not upset Masson. He recognised that the leader of Surrealism was charismatic and persuasive. However, throughout his long life, André Masson retained a sense of absolute freedom within himself, and this quality, more than anything, drew him close to the other Surrealists. According to Patrick Waldberg, "…he remained, in spite of the disillusionments and the conflicts, a Surrealist 'to his depths'".[147]

André Masson was born to a peasant family in 1896 in the village of Baligny (Oise) in the Ile-de-France. When he was eight, the family moved to Lille. It was there, in the museum, that Masson had his first glimpse of painting. Encounters of this kind tend to leave their mark on talented personalities. When the family settled in Brussels, André began to learn drawing – in the morning and in the evening he studied at the Académie des Beaux-Arts. In-addition, he worked in the afternoons as a draftsman in an embroiderer's workshop. In Brussels, he saw a James Ensor exhibition. Perhaps it was there that the interest in the strange and mysterious that would later lead him to Surrealism was awakened in him. One of André Masson's teachers was Constant Montald who introduced the young artist to the great Belgian poet Emilie Verhaeren. He persuaded Masson's parents to send André to study in Paris. In 1912, Masson was admitted to the École Nationale Supérieure des Beaux-Arts, to the studio of Paul Baudoin, to study the technique of fresco painting. In 1914, he succeeded in obtaining a government scholarship for travel in Italy. In April 1914, in the company of his friend Loutreuil, he went out to Tuscany to study fresco painting. They journeyed through central Italy on foot. His head full of new impressions, he stopped on his way back to visit his friends in Berne. This was where he found himself at the start of the war. André Masson returned to Paris. He did, however, make a copy of the famous fresco of Delacroix in the church of Saint-Sulpice before being drafted into the army.

For Masson, the war turned out to be a dreadful ordeal. He went into the army as a boy of eighteen. At the age of twenty-one he was seriously wounded in the chest during the offensive at the Chemin des Dames.

André Masson,
The Gamblers, 1923.
Oil on canvas, 81 x 54 cm.
Galerie Louise Leiris, Paris.

There followed long months spent in various hospitals, and it was only in 1919 at the age of twenty-three that he was able to resume a normal life. However, his art preserved the memory of this terrible period. Masson's friend Georges Limbourg left a portrait of the artist as he appeared to him after the war:

> A Nietzschean anarchist…, a tormented soul, not very well-washed, perhaps, dressed in an old sweater under which that infamous mark, a war wound, was still festering, irregular speech, a passionate tone, a rare agility of thought, a gift of cutting to the point, an imagination like hot iron, an explosive and harrowing laugh…[148]

In 1919, Masson settled not far from Marseilles in a run-down cabin at the edge of the Berre swamp near Martignes, where his friend Loutreuil was expecting him. Then he moved to the little town of Caret near the Spanish border. Masson did not return to Paris until 1922. The post-war life in the capital was difficult. Masson was prepared to take on work of any kind. He delivered glassware, decorated ceramics and was a checker at the print-works of a newspaper. In 1923, he rented a studio on the Rue Blomet, where his neighbour was Joan Miró. Daniel-Henri Kahnweiler, the dealer of Picasso and the cubists, described in his memoirs the condition of want in which the artists in Montmartre then lived:

> So with Masson it's not a million miles from Picasso's kind of life. Masson, too, lived in an absolutely wretched studio on the Rue Blomet, which had something else about it that was awful: it was near a factory that ran all day and made this studio shake. Everything moved around until the evening and the time when the factory stopped its machines. He lived there with his wife, as he was married, and with his little girl, who actually lived more often with us, in Boulogne, the sanitary conditions being too unsuitable for a baby.[149]

In Montmartre there lived painters, whose pictures Kahnweiler sold, and poets, many of whom were linked to Surrealism. Kahnweiler recalled, "The link was Max Jacob because Max Jacob knew all these young people equally well. The young poets went to see him. As for the painters, Masson knew nearly all of them in Montmartre because he had lived in Montmartre – before coming to Rue Blomet – in a bedsit in a cheap hotel. I got to know Lascaux through Max as well. Masson was Lascaux's friend in Montmartre… One day I saw two pictures round at Lascaux's of his friend Masson, he had put them up at his place so that I would see them. I immediately liked these pictures a lot.[150]

Contact with Kahnweiler not only enabled Masson to sell some of his works, but also brought him into a circle of artists. He got to know Derain and Juan Gris. "It was in 1924, at an exhibition of André Masson which I had organised, that the Surrealists Breton, Éluard and Aragon saw for the first time Masson's works which they admired straight away, and it was then that they met", Kahnweiler recounted.[151] The studio on the Rue Blomet became "one of the main sources of the modern adventure, the equivalent for Surrealism of the Bateau-Lavoir for Cubism. Around the dynamic Masson gathered writers and poets fired up by the same energy, Desnos, Artaud, Leiris, Tuel, Limbour, Salacrou, Prévert."[152] Limbour introduced him to Louis Aragon. As was bound to happen, one fine day André Breton turned up on the Rue Blomet as well, and he immediately bought the picture entitled *The Four Elements* which Masson had just finished.

In Ceret, Masson painted landscapes in which an admiration for the painting of Cézanne was palpable (*The Capuchin Convent at Ceret*). Like all the young people of his generation, he saw one of his important teachers in Cézanne. In 1923, in Paris, he painted still lifes in which traces of the Cubism

André Masson,
The Four Elements, 1923-1924.
Oil on canvas, 73 x 60 cm.
Centre Georges-Pompidou, Musée national d'art moderne, Paris.

of Juan Gris are evident – and it is in this period that they met (*Still Life with Candle*; *Card Trick*). In that same year, Masson's individual exhibition was held at the Galerie Simon. *The Four Elements* is the first enigmatic, symbolic picture in Masson's body of work. It internalizes Cézanne generalization of form and the structure of his own early still lifes. No doubt Breton saw in it the presage of Surrealism in Masson that was as yet unformed, and he invited him to join the Surrealists. In 1924, Masson entered the group at the very moment of its formation. In 1925, he contributed to the first exhibition of Surrealist painting at the Galerie Pierre.

André Breton's method captivated Masson. "The temptation was great at that time to try to operate magically on things and first of all on ourselves", wrote Masson. "The impetus was such that we could not resist it: from around the end of the winter of 1924 it was a time of frenetic abandonment to automatism."[153] His automatic drawings made a great impression on his friends within the group, and the journal *La Révolution surréaliste* consistently reproduced them. Masson became the Surrealists' portrait-painter. With his exact line he drew Aragon, Artaud, Éluard, Leiris, Peiret and Vitrac. Over the course of several years, he completed several portraits of André Breton. Among others, there is a drawing in his album in the spirit of Leonardo da Vinci, constructed with geometric exactitude, and conveying the appearnance of the aging but still handsome leader of Surrealism (*Portrait of André Breton*).

In the 1920s, Masson illustrated the books of his Surrealist friends – Georges Limbour, Michel Leiris, Robert Desnos – with engravings and lithographs. Masson's lines are nervous and expressive; sharp corners create a sense of fragility. In the interweaving of the lines, the eye guesses at a hint of the outlines of figures and objects which, failing to acquire definition, have disappeared. The character of these drawings is also preserved in the paintings of the 1920s; in them the line holds command, while colour merely supplements the drawing – "the line becomes wandering", according to Gertrude Stein, who was among the first admirers of Masson's painting (*Children of the Isles*; *The Rider*). In the 1920s, the influence of Juan Gris's Cubism are still very perceptible in Masson's pictures. The space is broken up and deepened, and sometimes it is formed from separate fragments of volume. The reminiscences of Cubism are combined with the delicate lines of the drawing (*The Dead Man*; *Skins*; *Constellations*).

"It is a fact", writes Waldberg, "that Masson's work comes across as a sublimation of violence, where nature relentlessly rages, releases itself and recreates itself – like an implacable dialectic of desire and death."[154] Apparently the war had never ended for him. In his painting there are no subjects directly taken from his impressions of war. In order to convey his sense of the horror of slaughter and the nightmare of aggression, a conviction which from the time of the war had never left him, André Masson employed motifs from the life of animals. Starting from 1927, they predominate in his painting and drawings – as is obvious from their titles: *The Dead Horses*, *Horses Devouring Birds*, *Bird Shot by Arrows*, *The Trap and the Bird*.

He added to the automatism of composition his own personal discoveries of new methods and the use of new materials. "Their necessity struck me when I became conscious of the gap between my drawings and my oil-paintings – a gap between the spontaneity and the lightning rapidity of the first, and the fatal reflection in the second", as Masson read in a lecture held at the Pavillon de Marsan in March, 1961. In 1926 and 1927, he began to paint pictures which involved the application of sand. "I suddenly discovered the solution", Masson recounted, "when I was by the sea, contemplating sand, composed as it is of myriads of shades, and of infinite variations ranging from the dull to the sparkling. As soon as I got back, I set out on the floor of my room an unprepared canvas onto which I threw a lot of glue, then I covered the whole thing with sand brought back from the beach... I enriched the process with successive layers of glue and then of sand of different consistencies and grains. However, as in the case of drawings in ink, the figurative appearance was sought, and this heterodox picture was

André Masson,
Armour, 1925.
Oil on canvas, 80.6 x 54 cm.
Peggy Guggenheim Collection, Venice.

André Masson,
The Andalusian Harvest Workers, 1935.
Oil on canvas, 89 x 116 cm.
Galerie Louise Leiris, Paris.

André Masson,
Massacre, 1933-1934.
India ink, 43.8 X 60.9 cm.
Centre Georges-Pompidou, Musée national
d'art moderne, Paris.

finished thanks to the help of a stroke of the brush, and, occasionally, a spot of pure colour"[155] (*Battle of Fishes*).

The application of sand produced a surprising effect, and the painting acquired an expressive texture. For Masson, the plasticity of the picture was always what counted most. His painting does not entice through the mystery of its subject-matter or the enigma of its fabulous characters. He reworked the same motifs connected with the savage battles of animals, with destruction and death. In 1928 and 1929, he continually painted pictures and made drawings and pastels on the theme of *The Destiny of the Animals*.

In 1929, Masson obtained a commission from Pierre-David Weil for two decorative panels: *Animals Devouring Each Other* and *Metamorphoses*. These were the largest canvases which Masson ever painted. His gift as a scene-painter, and the originality of his colouring built on contrasts, promised success. Alberto Giacometti handled the sculptural aspect of the planned ensemble. Unfortunately, both panels were destroyed during the Second World War.

In 1929, Breton excluded André Masson from the Surrealists, yet this did not have any impact on his art. His contemporaries continued to regard him as a Surrealist. "For me, the true Surrealist painting is by Masson and Miró, and also Max Ernst", said Kahnweiler. "But I do not like orthodox Surrealist painting for a very simple reason: the intentions behind this painting were so literary…"[156] There was never any literature in Masson's works. In 1931, he went to the slaughterhouses of la Villette and Vaugirard to make drawings. From these sketches emerged the series of pictures and drawings, *Massacres* and *Slaughterhouses*, which continued the theme of the *Destiny of the Animals*.

The 1930s were the heyday both of Surrealism and Masson's creativity. His works took many different forms. Life gave him a mass of new impressions. He travelled to England in 1930. In 1932, he went to live near Grasse which meant that he was often able to spend time with Matisse. Masson became a recognised illustrator: Georges Bataille invited him to work for the journal he had just founded, *Acéphale*, and despite the split with Breton he worked for *Minotaure*, the Surrealists' journal which just been established. In 1934, he went to Spain for the first time, where he and his wife walked around the whole of Andalucia. This country made such an impression on them that they decided to leave France.

Masson settled in Catalonia, in the town of Tossa de Mar. He and his wife journeyed about a great deal on foot, and walked through Aragon and Castile. Two sons were born to them in Spain. However, even in this beautiful country Masson discovered motifs connected to conflict and aggression, seeing them in the bullfight and in Spanish legends (*Massacre in a Field*). Even the Spanish landscape did not bring any peace into his painting (*Aragon Sierra*). He painted several strange pictures in which insects, recalling the painting of Max Ernst, live among the grass. However, even among the little crawling and flying creatures struggles take place (*Summer Entertainment*; *In the Grass*). The defeat of the Republic in Spain compelled Masson, a committed supporter of the Republic, to return to France. He settled in Normandy, in the little town of Lyon-la-Forêt, not far from Rouen. Increasingly, the themes of ancient mythology – Pygmalion, the Labyrinth and the Minotaur – appeared in his painting.

In the 1930s, Masson began to work for the theatre, an occupation which assumed an important position in his life. He started in 1933 with the ballet, *Les Présages*, for the Russian ballet of Monte Carlo. In 1937, Masson met Jean-Louis Barrault. He made scenery and costumes for Barrault's theatre, for Cervantes's *Numance*, and for the drama *Hunger* by Knut Hamsun. Then there was Armand Salacrou's play, *The World is Round*, put on by Charles Dullin. Finally in 1940 *Medea*, the opera by Darius Milhaud, was performed at the Paris Opera with Masson's scenery and costumes. Throughout this time, he was still busy painting, and drawing imaginary portraits and cities. In 1939 and 1940, he completed portraits of the German Romantics, including several of Goethe (*Goethe and the*

André Masson,
Broceliande, 1937.
Private Collection.

André Masson,
Cover of the « View », 1945.
Gouache.
Private Collection.

André Masson,
The Apple Eater, 1943.
Private Collection.

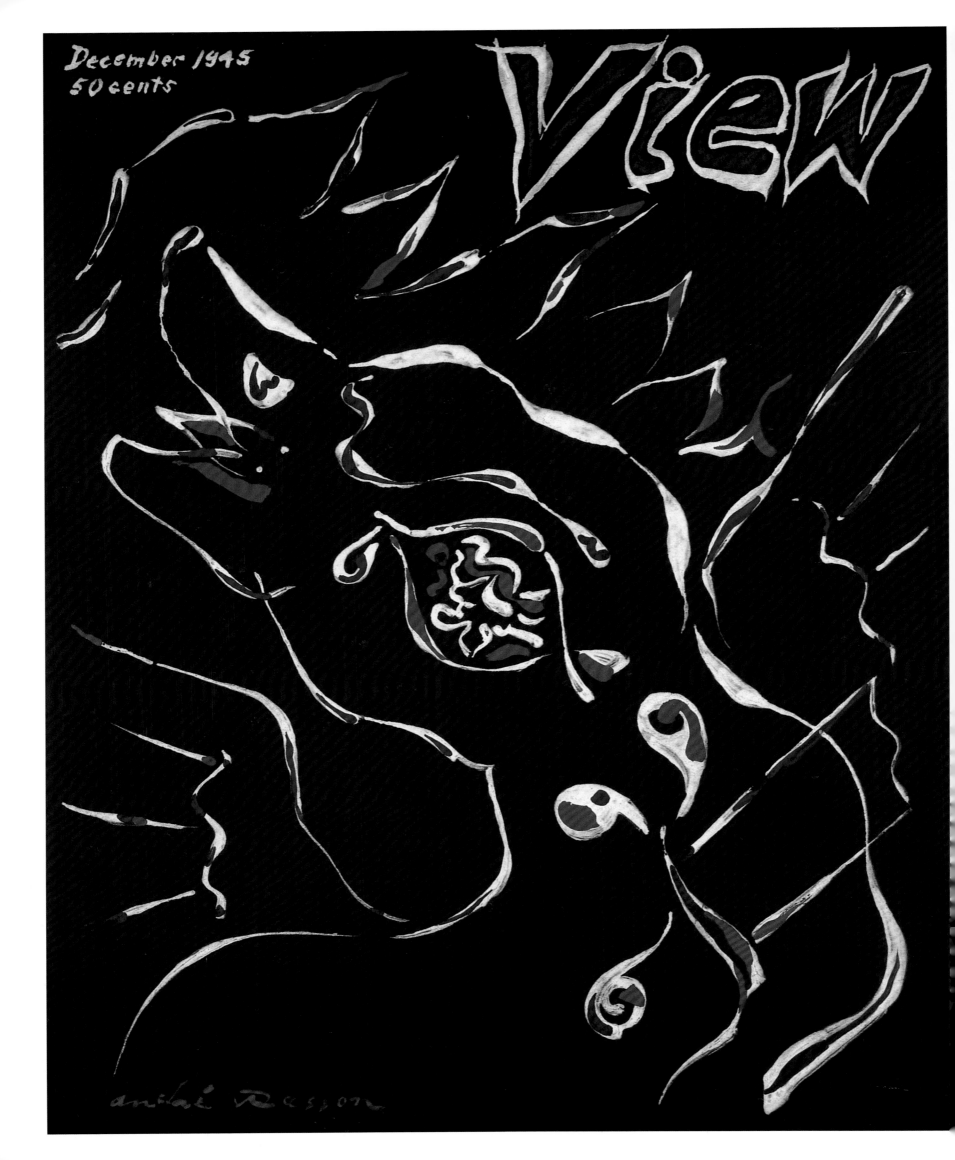

December 1945
50 cents

View

anibal Nesson

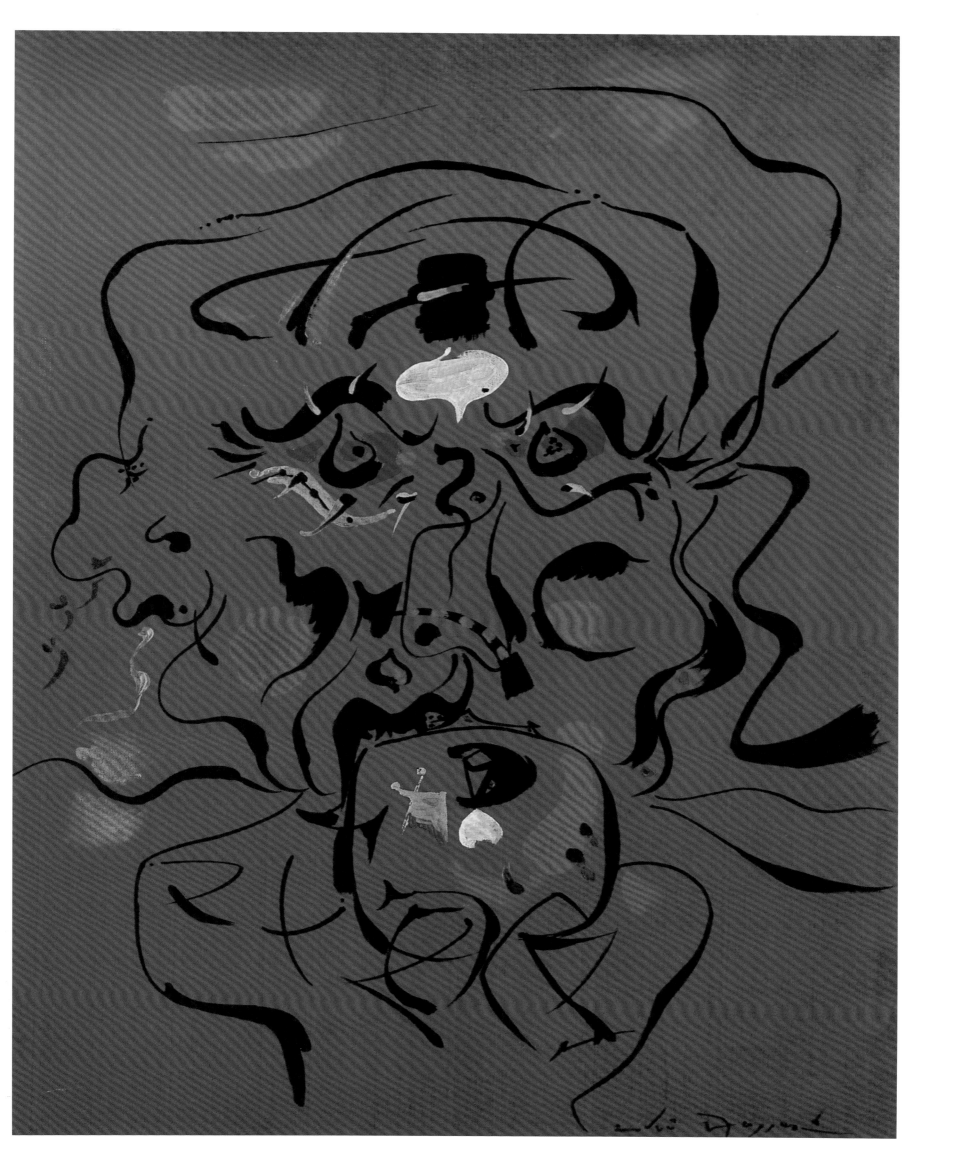

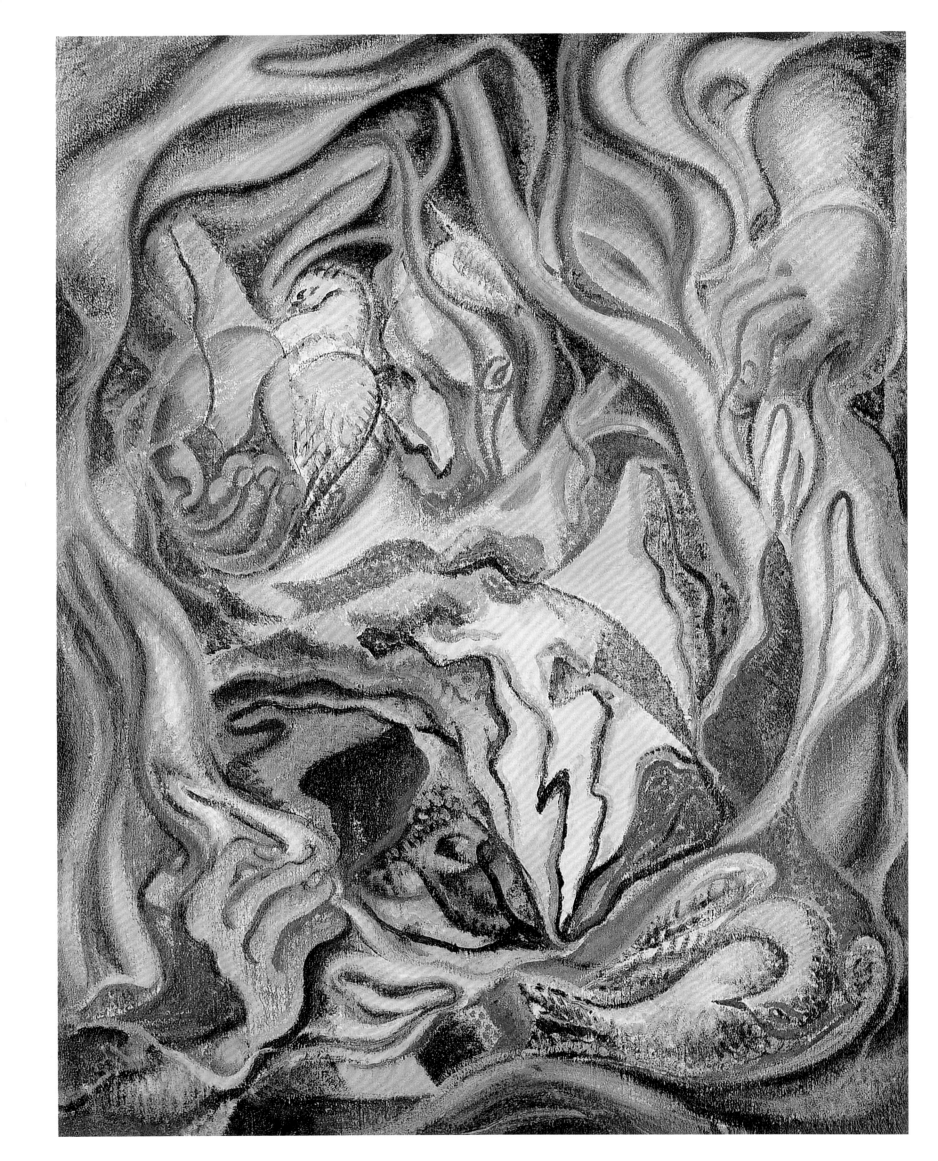

Metamorphoses of Plants). A sense of tragedy is always present in his pictures, no matter whether he has depicted the animal world, or a subject from Shakespeare (*Ophelia*). Masson continued to use sand in his painting; he gathered marine objects and fragments on the beaches of Brittany, and he used them in his pictures as well. His work was continuously shown in the Surrealists' exhibitions, and even earned Breton's praises. The war, however, brought this life to an abrupt end.

In 1940, Masson and his family moved first to the Auvergne, and then to Marseilles in order to sail from there across the Ocean. "Masson", Kahnweiler recalled, "had left France with his wife, who was of Jewish origin, and after a journey of about six weeks he arrived in Martinique and, from there, eventually got to America."[157] They settled in Connecticut, where they met Yves Tanguy. In America Masson felt ill-at-ease. "The disasters of the time could only add to the weight of his sorrow", wrote Kahnweiler. Masson painted *Iroquois Landscapes* and characters from ancient mythology (*Iroquois Landscape*; *Andromeda*). The art and life of Native Americans interested him, as did the mysteries of outer space. The style of his painting became more and more "calligraphic". Masson worked together with Breton and took an active part in the Surrealists' events and exhibitions in America. In October 1945, as soon as it was possible, Masson and his family returned to France. But it seems that his stay in the United States did have an impact on him. Responding to a question about the new school of American painting, Kahnweiler said: "It was the arrival in America of André Masson that kick-started this whole movement. Pollock himself has stated quite frankly that it was Masson's influence that had manifested itself in his painting at that time."[158]

In Paris, Masson immediately resumed work for the theatre of Madeleine Renauld and Jean-Louis Barrault: he made scenery and costumes for *Hamlet* and for Jean-Paul Sartre's play *Men Without Shadows*, and in 1959, as a commission from the theatre, he made models for Paul Claudel's *Head of Gold*. He had developed a close attachment to the theatre; it had become another aspect of his art, and he was in no hurry to move on from it; for the Opera-Comique he designed the scenery for two ballets put on by Massine; he worked for the theatrical festival in Aix-en-Provence; in the sixties he made scenery and costumes for the Opera de Paris, as well as many other similar endeavours.

Once he had returned to France in 1946, Masson settled in the vicinity of Poitiers, but in 1947 he returned to Aix-en-Provence. He lived on the Rue du Tholonet, in the same locality where Paul Cézanne painted Mont Saint-Victoire. The south of France fascinated Masson. He painted the landscapes of Provence and pictures that were inspired by them. He turned to Greek and Egyptian mythological characters, returned to the horrors of slaughter, and continued to create extraordinary images on his canvases (*Animal Labyrinth*; *The Fall of Bodies*). And behind Masson's work stood a man who was unusual, remarkable, and in his way enigmatic. "Before the ring, the crown, the rope, the flame and the constellations, the issue was man", wrote Éluard. "Man and his shared solitude, solitude. André Masson rose to bury time under the landscapes and the objects of the human Passion. Under the sign of planet earth."[159]

Masson possessed an astonishing energy; his work was incredibly varied. Besides easel painting, he painted huge decorative panels and murals – in 1965 he painted the ceiling of the Odeon-Theâtre de France. He became one of the most prominent graphic artists; he worked in engraving and lithography, and illustrated books. For a commission of the Gobelins works he composed a tapestry cartoon. Masson was known all over the world. His retrospective exhibitions were held in countries in Europe, Asia and America. He was awarded the "grand prix national des arts" and became a member of the Conseils des Musées Nationaux. Masson was a talented author, and wrote two books of memoirs: *Vagabond of Surrealism* and *Rebel of Surrealism* – throughout his life he regarded himself as a Surrealist. André Masson died in Paris on October 28, 1987 at the age of ninety-one.

André Masson,
The Dead Bird, c. 1924-1925.
Oil on canvas.
Private Collection.

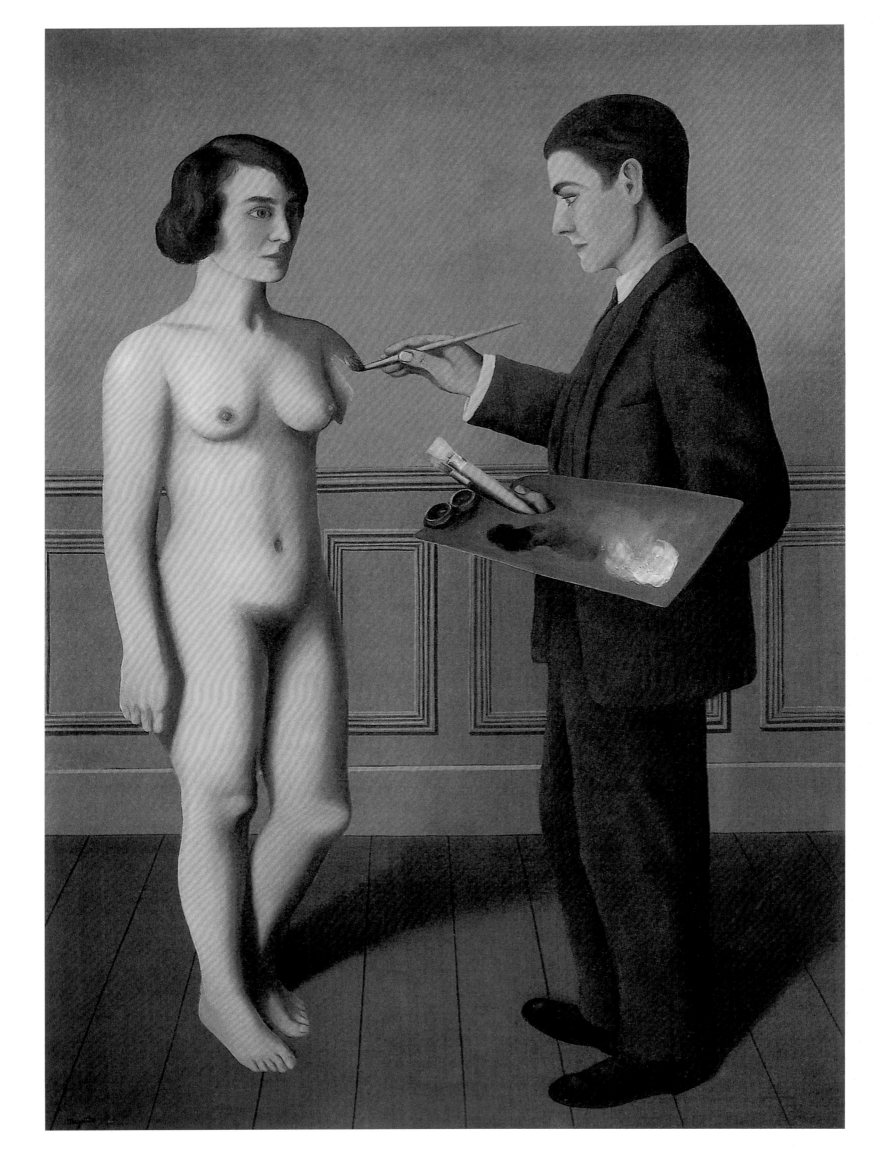

RENÉ MAGRITTE

1898-1967

To illuminate the love which I extol
Are signs, refrains, mysterious lightning
When a fabulous scene holds me back
In front of those windows clothed in gloom

Blue landscapes, all bathed in languor
Where stretch out shapes as yet indistinct
Shoulders, hands, attractive hair
I exorcise the turmoil deep within me

So that there may shine and lengthen and stretch out
Some spectre made of grace and splendour
Whose equivocal animal suppleness

When it reaches its full size
Then announces the beautiful visitor
It is she! Dark and yet luminous.[160]

In René Magritte's painting, everything is enigmatic. "The beautiful visitor… Dark and yet luminous", in the words of the poet, is a woman who crops up here and there on his canvases in the form of the plaster torso of Aphrodite of Cnidos, sometimes dressed in a bright, colourful gown; sometimes she is a real human figure in the form of Boticelli's Venus; and sometimes she glides noiselessly on her horse through a thicket of the forest, as Böcklin's *Silence*. She is so real that you want to stretch out your hand to touch her. But each time she slips away into another space, inaccessible, like the creature of a dream. "An art of painting of this kind allows for the advent of visible poetry", Magritte wrote about his painting.[161]

René Magritte was born in Lessines, Belgium, on November 21, 1898. His father was a merchant and his mother was a milliner. A family legend says that their forebears were two brothers whose surname was Margueritte, republicans who had fled after the death of Robespierre and hidden themselves in Picardy. When René was six or seven years old, he stayed with his aunts in Soignies during school holidays. There, in the local cemetery, his first encounter with an artist took place. In his imagination, it forever linked painting with the world of the strange and mysterious. "One day, in the middle of the columns of broken stone and heaps of dead leaves, I found an artist who had come from the capital, and who seemed to me to be performing a magical activity", Magritte remembered. "When I myself began to paint, around 1915, the memory of this enchanted meeting with painting turned my efforts in a direction which bore little relation to the common path."[162]

René Magritte began to draw at the age of twelve, when his family lived at Châtelet. When he was fourteen, his mother committed suicide one night by throwing herself into the Sambre River. In 1913, the family moved to Charleroi. When he was fifteen, on the merry-go-round at a local fair, René met a girl by the name of Georgette Berger who later became his wife. His first work in painting, in the

René Magritte,
Attempting the Impossible, 1928.
Oil on canvas, 116 x 81.1 cm.
Toyota Municipal Museum of Art, Toyota.

spirit of Impressionism, dates from 1915. In 1916, he enrolled as a student at the Académie des Beaux-Arts in Brussels, in the studio of the Professor of Drawing, Van Damme. His family moved to Brussels as well.

In the Belgian capital, Magritte came into contact with the milieu that would have a decisive role in his artistic formation. E.L.T. Mesens taught Magritte's brother how to play the piano - and was to become René Magritte's lifelong friend. Magritte rented a studio together with Pierre-Louis Flouquet, and he made friends with the poet Pierre Bourgeois. The three of them began to publish the journal *Au volant!*. At the beginning of the 1920s, Magritte met the Brussels writer Marcel Lecomte, and the poet Camille Goemans, who later, when he became a dealer, would play a part in the destiny of the Surrealist artists.

At this time, Magritte painted pictures that are reminiscent of Picasso's early Cubism, and he exhibited one of them, called *Three Women*. This was also when he became familiar with the painting of the Italian Futurists. His creative interests at the start of the 1920s lay in the field of Cubism and Futurism, and his painting at the time was closest to that of R. Delaunay and F. Léger. In 1920, Magritte's pictures and posters were submitted for exhibitions at the Brussels Art Centre and at the International Exhibition of Modern Art in Geneva.

At the same time, changes in his life were also taking place. In the spring of 1920, quite by chance, he met Georgette Berger, who worked in a shop that sold artists's materials, in the Botanical Garden in Brussels. After his return from military service, Magritte married Georgette in June, 1922. He himself did the drawings from which the furniture for their home was made. Needing to earn money, Magritte joined the Peeters-Lacroix factory, located in a Brussels suburb, as an artist who painted wallpaper. Together with its director, Victor Sevranckx, he wrote an essay entitled "Pure Art, a Defence of Aesthetics". Magritte soon left the factory and began working in the field of posters and advertising.

From France, echoes of Dadaism began to reach Belgium. Short-lived Dadaist newspapers came out in Brussels and Antwerp, and striking individual personalities appeared such as the poet Clement Pansaers. After the First World War, the cultural life in Brussels was becoming more active. The young were grouped around a few artistic journals: *7 Arts*, *La Lanterne sourde*, *Le disque vert*. Magritte's friends, the Bourgeois brothers and Pierre Flouquet, were involved in their publication. Camille Goemans also entered this group. In Brussels, new galleries sprang up which were interested in Modernist tendencies in art. The most interesting of them were the gallery of Geert van Bruaene, a very colourful character, and a gallery with the strange name Cabinet Maldoror – at this time both in France and in Belgium the artistic avant-garde was newly discovering Lautréamont. In 1923, Paul Nouge, Marcel Lecomte and Camille Goemans founded the journal *Correspondance*, and René Magritte, Edouard Mesens and several others joined them. This was the beginning of Surrealism in Belgium. The appearance of *Correspondance* attracted the attention of the Parisian Surrealists, and a delegation, consisting of Breton and Éluard, arrived in Brussels.

As far as Magritte's Surrealism is concerned, it began earlier than the founding of *Correspondance*. It sprang from the same source as the Surrealism of Yves Tanguy. The artist himself told the story of how, in 1922, Marcel Lecomte showed him a reproduction of Giorgio de Chirico's painting, *The Song of Love*, and how he could not hold backs the tears. Camille Goemans wrote that for all of them the encounter with de Chirico's painting was "an unforgettable event, as if all of a sudden poetry had made its entrance into painting and appeared to us in all its magnificence."[163] Magritte, like those of his generation, watched modern films and was fascinated by Nosferatu and Fantômas. In 1928, he depicted Fantômas in top-hat and mask, like a ghost emerging from a brick wall (*The Barbarian*). Like the other Surrealists, Magritte immersed himself in the detective stories of Dashiell Hammett and Simenon that appeared in the 1920s and the beginning of the 1930s. He himself wrote detective stories under the pseudonym of Renghis.

René Magritte,
The Menaced Assassin, 1927.
Oil on canvas, 150.4 x 195.2 cm.
The Museum of Modern Art, New York.

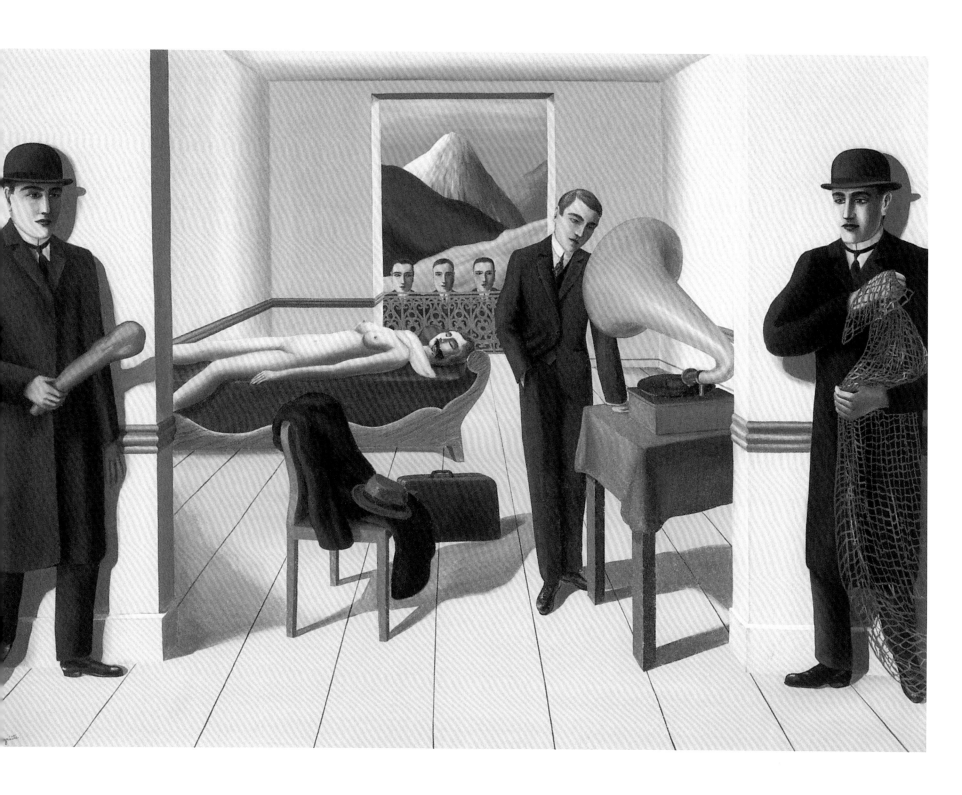

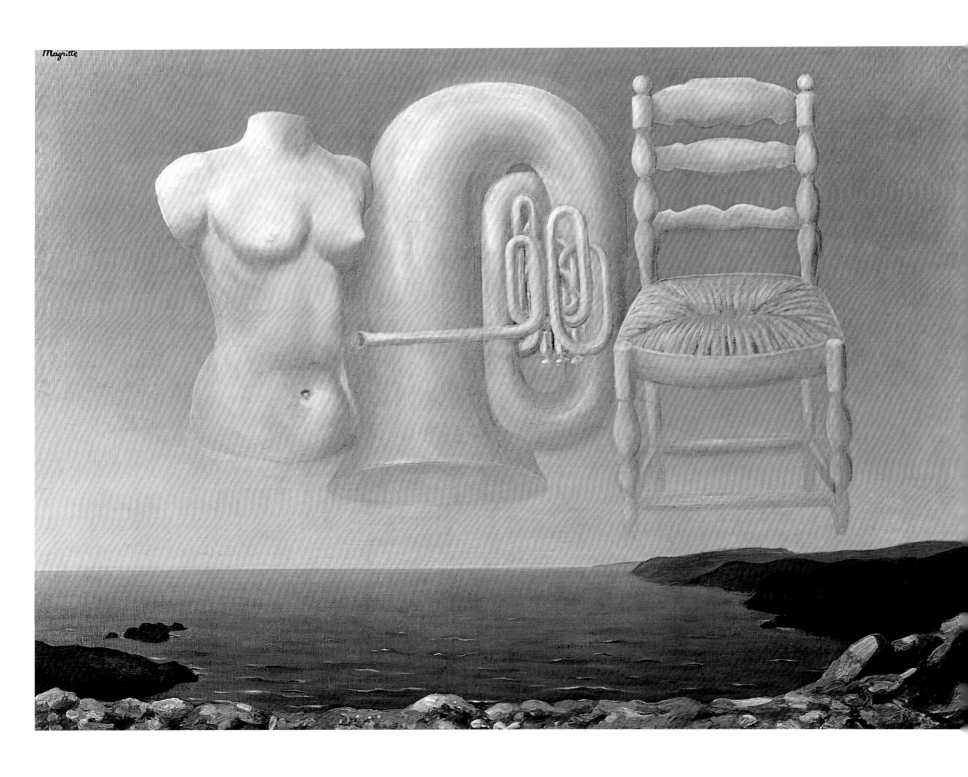

For Magritte, mystery was as attractive as poetry. Surrealism was born from a combination of the two, and for Magritte, at an earlier stage than when he joined the Parisian Surrealists. He told the story of how one day he caught sight of his wife Georgette taking bites out of a little chocolate bird. As a result, he painted a pretty girl devouring a live bird (*The Pleasure*). The unostentatious gentleman in the black coat and bowler hat, who is always seen from the back or in profile, already appeared in his first Surrealist paintings (*Dreams of a Solitary Wanderer*). Later, he would become an ever-present character in Magritte's paintings, disturbingly reminiscent of the artist himself. Contemporaries said that an ordinary bourgeois appearance reinforced the sense of mystery which he carried within himself. "He's a secret agent", wrote one of his friends. "His purpose is to put the whole apparatus of bourgeois reality up for discussion: like all saboteurs, he avoids detection by dressing, and acting, just like anybody else."[164]

At this time, Magritte's canvases began to fill with those objects for which his painting would later be well-known: cup-and-ball toys, pictures or empty frames, classical statues or fragments of them, and strange walls of buildings with empty eye-sockets for windows (*Difficult Crossing*; *The Flying Statue*). Magritte had already begun his favourite game with space and materials in which solid objects become transparent but the sky and the clouds are solid, where brickwork is revealed under the bark of trees, where branches sprout from human flesh and where the animate is naturally united to the inanimate. In fact, Magritte at that point had already developed his own form of alphabet which would subsequently be employed in paintings both by him and by Surrealist painting as a whole. Magritte regarded *The Lost Jockey*, painted in 1926, as his first Surrealist painting. In oil-painting, as in collage, Magritte depicted a strange forest, in which trunks – balusters – sprout live green branches, and around which a little lost jockey gallops in a state of panic. "It is the first canvas which I really painted with the feeling that I had found my own path, if one can use that term", he later said in one of his interviews.[165] Later, in the 1940s, Magritte repeated the jockey motif in *The Lost Jockey*, and it became one of the trademarks of his painting.

However, it is possible that the truly prophetic painting which points towards Magritte's future Surrealist path, is something he also created in 1926, *The Man from the Sea*. Here, many influences are apparent: memories of Fantômas, of the constructions from drawing instruments in de Chirico's paintings, of Hans Arp's abstract figures. Nevertheless, the design of the painting stands apart, and is absolutely independent of any influences. Actually imagining the coexistence of two different dimensions is difficult. Magritte embodies this very clearly with objects from the material world. Each of them is reconstructed with maximum precision: the floorboard grain, the fireplace marble and the door handle are real to the point of naturalism. A human being easily lives in this ordinary world, in the everyday setting of the bourgeois house. At the same time, here, at this actual moment (in the painting), the eternal ocean rhythmically rolls in waves onto the desert sand of the shore. Both dimensions coexist: they are interwoven, but each of them lives independently and does not suspect the existence of the other. The sensation of mystery in Magritte is constructed through the aid of naturalistic details typical of Surrealist art, and by combining elements that should be impossible to combine. Magritte wrote:

> So around 1925 I decided that I would no longer paint objects except with the
> details of their appearance. Effectively, I had replaced plastic qualities… with
> an objective representation of objects that is clearly understood and accepted
> by those whose taste has not been spoiled by all the literature that has been
> produced on the subject of painting. This detached way of representing
> objects seemed to me to fall within a universal style, where the obsessions and
> the minor artistic preferences of one individual no longer applied.[166]

René Magritte,
Threatening Wheather, 1929.
Oil on canvas, 54 x 73 cm.
Scottish National Gallery of Modern Art,
Edinburgh.

René Magritte,
The Flowers of Evil, 1946.
Oil on canvas, 80 x 60 cm.
Galerie Isy Brachot, Brussels.

René Magritte,
The Rape, 1934.
Oil on canvas, 73 x 54 cm.
The Menil Collection, Houston.

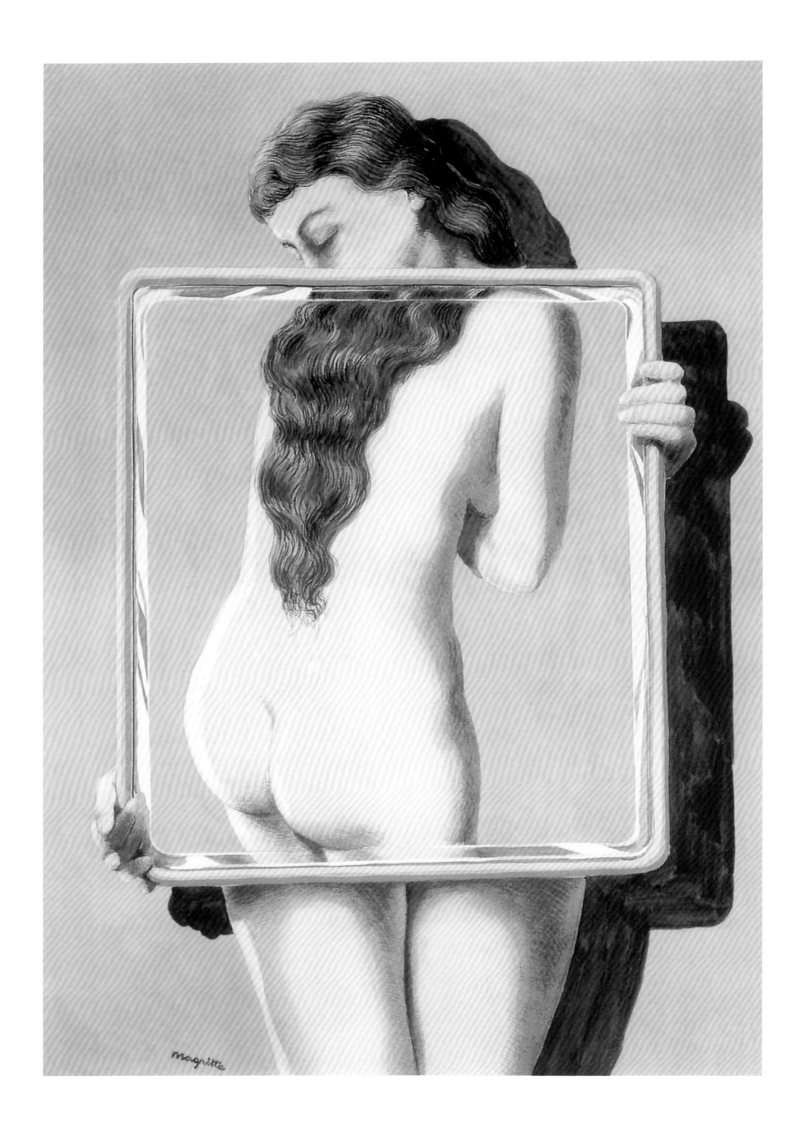

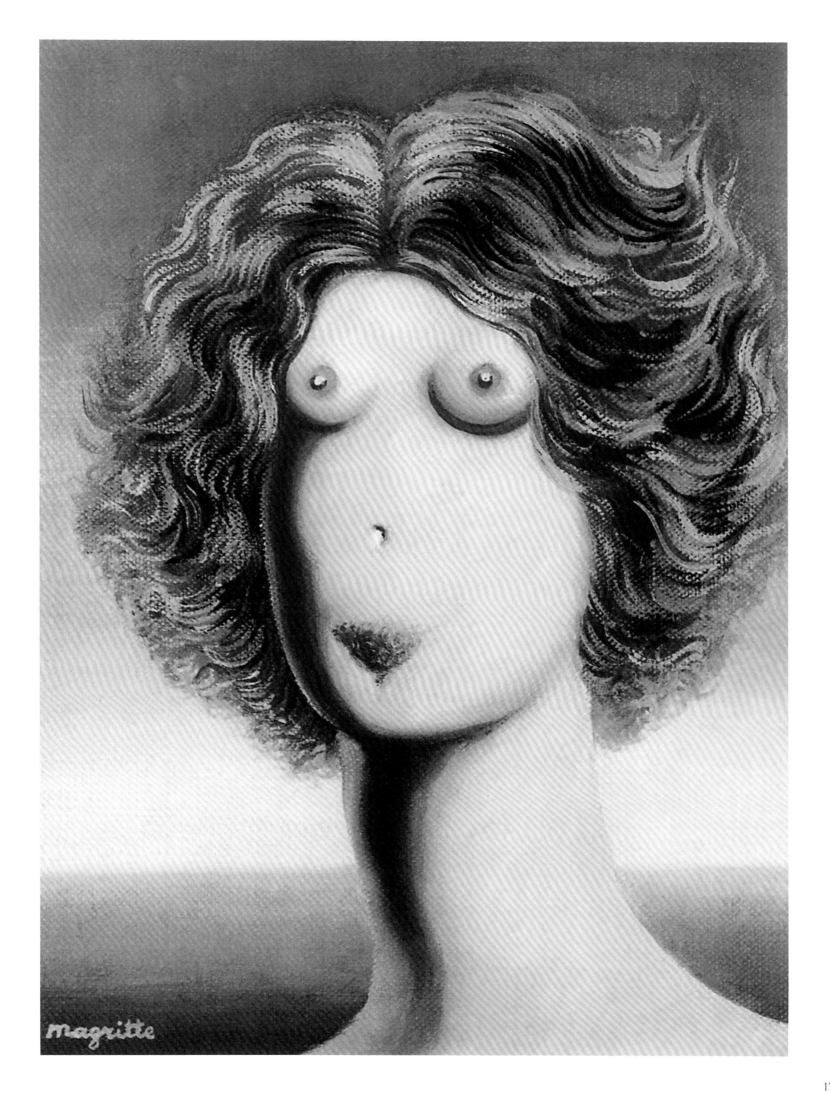

In the course of 1925 and 1926, Magritte painted more than sixty canvases, made a great number of collages, and worked in the advertising field. In the spring of 1927, Le Centaure gallery in Brussels organised a large solo exhibition of his work. Two galleries, Le Centaure and P.G. van Hecke, signed contracts with him which allowed the artist to devote himself exclusively to painting. Within four years, Magritte painted 280 pictures for the Le Centaure gallery alone. At this time, he came to know Louis Scutenaire who became his lifelong friend. A group of Belgian Surrealists gathered around Magritte including E.L.T. Mesens, Paul Nouge, Camille Goemans, Marcel Lecomte. From 1926 onwards, Margitte would meet up with Breton and Éluard. By then he had already developed into a Surrealist artist. He decided to move to France, and in 1927 René and Georgette Magritte settled in the Paris suburb of Perreux-sur-Marne.

Magritte, as was natural, joined the group of Paris Surrealists on equal terms with the other members. Hans Arp, Joan Miró, and later Salvador Dalí, became his friends. His Belgian friend Camille Goemans opened a gallery in Paris. In 1928, Goemans organised an exhibition of Surrealist painting, and, in 1929, an exhibition devoted to collage. Magritte took part in these two exhibitions. Among the Surrealists, he commanded the same degree of respect as did his Parisian friends. In 1929, René Magritte and Georgette spent some time in Spain as Salvador Dalí's guests. In 1930, in the final number of the journal *La Révolution surréaliste*, a piece by Magritte appeared under the title "Words and Images". Magritte's article was completely original. It corresponded neither to the model of automatism, nor to Dalí's paranoiac-critical method.

In the same year, 1930, Magritte cut his ties with Breton and returned to Brussels. He did not like to talk about himself, and gave no one an explanation for the break with the Paris Surrealists. He later explained its causes in very guarded fashion: "Finding Paris tiring 'close-up', my wife and I preferred to see it 'from a distance'... My relations with the Surrealists have not been affected by our return to Belgium, either for the better or for the worse."[167] His friend Louis Scutenaire wrote: "He employs powers all his own, which have nothing in common with certain of the group's weapons (dream, automatism, paranoiac activity...) and which are even opposed to them. Moreover, he finds it so hard to endure the transformation of these methods into dogmas that, to be sure of a free hand, he came back in 1931 to Brussels, from which he has not moved again save for a few trips to France, Holland and England."

Magritte had, however, already assumed a place in European art. In the course of the 1930s, his painting was exhibited in the joint exhibitions of the Surrealists in Paris, New York, London, Tokyo and Tenerife, and his solos exhibitions were organised in Brussels, Ghent, The Hague, New York and London. In 1934, Magritte did a drawing entitled *The Rape* for the dust-jacket of Breton's lecture titled "What is Surrealism?" that was published in Brussels. In 1938, Magritte gave a lecture in Brussels with the title "The Lifeline", in which he summed up his artistic quest. Shortly before the German invasion of Belgium, Magritte and his wife, together with Scutenaire and his wife, headed for France, and lived for a while in Carcassonne.

Magritte's painting captivates with its apparent clarity. However, it has its secrets. "Far from confessions, the artist lays his traps", wrote Scutenaire. "His curiosity, utterly direct, determines, fixes on precise and concrete problems, or ventures into the unknown with no other weapons than the most common objects."[168] A Doctor of Laws, Louis Scutenaire became Magritte's biographer. He knew the artist well and he was a witness to his life. "One can see him at home, not tall, stocky, with square shoulders which he throws back a little, unceremoniously toiling away at his painting without any indulgences", wrote Scutenaire.

With his thick hair, grey eyes, and a face in anguish, not like an aesthete's or a Romantic's but like the face of the melancholy and malicious old Chinaman on vases, he used an unpretentious lot of

René Magritte,
The Great War, 1964.
Oil on canvas, 81 x 60 cm.
Private Collection, Washington, D. C.

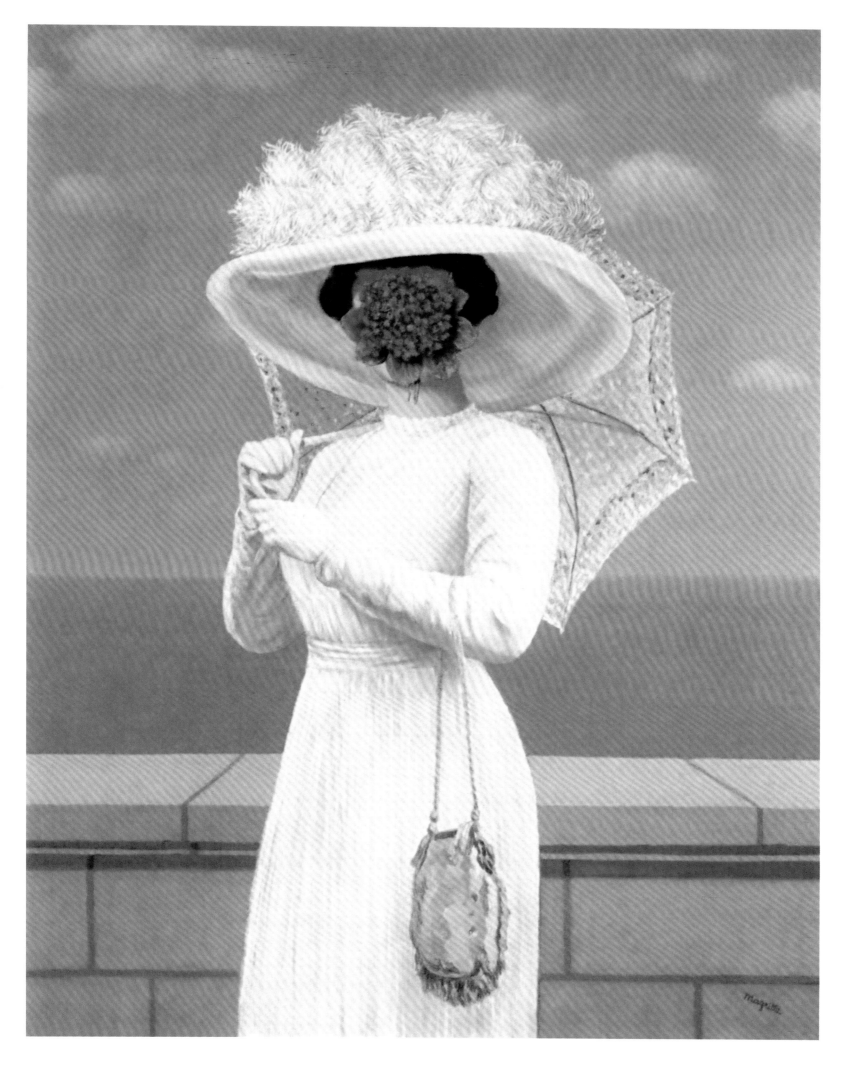

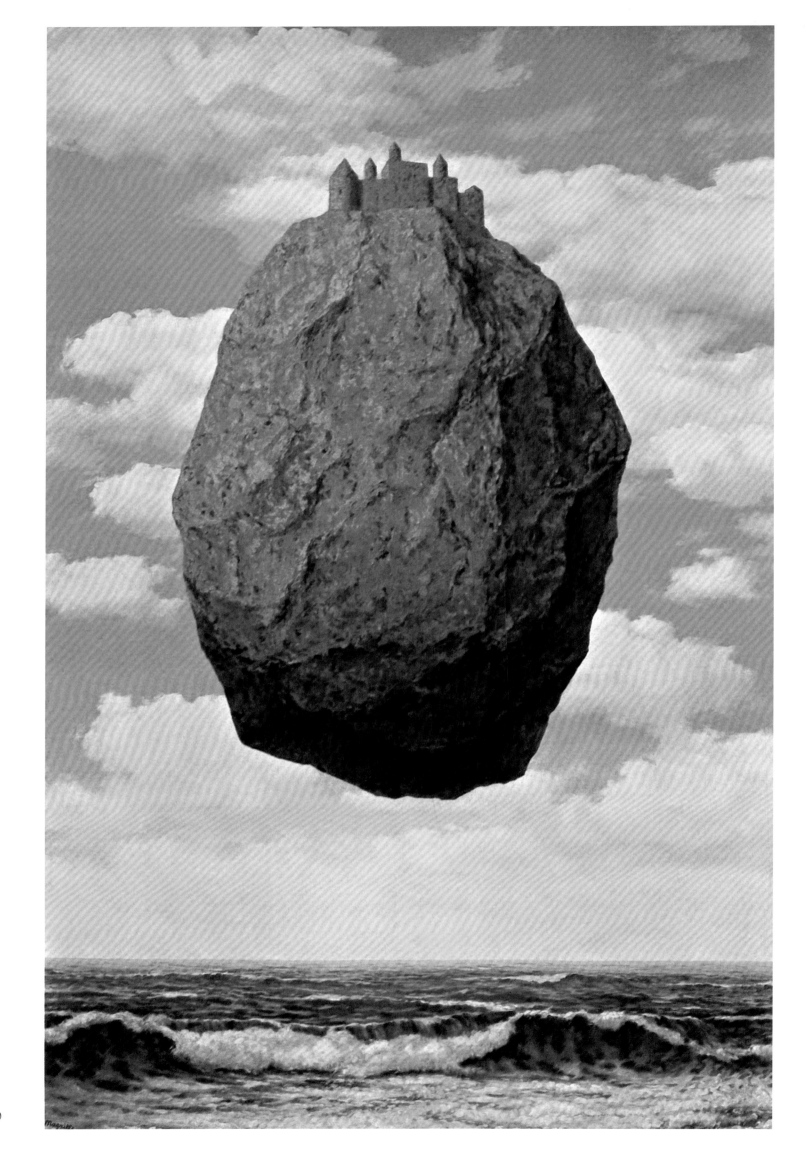

equipment; in a corner of his wife's boudoir, the easel, a few tubes of colour, the palette, ten paintbrushes, some sheets of white paper in a box, a rubber, a stamp, an old pair of dressmaker's scissors, a piece of charcoal, a bit of black pencil.[169]

Scutenaire attentively followed Magritte's work, saw its nuances and its changes, and discerned a whole range of periods within it. The enormous dimensions of the pictures from the mid-1920s gave place to small ones; the colour became more vibrant as he moved into the 1930s; in the 1940s, the customary smooth execution of the painting was replaced for a while by restive, almost impressionistic dabs. However, Magritte's philosophy of creation, his secrets and his poetry remained unchanged.

This is an artist who compels one to get to know afresh objects which are already familiar, and through them to see one's surroundings in a new guise. He repeats the depiction of the same thing many times, slightly changing the situation, sometimes adding a detail, and in this way compelling one to see another side of life. Everyday reality turns out to be unusual; it is full of secrets, and it is not the artist's task to provide an explanation of them. Magritte created his own personal, and, it would seem, distinctive Surrealist world, which turns out to be exceptionally complex, and where it is difficult for the viewer to find his way. Magritte said:

> I must… inform you that words like unreal, unreality and imaginary do not seem to be suitable for talking about my painting. I have no curiosity about the 'imaginary' or the 'unreal'. It is not a question – for me – of painting 'reality' as though it offered itself easily to me and to others, but of showing the most familiar reality in such a way that this immediate reality loses its anodyne or terrible character and at last appears in its mysterious character. This reality, understood like that, has nothing of the 'unreal' or 'imaginary' about it.[170]

One of the key devices in Magritte's paintings is the pipe, the first example of which he painted in 1929. Scutenaire wrote that Magritte only smoked cigarettes, and that his love for the pipe was purely platonic. He depicted a pipe, affectionately giving it a graceful twist, and the smoothness of delicately grained and polished wood. It is so real that one wants to take it in one's hands and to stroke it. The inscription, "This is not a pipe", is a continuation of reality. This is the same reality which, in the artist's own words, loses its everyday character and appears in mysterious character.

In this picture, Magritte yoked representation and speech together in a single composition, and this became one of the main themes of his painting. In the journal *La Révolution surréaliste*, he published a table in which he reviewed possible cases of a link between a word and an image – there turned out to be eighteen such cases. "An object is not so attached to its name that another name cannot be found within it that would suit it better;" "There are some objects which need no name"; "A word is sometimes only used to indicate itself"; "Sometimes the name of an object serves as an image"; "The word can take the place of an object in reality" etc. In the table, each thesis is accompanied by an illustrative image. In effect, Magritte supports each thesis with his paintings.

Words became an inseparable element of his painting. Sometimes he depicts specific objects – for example, a leaf, a stone and a jug – and accompanies them with words that designate other objects: the Table, the Ocean, the Fruit (*Table, Ocean, Fruit*). In one instance, he accompanies words on the canvas with dots in the manner of a map in an atlas: tree, cloud, village on the horizon, etc., and calls the picture *Swift Hope*. In another instance, the words themselves become representative objects, and he writes them at points he has set aside on his canvas: a figure bursting out laughing, horizon,

René Magritte,
The Castle in the Pyrenees, 1959.
Oil on canvas, 200 x 145 cm.
The Israel Museum, Jerusalem.

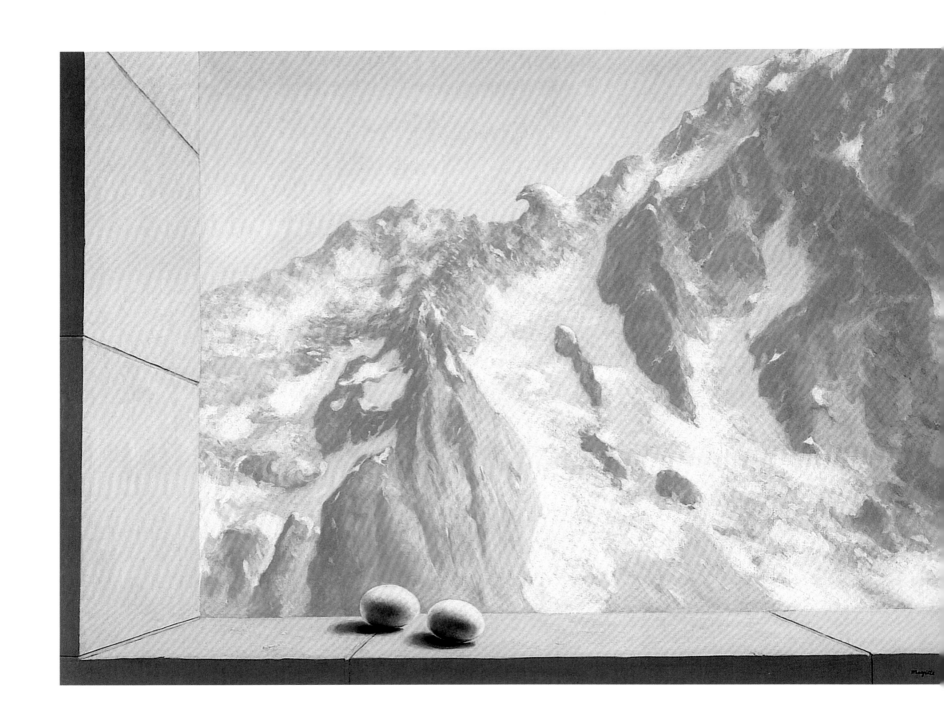

René Magritte,
The Domain of Arnheim, 1938.
Oil on canvas, 73 x 100 cm.
Private Collection.

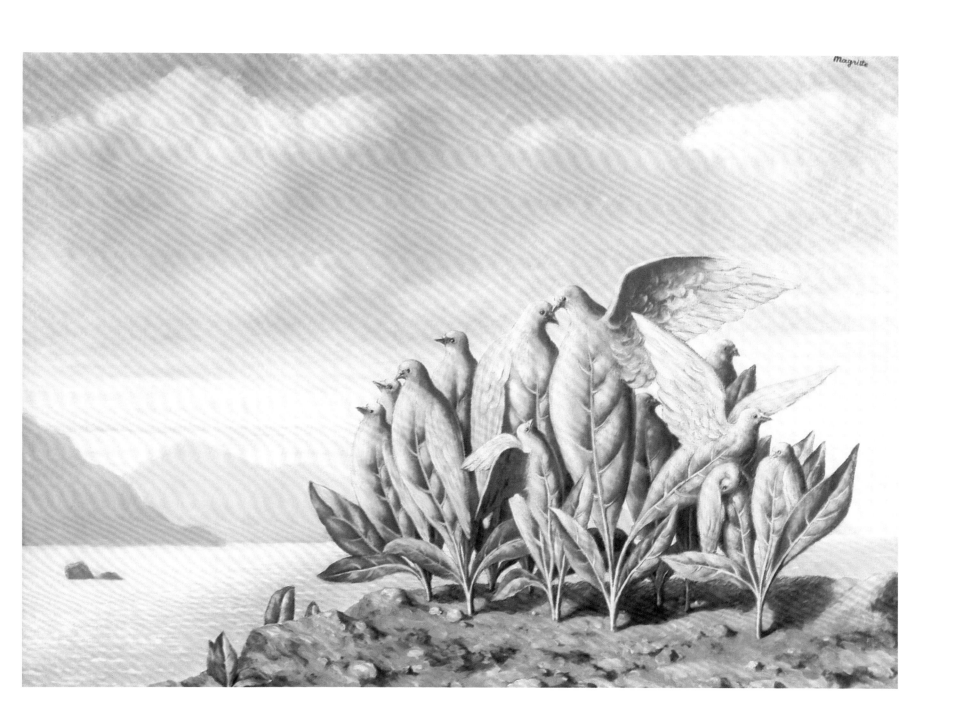

René Magritte,
Treasure Island, 1942.
Oil on canvas, 60 x 80 cm.
Musées royaux des Beaux-Arts de Belgique,
Brussels.

wardrobe, cried of birds; and calls it *The Living Mirror*. Moreover, each word is written in his vivid handwriting, and in this way becomes a graphic element of the picture. "To be able to answer the question: What is the meaning of these images?" said Magritte, "would be a matter of making the Meaning, the Impossible, look like a possible idea. To attempt to reply to it would be to acknowledge that it did have a meaning."[171]

The title of a Magritte painting is another of his enigmas and another of the ideas behind his painting. If the words "This is not a pipe" can be treated as an explanation of the fact that the representation of the object is not the object itself, then the title of the picture does more to conceal its sense than to reveal it: *The Treason of Images*. One of the methods of the Surrealist artists which had already manifested itself in Dada period was the way they gave absolutely inappropriate and often paradoxical titles to their pictures. The picture entitled *The False Mirror* depicts a human eye in which, just as in a mirror, the sky and the clouds are reflected. In a picture entitled *Marine*, a seascape is actually represented, but, as though in a mirror, it is reflected in a plaster female torso – this bust, something Magritte often employed in his paintings, lay in his possession at his home. Most often, the title would seem to imply another, hidden meaning which one would like to discover but which is indecipherable. One of Magritte's famous paintings is of a seated man whose torso has been replaced by a cage of pigeons and is called *The Therapist*. There are instances in which the painting title is composed to support the poetic element very often contained in these works: *The Call of the Peaks*, *The Autumn Princes* and *The Legend of the Centuries*.

Between 1925 and 1927, Magritte painted pictures of vast dimensions. "One could easily imagine that the explosion around them is something from prehistoric times, where excess is the rule and where beings and worlds are being formed", wrote Scutenaire.[172] The critics called this the period of "anti-painting". Nevertheless, Magritte's painting was still painting; his means were (the painted placement of) colour and texture on a surface. In this period the forms of the objects were rough, the surface was smooth and the colours dark and predominantly earthen. In the words of Scutenaire, "… he was thinking about the best way of operating on the local knowledge that we have of objects, and for this he made use of every form of thought."[173] He always retained this aim, though the constructions of the composition and the colours would change.

In the period from 1927 to 1940, his painting became softer, the provocative roughness vanished, and the poetry which is typical for him won out. "In the course of this period, the painter invented his *problems*", writes Scutenaire. "He associated an object of some kind with another object, to bring into view the obvious relationships which they have to one another when they are subjected to reason: the cage and the egg, the tree and the leaf, the mountain and the eagle." In this period, the "Keys", those "which will always create the illusion of having uncovered the meaning of his paintings, appeared." "One night in 1936, I woke up in a room where someone had put a cage with a bird asleep inside it", wrote Magritte in "The Lifeline". "A wonderful mistake caused me to see the bird in the cage vanish and be replaced by an egg. I was holding there a new and astonishing poetic secret, because the shock which I felt had been provoked precisely by the affinity of these two objects."[174] However, the transformations were not complete: the egg in the cage became enormous, to the point where it occupied all the space inside it. Magritte played with proportions, making the real unreal. Those same cup-and-ball toys, among which the jockey has lost his way, enter the design of the cage. And the name of the picture is the title of Goethe's novel: *Elective Affinities*.

The artist's play space, and the strange transformations of interiors and landscapes remained one of his obsessions in the 1930s. A window is smashed, and splinters of glass on which fragments of

René Magritte,
The Pleasure, 1946.
Gouache on paper, 36 x 49.5 cm.
Private Collection, Brussels.

the landscape have left their imprint are scattered on all sides (*The Key to the Fields*). "After a moment of astonishment that is easily understandable", one of Magritte's biographers wrote, "if we ask ourselves what the significance of all this is, one single answer comes to mind, to know that illusion has the same value as tangible reality."[175] More than once, a landscape in a painting resting on an easel constitutes a fragment of the real landscape and coincides precisely with it. Sometimes this image becomes more complicated: in *The Call of the Peaks* the mountainscape is transformed into an eagle made of stone. And, as always, Magritte himself explained everything very simply through his impressions of reality: "*The Domain of Arnheim* realises a vision which Edgar Allan Poe would have loved a great deal: it is an immense mountain which takes the exact shape of an eagle with outstretched wings."[176] The image of an eagle turned to stone was to remain a constant feature of his work. It is real, and other birds flock towards it, but the cracked stone of which it consists is also real (*Lost Steps*).

In Magritte's œuvre, the period from 1940 to 1946, around the time of the Second World War, is called the "*plein soleil*" (full sun) period, but the artist himself called it "accursed". "Strictly speaking, it is a challenge", Scutenaire explains, "to obtain the shattering impact, from the starting-point of joyful images that has hitherto been the preserve of horrifying or sombre images, and thereby to affirm man's right to give the kind of meaning to the world he desires."[177] In the pictures of this period, some objects acquire the attributes of others. Owls grow up from the ground in a setting of leaves, and although neither the one nor the other appears frightening in itself, the picture breathes suspicion and menace (*The Companions of Fear*; *The Saviour of Tears*). "I have had the idea of solving the problem of the infinite with the bird, and it is very fine, I am already thrilled about what you have yet to discover", Magritte wrote in one of his letters.[178] The motif of birds growing up out of the ground is a constant in Magritte's works. He introduced slight changes to the motif, turning over the problem from side to side (*The Saviour of Tears*; *Natural Graces*). In another picture, a man – none other than Louis Scutenaire – destroys the notion that a brick wall is firm by thrusting his hand into it (*Universal Gravitation*). Magritte depicted his friend with a gun and in a cap, accentuating the ordinariness of the situation. The thrusting of his hand into a brick wall not only evokes memories of Newton and Einstein's discoveries, but also provokes anxiety with its prophetic implications, signalling the changes that await any man. When Magritte depicts round rattles, magnified to gigantic dimensions, and suspends them in the sky over a simple rural landscape, he automatically evokes associations with spacecraft from another planet, with flying saucers (*The Flowers of the Abyss II*). However, he began to paint these spherical objects hanging over the earth in 1926, when no fantasist had yet written about the existence of flying saucers. He gave various titles to his pictures: *The Signs of Evening*, *The Voice of the Winds*, *On the Threshold of Liberty*. These titles emphasise that note of poetic sadness before the mystery of the unknown which is often particular to Magritte's pictures. And, as always, the mystery is born of everyday, ordinary reality. In "Lifeline", Magritte wrote: "I would prefer to believe that the small little iron bells hung around the necks of our fine horses grew like dangerous plants at the edge of the abyss."[179]

For a short period, one which can be called the "Renoir Period", Magritte changed his painting technique. In a letter to a friend, the artist explained the change as follows: "On the subject using the Impressionist technique in [creating] images, it is legitimate to make use of it because it is the best way that we know for bringing poetry into the sunlight."[180] His technique became like that of the Impressionists, but his images were still the old, enigmatic images of Magritte: a mermaid with the face of Georgette dozes on a pink sofa (*The Forbidden Universe*); living toes grow out of a pair of boots standing beside a wooden wall (*The Red Model*).

René Magritte,
The Art of Conversation, 1950.
Oil on canvas, 65 x 81 cm.
Private Collection.

In the changed post-war world, Magritte, in Scutenaire's words, "sought the Heart of the world with a cold excitement. The night brings round the day, the moon the sun, the bird becomes the air, the ship the sea, the eagle the mountain, men fall from the sky or else are formed from grey stone, while women are formed from blue water, and Scheherazade has a hint of pearl."[181]

The brief period in 1948, when the Galerie de Faubourg in Paris invited Magritte to mount his solo exhibition, is called the "*vache*" (cow) period. It was a moment of bold conceptual attempts in his art, drawing and colour. Despite the failure of the exhibition, where not a single painting was sold, from that moment a sense of the artist's absolute confidence in his vocation and in his chosen means of expression appeared in Magritte's painting.

To the end of his life, Magritte discovered surprising, poetic and mysterious motifs, and varied those that he had already employed. In 1948, he created a new version of *The Rape* which he had previously drawn for the publication of Breton's essay in 1934 (*The Rape*). Magritte knew how to combine the erotic with a sense of humour. The human face was one of the devices through which he was able to reflect on the world, and one of the elements he used to create an image of it. In the 1940s and 1950s, the artist repeated the composition entitled *Memory*. It represents a combination of a marble head from antiquity, his favourite round rattle, and a green leaf on a stone balustrade with a landscape as backdrop. It is possible that there is a reference here to the same de Chirico picture, *The Song of Love*, which was one of the wellsprings of his Surrealism. However, Magritte's secret consists in the fact that the combination of objects itself conceals a mystery. A beautiful woman's face is disfigured by a red spot – what is it, blood, or simply paint on a marble sculpture? The disposition of the objects changes a little, the day turns to a moonlit night, and the expression of the face changes. No one except Magritte knew how to run through such a range of constantly changing shades of emotion (*Memory II*; *Memory IV*). In Magritte's Surrealism, these transformations of the same motif occupy roughly the same position as do the series of landscapes in Claude Monet's Impressionism.

One of the most interesting of the series he completed was that on the theme of *Memory of a Journey*. Magritte depicted his friend, the poet Marcel Lecomte, in the prosaic setting of a room, standing in an overcoat with a book in his hand (*Travel Memory III*). The only unusual detail is the lion lying in the room. It is reminiscent of the *Sleeping Gypsy* by Le Douanier Rousseau, in whom, and not without reason, the Surrealists saw their predecessor. However, there is nothing out of the ordinary for Magritte about this composition, and his mystery is in something else. The real, everyday world is turned to stone under the eyes of the viewer – not only the man and the lion, but the table, the vase and the apples, and even the objects in the picture on the wall. For Magritte, the tragedy of the end of the world is contained in the motif of the transformation of the whole of one's surroundings into stone. To the end of his life he reworked this motif. Sometimes the transformation of animate matter into a mineral is accompanied by playing with contrasting dimensions – a gigantic stone apple is left on an empty beach, each crack in its surface clearly visible by the light of a tiny crescent moon (*Travel Memory*). In another version, a candlestick stands on a beach among stones under a cloudy sky, and the candlestick itself has been turned to stone.

Stone became a sort of obsession for Magritte. Everything animate is turned to stone. He knew how to convey the texture of the stone with surprising verisimilitude. Sometimes the lump of stone occupies the entire area of a small room, which would have been impossible for it to get into, and this is frightening (*The Birthday*). In the monumental canvas, *The Castle in the Pyrenees*, a whole rock is suspended over an expanse of the sea, and the castle sits on top of the rock. This is a frightening scene, yet in the reality of the painting, there is nothing frightening about it. It is instead a poetic image of a castle from a dream,

189

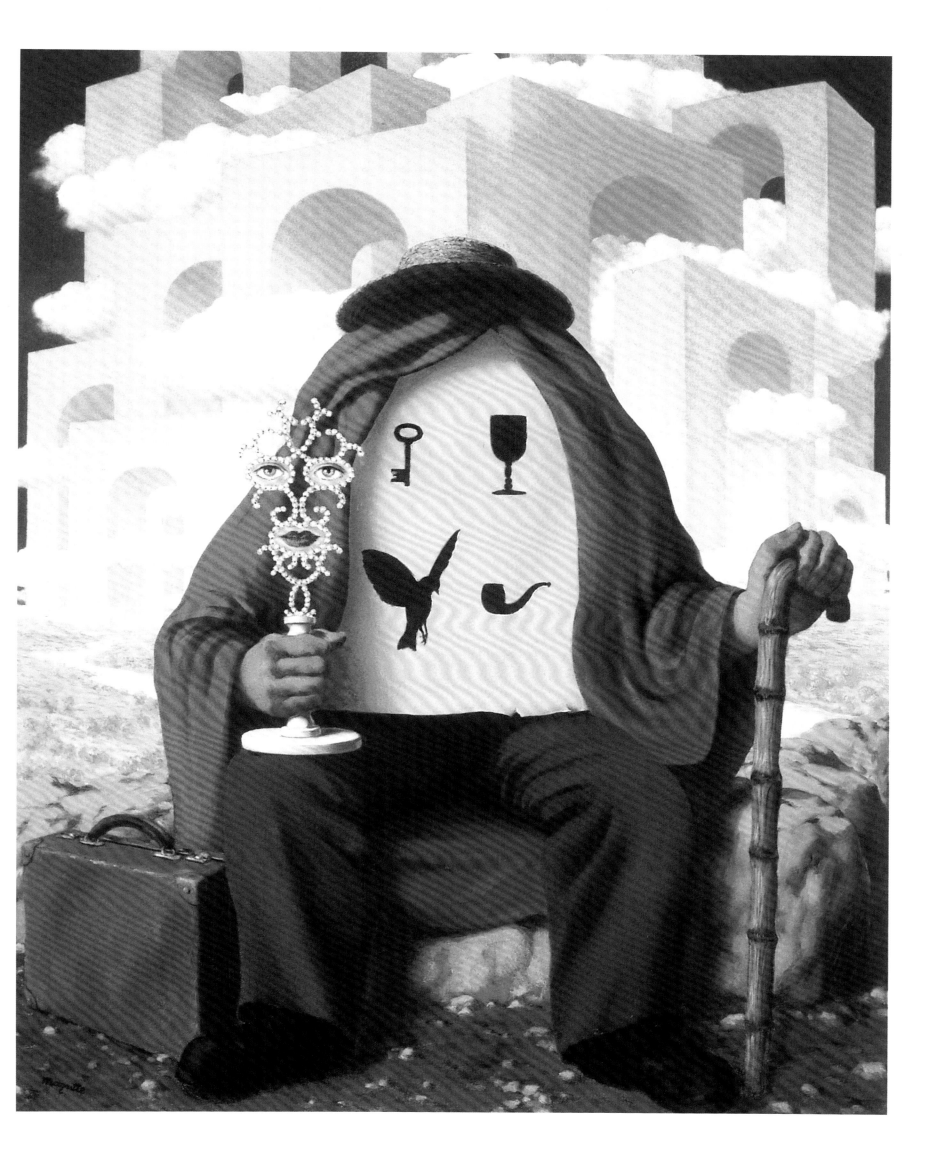

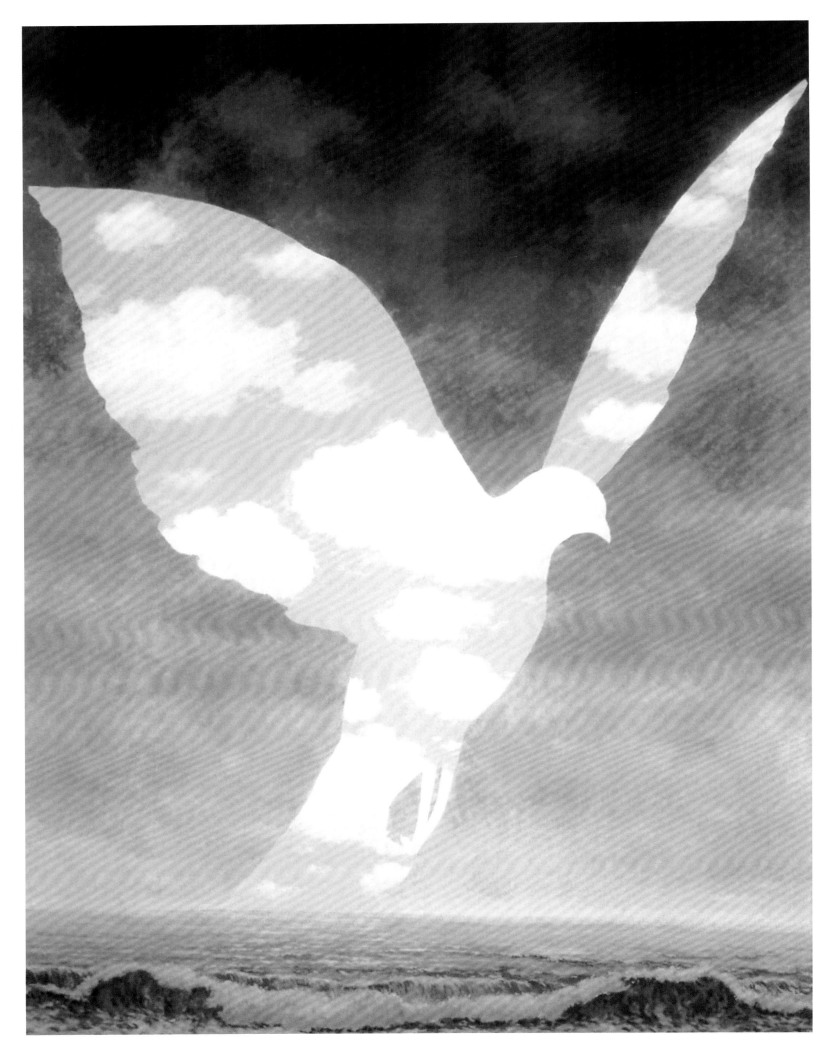

192

"between heaven and earth", as Magritte's favourite writer Edgar Allan Poe described it in *The Domain of Arnheim*. The stone of which the gigantic letters are composed conveys the grandeur of the primeval world, where it is a sort of language and method of communication (*The Art of Conversation*). Nothing that was subsequently created in the following centuries and millennia bears any kind of comparison with the powerful simplicity of the stone seat carved by the hands of primitive man (*The Legend of Centuries*). In the words of Magritte's friend Marcel Marien: "Before starting its career in the service of man, the chair, in its heart, is at rest."[182]

Objects which in themselves had nothing strange about them always remained a source of inspiration to Magritte, and he linked them together in puzzling combinations. A clear example is the composition consisting of a glass and an umbrella (*Hegel's Holiday*). In a letter to a friend, Magritte told the story of the process by which this motif was transformed:

> My latest picture began with the question: how can I paint a picture of which
> the glass of water is the subject? I have drawn numerous glasses of water,
> etc., and a line can always be found in these drawings. This line then got
> squashed, and took the form of an umbrella. Then this umbrella was put into
> a glass; and finally the umbrella opened up and was placed underneath a
> glass of water. This seemed to me to answer the initial question. The painting,
> thus conceived, is called *Hegel's Holiday*. I believe that Hegel would have
> loved this object, which has two contrary functions: to repel water, and to
> hold water. Perhaps this would have entertained him in the way you are
> entertained on holiday?[183]

It was necessary to have his poetic imagination in order, after making some slight changes to the combination of elements in the composition, to find the poetry in a prosaic setting. Who, apart from Magritte, could see the sky and the clouds through a bird in flight, or a landscape through a human figure – through his own figure (*The Big Family*, *Bluebird*, *The Friend of Order*)? Or, even more simply, near his own house, in a landscape seen a thousand times, who else could experience night and day at the same time (*The Empire of Lights*)? Magritte explained:

> The landscape evokes the night, and the sky evokes the day. This evocation
> of the night and the day seems to me to be endowed with the power to
> surprise and to enchant us. I call this power "poetry". If I believe that this
> evocation has poetic power of this kind, one of the reasons is that my
> emotions have always taken the greatest interest in the night and in the day,
> although I have never felt a preference for the one or the other. This great
> interest in the night and the day is a feeling of admiration and surprise.[184]

Magritte achieved what he wanted to do in his painting with remarkable clarity and simplicity. If a Magritte fan was asked to name one of Magritte's paintings, which one would he think of first? No doubt everyone has a particular favourite of his own. But there are canvases which evoke in everyone the same "feeling of admiration and surprise", such as *The Blank Cheque*. "The title refers to a displacement of space", said Magritte. "Visible things can always hide other visible things. The woman who is passing in front of the four trees hides them. The other trees hide her. *The Blank Cheque* is the authorisation she has to do what she is doing."[185]

René Magritte,
The Big Family, 1963.
Oil on canvas, 100 x 81 cm.
Utsunomiya Museum of Art, Utsunomiya.

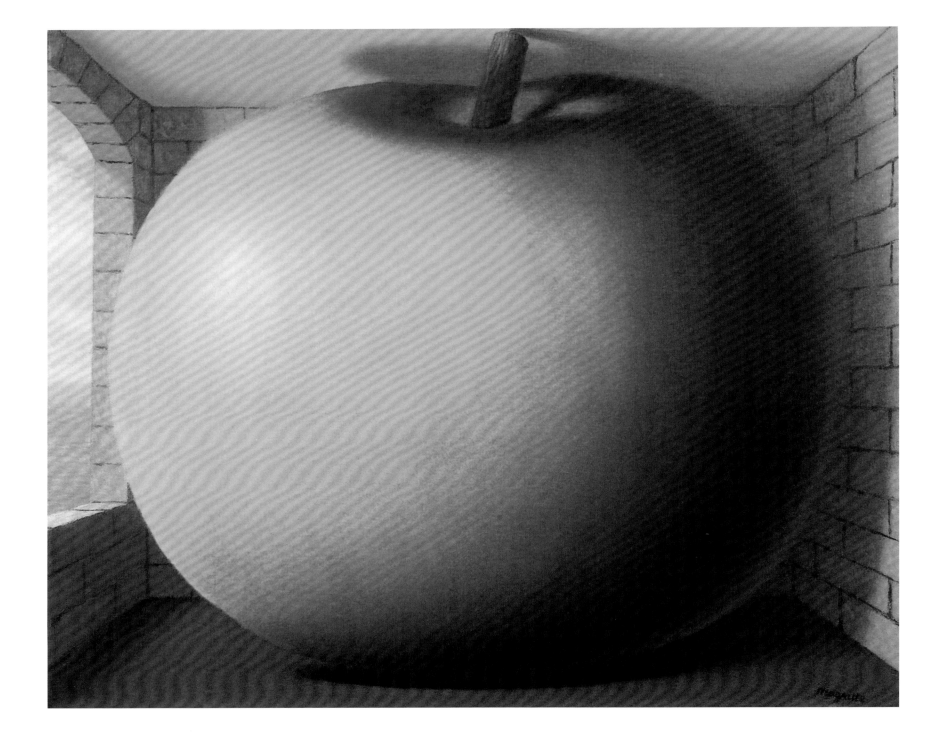

René Magritte,
The Listening Room, 1958.
Oil on canvas, 38 x 46 cm.
Private Collection.

René Magritte,
The Son of Man, 1964.
Oil on canvas, 116 x 89 cm.
Private Collection.

Belgium recognised René Magritte as one of its greatest artists. The 1950s saw the beginning of a succession of his exhibitions at the Palace of the Fine Arts in Brussels, in the galleries of Belgium and Paris, in Italy, England and America. Magritte completed monumental paintings for the Théâtre Royal des Galeries in Brussels and for the casino of Knokke-le-Zoute. He painted *The Mysterious Barricades* for the hall of the Congress of the Albertine, and for the Palace of the Fine Arts of Charleroi he painted a mural entitled *The Ignorant Fairy*. He made short films and was a frequent contributor to Belgian magazines. In 1965, Magritte went to the United States for the first time. He viewed America with the kind of admiration and surprise that were natural to him. "I had been told that there were squirrels running free in Central Park. I did not miss the chance to see them", Magritte said on his return. "Would you believe it? I did not meet a single gangster – a real pity, when I adore the 'Série Noire' and crime films."[186] He died on August 15, 1967 at his home in Belgium.

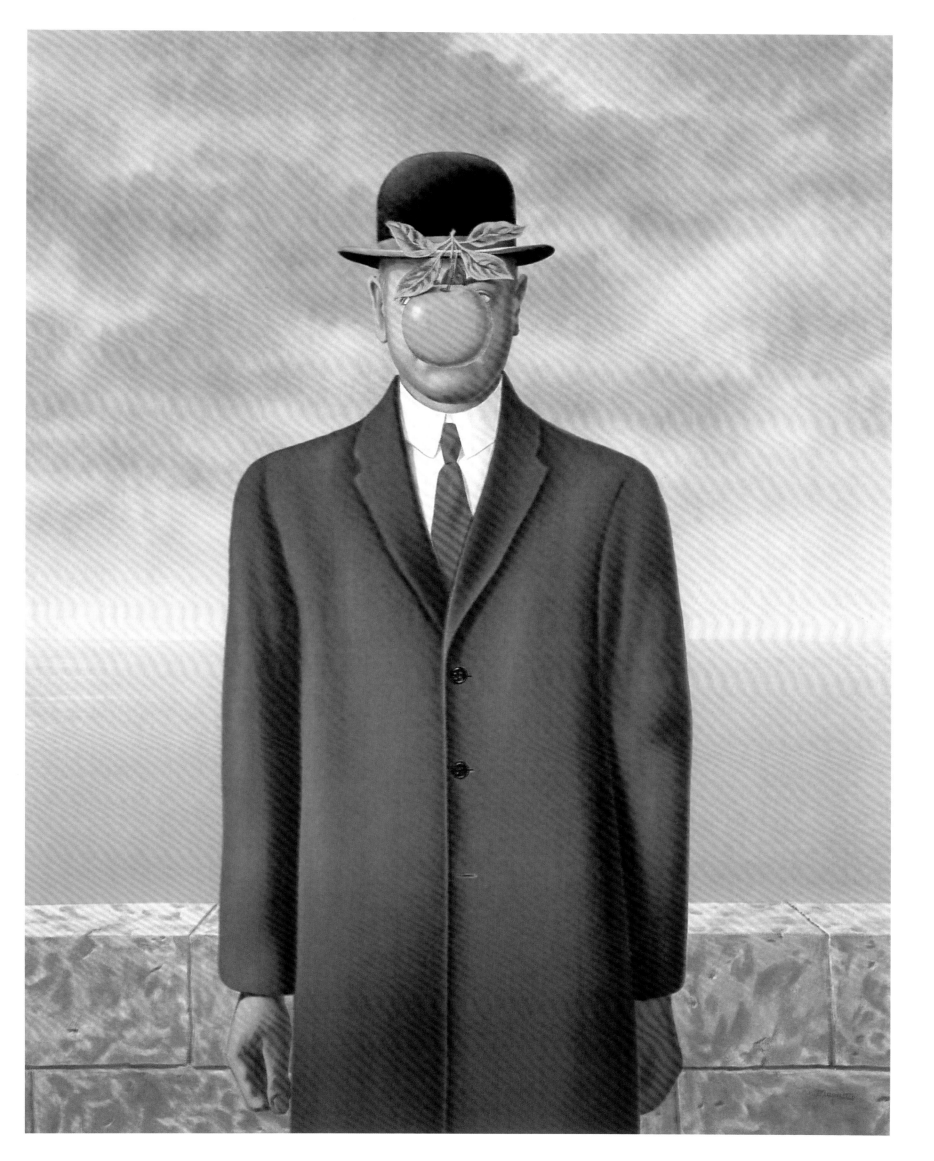

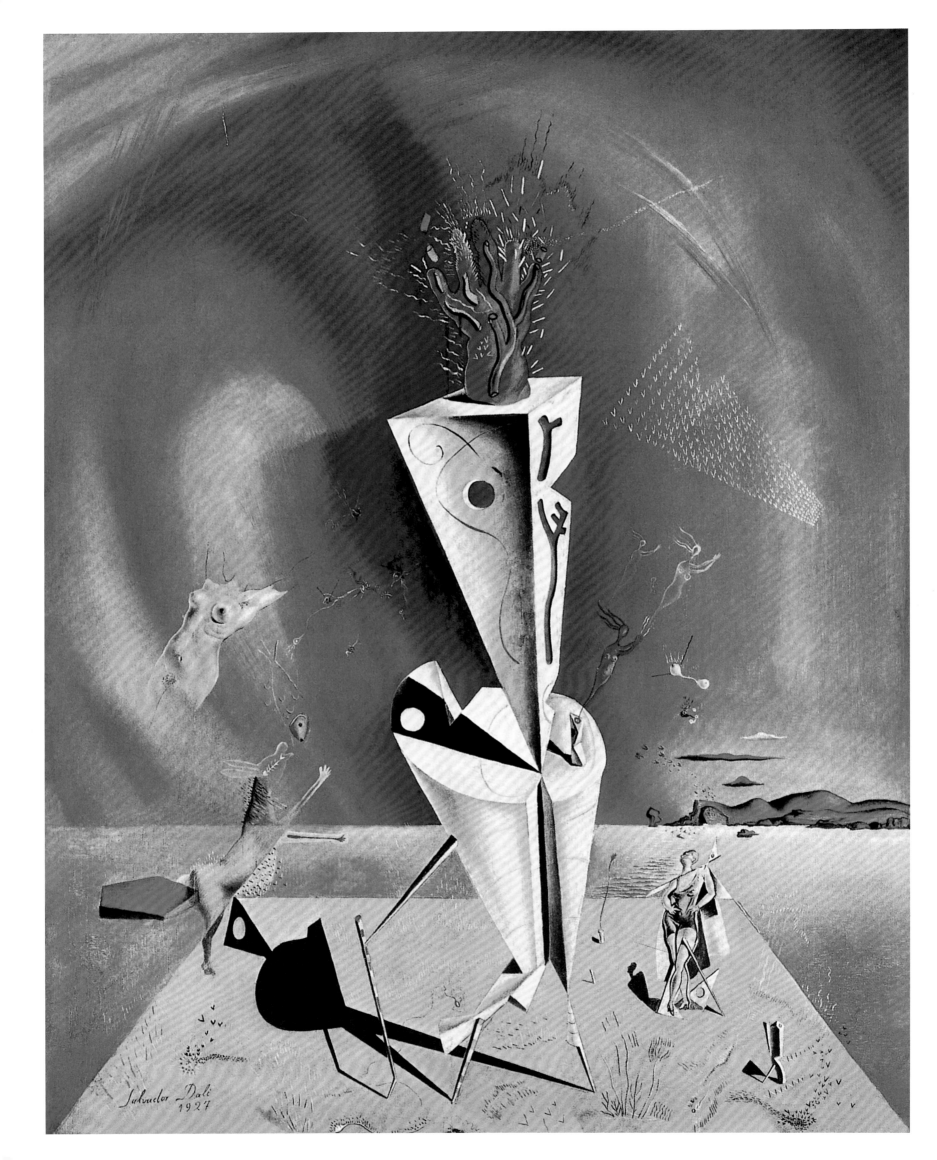

SALVADOR DALÍ

1904-1989

O Salvador Dalí of the olive voice!
I am saying what your person and your paintings say to me.
I do not praise your imperfect adolescent paintbrush,
But I sing the perfect direction of your arrows.

I sing the fine attempt you made with the Catalan light
And your love for everything that is explicable
I sing your astronomical and tender heart,
Your Heart made for the card-table, your heart without a wound.

I sing the anxiety of the law you constantly pursue,
The fear of emotion which awaits you in the street.
I sing the little siren of the sea who sings to you,
Atop a bicycle of corals and sea-shells.

But above all I sing a common way of thinking
Which unites us in the dark and golden hours.
The light of art has not spoiled our eyes,
It is love, friendship and fencing that blinds us…

May traces of blood on the gold-like typescript
Pierce the Heart of eternal Catalonia!
May the stars, like fists without a falcon, shine on you,
While your painting and your life prosper… ![187]

Salvador Dalí loved "the eternal Catalonia" and his wife Gala, Elena Diakonova. But what he loved most of all was himself and his work. He spent his life shaping the image of his genius, assembling it from the very smallest elements like a childish builder with his fragile model of little bricks. He lovingly sharpened and polished it, adding on more and more new details. Dalí was a talented writer, and his words were persuasive, creating the impression of absolute sincerity. It seemed as though he turned his soul inside out, sparing nothing of himself. Not surprisingly, when his sister Anna-Maria wrote about him in her turn, Dalí was beside himself. Although his sister's book is full of admiration for Dalí's genius, its candid and straightforward account of episodes from childhood and youth in its way debunked his carefully constructed image. It showed that his image was wholly artificial. "I wrote this book as a counterpoint to Dalí's mask", says Anna-Maria. "I wrote about the man who had not yet hidden his face behind a mask. Back then, Salvador had not yet thought of devoting himself to putting on an act day after day."[188] It has become extraordinarily difficult for those who come after him to imagine what kind of man the real Dalí was. One has to resort to rooting out the grains of truth one by one from among the dirt and showbiz tinsel under which he so assiduously buried them. In the final analysis, the true Dalí lies in the bare facts of his life and the works that he created.

Salvador Dali,
Apparatus and Hand, 1927.
Oil on wood, 62.2 x 47.6 cm.
The Salvador Dalí Museum,
ancient E. and A. Reynolds Morse Collection,
Saint Petersburg (Florida, USA).

Salvador Dalí was born on May 11, 1904, in the town of Figueres in Catalonia. His father, Salvador Dalí y Cusi, received a legal education and was a notary in Figueres. Brought up in his sister's anti-clerical family, he sent his son to the local school. When his son reached the age of eight, his father moved him to the École Catholique de la Salle, a French foundation. At this school, Dalí learned to speak French like a native. It was here that he received his first lessons in painting and drawing. His father allowed Salvador to set up his studio in the attic in the former laundry-room of their home. Mother, grandmother and aunt immensely spoiled the sickly little boy. Later on, he completed a portrait of himself at that age at Cadaques, where his father was born and where they spent the summer – a little boy with very big eyes and a scarf at his throat, sitting with the sea in the background, a bottle of medicine on the table, and a little parrot in a cage (*The Sick Child: Self-Portrait at Cadaques*). From her childhood, his sister Anna-Maria, who was four years younger than the artist, absorbed the atmosphere of religious devotion surrounding her elder brother within the family. In 1921, his mother, Felipa Domenech, died. For Salvador, who had admired her, this was a cruel blow. Very soon afterwards, his father married his wife's sister, Catalina, who had been living in their house for a long time already and who loved Salvador. In his books, Salvador Dalí paid much attention to childhood impressions. It turns out that Dalí had an elder brother who died of meningitis seven years before he was born. Dalí never saw his brother, but he was given the same name – Salvador, Saviour – and all his life Dalí had the sense of a certain duality, as though he lived in a state of coexistence with his brother and inhabited the same being. At the end of his life Salvador Dalí continued to paint portraits of the first Salvador, his brother (*Portrait of my Deceased Brother*). It is difficult to make a clear distinction between what is true in his memoirs and what is the product of his rich capacity for fantasy. In either event, his tales often explain the meaning of his pictures.

In Figueres, Salvador simultaneously studied at art school as well. In 1917, he received the artistic Academy's diploma and first prize for the best drawing. At fourteen, Dalí not only drew wonderfully, but also knew about modern developments in European art. In 1914, he painted a portrait of his nurse, Lucia (*Portrait of Lucia*). The old woman's face is painted with uncompromising expressiveness. The young artist not only gave professional shape to her form through broad brushstrokes, but also gave himself the freedom to use a style of painting which testifies to his own self-confidence. In love with the natural world of Catalonia, Dalí often painted in the open-air in Figueres and Cadaques. Occasionally, his landscapes bear witness to his knowledge of Claude Monet's impressionist painting, sometimes a familiarity with the style of the Neo-Impressionists Seurat and Signac can be sensed in the directness of his brushstroke. His sister did not stray very far from the truth when she wrote in 1917: "Summer. Salvador in Cadaques, paints in the style of the Impressionists. In these works there is not the slightest hint of the drawing – only strong, bright spots of colour: red, yellow, green."[189] Dalí never forgot about the role of Impressionism in his own painting. "This school is, in fact, the one in my life which has most impressed me", he wrote in *The Secret Life of Salvador Dalí*. "It represents my first contact with an anti-academic and revolutionary aesthetic. My eyes could not get enough of contemplating those spots of paint, thick and shapeless, which idealized the canvas in the most whimsical fashion, until the master's backward step or the blinking of an eye miraculously gave back their forms to these tumultuous visions."[190]

Dalí's painting from around this time attests to the fact that he was then already thinking not only about colour, but also about the role that a vivid surface could play in the expressiveness of the work. He was not familiar with collages and other such experiments, but he had already made use of the boldest methods (*Dusky Old Man*). "My research took a whole year to arrive at the conclusion that only the relief of the colour itself, intelligently piled up on the canvas, could manage to create an effective impact on the eye", he later wrote. "It was the era which my parents called "the age of stone". I used

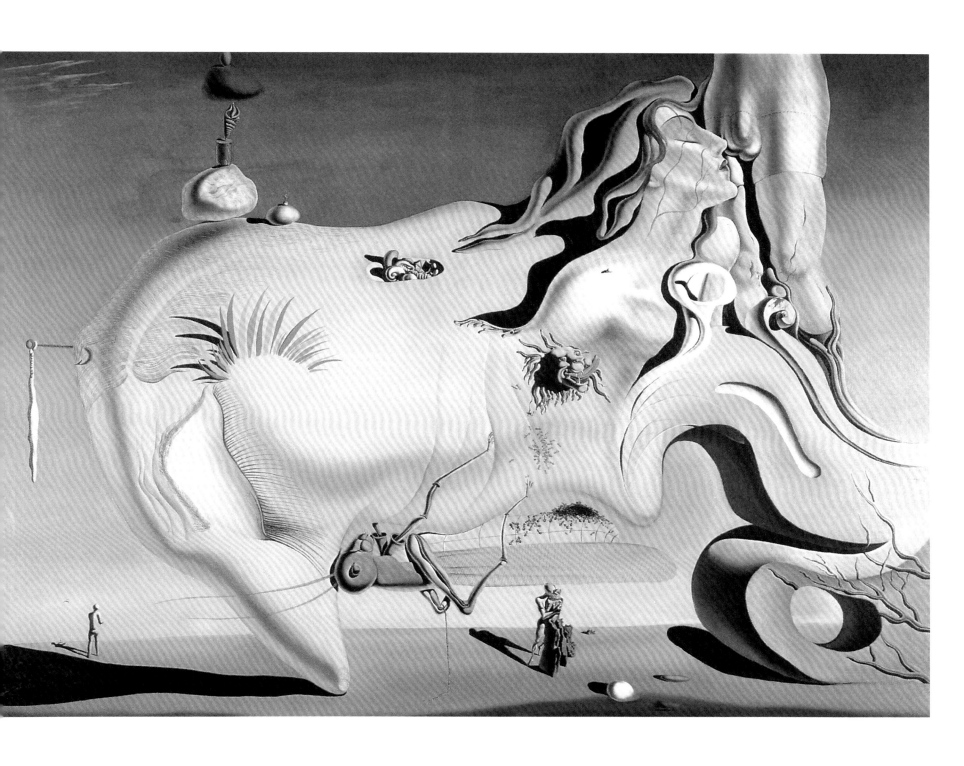

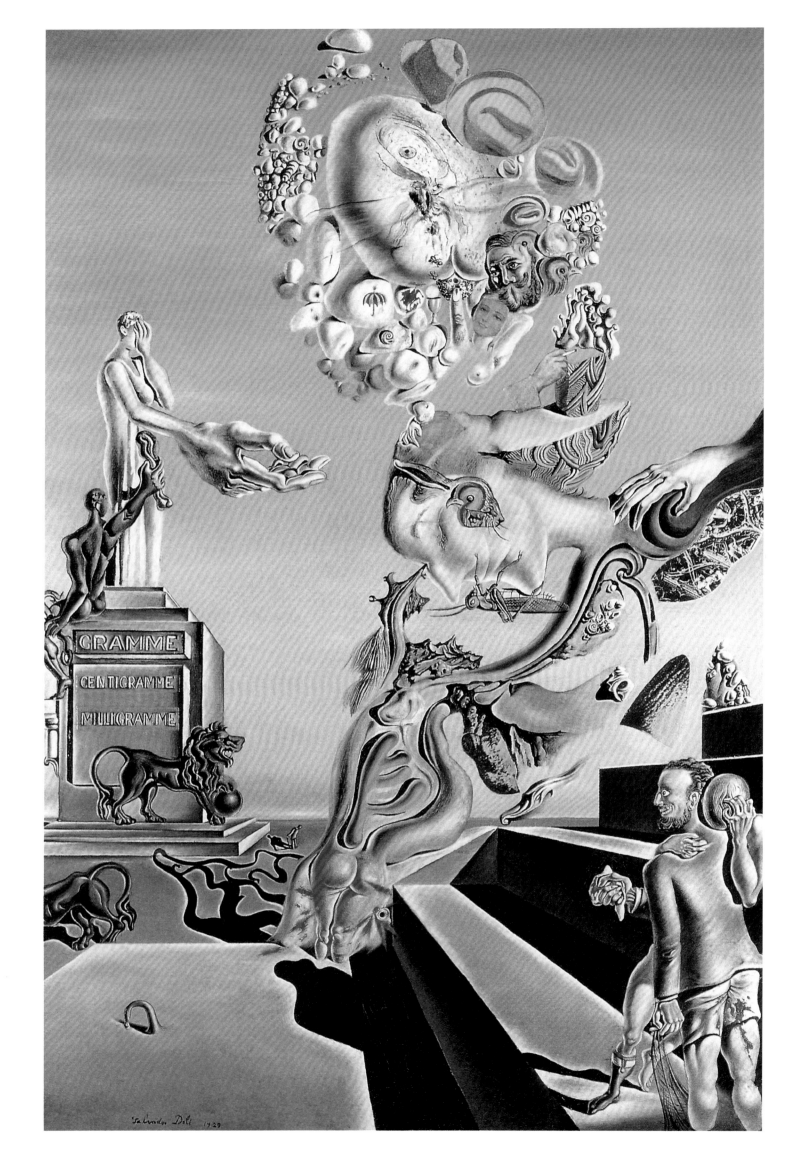

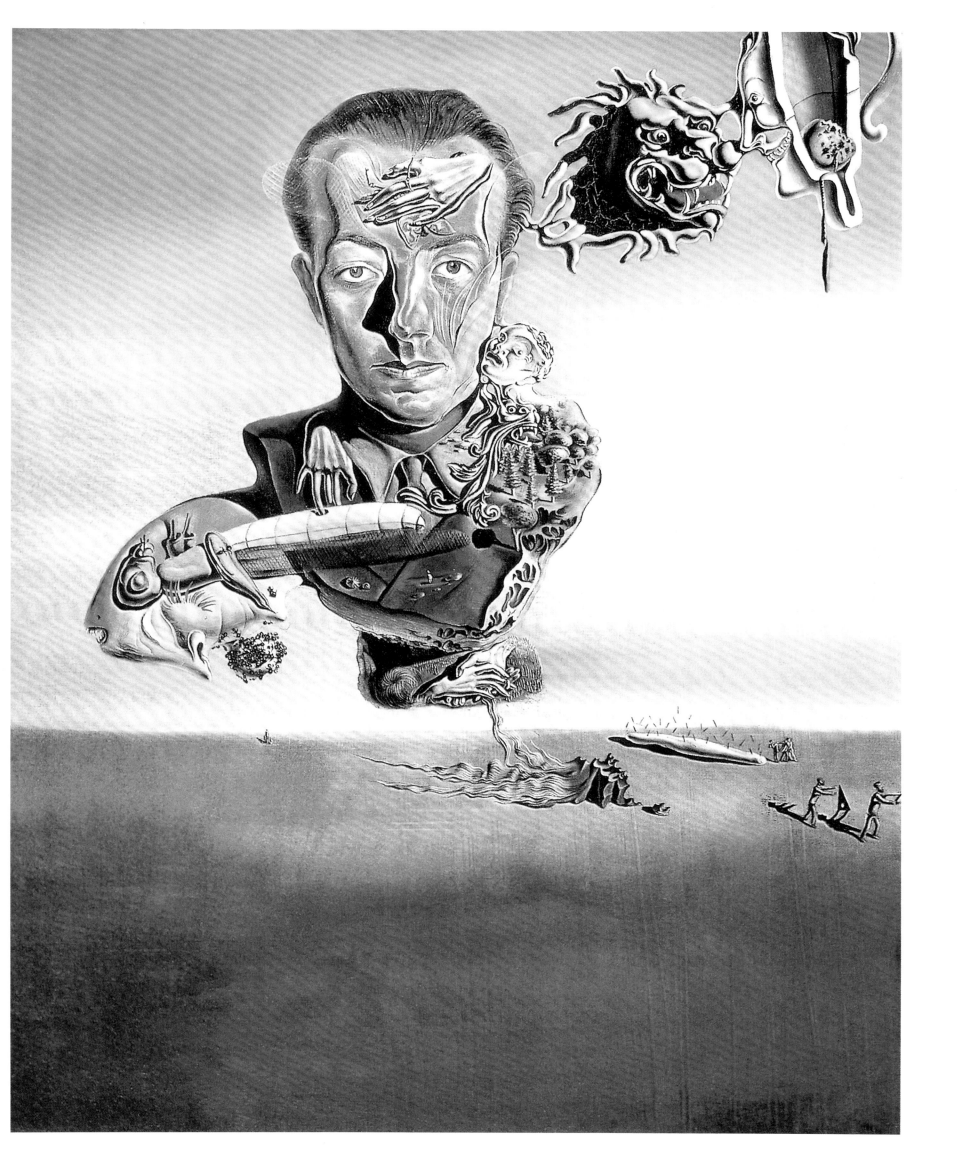

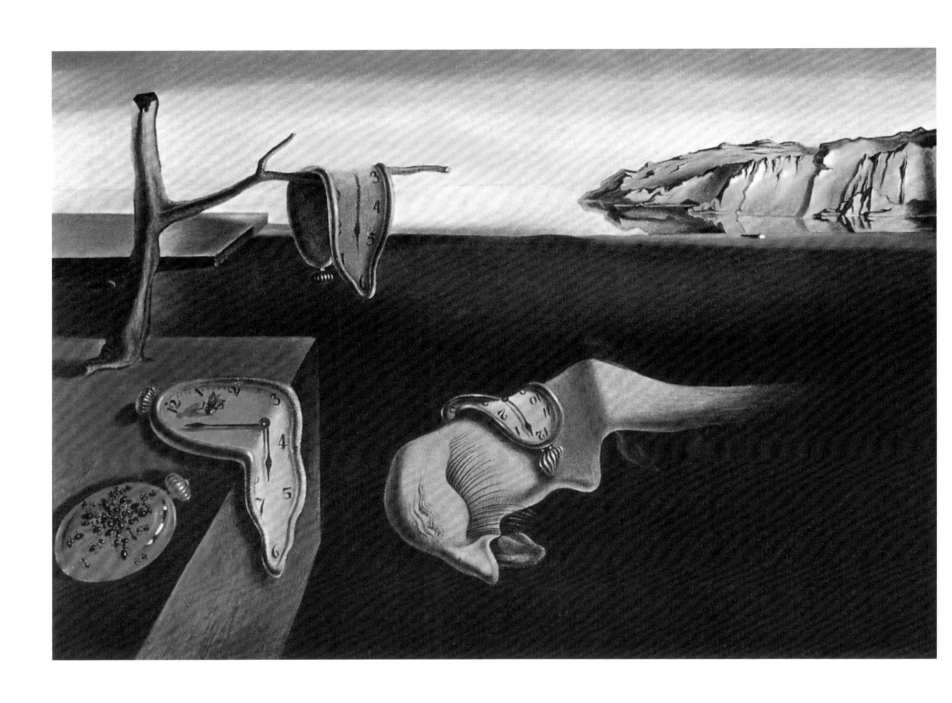

stones to obtain, for example, a very luminous cloud. Stuck onto the canvas, the stones were then painted in the desired colour."[191]

In 1919, Dalí showed a few of his works in a collective exhibition in the foyer of the Edison cinema in Figueres. People began to buy his pictures. In 1920, on commission for the municipality of Figueres, Salvador constructed a carriage for the festival of the Three Kings – he made it in the shape of an Egyptian temple. Anna-Maria cites in her book the words of a journalist from the local weekly who visited Salvador's studio:

> Dalí is tireless in his work, and works energetically, with enormous love and great faith. His pictures are sure and exact, they are vigorously worked. His talent is obvious, just as it is obvious that, from the point of view of the philistine who decorates his house with wretched oleographs, Dalí 'kicks over the traces'. The pictures which really impressed me were the ones painted this summer in Cadaques .. And the individuality of the young artist, who has a total grip on his craft and who is enchanted by the fierce light of our Ampurian sky, is felt in all of them."[192]

A self-portrait by the sixteen-year old Dalí shows him as a handsome, refined youth with a meditative expression in his large eyes and the proud countenance of Don Quixote (*Self-Portrait with Raphael's Neck*). In another canvas, light snatches a profile of the young man with a pipe between his teeth, and in a black hat out of the darkness. It recalls the romantic self-portraits of Courbet, and its expression is full of mystery (*Self-Portrait*). This was how Salvador Dalí looked when he arrived in Madrid.

The Madrid period of Dalí's youth was extraordinarily important for his artistic formation. In the spring of 1922, Salvador, accompanied by his mother and sister, arrived in Madrid to enroll as a student in the École Nationale Supérieure des Beaux-Arts. He later recalled how agitated his father was: Salvador was never able to put a drawing on a piece of paper to the scale required. Despite this, he was admitted. Dalí found a wonderful place to live. La Résidence Universitaire, an ivy-clad house on a hill, surrounded by a rich growth of poplars, acacias and pink bay-trees, was a centre of intellectual and cultural life. Many researchers and men of letters lived there, discussions and poetry readings were constantly held there, and scholars came from every country in the world. The reigning spirit in the residence was that of the Institution Libre d'Enseignment, established by the philosopher and educator Francisco Giner de los Rios, who oriented him towards "what is most liberal and tolerant in European life and culture."[193] The young Dalí immediately attracted attention with his appearance: he had long hair and sideburns, and wore an exaggerated floppy necktie, a black angora beret, and a peculiar cape. For the first time, he was somewhat on his own, until one of his neighbours noticed the young Catalan's remarkable drawings. "Dalí struck me then as very timid and taciturn", the poet Rafael Alberti recalled.

> I was told that he worked all day long, sometimes forgetting to eat… Dalí had a wonderful vocation, and in this period, in spite of his young age, he was an astonishing draftsman. He drew as he wished, after nature or from imagination. His line was classical and pure. His perfect strokes, which also recalled the Picasso of the Hellenistic period, were no less admirable: lines jumbled up with highlighted spots, lightly relieved with watercolour, clearly presaged the great Surrealist Dalí of his first years in Paris.[194]

Salvador Dalí,
The Persistence of Memory, 1931.
Oil on canvas, 24.1 x 33 cm.
The Museum of Modern Art, New York.

The most remarkable event of his life in Madrid was meeting Federico Garcia Lorca. They both lived in the University Residence. In the spring of 1925, Dalí invited Lorca to spend Holy Week in Catalonia, in Figueres and Cadaques, one of the most beautiful places of the Ampurdan district, where their house stood on the beach of Llanes. The poet was warmly received by Dalí's family and made friends with Anna-Maria. The words of Lorca's first Ode to Salvador Dalí preserve his sense of excitement:

Cadaques, poised between the water and the hill
Raises up terraces and buries shells.
Wooden flutes calm the air
And an old sylvan god gives fruit to the children.

Without taking any time to go to sleep, the fishermen sleep on the sand.
On the high seas, they have a rose for a compass.
The virgin horizon of injured handkerchiefs
Joins the glazed masses of fish and of the moon.

A solid crown of white sails
Lies round some bitter brows, some sandy hair.
The persuasive sirens are not beckoning to us.
They show themselves to the first glass of sweet water.[195]

In Catalonia, Lorca read out the drama he had written, "Mariana Pineda", which provoked excitement in the Dalí family. The romantic heroine of Granada, of which Federico Garcia Lorca was a native, Mariana Pineda became a symbol of nineteenth century noble ideals of liberty. Dalí began to work on the decorations and costumes for its staging at the Theatre Goya in Barcelona. The cooperation of poet and artist was absolute, and they understood each other instinctively. In Dalí's design, the decorations were almost monochrome, white, and the colour was wholly concentrated in the costumes. Recollections of the friendship of Lorca and the Dalí family are preserved in his correspondence with Salvador and Anna-Maria. In the collection, *Songs*, Lorca dedicated a poem to Anna-Maria. It seems that nothing threatened the warmth of these relationships.

Their estrangement was connected with Dalí's move towards Surrealism, and with the appearance of "The Catalan Anti-Art Manifesto". When Lorca's collection, "Romancero gitan", came out, Dalí wrote to him that all poetry in the classical style in which Lorca wrote was rotten and failed to express modern trends. Their friendship came to an end. Dalí saw Lorca for the last time in Barcelona, two months before the start of the Civil War. The poet Edward James, who had a villa in Amalfi, Italy, invited Dalí and Lorca to move in with him and live there for as long as they wanted. But Lorca had to go to Granada, to his ailing father. Then the Spanish Civil War began. Lorca was shot. In Dalí's memoirs Lorca would always be the bard of death. "Federico Garcia Lorca, the poet of cruel death, is dead himself, shot in Granada!" wrote Dalí. "Olé! In Paris, with this utterly Spanish exclamation, I greeted the news of the death of Lorca, the best friend of my restless youth."[196] Dalí stated that for his whole life he carried within himself a heavy feeling of guilt over Lorca's death. He thought that if he had been more insistent, then he might possibly have been able to tear Lorca away from Spain. Dalí accused himself of egotism, of reluctance at that time to share his solitude in Italy with Lorca. "He ended up being sacrificed to atone for personal, overly personal local passions, and, mainly, he fell an innocent victim to that all-powerful, convulsive, universal chaos which was called the Spanish Civil War. In any case one

Salvador Dalí,
*Partial Hallucination. Six Apparitions
of Lenin on a Grand Piano*, 1931.
Oil and varnish on canvas, 114 x 146 cm.
Centre Georges-Pompidou,
Musée national d'art moderne, Paris.

thing is not in doubt. Each time, when having sunk into the depths of solitude, I manage to kindle in the brain the spark of an idea of genius, or to draw on the canvas a stroke of fantastic, angelic beauty, I invariably hear the hoarse, deafening cry of Lorca: 'Olé!'."[197] Portraits of Lorca, which he began to paint at the moment of their warmest friendship, appear a few times later on as well in his Surrealist painting (*Invisible Afghan with an Apparition in the place of Garcia Lorca's Face in the Form of a Fruit Dish with Three Figures*).

In the summer of 1928, Dalí invited Luis Buñuel, his other friend from the period of his University Residence life, to Figueres and Cadaques. In the portrait he had painted before that visit, Dalí conveyed Buñuel's colourful individuality. His tightly pursed lips, large, expressive eyes, and the proud curve of his eyebrows create an impression of force and confidence (*Portrait of Luis Buñuel*). This portrait is evidence of the young Dalí's mastery of realism. Buñuel had been in Paris in 1925, where he had met the Surrealists.

While still in Madrid, Buñuel and Dalí planned to make a Surrealist film. Both of them got down to work on it at Cadaques. "We worked in close collaboration to make a wonderful scenario, without precedent in the history of cinema", wrote Buñuel.[198] In his memoirs, Dalí said that he did not like Buñuel's scenario, and that he rewrote it. Whatever the case, they worked together on the film, and Dalí later used many of the instances they had thought up in his own Surrealist art. Their most effective discovery was the close-up of the film in which a razor-blade cuts into a living human eye. Dalí was very pleased with how they had managed to get the revolting shot of the dead donkeys, on which he had poured glue, afterwards enlarging their jaws so as to make a frightening grin. The ants, the little insects which ran about on the palm of the hero's hand, appear more than once in his painting.

On 6 June, 1929, the silent film *Un Chien andalou* was shown in Paris at the Studio des Ursulines. Dalí came to Paris for its screening. He wanted the mixture of eroticism, death and disgust with which he had filled the seventeen minutes of his film to shock and to amaze the viewers. They got this result. "*Un Chien andalou* was the film of adolescence and death which I was going to plunge like a knife right into the heart of intellectual, elegant and cultured Paris", Dalí wrote in the book *The Secret Life of Salvador Dalí*.[199] The opinions of the press were divided: the horror of some publications counterbalanced the excitement of those others who were on the side of Surrealism. Buñuel and Dalí began work on the scenario of a second film they had thought up, but their opinions diverged: Dalí, drawn at this moment to Catholicism, was against the anti-clericalism of Buñuel. As a result, Buñuel shot *The Golden Age* alone. But Salvador Dalí entered the Paris Surrealist circles in triumph, at the peak of the success of *Un Chien andalou*. "The film obtained the results I had anticipated", he wrote. "It ruined, in one sole evening, the ten years of pseudo-intellectual avant-gardisme that had followed the end of the war. This hideous thing they called abstract or non-figurative art fell at our feet, mortally wounded and never to get up again, after it had seen a young girl's eye cut in two by a razor at the start of our film. There was no longer room in Europe for the finicky little lozenges of Mr. Mondrian."[200]

Rumours about the talented Catalan had already reached the Paris Surrealists. Dalí was in Paris for the first time in 1924. One of the Spanish artists introduced him to Picasso. Dalí showed him his painting – in any case, he always carried a painting of some kind around with him. Picasso invited Dalí to his studio. It appears as though the artists were appraising each other's work. There was already one Catalan in the Surrealist group – Joan Miró. He and Salvador Dalí's parents had acquaintances in common. Now Miró introduced Dalí to the Surrealists. The patrons vicomte Charles de Noailles and his wife Marie-Laure offered to finance a second film from Buñuel and Dalí. The Surrealists turned out in support of a showing of *The Golden Age* in Paris in 1930, and accompanied it with an exhibition. The members of the extreme right-wing organisation *Action Française* invaded the cinema and smashed up the exhibition. After this *The Golden Age* was banned from being shown in France.

Salvador Dalí,
Fried Eggs on a Plate without the Plate, 1932.
Oil on canvas, 60 x 42 cm.
Dalí Museum, Saint Petersburg (Florida, USA).

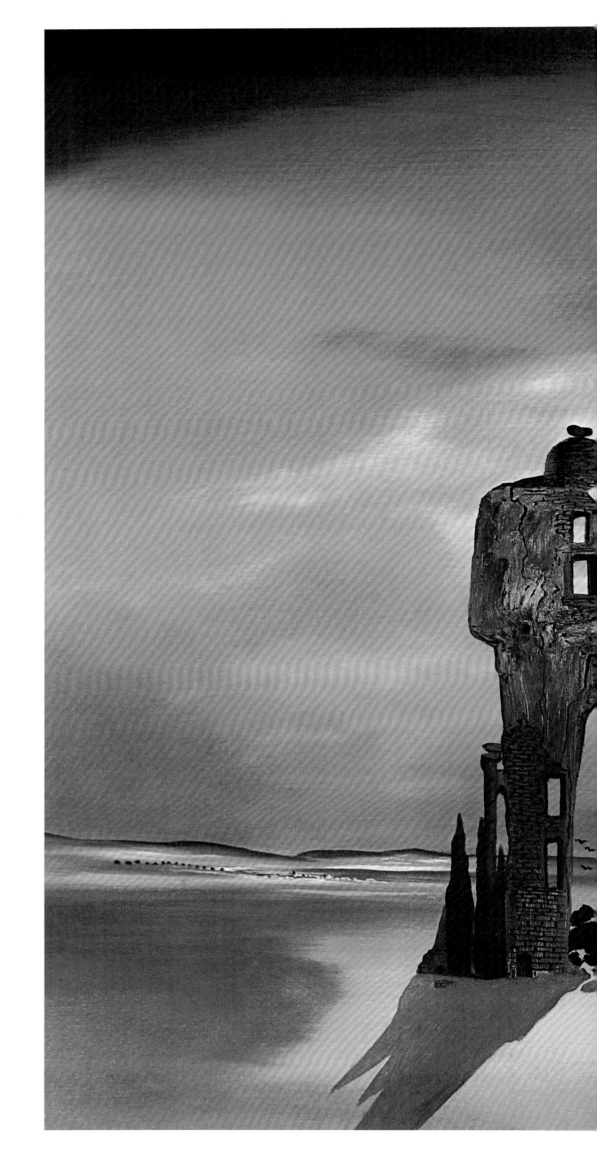

Salvador Dalí,
Archeological Reminiscence of Millet's Angelus, 1933-1935.
Private Collection.

In Dalí's private life, 1929 was marked by two events. First, he showed one of his pictures in an exhibition in Paris alongside some words insulting to the memory of his mother, and this was to cause Dalí's rupture with his family. The artist's father forbade him to return home to Figueres.

Second, during his stay in Paris Dalí invited the Surrealist group to come and stay with him in Cadaques. That summer, along with Buñuel, the art dealer Camille Goemans and his wife came to stay with him, as well as René Magritte and his wife, and Paul Éluard and his wife. A love affair between Salvador and Gala Éluard flared up at once, with dramatic consequences. In the book *The Secret Life of Salvador Dalí, written by himself*, the artist says that Elena Diakonova, Gala, as her mother preferred to call her, was intended for him by fate. In the chapter, "Childhood Memories of What Never Was", he tells the story of how in childhood, in the big box of his schoolteacher's toy theatre of optical illusions, a little Russian girl with whom at that very moment he fell in love, appeared to him : "A troika was carrying away my little Russian girl, wrapped in white fur – my little girl had saved

Salvador Dalí,
Woman with a Head of Roses, 1935.
Oil on panel, 35 x 27 cm.
Kunsthaus Zürich, Zürich.

210

herself almost miraculously from a pack of fierce wolves with burning eyes. She looked at me, not taking her eyes off me, and there was so much pride in her expression that my heart burst with admiration… Was it Gala? I never had any doubt about it – it was her."[201] In addition, the little girl was called Galiushka – Dalí's erroneous attempt at a diminutive in the Russian style from the Christian name Gala, Galina (the correct form of the diminutive is Galochka, which was how Paul Éluard addressed his wife in his letters to her).

Dalí describes his trepidation and indecisiveness at Cadaques in some detail, as well as the way Gala responded to his feelings. He writes that she cured him of the state of madness in which he then found himself. He called her by the name of Gradiva – a girl from the novel of the writer V. Jensen who cures the hero of his spiritual sickness. The Surrealists' muse became, from that moment, Dalí's personal muse. However, this did not lead to a break with Paul Éluard. "For me, Éluard was a legend, and he even bore himself as befitted a legendary figure. Paul was in no hurry, absent-mindedly glancing at the

Salvador Dali,
The Horseman of Death, 1935.
Oil on canvas, 54 x 64 cm.
The André-François Petit Collection, Paris.

beautiful women. We arranged that in summer he would meet me in Cadaques", Dalí wrote of his first meeting with Éluard in Paris.[202] In Spain, in the summer of 1929, Dalí painted a Surrealist portrait of Éluard – actually, a realist portrait, framed with a large number of little Surrealist details. Éluard very much liked the portrait and begged Gala to bring it to Paris. And in 1932 Éluard wrote a remarkable poem, "Preface to the catalogue of the Dalí exhibition at the Pierre Colle gallery":

> … It is so as not to leave these our eyes empty between us
> That she puts out her bare arms
> The girl with no jewels this way and that of the rocks and the waves
> Some women to entertain us to dress us
> Or some cherries of emerald in the milk of the dew.[203]

Éluard carried on hoping for Gala's return for a long time. But in the summer of 1929, everything was finally decided. To the end of her life Gala would remain the wife, sister, secretary, assistant and chief advisor to Salvador Dalí. Gala became one of Dalí's fetishes, his idol, and the symbol of his art. Each of his works was marked by his worship of Gala. Dalí made the following dedication to his book, *Diary of a Genius*: "I dedicate this book to MY GENIUS, to my triumphant goddess GALA GRADIVA, my HELEN OF TROY, my St. Helena, to my SERENÉ GALA GALATEA, as brilliant as the surface of the sea." Throughout the whole of his work, Dalí painted and drew new pictures of Gala again and again. For him, Gala was the Madonna (*The Madonna of Port Ligat*). She was his Leda (*Leda Atomica*). Even in those instances where the picture bore an entirely Surrealist character, Gala remained as beautiful a woman as the artist's classical skill could make her (*Portrait of Gala with Two Lamb Chops Balanced on Her Shoulder*; *Paranoiac Metamorphosis of Gala's Face*; *Portrait of Gala with Symptoms of Rhinoceritis*). When Christopher Columbus stepped out onto the soil of America, he carried the image of Gala on his standards (*The Discovery of America by Christopher Columbus*). And when Salvador Dalí was 74, the lovely Gala was depicted on a cross against the background of the vast Catalonian sky over the cliffs of Figueres (*Gala's Christ*).

Dalí came into contact with the Surrealists at the age of twenty-five. By this time he was already a Surrealist himself. The film, *Un Chien Andalou*, serves as evidence of this. However, the first attribute of the Surrealist is the possession of a realistic method. Dalí's early paintings testify to the fact that, in terms of the realism of his draughtsmanship, he had already become a professional. In 1925, when he was twenty-one, he first made a drawing of his father, and then a painted portrait of him. This portrait was done with an irreproachable modeling of both the shape of the face and the folds of the fabric, and it also had an individual character (*Portrait of the Artist's Father*). It was painted at the moment when Salvador Dalí had just been sent to prison for his involvement in anarchist student disturbances, and afterwards excluded from the Academy of Arts. "My father was overcome", the artist wrote in *The Secret Life of Salvador Dalí*. "This expulsion from the Academy of Fine Arts ruined all his hopes of seeing me make an official career. He posed with my sister for a drawing in graphite which was one of the most successful of this period. One can detect in the expression of his face the pathetic bitterness which in those days was wearing him down. At the same time as these drawings of a rigorous classicism, I was making more and more effort to join my cubist experience to a tradition."[204] Anna-Maria posed for many canvases which demonstrate that the artist was firmly in control of form and space in a picture (*Young Girl Standing by a Window*; *Young Girl Sitting, Seen from Behind*). His nude figures were painted with the admiration which he had long held for the masters of classicism, especially for Ingres (*Venus and Cupids*).

Dalí's favourite scenes from nature were the Cadaques landscape and the country round Figueres, and he never tired of painting them. "I have been faithful to Cadaques all my life, and over the years my

Salvador Dalí,
Portrait of Gala with Two Lamb Chops Balanced on Her Shoulder, 1933.
6 x 8 cm.
Fundació Gala-Salvador Dalí, Figueres.

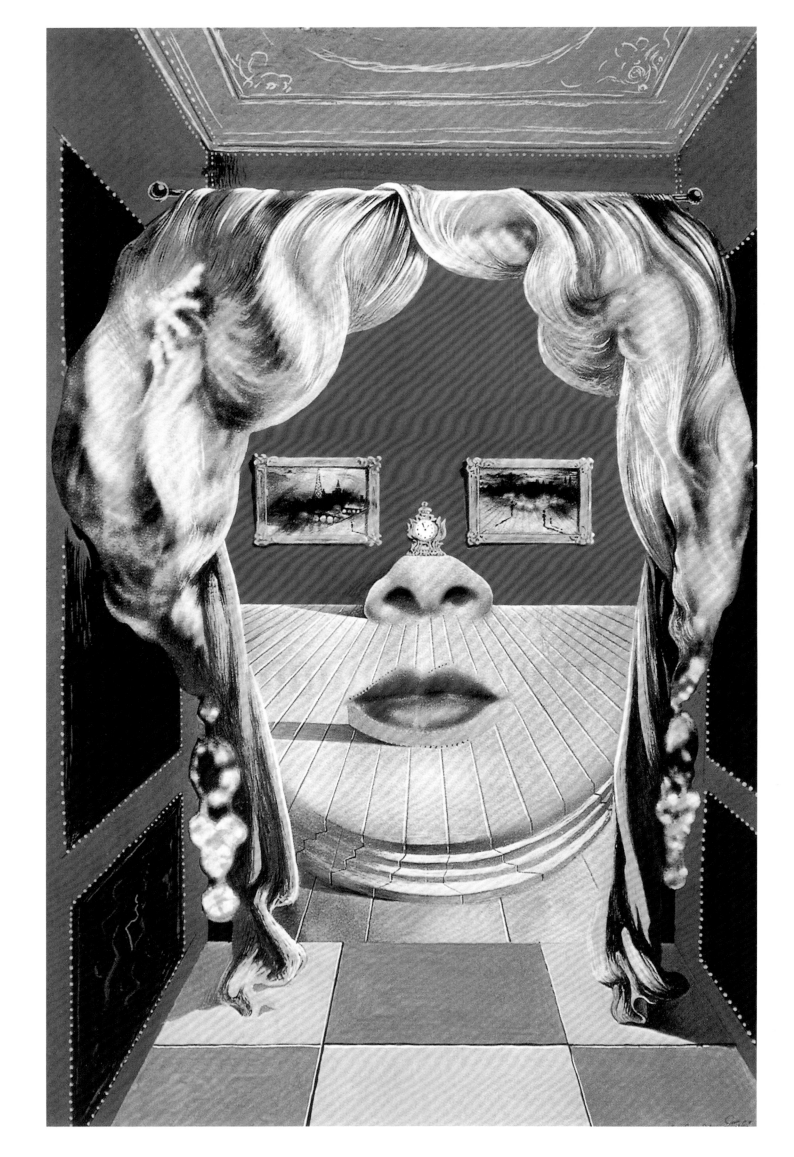

214

devotion has grown and become even more fanatical" – these words of Dalí were written in 1942 as a summing-up of his many years' experience. "I will say without any kind of exaggeration, I know every cliff here by heart, every curve of the banks, every geological layer of Cadaques and its light, for all the years of my solitary wanderings day after day, these indifferent cliffs and lights – the pith and core of the landscape – were both the scene and the protagonist of the tense drama of my unquenchable love and apprehension. No one apart from me knows the exact way the shadows glide over the surface of the cliffs, when the sea recedes in obedience to the moon…"[205] Dalí studied this landscape with the passion of a lover and the diligence of a pupil. "In what does the peerless beauty and uniqueness of this wonderful landscape consist?" he wrote. "In the backbone, and the backbone alone. Here, each cliff and each hill are made as though Leonardo himself had painted them! That can only be the backbone, and nothing else."[206] In his canvases, he shapes these cliffs with colour. And consequently, whenever the cliffs of Cadaques lie in the background of his Surrealist subjects, his youthful fascination with this landscape has left its mark. He came to the group of Surrealists fully prepared with a capacity to present a realist reflection of the world.

As regards Surrealism, as it took shape in the works of Dalí, a large influence turns out to have been his familiarity with the painting of the Paris artists. He even directly borrowed certain elements that other Surrealists had already found. In the pictures of 1929-1930, Dalí constantly depicted small stones or natural objects such as the ones with which Yves Tanguy had filled his own Surrealist world. As with Tanguy, they are scattered along the plain to the horizon. Sometimes Dalí fills up the openings in these natural objects with other objects (*The Enigma of Desire*; *Specter of the Night*). Later they grow larger and are transformed, but they always remain in Dalí's painting (*The Birth of Liquid Desires*). Shadows fall from natural objects. Sometimes the shadows in a Dalí picture openly acknowledge their debt to the painting of Giorgio de Chirico, and a raised platform of wooden boards recalls the earlier artist's daises. And, of course, Dalí noticed the simple and brilliant inventions of René Magritte. His round rattles and granite balustrades entered into Dalí's pictures (*Tower of Pleasure,* or *Vertigo*). Nor did Magritte's play with space escape Dalí's attention. He wrote in his autobiography that from his childhood he had always liked cypresses. But it may be that it was actually from the Paris Surrealists that Dalí had caught the fascination with Böcklin's symbolism, and that it was in fact thanks to Böcklin that, from the beginning of the 1930s, the cypresses and the Isle of the Dead were added to Dalí's artistic arsenal (*Matinal Ossification of a Cypress*; *The Real Painting of Arnold Böklin's Isle of the Dead at the Hour of the Angelus*).

It seems as though it was at this time, at the start of the 1930s, that Dalí assembled the stores of Surrealist objects that he was later to deploy. "What is a Surrealist object?" wrote the historian of Surrealism, Maurice Nadeau. "Putting it simply, one could say: it is any disoriented object, that is to say, any object which has left its habitual setting and which is used for purposes other than those to which it had been intended, or for purposes which one does not know. As a result, it comes to be any object which seems to be made to no purpose at all, intended only for the satisfaction of the person who has created it, and as a result, is any object made following the desires of the unconscious, of the dream."[207] For Dalí, this object acquired a special meaning: it not only moved him closer to the work of the Dadaists and Surrealists, but also confirmed the independence of his situation in the context of automatic drawing. "I decided to construct as many Surrealist objects as possible", he wrote. "In them I embodied irrationality itself with all its symbolism, and in that way destroyed automatic drawing and the idiotic lists of dreams. A Surrealist object is absolutely useless and cannot be employed in any rational way. It is created, like a fetish, in such a way that any kind of nonsensical idea may obtain its visible and tangible embodiment."[208]

A large number of Surrealist objects entered Dalí's paintings. "I do not understand why, in a restaurant, I have not once been given braised telephones instead of baked langoustines!" he wrote. "… And in general, one can make so many delicious telephones: an iced telephone, telephone the colour of mint, stimulator telephone, telephone with crayfish receiver, telephone in a lacquered holster – exclusively for lovers of the sirens! – with

215

ermine finger-holes; a telephone named Edgar Allan Poe with a dead mouse inside; a telephone named Böcklin, hidden in the hollow of a cypress tree (and which must have an allegorical representation of death – a skeleton with a silver scythe on the dial), a self-propelled telephone, an adhesive telephone, a tortoise telephone (let us take a live tortoise and yoke the telephone to the skull)…"[209] A telephone often appears in his paintings. A crutch supports a giant telephone with a backdrop of the cliffs of Cadaques – the play with scale and the unusual combinations of objects generating a sense of anxiety (*Beach with a Telephone*). A telephone with a voraciously gaping mouth hangs on a dry branch, above a fried egg (*The Sublime Moment*). A drop of saliva dangles from an enormous telephone over a plate with a tiny photograph of Hitler (*The Enigma of Hitler*).

At this time, Dalí created his mythology which he used *post factum* to explain his pictures. He wrote *The Secret Life of Salvador Dalí Written by Himself* in 1941. By that time, the ants, the grasshoppers and the fried eggs, which, according to the author, dated from the vivid impressions of his childhood, had already appeared in his paintings and films. In 1941 he told the story of how at the age of six he had found a wounded bat on which hordes of ants were scurrying. Later, in the chapter, "Memoirs of What Never Was", he wrote: "I look at how someone's naked body is being washed. I do not even know whether it is a woman or a man, but I cannot tear my eyes from the gaping hole the size of an orange on the buttock, swarming with ants."[210] These ants crawl out of the hole in the hand of the hero of *Un Chien andalou*, spread all over the porcelain baby face of a doll, swarm over the face of the watch in *The Persistence of Memory*.

Dalí recounted his impressions of his mother's womb: "The internal foetal paradise is similar in colour to hell: it is fiery-scarlet, twinkling, orange-gold, blazing up with blue tongues of flame, fluid, warm, sticky, and at the same time, motionless, strong and symmetrically regulated. What blessedness, what rapture I experienced on those wonderful occasions when two fried eggs floated towards me without any kind of frying-pan!"[211] A fried-egg without the frying pan is an ideal Surrealist object which does not require any additions! (*Fried Eggs on a Plate without the Plate*). Dalí told of how in childhood, he was hysterically afraid of the grasshoppers with which little boys used to tease him. Grasshoppers appeared in his pictures very early on (*The Lugubrious Game*). In his lessons at Catholic school, Dalí saw two cypresses out of the window, and could not take his eyes off them. "I was the only one in the whole class over whom the window with the cypresses had such power", he wrote. "Having observed this, the father-preceptor moved me, but there too, in the new place from which it was impossible to see them, I was stubbornly drawn towards the cypresses, and pointed in their direction like the needle of a compass."[212] Cypresses became as essential a feature of a Dalí landscape as the cliffs of Cadaques. They spring up in the middle of a barren plain, they are conceded behind strange theatre curtains and their outlines merge with the profile of the castle of death (*The Horseman of Death*).

One of the important objects appeared to Dalí as a boy when he stayed on the estate of the Pichot family on the outskirts of Figueres. In the attic he found a miracle. "… The object which immediately overshadowed everything visible and shook my soul to its very depths was the crutch! I had never before seen a crutch – so at least it seemed to me then. And its deathly poetry pierced my heart."[213] Dalí claimed that the crutch was a sign of his contempt for the aristocracy that was tending towards its decline, a way for it to "keep its shoulders up": "I made an image of the pitiful crutch – he wrote – the support of my childhood, all-powerful symbol of the post-war years, and also the enormous variety of supports to prop up the so-called "astral skulls", to say nothing of the crutches that enable people to preserve the most uncomfortable and artificial poses for as long as they wish, and to bring them to the ultimate degree of perfection…"[214] Crutches and supports found the most varied application in Dalí's pictures, and remained in them to the end of his artistic career.

Salvador Dalí took the lessons of Sigmund Freud much more seriously than any others. First the Dadaists, then the Surrealists, were delighted to discover Freud for themselves. They found in him a basis for their own ambition towards irrationality. Freud wrote about the role of childhood impressions, often as yet unconscious, in the formation of complexes in the adult. Freud gave expert medical confirmation of the

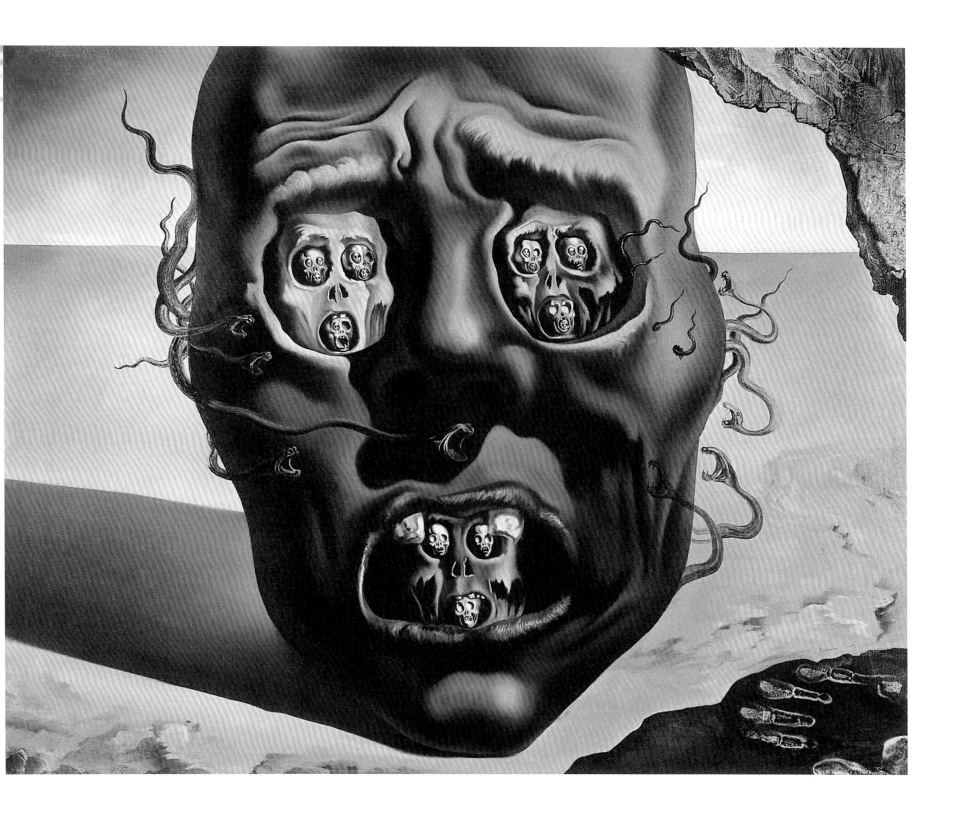

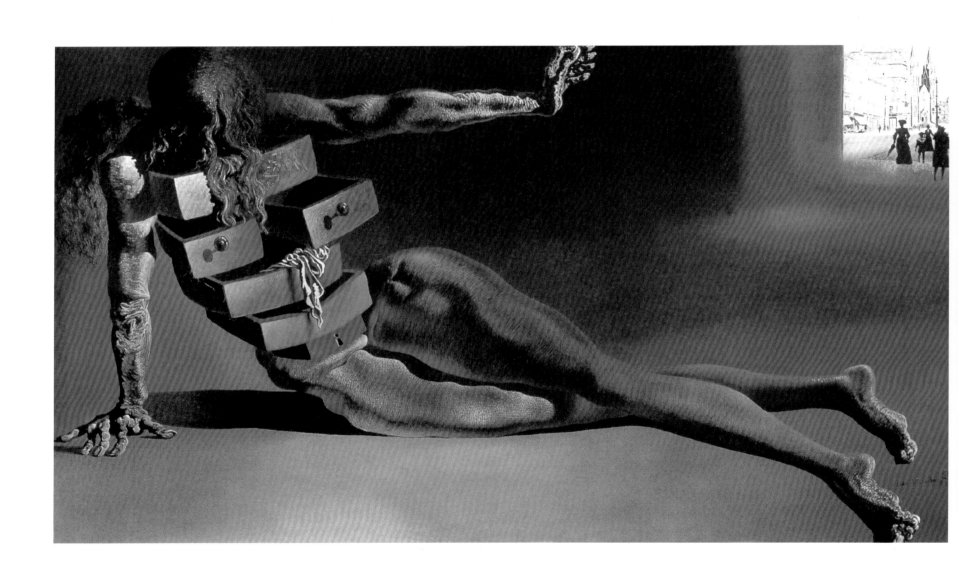

position of the Romantics and the Symbolists on the role of dreams, and the role of the subconscious in creativity. Each of the Surrealists, shipping out from Freud's harbour, sailed away to his own personal Surrealist world. The youthful enthusiasm of Dalí for the works of Freud was no less sincere and direct. However, Dalí would also continue to follow in his footsteps later on, in the manner of the most diligent pupil. He said that Freud's ideas had the same significance for him as the Bible had had for the medieval masters. De Chirico and even Yves Tanguy created their dummies and object-creatures before they got to know Freud's theories. For Dalí, Freud became a point of reference, and he used all of Freud's theories, even the accounts of the dreams of his patients, as direct guidance in his work.

In his memoirs, Dalí relates almost all the images of his painting to childhood impressions, to which he attached much more significance than even Max Ernst had. This is the case, even without acknowledging that none of the Surrealists applied the teaching of Freud on the libido as literally and with such obsessive consistency as did Dalí. One of his first truly Surrealist pictures was *The Great Masturbator*. Dalí's play of erotic and sexual motifs, and their direct employment in his painting in the most repellent fashion, gave rise to protests from Breton and several other Surrealists. However, the fantastic, openly shocking and brilliant construction that is his memoirs leads one to conclude that Dalí's enthusiasm for Freud was a mixture of not only rational, but also ironic use of the postulates of the Master. His attitude to Freud himself also acquired a mocking and ironic character. Dalí told the story of how one day, indulging himself with snails in a French restaurant, he caught sight of a portrait of Freud in the newspaper. "And at that very moment I discovered the secret of the Freudian morphology", he wrote. "I realised that Freud's cranium was the exact duplicate of a snail's shell: his thought twists round it in exactly that kind of spiral, and you need a skewer to pick it out! This revelation was reflected in my portraits of Freud and in the sketch which I made from the life a year before he died."[215]

Although it was laced with a heavy dose of self-irony, the cult of his own person was very important for Dalí. He could not come to Surrealism empty-handed. And he brought to it his paranoiac-critical method, as set out in his collection of articles published in 1930, *The Visible Woman*. Dalí was not tempted by the thought that he might obtain the kind of power which Breton held within the group. But in terms of the idea of Surrealism and what lay at its heart, he had to be number one. The declaration later made by him, "I am Surrealism" was Dalí's slogan. He opposed his new method to the recognised automatism of Breton.

Around the beginning of the 1930s, all the Surrealists were interested in Dr. Lacan's work, *On Paranoiac Psychosis as it relates to the Personality*. But Dalí was the only one of them to use the Lacan's work in the creation of his method. Paranoia is an illness in which, for the patient, the individual "I" plays the main role. Although the sick man does not abandon rationalism in how he behaves in real life, paranoia can be accompanied by hallucinations and visions, something which was very attractive to every Surrealist. Dalí made use of the idea of paranoia in his ambition to do away with automatism. "Paranoia", he wrote, "uses the external world as something on which it can impose the obsessive idea, with the troubling peculiarity that it can make the reality of this idea valid to other people. The reality of the external world serves as illustration and proof, and is put to the service of the reality of our intellect."[216] The artist must critically examine his paranoid visions and put them to work in his art. What makes them more appealing is that one vision often hides another, behind which in its turn is hidden a third. The announcement of a new method played, like everything Dalí ever did, a provocative role. One of his slogans was the declaration: "The only difference between me and a madman is that I am not mad."[217]

Dalí worked on his *The Invisible Man* at the same time as he was writing about his paranoiac-critical method. This picture was almost a literal illustration of his theory. From the architectural remains, nude models, interior décor and landscape, he constructed the figure of a man, which at first is barely guessed at among the quantity of detail. "One does not see everything that one is looking at, which is not a vulgar phenomenon of inattention, but a hallucinatory phenomenon", he wrote in *The Secret Life of Salvador Dalí*. "The ability to provoke it at will

Salvador Dalí,
The Anthropomorphic Cabinet, 1936.
Oil on panel, 25.4 x 44.2 cm.
Kunstsammlung Nordrhein-Westfalen,
Düsseldorf.

Salvador Dalí,
Metamorphosis of Narcissus, 1937.
Oil on canvas, 51.1 x 78.1 cm.
Tate Gallery, London.

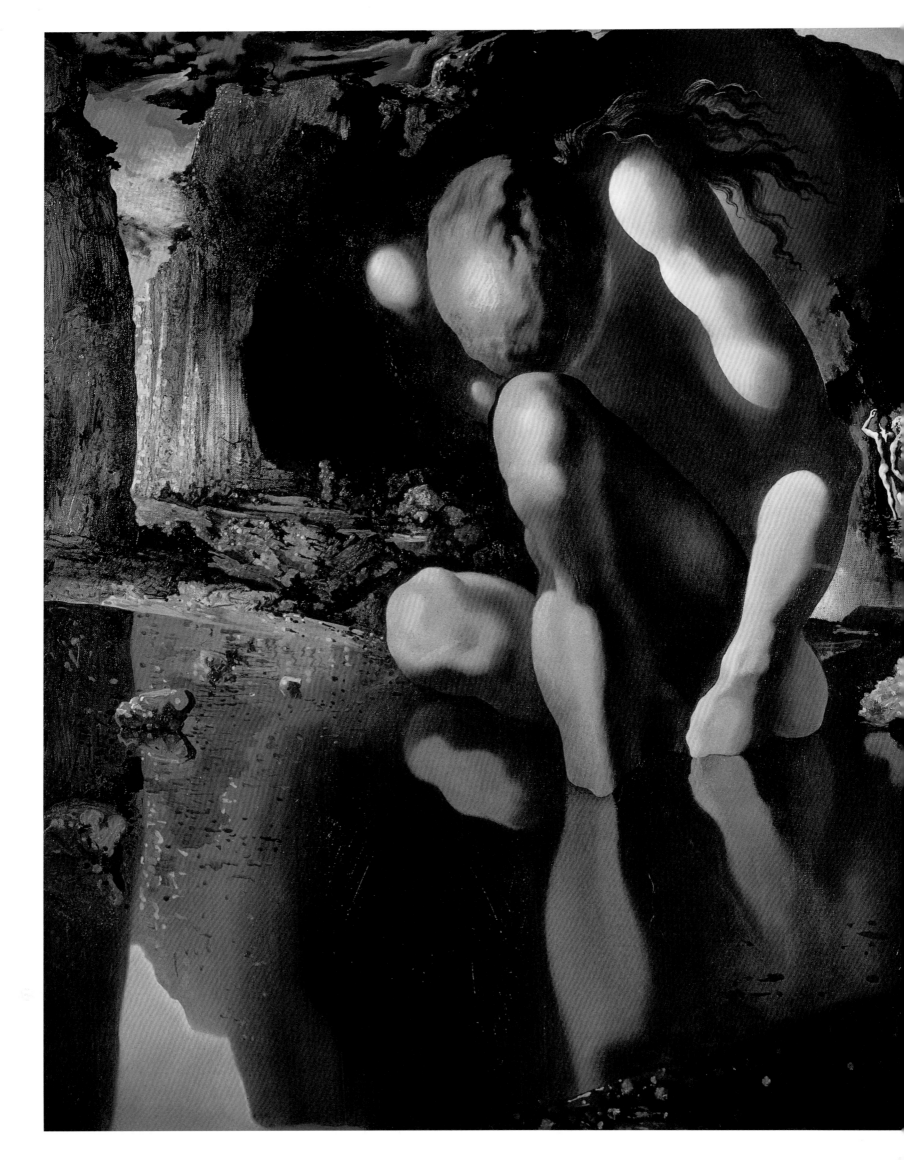

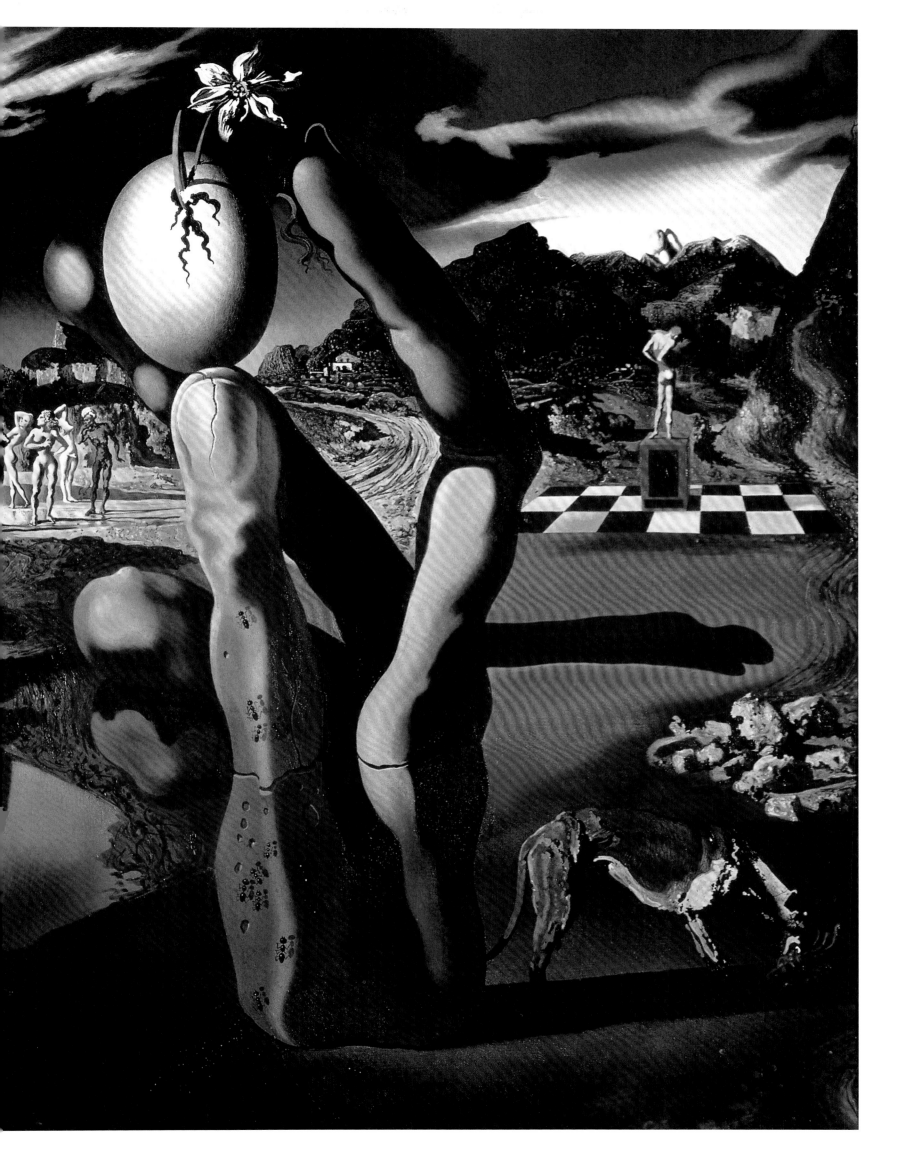

obviously enabled one to make some physical realities invisible and to give to paranoid magic one of its most effective weapons."[218] Later on, Dalí resorted more than once to such a method, in a sort of mosaic composition of an object or a portrait (*The Great Paranoiac*; *The Endless Enigma*; *Spain*). However, canvases of this sort are distinguished by an extraordinary complexity which has even hidden the secret of the painting itself.

The pictures which brought Dalí success were those distinguished by their great simplicity of composition and clarity of intent. At the beginning of the 1930s, he painted *Partial Hallucination. Six Apparitions of Lenin on a Grand Piano*. Eventually, Dalí explained the appearance of this painting as a vision he had in the changing evening light. "In 1932", he wrote, "at the time I went to bed, I saw a very shiny, bluish piano keyboard, a vision which essentially presented to me a series of smaller and smaller yellow and phosphorescent halos surrounding Lenin's face. This image came into being at the moment I got into bed, before turning out the light. It does not belong to a series, and was not succeeded by any other images."[219] Creating a picture like this was not, for Dalí, a political act, and Lenin's popularity was enough by itself to lead Dalí to make use of his image in a Surrealist game.

In 1931, Dalí painted *The Persistence of Memory*. Dalí told the story of how the image of this picture came to him one evening when Gala went out with friends to the cinema and he stayed at home. "We had finished our dinner with an excellent camembert", he wrote:

> And when I was alone I stayed a moment leaning at the table, reflecting on the problems posed by the "soft supper" provided by this cooling cheese. I got up and went back to my studio to take a last look, as I usually did, at my work. The picture which I was in the middle of painting showed a landscape of the area around Port-Lligat whose rocks appeared to be lit by a transparent light at the day's end. In my first plan, I had sketched out a broken and leafless olive-tree. This landscape was supposed to be the backdrop for some sort of idea, but what? I had to have an arresting image, and I had not found it. I was about to put out the light and leave, when out of the corner of my eye I "saw" the solution: two soft watches, of which one would hang wretchedly from the branch of an olive-tree... Two hours later, when Gala came back from the cinema, the picture which was destined to be one of my most famous was finished.[220]

In the Museum of Modern Art in New York there is a preserved manuscript in which Dalí links his idea of the soft watches with modern scientific conceptions of the physical states of matter. "... There are some substances", he writes, "which do not move from a liquid state to a crystalline state, but to the state of a more or less hard jelly or gel of a granular structure."[221] By changing the usual properties of objects, Dalí found a means to provoke the feeling of disgust he so favoured and cultivated in the viewer of the painting. Following the watches, a violin was melted and hung up like a crumpled rag (*Masochistic Instrument*). Next, a grand piano was transformed into a piece of cloth so as to make it look as though one could pull it by the corner and remove it like a cover (*The Pharmacist Carefully Removing the Cover of a Grand Piano*). The Surrealist world of Salvador Dalí was transformed into a world of insane objects which had ceased to be what they should have been. Finally, the head of the artist himself was subjected to this kind of transformation and also lost its solidity, while still retaining the fine likeness of a portrait (*Soft Self-Portrait with Grilled Lard*).

Many of Dalí's visions took his favourite classical works or subjects as their starting-point. The legend of William Tell became one of his obsessions. When he described his tragic break with his father in 1929, Dalí recalled his departure from Cadaques: "While I was waiting for the taxi... I had breakfast: sea-urchins, fried bread, rough red wine. And suddenly, on the white-washed wall, I noticed my own

Salvador Dalí,
The Geopolitical Child Observing the Birth of the New Man, 1943.
Oil on canvas, 45.5 x 50 cm.
Fundació Gala-Salvador Dalí, Figueres.

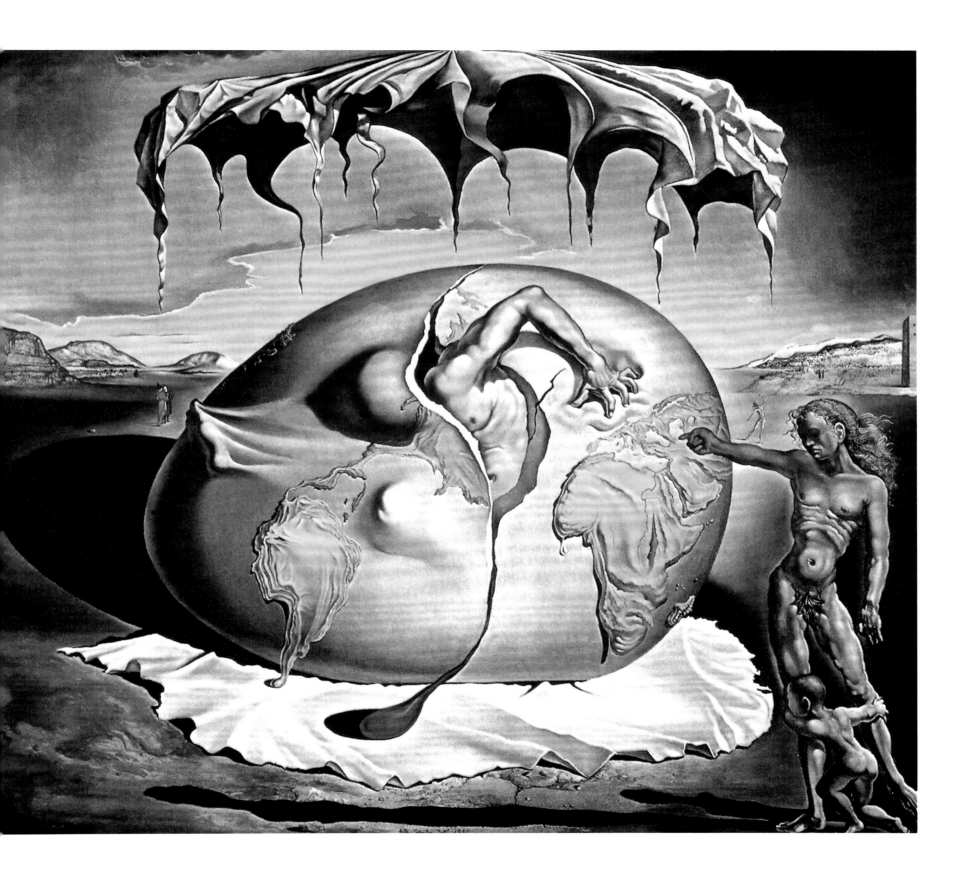

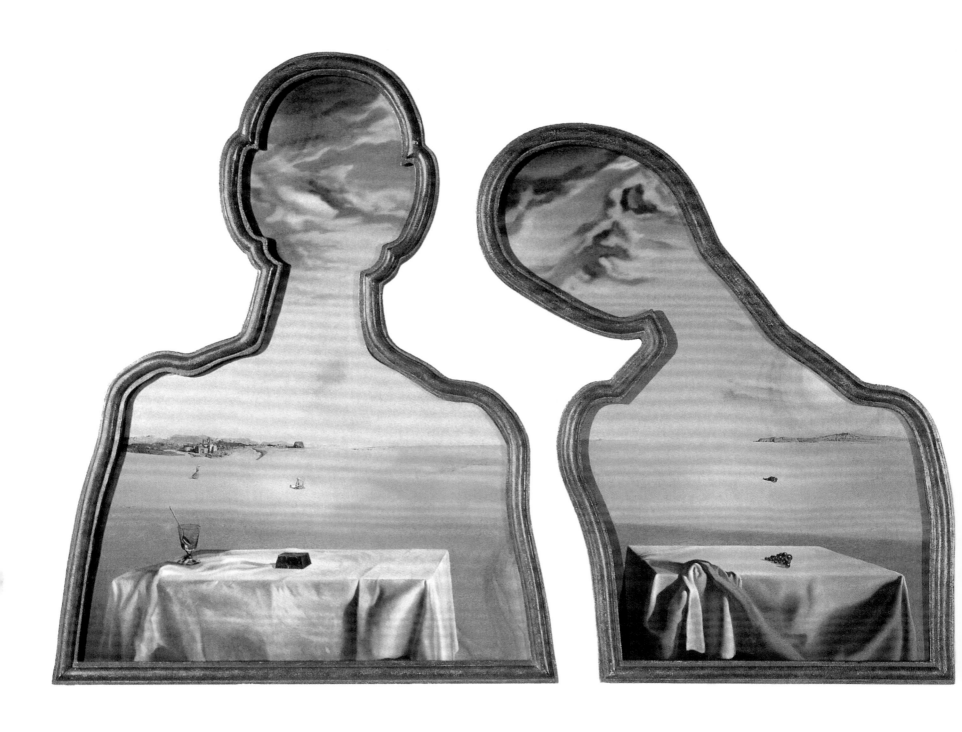

shadow. I picked up a sea-urchin, stuck it on my head and stood up straight in front of the shadow – it was William Tell."[222] A reflection of this episode immediately made its appearance in Dalí's painting. William Tell is transformed into a participant in a mysterious spectacle, where naked figures play out a drama behind a primitive curtain on a plain (*The Old Age of William Tell*). He became the same kind of obsession for Dalí as Gradiva. Sometimes they come together in the same plain, together with the cliffs of Cadaques, when they continue Salvador Dalí's endless sexual and erotic performance *(Untitled (William Tell of Gradiva))*. William Tell himself, painted on a vast canvas, a monumental and distinctly naturalistic figure, becomes the embodiment of a shocking erotic world (*The Enigma of William Tell*). Once Dalí had become rich and famous, and after he had experienced numerous conflicts within the Surrealist circle, he wrote: "I am the son of William Tell, and the 'cannibalistic apple' with a double meaning which my fathers, André Breton and then Pablo Picasso, balanced uneasily on my head, is something which I have transformed into a gold bar. They put it on the priceless head, the delicate and marvelous head, of Salvador Dalí himself!"[223]

At the beginning of the 1930s, Francois Millet's painting, *The Angelus*, became another of Dalí's obsessions. Dalí related the shock provoked by this painting to the impressions of his childhood. Faithful to Freud's theories, his first recollections of the picture date from his studies at the Catholic school – from his place behind the desk he could look at a reproduction of it. "This picture", he wrote, "has always produced in me an acute sorrow and agitation, and its two motionless figures are permanently engraved on my memory, their hidden meaning a source of disquiet to my imagination."[224] In several of Dalí's compositions, this picture appeared as a whole, and it was the only real object in its Surrealist setting (*Gala and the Angelus of Millet Preceding the Imminent Arrival of the Comical Anamorphoses*). The "Angelus" became Dalí's property, and he supplemented the composition by Millet with new details, and changed the figures' poses (*Retrospective Female Bust*; *Portrait of Gala or the Angelus of Gala*). Dalí wrote that he could see the composition of the *Angelus* in the outlines of the stones on the plains of Catalonia. In 1963, in a text entitled "The Tragic Myth of the Angelus of Millet", Dalí wrote:

> With Millet's *Angelus*, I associate all the twilight and pre-twilight memories of
> my childhood, and see them as the most delirious, or in other words… poetic…
> The apparition of the image of Millet's *Angelus* therefore presents itself to me as
> a paranoiac image, that is to say, one which involves an associative system which
> could coexist with the ideas of delirium themselves: following the shock and
> reaction caused by the image, the object for me would become charged with
> the content of delirium…[225]

The metamorphoses of *Angelus* in his paintings was prompted by its dark poetry and mystery of death, especially after Dalí became conscious of the alteration in the picture that had been made by Millet himself: research has shown that a grave had at first been depicted between the female and the male figures (*Twilight Atavisms (Obsessive Phenomenon)*; *Archeological Reminiscence of Millet's Angelus*; *The Architectonic Angelus of Millet*). The spectre of the *Angelus* still haunted Dalí when he came to work in 1934 on the illustrations to Lautréamont's *Songs of Maldoror*.

Dalí's idol was Vermeer of Delft. In the "Comparative table of values according to a Dalian analysis" that he subsequently compiled, he awarded Vermeer top marks across the board: for technique, inspiration, light, subject, mystery and in the final category, genius. He did not even give Leonardo such a high score, only Raphael and Velasquez – and, of course, himself, received them. In his text entitled *My Struggle*, Dalí set out his aesthetic credo in a peculiar table, dividing the whole world into "for" and "against". The positions, which sound shocking, are for him entirely normal: against the collective and in favour of individuality, against women and

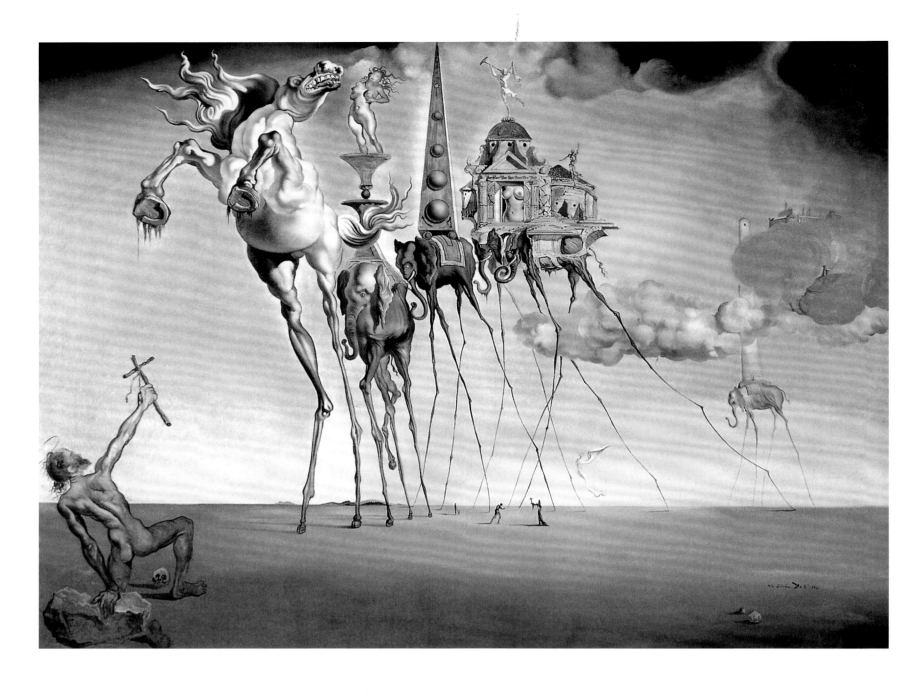

Salvador Dalí,
The Temptation of Saint Anthony, 1946.
Oil on canvas, 89.5 x 119.5 cm.
Musées royaux des Beaux-Arts de Belgique,
Brussels.

Salvador Dalí,
*Dream Caused by the Flight of
a Bee around a Pomegranate a Second
before Waking up*, 1944.
Oil on panel, 51 x 41 cm.
Museo Thyssen-Bornemisza, Madrid.

in favour of Gala, or against men, and in favour of himself. But when it comes to aesthetics, it all becomes more serious. Dalí is against Michelangelo and for Raphael, against Rembrandt and for Vermeer. He stuck to these positions from his youth until the end of his life. Dalí recalled the excitement he felt when, for the first time, he saw Vermeer's *The Lacemaker* in the Louvre. To Dalí, Vermeer was the most authentic Surrealist before Surrealism, and a mystery was included in each of his simple subjects. "Vermeer is the authentic painter of ghosts", he wrote. "The woman trying on her pearl necklace in front of the mirror is the most authentically ghostly that was ever painted – it is a case of a hyper-material ghost… The Vermeer, seated from behind, that is identified with his own *Woman Holding a Balance,* only renders substantial and capable of being weighed (though one is only weighing ghosts of pearls) this emotional pearl of the iridescence of space that is his own pictures."[226] Vermeer, seated behind the easel or the town of Delft, appears in the Dalian landscape (*Enigmatic Elements in a Landscape*; *Apparition of the City of Delft*). The figures of Vermeer himself, or of his protagonists, are never rendered ugly or disgusting, and yet, as with all the objects in Dalí's world, they are subjected to transformation. One leg of a kneeling figure in Dutch costume is extended, its foot falling off, and the knee turned into a table on which stand a distinctly material glass and a bottle of wine. The result of transformations like these was to become one of the most brilliant of Dalí's discoveries – his furniture figure.

Even the Venus de Milo underwent a "furniture" metamorphosis. Dalí found it possible to use her ideal figure to utilitarian purposes. Little drawers with coquettish handles jut out from her breasts and belly. In his drawing and painting Dalí developed possibilities of combining a human being, depicted with all his

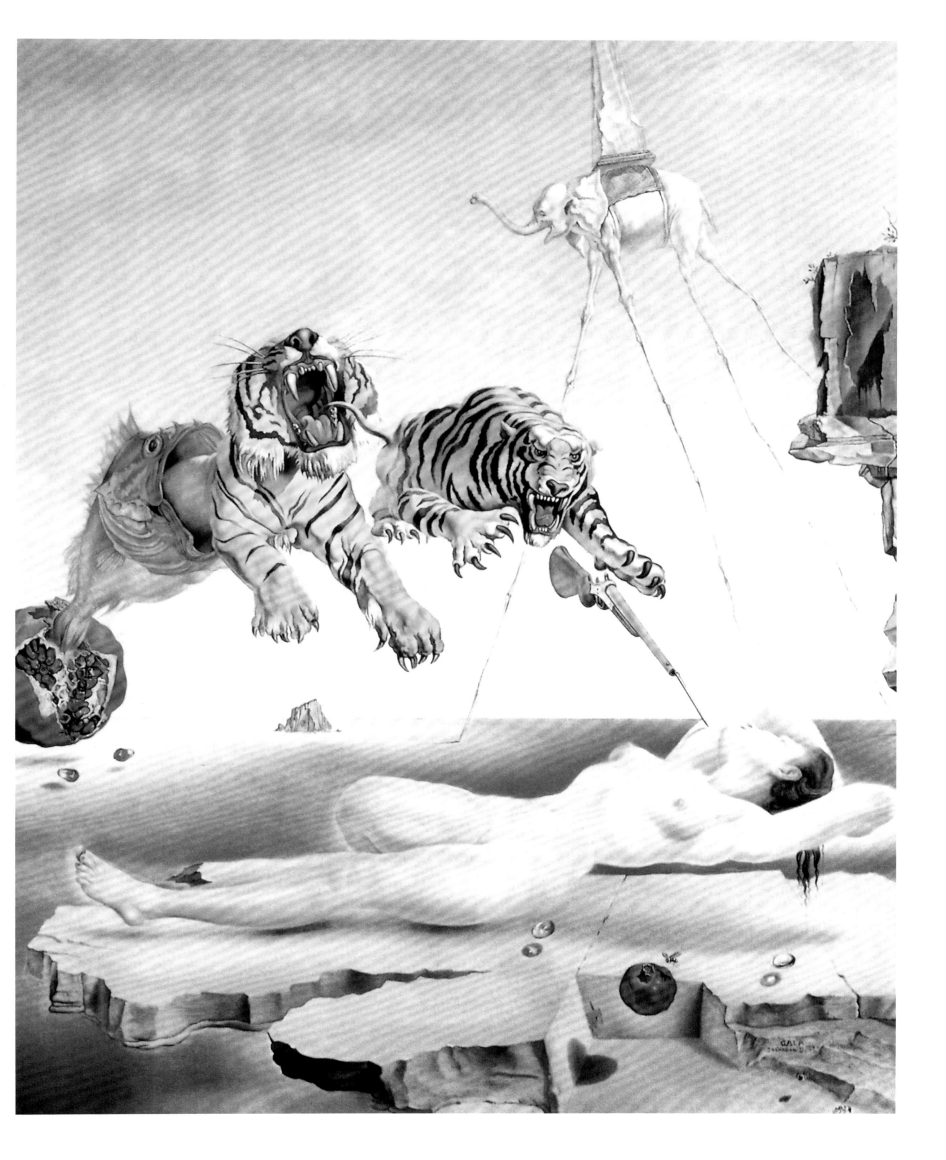

typical naturalism, with a cupboard, the animate with the inanimate. The wooden drawers thrust themselves forward from living flesh, causing it pain (*The Anthropomorphic Cabinet*). The most vivid result of the development of paintings of this type is *Giraffes on Fire*. The paradox of the flaming giraffe in the background is itself a statement about the dreadful unnaturalness of what is happening in the painting. The central figure with drawers thrusting out from and with crutches supporting it is turned into a skeleton in the eyes of the viewer.

In the words of Dalí himself, "the first poem and the first picture entirely obtained from the complete application of the paranoiac-critical method" was Narcissus (*Metamorphosis of Narcissus*). The transformation of Narcissus occurs under the viewer's eyes. The classical beauty of the painting's execution is combined with the inevitable Freudian subject. Something that is essential for Dalí's aesthetic was the combination of colour and words, painting and poetry, that he himself created:

> When the clear and divine anatomy of Narcissus
> Leans
> Over the cloudy mirror of the lake,
> When his white torso bends forward,
> Congeals, freezes,
> In the silver and hypnotic arc of his desire,
> When time passes
> On the hourglass of flowers made of the sand of his own flesh,
> Narcissus vanishes into the stratosphere
> In the deepest part of which
> Sings
> The cold and Dionysiac Siren of his own image.[227]

In July 1936, the Spanish Civil War began. Dalí repeatedly stated that he was an apolitical man. His picture, *The Enigma of Hitler*, cost him, in his own words, "anathemas from the Nazi side and stormy applause from the camp of their opponents. Although this picture, and, for that matter, all my works, as I will go on repeating to the end of my days, did not have the slightest deliberate political subtext."[228] This picture gave rise to a serious conflict between Dalí and the Surrealists. "I endlessly, purposelessly repeated to myself that this Hitlerian hallucination was absolutely apolitical, and that the work… was scandalously equivocal, that all these images are no less tinged with black humour than the portraits of William Tell and Lenin, I vainly repeated the same thing to my friends as well – to no avail."[229] "The vocation of Salvador Dalí is to be the greatest courtesan of his era", he wrote in *The Diary of a Genius*.[230] However, Catalonia, and Spain as a whole, were his great loves. Dalí thought that in the actual conditions of modernity, only the irrational language of the Surrealists could be accepted by the public. "People are eager for the corruption of imaginative civilisation which we alone can offer them, and which they utterly lack", he wrote to Éluard.[231] And perhaps no politically oriented artist expressed his anguish over Spain with as much force as did Dalí (*The Automobile Fossil of Cap de Creus*). Dalí alone was capable of creating compositions from portions of human flesh, metamorphosing, rotting and decaying under the eyes (*Soft Construction with Boiled Beans. Premonition of the Civil War*). Only his irrational fantasy could have created such a monstrous image of cannibalism (*Autumn Cannabalism*). Dalí gave his own explanation, which should probably be taken with a grain of salt, of how his picture *The Dream* came into being. "I have often imagined and represented the monster of sleep as a heavy, giant head with a wire body held in balance by the crutches of reality", he wrote in *The Secret Life of Salvador Dalí*[232] (*The Dream*). However, Dalí's *The Dream*, created in 1937, can be perceived as the horrible metamorphosis of a human being, the shedding of his humanity as he loses his face in an era of monstrous calamities.

Salvador Dalí,
Palace of the Wind, 1972.
Painting of the ceiling of old Teatro Museo.
Figueres.

Salvador Dalí,
Leda Atomica, 1949.
Oil on canvas, 61.1 x 45.6 cm.
Fundació Gala-Salvador Dalí, Figueres.

In the course of the 1930s, Dalí's painting was showed more than once in the Surrealists' group exhibitions and in his own individual exhibitions, including those held in America. In 1934 and 1936, he spent time in the United States. With the beginning of the Second World War, many European artists went to North America. Dalí and Gala also headed there in 1939. Dalí was still young, and he channeled his inexhaustible energy into a wide range of activities. He resumed his work in the cinema which had previously begun with Buñuel, and he collaborated with Alfred Hitchcock and Walt Disney. Dalí turned out to be a no less talented jeweler, and his Surrealist items of precious stones impressed his contemporaries. At one point he landed in prison because he smashed a shop-window whose owners had altered one of his designs. People bought Dalí's pictures, and he began to receive substantial commissions for murals. He was truly becoming the personification of Surrealism. André Breton gave him his due in terms of his contribution to the Surrealist movement. In *What is Surrealism*, he wrote: "Dalí has made Surrealism the gift of an instrument of the very first order in the form of the paranoiac-critical method, which he has at once shown himself capable of applying equally well to painting, to poetry, to film, to the construction of typical Surrealist objects, to fashion, to sculpture, to the history of art, and even, if the occasion should arise, to any variety of exegesis."[233] However, from 1939 everything changed. Breton excluded Dalí from the Surrealist group. He called Dalí, cleverly changing the places of the letters in his

name, "Avida Dollars" – the idea of bourgeois self-enrichment was alien to the Surrealists. Moreover, it turned out that the accusations against Dalí of Hitlerite sympathies were not totally wrong. It was now that Dalí started to lean towards racism, and later on, in 1955, he was even received by the dictator, Franco. At the same time he turned to Catholicism. In 1948, Dalí and Gala returned to Spain. In 1955, Dalí was granted an audience with Pope Pius XII, and, in 1959, an audience with Pope John XXIII. In 1958, Dalí and Gala were married in church.

Dalí's paintings of Christian themes date from the post-war era, beginning with a Madonna, and ending with The Last Supper (The Last Supper) and with various versions of the Crucifixion (The Christ of Saint John of the Cross). At the same time, he continued to make pictures from a series of visions, in which he endeavoured with scrupulous precision, to reproduce the images of dreams (Dream Caused by the Flight of a Bee around a Pomegranate a Second before Waking up). For the majority of people in the world who appreciated Surrealism, Dalí did indeed become the personification of it. Museums of his works appeared in America and Europe. In 1974, Dalí opened his own museum in Figueres, in the building of a theatre which had been destroyed during the war. In 1982, a terrible misfortune befell the artist – Gala died. At almost eighty years old, the artist immediately found himself helpless and lost; he fell seriously ill and he was robbed by his secretary. Dalí spent his last years chiefly in Spain, where he died in his castle in 1989.

Salvador Dalí,
The Madonna of Port Lligat, 1950.
Oil on canvas, 144 x 96 cm.
Private Collection, Tokyo.

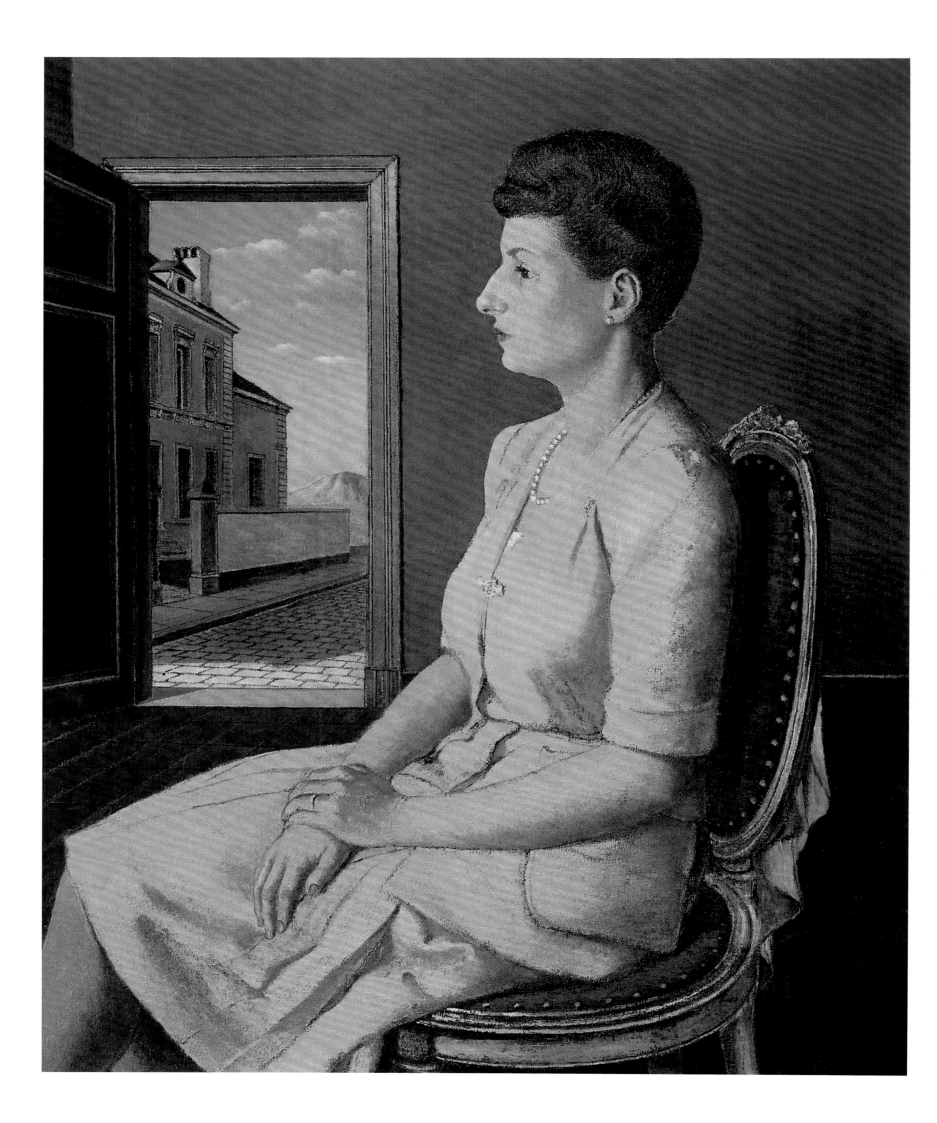

PAUL DELVAUX
1897-1994

The deepest sleep, animal, vegetable
Causes me to be born and to survive the endless night.

There is enough shade in the eyes to see the night there
To see the oldest image of the night

Extended as far as myself good night on this bed.

Great naked women nullify the desert
This world is within the empire of glorious flesh

Everything in an instant reduces to the abandonment
Of the reflection of a dress in an empty mirror.

To know the form and the weight of her breasts
The most beautiful woman in the morning encloses herself in her arms.

The Heart hides in this white shell
It escapes from the bloody flooding of the dawn

Bodies watermarked by their pale skeleton
Confirm the fossil shed light on the gangue.

The vaults of the night ideal caress
Grasses never knotted go higher than time

The area of the earth thus opens up and lives.[234]

He parted this life as the twentieth century was coming to a close, missing its end by a few years. He was the last Surrealist. "What does painting mean to you, Paul?" a journalist asked him. He replied:

> Painting is not simply the pleasure of putting colour on a canvas, it is also about expressing a sentiment and in particular, a poetic sentiment. Of course I use colour, because colour has an important function in poetic expression. It is a mixture of poetry and colours, it is difficult to separate the one from the other, and I believe that, for me, painting is the expression of a sentiment, of a climate.[235]

Paul Delvaux was born in the Belgian town of Antheit. His father was a lawyer in Brussels, where Paul studied at the Athenée de Saint-Giles. In 1916, he entered the Académie des Beaux-Arts, where he first studied architecture and then monumental painting. The landscape painter Frans Courtens persuaded Delvaux's parents that the young man was talented and should devote himself to painting.

Paul Delvaux,
Madame Pollet, 1945.
Oil on canvas, 100 x 80 cm.
Fondation Paul Delvaux, Saint-Idesbald.

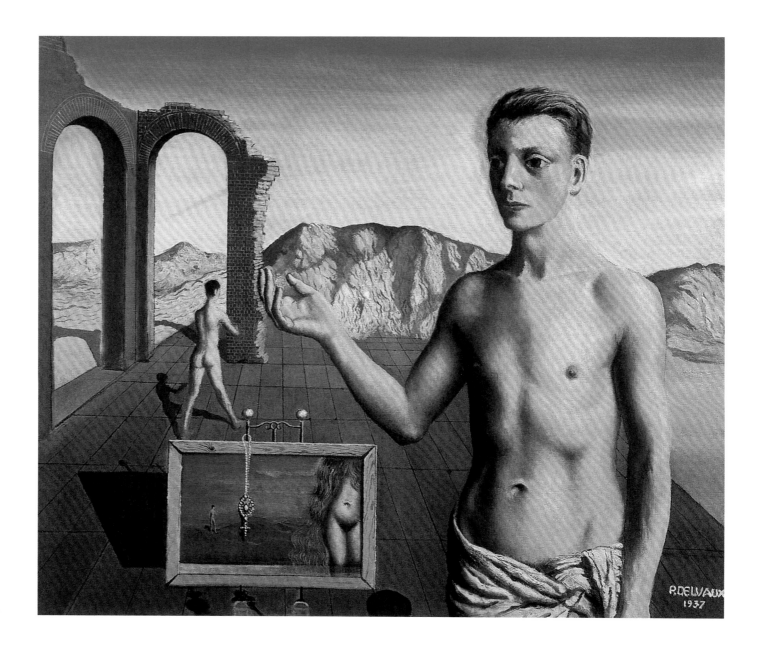

One day, while he was painting a study on the outskirts of the forest of Soignes, Delvaux met the artist Alfred Bastian who appreciated the lad's talent and became his friend. Delvaux was attracted to Post-Impressionism and, like all the Belgian Surrealists, to the work of James Ensor, as well as Constant Permeke and Gustave de Smet.

In 1922, at the age of twenty-five, Delvaux began to paint stations which became one of his life-long themes and fixations. In 1930, at a fair in Brussels, he saw the Spitzner Museum. It was a long wooden shack opposite the Gare du Midi. Pictures from around the 1880s hung on every wall against a background of red velvet curtains. One of them, a highly realistic painting, represented Doctor Charcot in front of a woman in a trance. At the same time, skeletons of a monkey and a man were on exhibition, together with Siamese twins, a great number of medical anatomical waxworks, and even a sleeping Venus made of papier-mâché. In the midst of the hut sat the figure of the cashier. It was a museum of dramas, all around which was the cheerful noise of the fair, creating a strange contrast. "That Spitzner Museum was for me a wonderful revelation", Delvaux stated in an interview. "It really was a very important turning-point, and I think I can even tell you that it preceded the discovery of Giorgio de Chirico, but it veered in the same direction. The discovery of the Spitzner Museum made me completely turn around my conception of painting. It was then that I found that there was a drama which could express itself through painting while still remaining plastic."[236] The figures in this museum subsequently entered Delvaux's painting. At one point, he painted a poetic reminiscence of the Spitzner Museum. In it there is the skeleton, cashier, nudes, and a group of the artist's friends who look at the

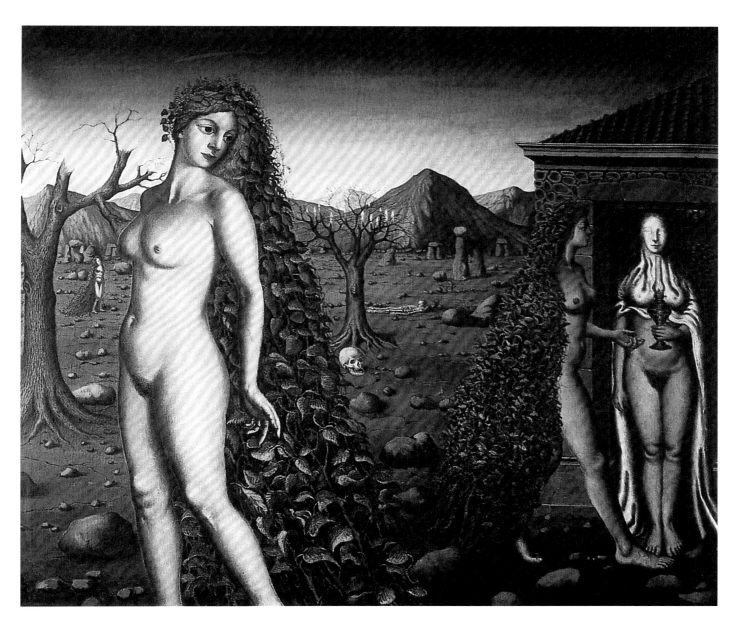

other figures. Among them are the writer Paul-Gustave van Hecke, the composer Gérard Bertouille, the painter Olivier Picard and the painter Emile Salkin.

Asked which artists he admired, Delvaux offered the names of Piero della Francesca, Mantegna, Paolo Uccello, Poussin, Boticelli and above all, Ingres. "He has a dangerous side", Delvaux said of Ingres. "He walks on a tightrope with his classical pictures, which might be very boring and which, deep down, retain an extraordinary youth and serenity."[237] The classical beauty of Ingres's draughtsmanship taught Delvaux a great deal. However, the artist who played the greatest role in his development was the one who had brought almost all the masters of Surrealism to it. "And in the twentieth century, more than anyone, it is de Chirico who, before 1914, made an impression on me because he conjured up this poem of silence and absence. He is the poet of emptiness. This was a very extraordinary discovery, a point of departure."[238] Delvaux also became a poet of solitude and silence.

In 1934, at the Palais des Beaux-Arts in Brussels, the magazine *Minotaure* organised an exhibition of Surrealist works in which Delvaux encountered paintings by de Chirico, Dalí and Magritte. By 1936, Paul Delvaux's pictures had already been exhibited alongside those of Magritte in Brussels, and in 1938, Delvaux took part in the international Surrealists' exhibition in Paris. Paul Éluard dedicated a poem, "Exile", to him, and this was how their friendship began. In 1943, they met in Brussels, and Delvaux painted a picture for Éluard called *The Echo*. Later, in 1948, they published their *Poems, Paintings and Drawings* together in Geneva, and Éluard wrote his "Nights without Smile" in Delvaux's honour. In 1938, Delvaux journeyed to Italy for the first time. In addition to Italian painting, he saw

Paul Delvaux,
The Call of Night, 1938.
Private Collection.

235

the architecture of ancient Rome and the Renaissance, which before then he had already featured in his pictures.

At the age of forty, Delvaux came to Surrealism much later than the other Surrealists. When he was asked what he thought about the influence of Freudian psychoanalysis on his art, he replied: "It's far too complicated for me, and I have not attached the slightest importance to it. I have always carried on this way and I have never troubled myself with complications."[239] Regarding his style of painting, Delvaux explained: "It is in a way a return to a certain reality, but one which is the reality of the painting, which is not the same thing as actual reality… One can call this Surrealism, not that I mind one way or the other, but it does not always work in a Surrealist sense, it can work in a different way, but in any case it is always a 'second reality'."[240] Delvaux absolutely rejected the notion that the subconscious, or the creation of pictures on the basis of dreams, was at all significant in his painting. "I have never yet painted a picture which was really a dream, never", he said.[241] However, Breton more than once spoke excitedly about Paul Delvaux, who, in his words, had often taken the high road of dreams. Delvaux himself said that his pictures were created on the basis of reality and imagination, nevertheless, they remind one more than anything of a peculiar dream. It seems as though their images emerge from the subconscious, become a hallucination and are endlessly repeated without uncovering their mystery. His artistic world is one of silence and poetry. Delvaux occupied a position among the Surrealists that was his due, although he did not officially enter a single one of the Surrealist groups.

Delvaux's first Surrealist pictures date from 1936, and the figures which later became constant presences had already made their appearance in them. *The Procession in Lace* depicts a procession of little girls dressed in white lace frocks. Their faces cannot be seen. They head towards a Roman triumphal arch reminiscent of de Chirico's arcaded cities. Nothing truly special is happening in the painting, yet it contains a secret within its peaceful, ceremonious moment. In another picture, *The Beauties of the Night*, half-naked girls appear once again in ancient architectural surroundings, and in the background, the hills of the Pays Noir of Wallonia can be seen. The sharply outlined shadows once again recall pictures painted by de Chirico. This was how Delvaux began to create his marvelous country, his island, inhabited by mysterious, unfamiliar people. Sometimes they recall figures in the pictures of naïve painters such as Le Douanier Rousseau. They are real and corporeal, but at the same time they resemble wax dolls. They are feminine and erotic, but at the same time they are void of all emotion. The girls gradually acquire their own attributes which also become constants. Sometimes a strange hat, a splendid wreath, or an enormous bow is the nude models' only decoration (*The Pink Boughs*). "Delvaux has made the universe the empire of a woman, always the same one, who reigns over great suburbs of the Heart where the old windmills of Flanders turn a pearl necklace around and around in a starry light", wrote André Breton.[242]

New figures gradually entered Delvaux's closed world. At first, they seem to be outsiders, too prosaic for the magical land. They turn up in the pictures like visitors to a museum. However, they pay no attention to the strangeness of their surroundings. A nude beauty is set out in front of them as though in a shop window; a "Pied Piper" leads the nude girls out of town… But the others are absorbed, no doubt, in their learned conversations (*The Phases of the Moon I*). These absent-minded visitors conduct themselves in a similar fashion in other pictures as well. They do not notice that the wood is full of naked girls running between the trees and clambering up them (*The Awakening of the Forest*). And even when, in the background of an Italian landscape, two nudes pose as in a French painting of the Fontainebleau School, they continue their endless discussions (*Nighttime*). Delvaux said that it all began with the image of the absent-minded scholar in spectacles, Professor Otto Lidenbrock, which he had formed under the influence of his favourite writer, Jules Verne. In his childhood, he read Verne's novels with Riou illustrations, and they made an unforgettable impression on him. The artist recalled:

> One evening, I thought about this scholar again with fondness, and I suddenly
> realised that this youthful memory, and God knows how vivid the memories of one's

Paul Delvaux,
Sleeping Venus, 1944.
Oil on canvas, 172.7 x 199.1 cm.
Tate Gallery, London.

Paul Delvaux,
The Green Sofa, 1944.
Oil on canvas, 130 x 210 cm.
Fondation Paul Delvaux, Saint-Idesbald.

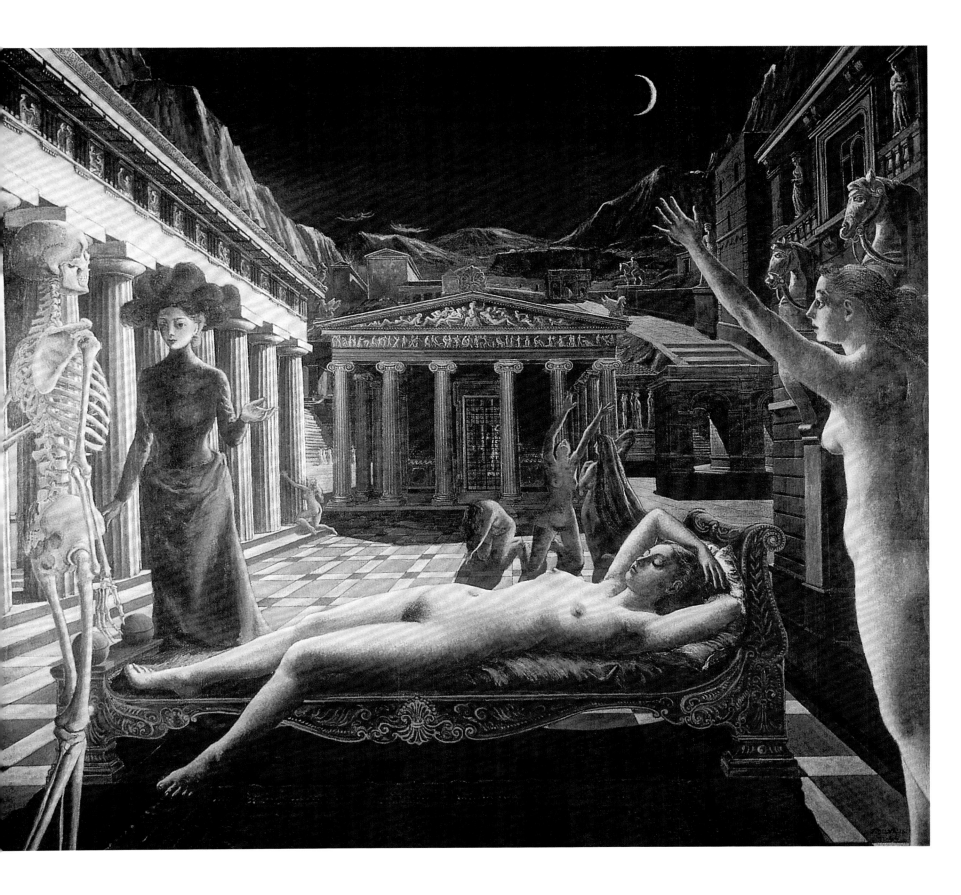

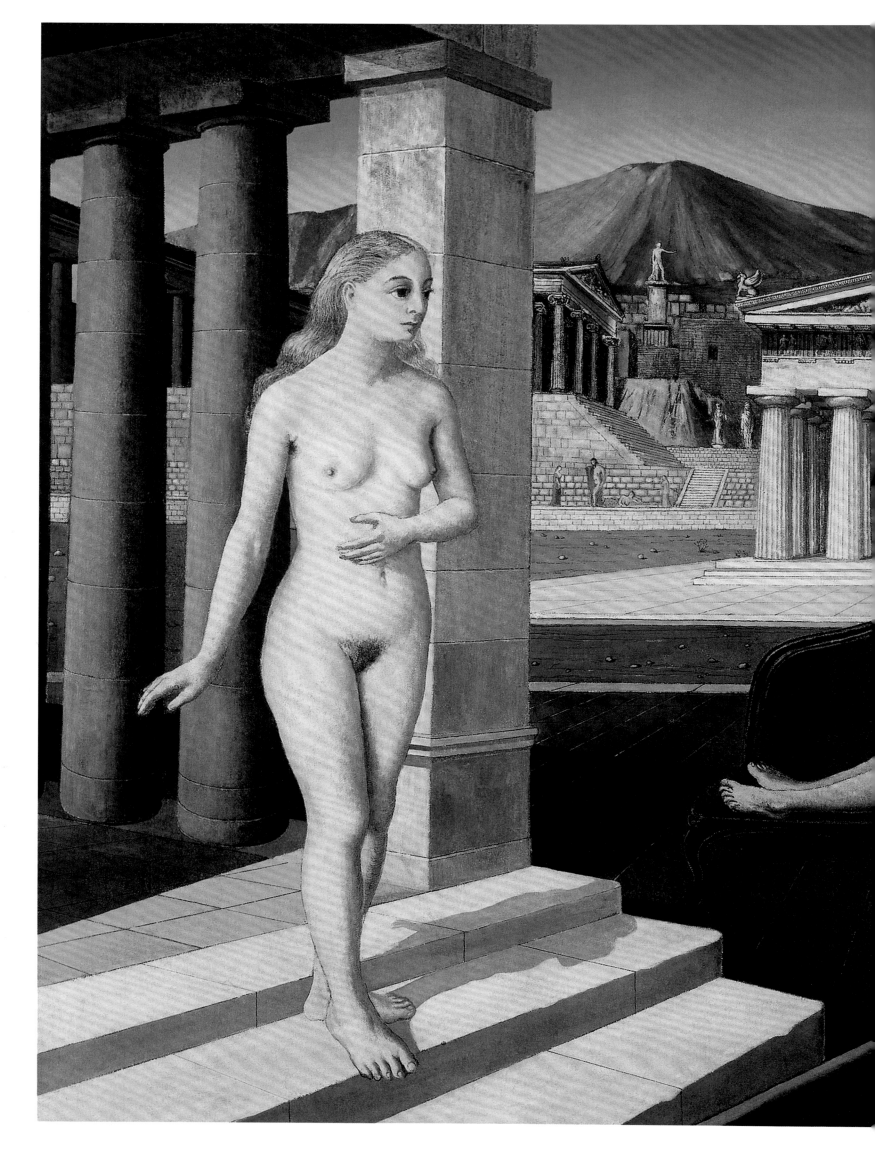

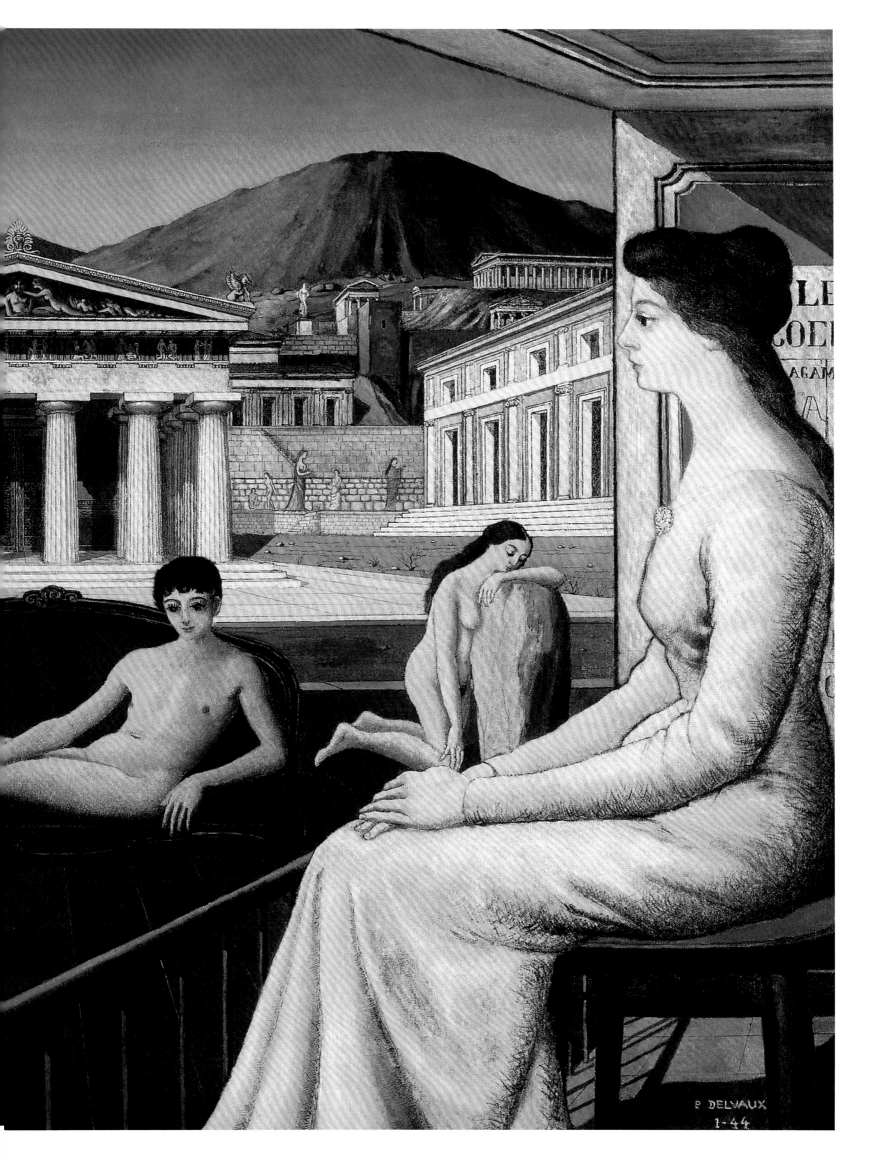

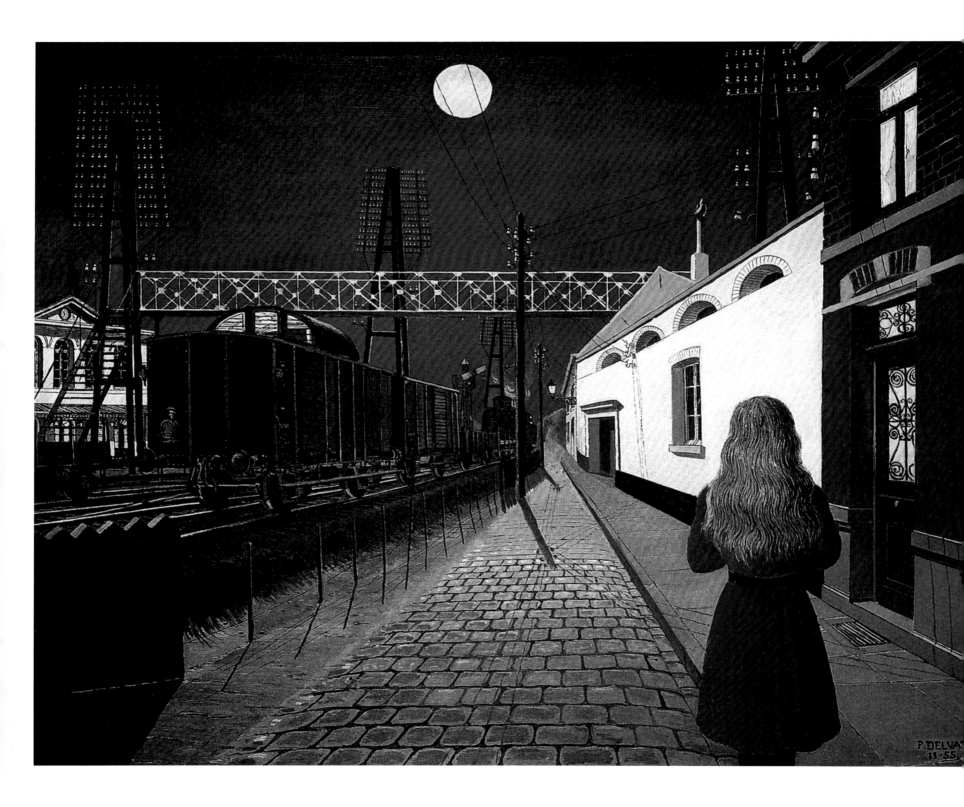

youth are, could find a place of some kind in a picture, but that with its strange appearance it was bound to dominate the atmosphere of the whole scene. So I chose the subject "The Phases of the Moon", in line with the scientific character of the distinguished gentleman, but since it was necessary to work 'against' this extremely austere character and to give it a more universal meaning, I added the nude figures and a landscape which to some extent took it out of its element![243]

Sometimes a visitor from contemporary, real life arrives in Delvaux's pictures. Once he comes into the classical land populated by girls, the prosaic figure stays there forever. He also passes across this country without paying any attention to the strange beings surrounding him. Sometimes he even reads the newspaper as he walks (*The Man in the Street*). He is reminiscent of the male figure in Magritte's paintings, in profile, in overcoat and bowler hat. He is ordinary and unremarkable. Even when something absolutely incredible is happening in the picture, he modestly slips past, and his silhouette vanishes into the distance (*Pygmalion*). And at that point, the legend of Pygmalion appears before our eyes, turned upside-down. It is not the sculptor who is striving to bring the statue he has created to life, but a living Galatea who embraces Pygmalion's marble torso.

Delvaux lived at a distance from the Surrealists's scandals, and in his painting a direct reaction to the current world events cannot be sensed. However, in the era of the Second World War, a mood of anxiety did appear in his paintings. In the midst of a forest of classical columns, a nude model finds herself alone and lost (*The Prisoner*). Strange cities inspire a mood of anguish and fear. The helpless female in the picture *Echo* becomes smaller and smaller, receding along the barren vista of the street as the echo of the human voice becomes ever fainter (*Echo*).

New figures came into Delvaux's pictures. In 1941, he began to visit the Museum of Natural History, and to draw skeletons there. This was more than a recollection of the Spitzner museum: his skeletons came out of the pictures of Breughel, Rops and Ensor. However, Delvaux determined the theme of the "memento mori" in his own fashion, and his skeletons possess a sense of humour and a special fascination. They carry themselves like characters of flesh and blood, and they represent the skeletons of these characters. Sitting beside an unknown young woman, a skeleton imitates her pose and movement – life and death are always found together (*The Red Courtisans*; *The Woman and the Skeleton*). The skeletons in Delvaux's pictures conduct themselves ever more freely, gradually taking the place of living people on the street and in the office (*Skeletons in an Office*). In one of his interviews the artist said:

> The skeleton is for me a very, very, very powerful form of human expression…
> What strikes me about the skeleton is its humanity, the sensation that the
> skeleton is after all the framework for the human being, for a living being…;
> that every living being possesses a skeleton under his muscles and face; and this
> skeleton is the image of the human being. So you only need to take one more
> step to move from that to giving a skeleton an expression: to make a skeleton
> come alive, in other words to give it life, to make it walk, to make it think, to
> make it talk, to get it to make movements like those of a living being. I think
> that it's possible to get there. I did not want to represent death. That was not
> my idea at all. I wanted to make scenes with expressive skeletons.

Skeletons take the place of living characters in biblical scenes. Delvaux thought that he could never paint *The Deposition from the Cross* or *The Laying in the Tomb* better than the old masters had done. "What I could do", he said, "was to replace the living figures with skeletons, because then I could immediately

Paul Delvaux,
Solitude, 1955.
Oil on panels, 99.5 x 124 cm.
Musée des Beaux-Arts, Mons.

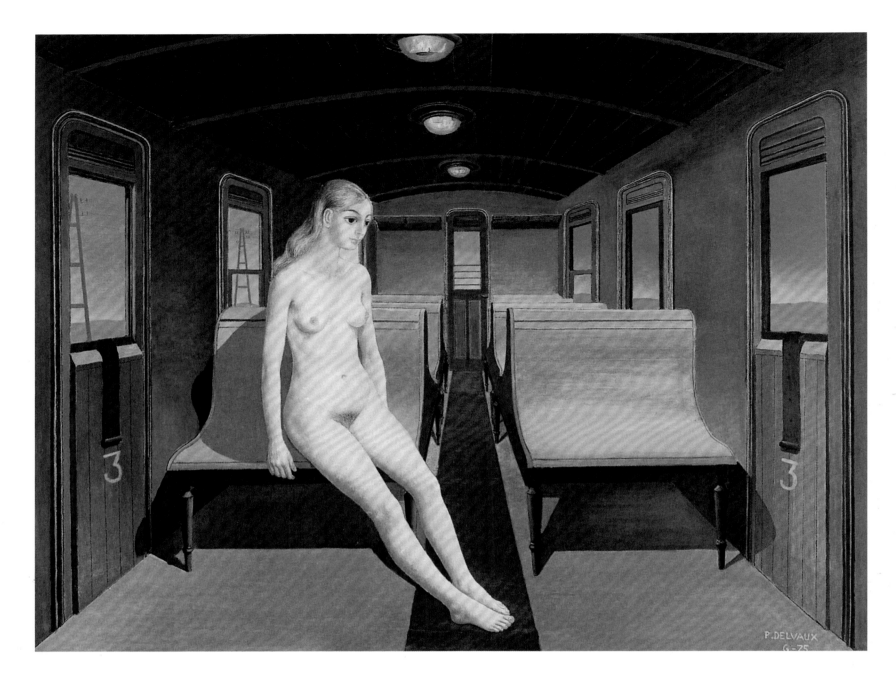

give my skeletons something extra, different, dramatic, alive. That is why I made scenes of the Passion with skeletons…"²⁴⁴ (*The Deposition from the Cross*; *The Entombment*).

The height of Delvaux's creative output occurred in the period between the 1940s and 1950s. During this period, all the figures he had created earlier continued to live in his pictures. They are gathered together, but each of them continues to live its own separate life, linked in no way to the others' lives. They exist in fantastic classical or renaissance towns in the quiet of a strange dream. In these circumstances, the sleeping Venus quite naturally appeared. She was never a copy of the images of the renaissance masters or of Delvaux's beloved Ingres, only a troubling reminder of them. Sometimes skeletons appear beside her. It may be that they appear to her in a dream, as Le Douanier Rousseau's sleeping gypsy dreams of a lion. For Delvaux, the image of the sleeping Venus was the motif in which he expressed a state of disquiet, a sense of the tragedy of war.

He painted his best Venus at the time of the bombing of Brussels in 1944. The artist recalled that in the evening, once he had finished work, he put the picture at right angles to the window, naively believing that this was the best way to protect it. He said:

> I think I evoked, perhaps unconsciously, a mysterious and intangible anxiety with the temples in the moonlight… and a few troubled figures, in contrast to this Venus, sleeping peacefully and watched over by a dark mannequin and a skeleton. I tried to put contrasts and mystery into this picture. I should add that

Paul Delvaux,
The Last Wagon, 1975.
Oil on canvas, 150 x 190 cm.
Fondation Paul Delvaux, Saint-Idesbald.

Paul Delvaux,
Chrysis, 1967.
Oil on canvas, 160 x 140 cm.
Fondation Paul Delvaux, Saint-Idesbald.

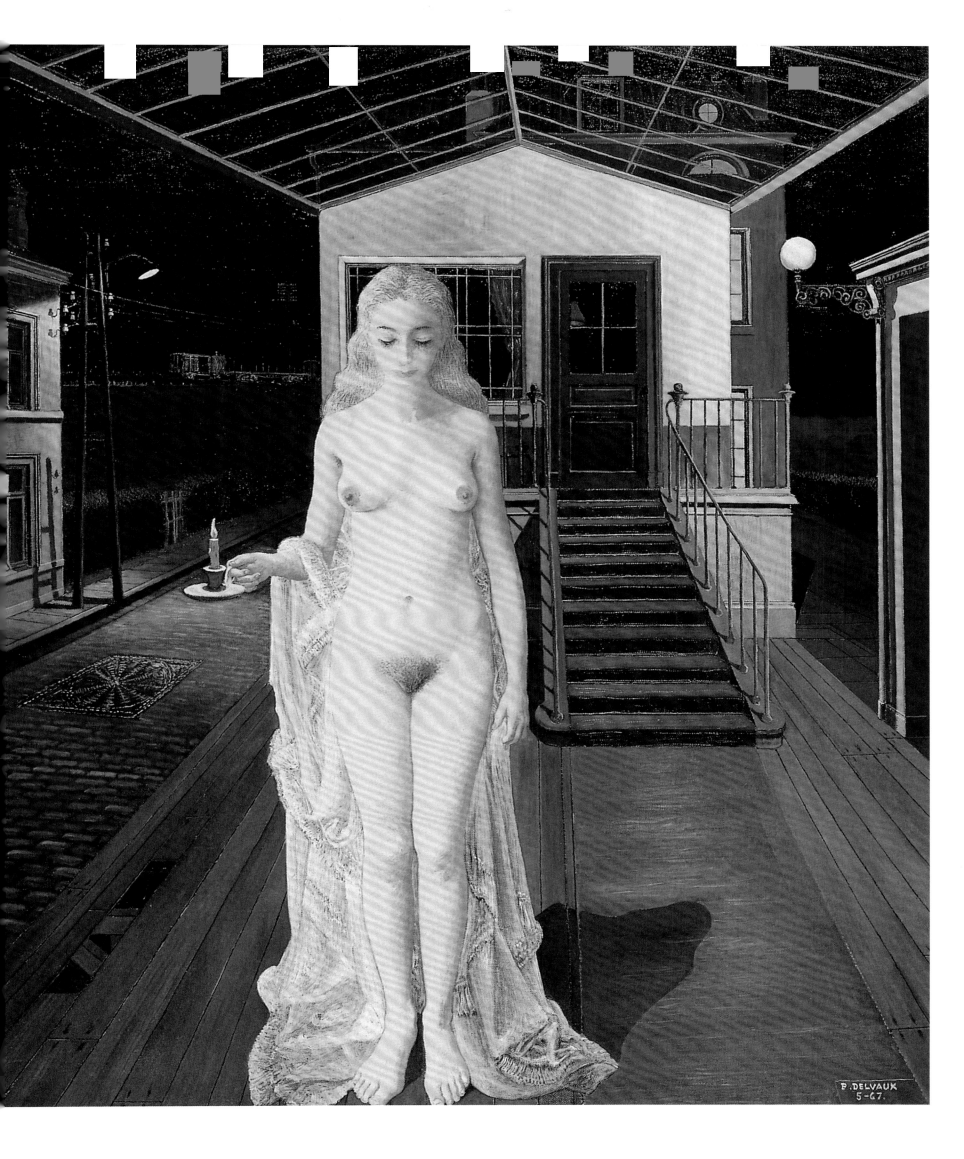

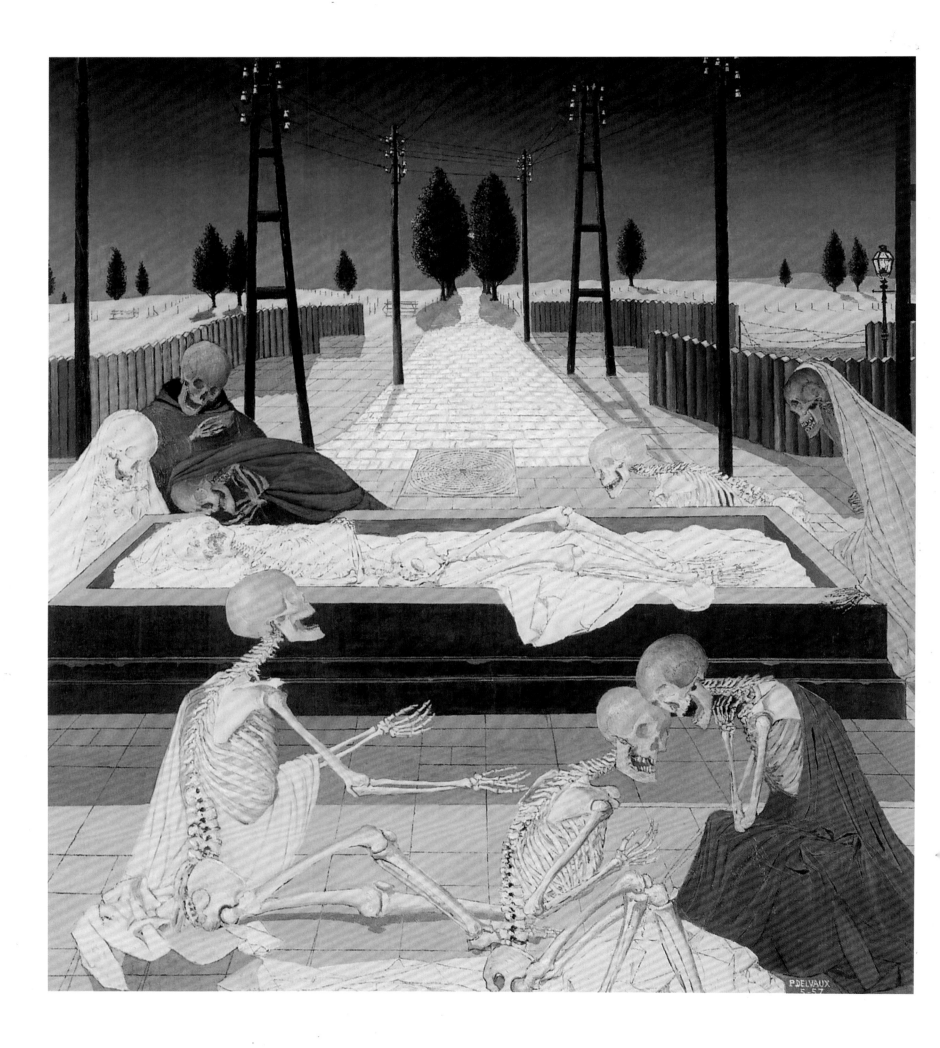

the psychological moment was exceptional, full of drama and anxiety. I wanted
to express such anxiety in contrast to the serenity of the Venus.[245]

And indeed, Delvaux's Venus, his nude model, possessed the gift of expressing all the most delicate nuances of his attitude to the world. Paul Éluard wrote in 1939:

Among the jewels the palaces the countryside
To reduce the sky
Large immobile women
On the robust days of summer

To cry as one sees these women come
To reign over death and to dream under the earth

They are neither empty nor sterile
But they lack boldness
And their breasts bathing their mirror
Eye naked in the clearing of expectation

They are peaceful and more beautiful for being alike

Far from the destructive smell of flowers
Far from the explosive form of fruits
Far from the useful gestures, the timid women

Delivered up to their destiny know nothing besides themselves."[246]

Another passion remains in Delvaux's painting. He always loved trams and trains. "As a child, I wanted to become a station-master", the artist remembered. He admitted that as an adult he still collected models of engines and carriages: "When I was a kid, I loved trains and I still love them now. I pick up the old carriages which my little nephew leaves lying around."[247] He drew them from a young age. Trains generally became characters in his paintings as well. In his sketchbooks for 1922, there are drawings of train-tracks receding into the distance and cargo trains. At this stage in his painting, he had already depicted the Gare du Luxembourg in Brussels. Provincial Belgian stations would appear in his drawings as childhood memories. Trams appeared in his pictures in the 1940s. And in the 1950s, trains and stations become almost the only motif in his paintings. Day and night, the stations were empty but the trains always recede into the distance. The stations were genuine, he drew them from life and down to the smallest detail, but very often there were no people in them (*Little Station at Night*). Delvaux's empty stations are alluring and mysterious. Sometimes a nude figure appears on the station platform or in the waiting-room. Venus sleeps on the sofa in the underpass below the railway-line near Paul Delvaux's home at Watermael-Boitsfort (*The Blue Sofa*). For the whole of his long life, Paul Delvaux stayed true to himself.

In the 1950s, Delvaux ranked alongside the most outstanding artists of Belgium. He obtained commissions for murals. In 1959, he painted the Palace of the Congress in Brussels, and in the 1960s, the Institute of Zoology at the University of Liège. He became the President and Director of Belgium's Royal Academy of Fine Arts. In 1977, Paul Delvaux was admitted to France's Academy of the Fine Arts as an associate foreign member. Paul Delvaux died in 1994 at the age of ninety-seven.

Paul Delvaux,
The Entombment, 1957.
Oil on canvas, 130 x 120 cm.
Fondation Paul Delvaux, Saint-Idesbald.

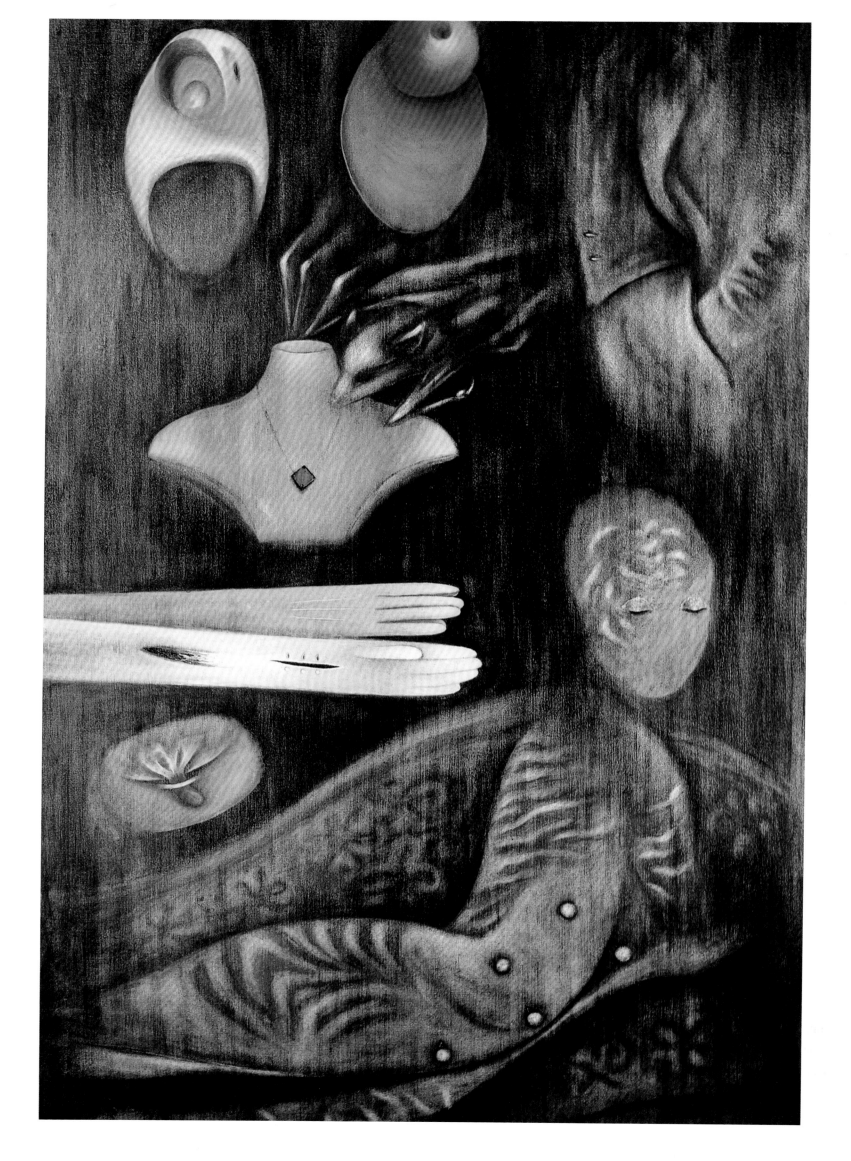

SURREALISM WITHOUT FRONTIERS

Overall, the greatest flowering of Surrealism in the fine arts occurred in the 1930s. Surrealism as an artistic movement expanded beyond the borders of France. Groups of Surrealists were everywhere – in Belgium, Czechoslovakia, England and Japan. Among the Surrealists there were emigrants from Yugoslavia, Romania, Hungary and Poland. The collective exhibitions of the Surrealists' art and exhibitions of individual artists reached every continent of the world. Indeed, until then, no movement in the fines arts had enjoyed such popularity. The superb journal *Minotaure*, published by A. Skira and E. Teriade, has come to symbolise all the other vanished Surrealist journals. Between 1933 and 1938, eleven numbers of the journal were published. *Minotaure* was not an exclusively Surrealist journal and all the important contemporary painters contributed to it. Pablo Picasso provided an image of the minotaur for the cover of the first number. But the Surrealists at that time were in possession of such a supply of energy, and were the objects of such fascination, that, in practice, they made the journal the expression of their ideas. Their apotheosis was the International Exhibition of Surrealism at the Galerie des Beaux-Arts, Rue Faubourg Saint-Honoré, in Paris in 1938. The exhibition caused a great stir, the press was outraged, but the popularity of Surrealism knew no bounds.

When it came to Surrealism, even Picasso could not resist its temptation. His insatiable curiosity and interest in everything new not only drew him at certain points towards elements of Surrealism, but also made the language of Surrealism one of the means of expression in his art. "Pablo Picasso can be surrealist when he wants to be, in the same way that he can be Greek, baroque, realist or Negro, without ever ceasing to be Picasso", writes Patrick Waldberg, an historian of Surrealism.

> … Picasso is effortlessly surrealist when he makes a bird or a human figure spring to life from a bit of string, or when an antelope is born, as if by a miracle, from the conjunction of a bicycle saddle and a pair of handlebars, or when from an ordinary burner, separated from its stove and set upright, he creates, without touching anything, what he calls the 'Venus du Gaz'. With this qualification, one can say that Picasso did make use of Surrealism."[248]

The number of artists attracted to the Surrealist movement was not limited to the biggest names, and in fact there are many more of them than that. Between 1931 and 1935, Alberto Giacometti (1901-1966) was a member of Breton's group, but he had been a Surrealist before then. Alberto Giacometti's talent took shape in Switzerland, in a family of artists, and in 1927 he based himself in Paris in a small studio in the Montparnasse area. He met André Masson and Michel Leiris, and came to know the Surrealist poets and Joan Miró. The exhibition in 1929 at the Galerie Jeanne Bucher made him renowned in artistic circles. Pierre Loeb, the owner of the Galerie Pierre, the gallery of the Surrealists, signed a contract with him. In 1930, he met Aragon and Breton, and the latter persuaded him to join his group. Giacometti's Surrealist objects attracted attention in all the exhibitions; they were incomprehensible and enigmatic. "The world is a sphinx in front of which we are continually standing, a sphinx which stands continually in front of us and which we question", said Giacometti.[249] However, in 1935, Alberto Giacometti left the group whose confines he found too narrow.

Toyen (Marie Cermínová),
The One in the Other, 1965.
Private Collection.

It is difficult to forget Oscar Domínguez (1906-1957), who brought a new technique to the pictorial media of the draftsman, "decalcomania". Max Ernst began at once to use it in his painting. Wolfgang Paalen (1907-1959), a native of Vienna, also made Surrealist objects. His ghost ships and compositions inspired by the art of American Indians hold a special place in the context of Surrealism. The Pole Hans Bellmer (1902-1975), who studied in Berlin, was made famous in Paris through his *Doll* – a dismantled mannequin of a little girl of which parts are arbitrarily distributed over the space of a canvas. The Czech artist Marie Cermínová, who remained a loyal supporter of Breton, is famous under the name of Toyen (1902-1980). She came to Surrealism in the early 1930s, after her involvement in avant-garde trends in Czech art. In 1935, Breton traveled to Prague. From that point on, Toyen featured in all of the Surrealists's exhibitions. Her erotic canvases and drawings, with their special sense of humour, are the basis of her fame. The Romanian painted Victor Brauner (1903-1966) arrived in Paris in 1925. What drew him, like so many others, to Surrealism was the painting of Giorgio de Chirico. In 1932, he was officially admitted into the Paris group of Surrealists. From then on, he took part in all the group exhibitions. He painted mystical, often sinister pictures. What struck Brauner's contemporaries about him was that his life was just as Surrealist as his painting. In his pictures, he often employed the motif of the accident, and he himself was to be the victim of a tragic collision with his friends in which he lost an eye.

What expanded the frontiers of Surrealism was the way in which it was interpreted as an art which allowed one to break into a world of mystery; and the mystery attracted many people. "The marvelous is always beautiful, the marvelous of any kind is beautiful, and it is only really the marvelous that can be beautiful", wrote André Breton.[250] This is why the painting of the Pole, Balthazar Klossowski de Rola, who called himself Balthus, attracted the Surrealists's attention. His famous picture *The Street* (1933) was reproduced in *Documents surréalistes*. It is difficult to define Balthus's secret. His pictures, painted in the classical style, represent subjects from ordinary, everyday life, but in each of them there is a mystery, the feeling of a dream. It would be possible to name a whole series of artists who had risen on the crest of the Surrealist wave. However, the Second World War cut short the progress of Surrealism around the world. A certain number of artists had to endure the war in Europe, but many left for America.

During and immediately after the war, there arose a new wave of Surrealism, and new Surrealists emerged. Among them were those artists from the Americas who had come under the influence of the new European arrivals to America, and who included the Cuban Wilfredo Lam, the Chilean Roberto Matta and the Armenian Adoyan. The latter came to know the Surrealists in New York, and became famous under the pseudonym Arshile Gorky. Young artists arrived in Paris from various countries, and one or two of them, such as the Romanian Jacques Harold, also started down the Surrealist road.

After the war, the art world changed in many ways – abstract painting assumed an ever greater place, and the centre of modern art moved West, from Europe to North America, where new tendencies took shape. On their return to Paris, the Surrealists continued to work and to be exhibited, but now they were no longer the dominant ones in the art scene. It looked as though the last lights of Surrealism were flickering in the gusts of a new wind and were just about to be blown out. However, the secret of Surrealism is contained in the fact that its foundations – mystery, the magic of the dream and the mystique of the incomprehensible – attracted people and will always attract many. Even without the gift of prophecy, one can be fairly sure that the Surrealist flame still smoulders below the surface of even the most recent artistic developments. A moment will come when it will be revived under another name, and then it will flare up again with such force that our descendants might never need to call it by a different name.

Roberto Matta,
Earth is a Human Being.
Private Collection.

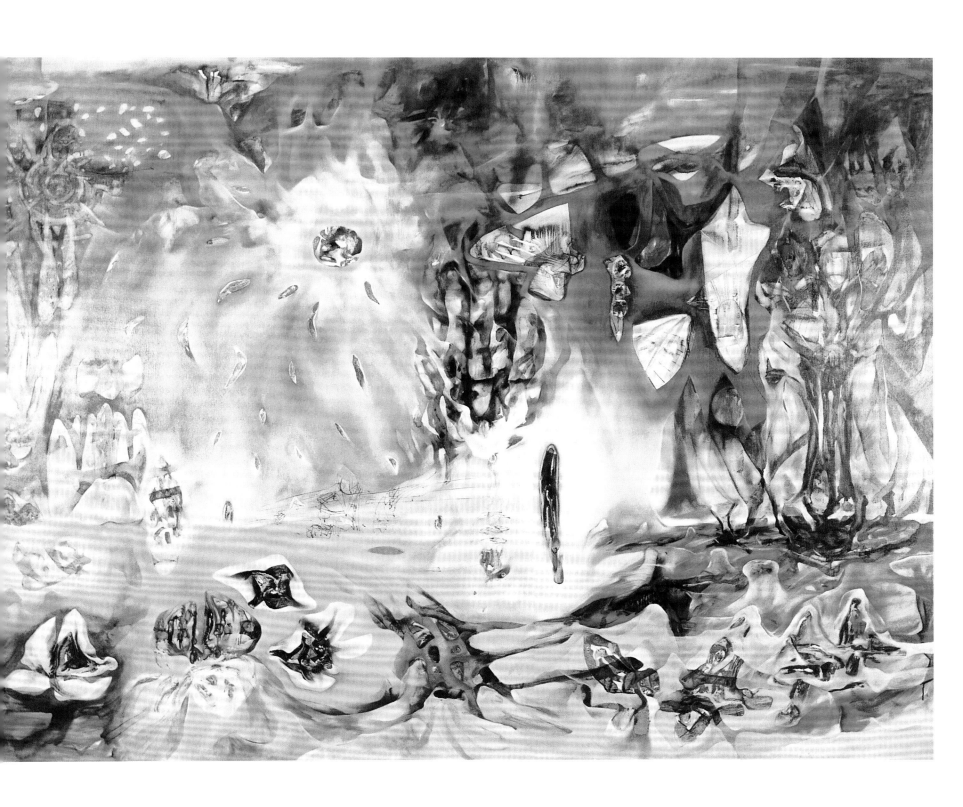

Notes

1. *Yves Tanguy*, Paris, MNAM, 1982, p. 43
2. *Ibid.*
3. *Chirico*, Paris, Grands peintres, 1968, p. 3
4. Paul Éluard, *Capitale de la douleur*, Paris, 1966, p. 62
5. *L'opera completa di de Chirico, 1908-1924*, Milan, 1984, p. 74
6. *Chirico, op. cit.*, p. 6
7. Guillaume Apollinaire, *Calligrammes*, Paris, 1966, p. 134
8. Agnès Humbert, *Les Nabis et leur époque*, Geneva, 1954, p. 137
9. Henri Matisse, *Zametki zhivopistsa*, St. Petersburg, 2001, p. 372
10. *Dadaism*, Moscow, 2002, pp. 49-50
11. *Kazimir Malevich, 1878-1935*, exhibition catalogue, Leningrad-Moscow-Amsterdam, 1989, p. 131
12. Fernande Olivier, *Picasso et ses amis*, Paris, 2001, p. 49
13. Louis Chaumeil, *Van Dongen*, Geneva, 1967, p. 94
14. Guillaume Apollinaire, *op. cit.*, p. 74
15. *Ibid.*, p. 107
16. Michel Sanouillet, *DADA à Paris*, Paris, 1993; Moscow, 1999, p. 59
17. *Ibid.*
18. Quoted in *Dadaism, op. cit.*, p. 92
19. Tristan Tzara, *Dada est tatou, tout est Dada*, Paris, 1996, p. 204
20. *Ibid.*
21. *Ibid.*, p. 212
22. *Ibid.*, p. 210
23. *Dadaism, op. cit.*, p. 94
24. Tristan Tzara, *op. cit.*, p. 98
25. *Ibid.*, p. 228
26. *Ibid.*, p. 250
27. *Ibid.*, p. 166
28. *Ibid.*, p. 206
29. Quoted in Michel Sanouillet, *op. cit.*, p. 87
30. "Les Sentiments sont gratuits", André Breton, Philippe Soupault, *Les Champs magnétiques*, Paris, 1971
31. "L'Eternité", André Breton, Philippe Soupault, *ibid.*, p. 110
32. Quoted in Michel Sanouillet, *op. cit.*, p. 141
33. Tristan Tzara, *op. cit.*, p. 188
34. Quoted in Michel Sanouillet, *op. cit.*, p. 228
35. *Ibid.*, p. 325
36. *Ibid.*
37. Quoted in Maurice Nadeau, *Histoire du surréalisme*, Paris, 1964, p. 44
38. Aragon, "Une vague de reves", Nadeau, *ibid.*, p. 47
39. Quoted in Michel Sanouillet, *op. cit.*, p. 57
40. "Apollinaire", St. Petersburg, 1999, p. 440
41. *Ibid.*, p. 547
42. *Ibid.*, p. 438
43. Maurice Nadeau, *op. cit.*, p. 16
44. André Breton, *Manifeste du surréalisme*, Paris, 1991, p. 35
45. Gérard de Nerval, *Les Filles du feu*, Paris, 1994, p. 82
46. Patrick Waldberg, *Le Surréalisme*, Geneva, 1962, p. 21
47. André Breton, *op. cit.*, p. 24
48. *Ibid.*, p. 16
49. *Ibid.*, p. 20
50. *Ibid.*, p. 24
51. *Ibid.*
52. *Ibid.*, p. 36
53. *Ibid.*, p. 44
54. Maurice Nadeau, *op. cit.*, p. 56
55. *Ibid.*, p. 61
56. "The River", Paul Éluard, *op. cit.*, p. 22
57. "Interior", *ibid.*, p. 31
58. "Nil", *ibid.*, p. 30
59. "Nil", *ibid.*, p. 30
60. Maurice Nadeau, *op. cit.*, p. 82
61. *Ibid.*, p. 93
62. Quoted in Virginia Pitts Rembert, *Bosch*, New York, 2004, p. 17
63. *Yves Tanguy, L'Univers surréaliste*, Paris, 2007, p. 13

64. André Breton, *op. cit.*, p. 37
65. *Ibid.*, p. 38
66. Patrick Waldberg, *op.cit.*, p. 25
67. Odilon Redon, *A Soi-même*, Paris, 1922, p. 100
68. *Ibid.*
69. *Ibid.*, p. 27
70. *Ibid.*, p. 29
71. *Ibid.*
72. *Ibid.*
73. *Ibid.*, p. 97
74. Friedrich Nietzsche, "The Birth of Tragedy from the Spirit of Music", in the collection *Stikhotvoreniia. Filosofskaia proza*, St. Petersburg, 1993, p. 136
75. *Ibid.*
76. *Ibid.*
77. *Ibid.*, p. 137
78. *Ibid.*
79. "Max Ernst", Paul Éluard, *op. cit.*, p. 116
80. Patrick Waldberg, *Max Ernst*, Paris, 1958, p. 102
81. *Ibid.*, p. 134
82. *Ibid.*, p. 136
83. *Ibid.*, p. 138
84. *Ibid.*, p. 26
85. *Ibid.*, p. 282
86. Paul Éluard, *op. cit.*, p. 13
87. Max Ernst, *Histoire de forêt*, Nantes, 1987, p. 54
88. Quoted in Max Ernst, *ibid.*, p. 51
89. *Ibid.*, p. 52
90. *Ibid.*, p. 52
91. *Ibid.*, p. 53
92. *Ibid.*, p. 28
93. Waldberg, *Max Ernst, op. cit.*, p. 276
94. *Ibid.*, p. 277
95. Paul Éluard, *Pis'ma k Gala*, Moscow, 1999, p. 17
96. Max Ernst, *op. cit.*, p. 54
97. *Ibid.*, p. 55
98. Patrick Waldberg, *Max Ernst, op. cit.*, p. 342
99. Max Ernst, *Peintures pour Paul Éluard*, Paris, 1969, p. 16
100. "La maison d'Yves Tanguy", André Breton, *Signe ascendant*, Paris, 1968, p. 24
101. *Yves Tanguy, L'Univers surréaliste, op. cit.*, p. 13
102. *Yves Tanguy*, op. cit., p. 192
103. *Ibid.*, p. 178
104. *Yves Tanguy, L'Univers surréaliste, op. cit.* p. 136
105. *Ibid.*, p. 60
106. Jacques Prévert, *Paroles*, Paris, 1949, p. 206
107. *Ibid.*, p. 67
108. *Yves Tanguy, L'Univers surréaliste, op. cit.*, p. 104
109. *Ibid.*
110. *Yves Tanguy, op. cit.*, pp. 92-93
111. *Yves Tanguy, L'Univers surréaliste, op. cit.*, p. 141
112. *Yves Tanguy, op. cit.*, p. 124
113. *Ibid.*, p. 117
114. *Ibid.*, p. 229
115. *Yves Tanguy, L'Univers surréaliste, op.cit.*, p. 214
116. Paul Éluard, *op. cit.* , p. 129
117. *Joan Miró*, Paris, Grand Palais, 1974, p. 30
118. *Ibid.*, p. 32
119. *Miró: L'Artiste et l'Œuvre*, Paris, 1971, p. 8
120. *Joan Miró*, 1974, *op.cit.*, p. 30
121. *Ibid.*, p. 11
122. *Ibid.*, p. 13
123. *Miró*, Paris, Maeght, 1971, p. 11
124. *Joan Miró*, 1974, *op. cit.*, p. 32
125. *Ibid.*, p. 34
126. *Ibid.*

127. *Miró*, Martigny, Switzerland, 1997, p. 40
128. *Ibid.*
129. Michel Leiris, "Fissures", *Viro*, Paris, 1974, p. 46
130. *Miró*, 1997, *op.cit.*, p. 66
131. *Ibid.*, p. 72
132. *Ibid.*, p. 82
133. *Ibid.*
134. *Miró*, Maeght, 1971, *op. cit.*, p. 14
135. *Miró*, 1997, *op. cit.*, p. 94
136. *Miró*, Maeght, 1971, *op. cit.*, p. 15
137. Joan Miró, *Cahiers d'Art*, vol. 20-21, 1945-1946, p. 272
138. *Miró*, Maeght, 1971, *op. cit.*, p. 15
139. *Joan Miró*, 1974, *op. cit.*, p. 34
140. *Ibid.*
141. *Miró*, 1997, *op. cit.*, p. 114
142. *Ibid.*
143. *Ibid.*
144. Jacques Prévert, *Joan Miró*, Paris, Maeght, 1956, p. 58
145. Paul Éluard, *op. cit.*, p. 105
146. André Breton, *op. cit.*, pp. 78-79
147. Patrick Waldberg, *Le Surréalisme*, *op. cit.*, p. 70
148. *Ibid.*, p. 65
149. D.H. Kahnweiler, *Mes galeries et mes peintres. Entretiens avec Francis Cremieux*, Paris, 1961, pp. 150-151
150. *Ibid.*, p. 152
151. *Ibid.*
152. Jean Leimaris, in: *Joan Miró*, 1974, *op. cit.*, p. 12
153. André Masson, *90 œuvres sur papier*, Paris, Louis Leiris, p. 6
154. Patrick Waldberg, *Le Surréalisme*, *op. cit.*, p. 66
155. *André Masson*, Lyon, 1967.
156. D.-H. Kahnweiler, *op. cit.*, p. 161
157. *Ibid.*, pp. 184-185
158. *Ibid.*, p. 205
159. Patrick Waldberg, *Le Surréalisme*, *op. cit.*, p. 70
160. Charles Baudelaire-Nouage, "The Faithful Lover", 1945
161. Louis Scutenaire, *René Magritte*, Brussels, 1964, p. 7
162. "René Magritte", *Beaux-Arts Magazine*, Montreal, 1996, p. 8
163. *René Magritte*, Lausanne, 1987, p. 12
164. "René Magritte", *Beaux-Arts Magazine*, *op. cit.*, p. 11
165. *René Magritte*, 1987, *op. cit.*, p. 185
166. *Ibid.*, p. 17
167. "René Magritte", *Beaux-Arts Magazine*, *op. cit.*, p. 22
168. Louis Scutenaire, *op. cit.*, p. 10
169. *Ibid.*, pp. 9-10
170. "René Magritte", *Beaux-Arts Magazine*, *op. cit.*, p. 36
171. *René Magritte, La Pensée et les images*, in cat. Palais des Beaux-Arts, Brussels, 1954
172. Louis Scutenaire, *op. cit.*, p. 11
173. *Ibid.*
174. *René Magritte*, 1987, *op. cit.*, p. 179
175. Jose Pierre, *Magritte*, Paris, 1984, p. 59
176. "Lifeline", *Magritte*, 1987, *op. cit.*, p. 185
177. Louis Scutenaire, *op. cit.*, p. 12
178. *René Magritte*, 1987, *op. cit.*, p. 185
179. *Ibid.*, p. 200
180. *Ibid.*, p. 187
181. *Ibid.*, p. 191
182. *Ibid.*, p. 196
183. *Quatre-vingt-deux lettres de René Magritte à Mirabelle Dors et Maurice Rapin*, Paris, 1976
184. René Magritte, "L'Empire des lumières", in *Peintres belges de l'imaginaire*, Paris, 1972, p. 118
185. René Magritte, "Interview pour *Life*", in *René Magritte*, 1987, *op. cit.*, p. 208
186. *René Magritte*, 1987, *op. cit.*, p. 44
187. Federico Garcia Lorca, citied in: *Salvador Dalí, Retrospective*, Paris,

188. Salvador Dalí, *Surrealizm – eto ia*, Moscow, 2005, p. 605
189. *Ibid.*, p. 489
190. Quoted in *Salvador Dalí, Retrospective*, *op. cit.*, p. 21
191. Salvador Dalí, *La Vie secrète de Salvador Dalí*, Moscow, 1998, p. 20
192. Salvador Dalí, *Surrealizm – eto ia*, *op. cit.*, pp. 491-492
193. *Salvador Dalí, Retrospective*, *op. cit.*, p. 24
194. *Ibid.*, p. 25
195. *Ibid.*, p. 35
196. Salvador Dalí, *Dnevnik odnogo geniia*, Moscow, 1991, p. 111
197. *Ibid.*, pp. 112-114
198. *Salvador Dalí, Retrospective*, *op. cit.*, p. 32
199. *Ibid.*, p. 95
200. *Ibid.*, p. 97
201. Salvador Dalí, *Surrealizm – eto ia*, *op. cit.*, p. 44
202. Salvador Dalí, *La Vie secrète de Salvador Dalí*, *op. cit.*, p. 182
203. *Salvador Dalí, Retrospective*, *op. cit.*, p. 155
204. *Ibid.*, p. 39
205. Salvador Dalí, *Surrealizm – eto ia*, *op. cit.*, p. 69
206. *Ibid.*, p. 71
207. Maurice Nadeau, *op. cit.*, pp. 149-150
208. Salvador Dalí, *Surrealizm – eto ia*, *op. cit.*, p. 183
209. *Ibid.*, p. 157
210. *Ibid.*, p. 42
211. *Ibid.*, pp. 35-36
212. *Ibid.*, p. 50
213. *Ibid.*, p. 61
214. *Ibid.*, p. 149
215. *Ibid.*, p. 34
216. Quoted in Maurice Nadeau, *op. cit.*, p. 148
217. Salvador Dalí, *Dnevnik odnogo geniia*, *op. cit.*, p. 54
218. Quoted in *Salvador Dalí, Retrospective*, *op. cit.*, p. 246
219. *Ibid.*, p. 176
220. *Ibid.*, p. 173
221. *Ibid.*, p. 174
222. Salvador Dalí, *Surrealizm – eto ia*, *op. cit.*, p. 145
223. Salvador Dalí, *Dnevnik odnogo geniia*, *op. cit.*, p. 72
224. Salvador Dalí, *Surrealizm – eto ia*, *op. cit.*, p. 50
225. *Salvador Dalí, Retrospective*, *op. cit.*, p. 320 and 322
226. *Ibid.*, p. 202
227. *Ibid.*, p. 287
228. Salvador Dalí, *Dnevnik odnogo geniia*, *op. cit.*, p. 64
229. *Ibid.*
230. *Ibid.*, p. 70
231. *Salvador Dalí, Retrospective*, *op. cit.*, p. 300
232. *Ibid.*, p. 307
233. *bid.*, p. 285
234. Paul Éluard and Paul Delvaux, *Poèmes, Peintures, Dessins*, Geneva-Paris, 1948
235. *Paul Delvaux*, Rotterdam, Museum Boijmans Van Beuningen, 1973, p. 13
236. *Ibid.*, p. 14
237. *Ibid.*
238. *Ibid.*
239. *Ibid.*, p. 15
240. *Ibid.*
241. *Ibid.*
242. *Paul Delvaux*, *op. cit.*, p. 109
243. *Ibid.* p. 122
244. *Ibid.*, p. 116
245. *Ibid.*, p. 136
246. Paul Éluard and Paul Delvaux, *op. cit.*
247. *Ibid.*, p. 149
248. Patrick Waldberg, *Le Surréalisme*, *op. cit.*, p. 51
249. "Giacometti, la sculpture en marche", *Beaux-Arts*, Paris, 2007, special edition, n° 15
250. Patrick Waldberg, *Le Surréalisme*, *op. cit.*, p. 109

INDEX